BEST MOVIES OF THE 70s

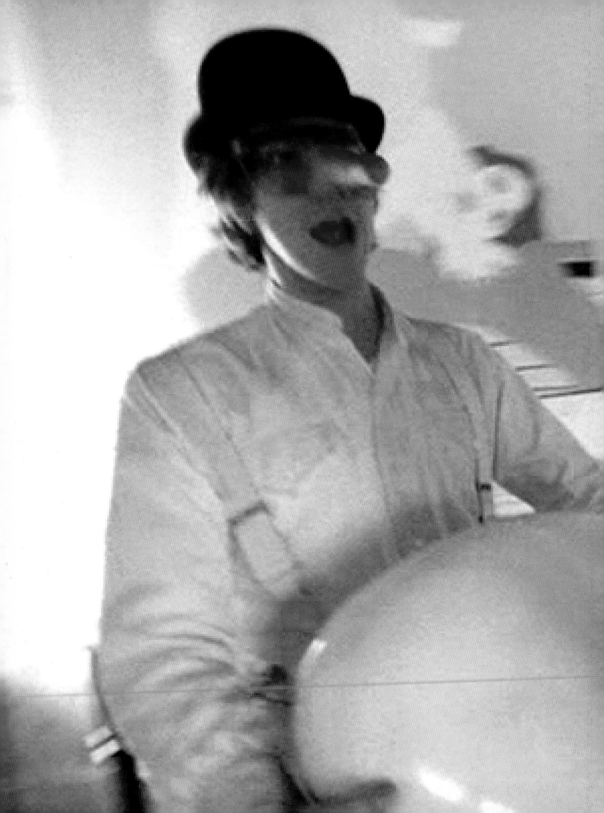

JÜRGEN MÜLLER (ED.)

BEST MOVIES OF THE 70s

IN COLLABORATION WITH
defd AND CINEMA, HAMBURG
BRITISH FILM INSTITUTE, LONDON

TASCHEN

KÖLN LONDON LOS ANGELES MADRID PARIS TOKYO

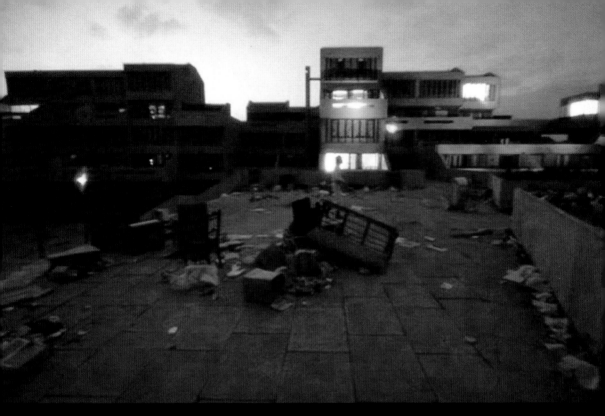

THE SKEPTICAL EYE
Notes on the Cinema of the 70s

"Municipal Flatblock 18a, Linear North. This was where I lived with my dadda and mum," says Alex (Malcolm McDowell), as he strolls home whistling between the houses of a suburban housing development somewhere in the middle of nowhere. The place is like a labyrinth. Lights burn in a few windows, weakly illuminating the protagonist's path. There's something strangely static about the camera that accompanies him through these streets in a single parallel tracking shot. The dramatic impression is not created by Hollywood's standard techniques – shot/reverse shot – but by a camera that glides like a ghost through dilapidated flowerbeds full of discarded junk.

In this dismal environment, the film's young hero is the only sign of life, and he's just enjoyed a good night out. Alex and his droogs have tol-chocked an old tramp and a writer, raped a devotchka, stolen a car, and forced a respectable number of fellow-drivers into the roadside ditch. Hor-rorshow.

Alex is in a splendid mood. Accompanying him homewards, we become highly aware of the camera's presence. We're waiting for a cut, but the camera does not blink, staring persistently at Alex as it slides along at his side. What we see here is more than a happily whistling hoodlum; we're seeing the

Stanley Kubrick's *A Clockwork Orange* (1971, p. 58) is one of the key cult movies of the 70s, and certainly the most controversial. It might be described as the hinge that links the 60s with the 70s, for Kubrick's film may well be seen as a skeptical critique of the ideals formulated by the 60s student movement. Yet although the movie makes constant allusions to the progressive optimism of that decade, its purview includes the entire century and the inhuman ideologies that marked it out.

It's hard to think of another film that assigns us the role of voyeur so effectively. In a shocking way, *A Clockwork Orange* makes all of share responsibility for the things it shows. Thus the eloquent off-screen narrator who tells us his story never doubts for a second that he has our sympathy – and our consent. Again and again, he addresses us as "brothers." Still, the risk remains that we might have to see things from another perspective; and once, indeed, we find ourselves in the role of the victim – with Alex insisting we take a *veddy* good look... In this respect, Kubrick plays with the viewer's expectations. The film insists on breaking the bounds of fiction and assigning a series of different roles to us, the spectators. It's as if the director wanted to demonstrate his awareness of the pleasure we take in voyeurism, while

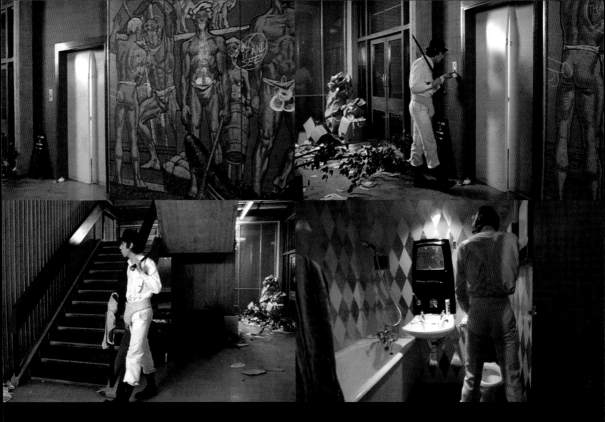

But Kubrick takes possession of us to an even greater extent than this, using all cinematic means available to give an authentic representation of Alex's world. We don't just see through Alex's eyes; we hear through his ears; and the music that accompanies his atrocities "allows" us to share his visceral pleasure in cruelty. As we watch a vicious brawl in a disused cinema, we hear Rossini's *La gazza ladra*; but this doesn't mean that Kubrick is trivializing violence.

On the contrary; the fighters' fun is simply being made plain to us. Kubrick is attempting to show – to make us *feel* – what violence looks like from the inside. Here, violence is presented as a creative principle. It signifies lust, intoxication, as described by Nietzsche in the "The Birth of Tragedy." The film sketches a theory of ecstasy as the true fulfillment experienced by any human being who escapes the limits of his individuality. One scene shows this with particular vividness: like a satyr of the ancient world, Alex embraces a stone phallus – life petrified into art – and reawakens it in a grotesque balletic dance.

As we accompanied Alex back to the flat, we got so close to him that we almost entered his Holy of Holies – home itself. with dadda and mum. In the entrance hall of his apartment block, the camera blinks: and now we're gliding along in front of a mural. Once again, the director has flouted our expectations. Naturally, we interpret this tracking shot as if we see what we're seeing through Alex's eyes. or as if we had just escorted him into the foyer; yet now, to our surprise, we see him enter the frame from the opposite direction. And while we wait for him to arrive. there's time to ex-

amine the heaps of garbage, the parched and trampled lawns. With the passage of time, this once impressive stairwell, with its murals and its potted plants, has adapted itself to the forbidding and inhospitable concrete jungle that surrounds it. The tenants' rage is directed at the "beautifications" – and especially at the mural, which is now disfigured by paint smears and obscene graffiti. The building's inhabitants, waiting in vain for the broken-down elevator, can only have taken pleasure in this fresco for a very short period. For they've "improved" it by adding enormous male sex organs, along with some helpful advice: "Suck it and see," says a boy bearing a narrow barrel, as he gazes down on his beholders from the painting on the wall.

Yet even without the obscenities, these heroic images of the working class don't really fit into their grim concrete environs. We see men and women of all ages united in their praise of skilled labor, agriculture and industry, an assurance of the happy future awaiting mankind. Here, careful planning and conscientious work are two sides of the same coin. Thinkers and doers, young and old, farmers, laborers and craftsmen, all striving together in the service of a better life, a new world forged by a vigorous humanity. At the center of the painting stands a man whose physique and headgear mark him out as a leader, brave and strong, he gazes heroically towards the future.

The fresco in the foyer of Alex's parents' apartment block seems very familiar – as if we had encountered it all over Europe in course of the 20th century. We know this kind of agitprop art; we've seen it in Berlin and

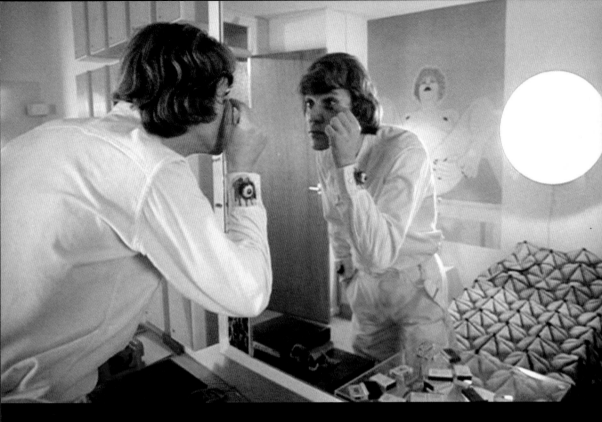

Rome, in Bucharest and Moscow. It's as if Kubrick wished to comment, in passing, on a century marked by totalitarian systems. But this director doesn't make it easy for the audience; for he's set us a trap by asking us to sympathize with this apparently peaceful world, now defiled by vandalism. But who in fact are the vandals? The kids who've desecrated the artwork with filthy graffiti? Or the state technocrats who think they know the fate of humanity, and who paint a rosy future to conceal the inhumanity of the present?

Alex and his droogs counter moralists of all colors with the growled refrain, "If it moves, kiss it," while attaching outsized phalli to the heroes of classical antiquity. The droogs are shamelessly, indeed proudly, evil, and they're clearly convinced that work is for jerks.

Commentators who have written about this film have so far failed to notice that the mural in question is based on designs by Fritz Erler, a German painter and Hitler portraitist who readily adopted the themes of National Socialist art. Kubrick confronts us with two separate examples of state-ordained schemes to improve the world – modern urban architecture and the painted image of a utopian society – before letting loose their anarchistic adversaries. For the patently starry-eyed idealism debunks itself, leading inexorably as it does to a world in which the only choices left are between violence or boredom, hurting or being hurt; a world inhabited solely by brainless conformists and evil geniuses.

"Viddy well"

Alex, the hoodlum, is pure literature. His language is a bizarre patois invented by Anthony Burgess, a potpourri of adolescent slang, onomatopoeia and Russian. In Kubrick's apocalyptic vision, Alex mutates into a creature of cinema whose "Gulliver" is haunted by the dreams and nightmares of 60s movies, from Warhol's *Vinyl* (1965) via Hammer's *Dracula* (1958, 1960, 1965; further productions of the same subject were realized by the Hammer Studios in 1968, 1970, 1972 and 1974) to Antonioni's *Zabriskie Point* (1969). We all have the freedom to worship our own personal graven images; and in Alex's case, these happen to be Beethoven, manslaughter, rape, and the products of the Deutsche Grammophon record label.

The paradoxical truth of Kubrick's film consists in the assessment that there can be no morality as long as human beings are not free to flout it – even if the upshot is the collapse of civilization while Free Will stands by and applauds. *A Clockwork Orange* aestheticizes violence in order to express the autonomy of creativity; indeed, this is one of the film's central theses. Implicitly, the American director Kubrick is narrating the Fall of Man in the 20th century. He is showing us how the dictators – Hitler first and foremost – became conscious of the power of film and realized that the medium could do much more than merely tell stories and deliver snapshots of reality. In the 20th century, the camera became a perpetrator of violence. What's more, the camera is the viewers' ally, and it presupposes they will acquiescence – and relish

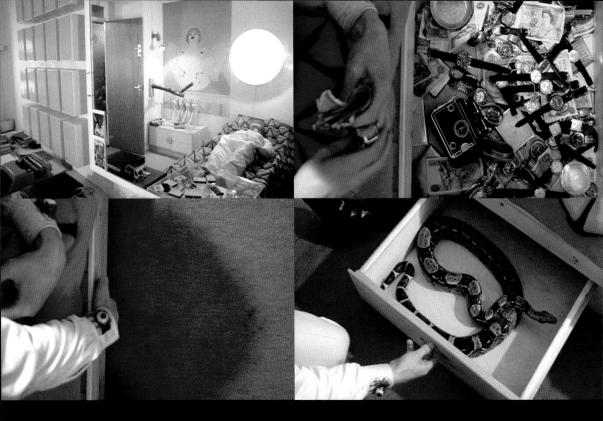

the experience – when it shows them images of brutality. "Viddy well, little brother. Viddy well," says Alex, getting ready to rape, as he stares into the camera and makes direct contact with the viewer

In *A Clockwork Orange*, the camera does not move enquiringly through cinematic space: instead, the camera's large-scale movements constitute and confirm this space's right to exist. It forms the stage on which the camera operates with icy precision, putting the beloved protagonist through his paces; first with pathos, later with pity, the camera follows its hero, bending the cinematic space to its will, so that Alex may bestride it like a king. When he struts through the record store, it's his spatial environment that seems to adjust to his trajectory, rather than vice-versa.

The few scenes we have described are enough to make it clear that *seeing* constitutes one of the major themes of *A Clockwork Orange*. The film sketches seeing as a sensual pleasure, if not an instinctual drive, and shows us as no more than its agents: cheerful voyeurs and accomplices, gourmets of the violence displayed with such narcissistic vanity. Thus it's no surprise that we even continue watching as Alex pisses blissfully in the toilet bowl.

Only a few films in the history of cinema have provoked such varying reactions. The legendary Pauline Kael, for example, was one film critic who despised this movie, and it inspired her to pen a veritable tirade: *A Clockwork Orange*, said Kael, "might be the work of a strict and exacting German professor who set out to make a porno-violent sci-fi comedy." Well, Alex would probably be delighted by this judgment; but why, one wonders, a "German" professor...?

In any case, the peasants and proletarians in the foyer mosaic do seem to be German; and this grandiloquent glorification of social upheaval is lost in the midst of an urban landscape that has now buried Utopia in a concrete crypt. Though Anthony Burgess tells us that the story takes place "somewhere in Europe," the location could as easily be anywhere else in the world.

Yet there's even more German in Kubrick's film: the uniforms sported by Billy Boy's gang, for instance; and of course the music of Ludwig van Beethoven, which fills Alex's head with magnificent dreams of death and destruction. (In this respect at least, he may well resemble some German professors before him...) In the conglomerate of qualities regarded as "typically Teutonic," Kubrick finds a paradigmatic relationship between genius and madness, high art and barbarism, the creative powers of genius and the horror of mass murder.

A Clockwork Orange is also, and not least, a film about the power of music. Though the book describes a lover of classical music in general, Kubrick makes him a fanatical fan of Beethoven in particular. Alex describes his auditory experiences with his usual inimitable eloquence: "Oh bliss! Bliss and heaven! Oh, it was gorgeousness and gorgeousity made flesh. It was like a bird of rarest-spun heaven metal or like silvery wine flowing in a spaceship, gravity all nonsense now. As I slooshied, I knew such lovely pictures!"

The second movement of Beethoven's Ninth Symphony (*Molto vivace*) is accompanied by a wild carnival of images; this associative montage does not balk at mocking Jesus as a naked, quadrupled, porcelain Messiah, flinging his arms around to the strains of the glorious Ninth. In this world, there is

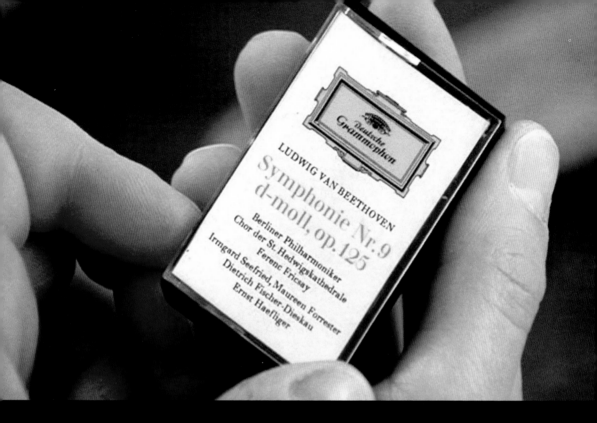

no inconsistency between the outer limits of blasphemy and the adulation of the Most Sacred – though in this case, of course, the latter is represented by Beethoven. Kubrick is attempting nothing less than to show, without losing his ironic distance, the ecstasy of a human being whose individuality dissolves in the experience of music. Alex loses himself deliberately in order to find refuge in the sublime. Images of Beethoven's portrait and Alex's face are repeatedly intercut. For Alex, the German composer is a kind of *Übermensch*, an ideal representation of creative genius; and above all, he's the source of inspiration for Alex's explosions of violence.

This is one of the most absurd sequences in film history: the prostrate Pop Art goddess, the Jesus can-can, the designer nightmare of the parental apartment… These images overwhelm us and capture our sympathies for these slick-talking sadists. The pictures we see are indistinguishable from Alex's narcissistic view of himself: Alex *is* the camera, and he has his eye on us, his "brothers and only friends." Anyone who observes participates; and why should we of all people, the audience in the cinema, not be seduced by the pleasures of violence and sly blasphemy?

Pavlov's Dog

Seeing is always a deliberate act, as Kubrick makes clear in a variety of ways. Most clearly perhaps, when he decorates Alex's cufflinks with a set of artificial eyeballs: every criminal act committed by his hands is witnessed

by these symbolic onlookers. There's a similarly suggestive connection between the eye and the phallus in the sequence where Alex kills "Cat Woman" (Miriam Karlin). First of all, we see this elderly woman performing her gymnastic exercises. She is presented in a vulgar and somewhat indecent manner, which already places any male viewer in the position of a Peeping Tom. At the climax of the struggle between her and Alex, he beats her to death with an outsized sculpture of a penis. The killing itself creates a parallel between the camera and the phallus, so that seeing itself becomes an act of homicide. For as Alex raises his arms to work up the momentum for the fatal blow, we find we are watching from the viewpoint of the phallus. The camera must be located at its tip. Kubrick makes much of this scene, showing us twice in quick succession how Alex hoists the statue aloft.

Seeing as a starting-point for profound manipulations: this is a theme examined by the director in other sequences too, as when Alex is committed to the care of Dr. Brodsky (Carl Duering) and forced to sample his methods of treatment. "The ineluctable modality of the visible" (James Joyce) is misused in the interest of the state: Alex, his head immobilized and his eyes prised open, is forced to watch images of the Second World War while the "therapists" play the works of his beloved "Ludwig Van."

Dr. Brodsky's methods are reminiscent of the experiments of Ivan Pavlov, the famous Russian behavioral scientist who conducted experiments on dogs at the beginning of the 20th century. He succeeded in conditioning his animals to salivate at the mere sound of a bell. The tests carried out on Alex after his therapy demonstrate Dr. Brodsky's success: for Alex, the very

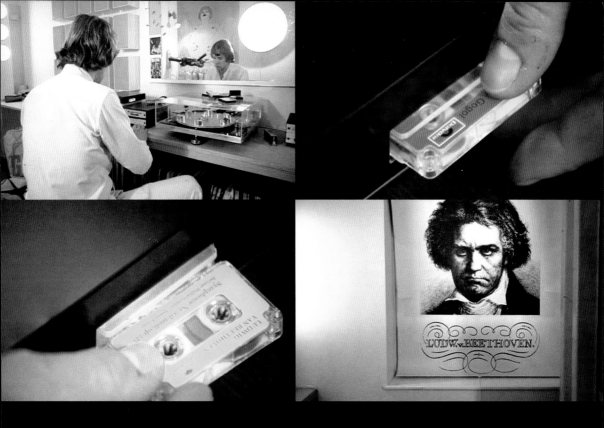

thought of violence has become equivalent to the violent act itself. The image has replaced the deed.

A Clockwork Orange conveys a significant and pervasive mood in the cinema of the 70s. With this film, an American director expresses his skepticism about the emancipatory potential of technology, science and morality. Kubrick doubts whether any of these can ever lead humanity, driven as it is by fears and instincts, onto the right path – whatever that may be. At the same time, the director is providing a commentary on the 20th century, which began with unparalleled aspirations to improve the world, and soon led to the most dreadful catastrophes. In the 20th century, the cinema became an important artistic medium; and at the same time, it turned out to be the most effective method of manipulation (as with the propaganda of the totalitarian systems). But Kubrick is not content to leave it at that. For it's significant that two of Alex's droogs have become policemen in the second half of the movie. Although his former friends have now changed sides, they haven't had to give up their passion for brutality. Humankind, whatever it does, is always stuck with violence.

The Wunderkinder

Even today, the films of the 70s have an astonishing potency. This applies not least to the American cinema of the decade, which experienced an unprecedented renewal that few would have considered possible. It was a time of unparalleled freedoms, and many felt they were living through a kind of revolution.

By exploiting the possibilities of commercial cinema with a new vigor, and by examining the myths as critically as the social realities, cinematography achieved a new truthfulness, which emancipated it once more from the pre-eminence of TV. Though the monumental Cinemascope epics of the 60s may have paraded the silver screen's superiority to the box, the cinema only realized its true strength when it began to fill that screen with new subject matter. In America, there were particularly good reasons to do so, for the USA was a deeply traumatized and divided nation. The war in Vietnam continued to drag on unbearably, consuming more and more victims; and the political justification for the military intervention was in any case more than questionable. What little trust was left in the political administration was destroyed by the Watergate scandal. America had lost its credibility as a moral instance, and U.S. cinema traced the causes and effects of this trauma in a series of memorable films. The basic skepticism of 70s cinema is balanced by the filmmakers' huge enthusiasm for their medium. Their curiosity, creative will and refusal to compromise now seem more fascinating than ever for we live in an age in which Hollywood seems ever more rationalized and conformist.

At the end of the 60s, a period described by Hans C. Blumenberg as "the most dismal and boring decade" in American cinema history, Hollywood was on the ropes, both economically and artistically. In the face of the prevalent societal crisis, the cinema had lost its power to form identity; and for anyone

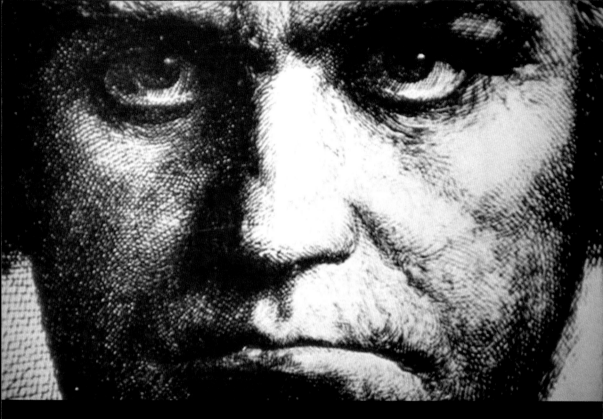

after mere distraction, the TV was clearly the simpler and cheaper alternative. As the movies declined in importance, the old studio system was doomed to collapse, for it had been showing signs of sickness since the early 1950s. The last of the old-style Hollywood moguls stepped down, and a younger generation took over the management of the studios, which were now almost all owned by major corporations. By this time, the studios were barely developing a single project themselves.

Such was the situation as the 60s drew to a close; until a few small movies, most of them produced independently, turned out to be surprise hits – simply by encapsulating the rebellious spirit of the age. In *Bonnie and Clyde* (1967), for example, Warren Beatty and Faye Dunaway blaze an anarchic trail through the mid-West, each bank heist and shoot-out a token of their mutual love and a gesture of defiant revolt. In *Easy Rider* (1969), Peter Fonda and Dennis Hopper transverse the vastness of America, ostensibly to sell drugs, but in fact quite simply for the hell of it – to be on the road, to be free. These new heroes were not just excitingly beautiful and cool; they also embodied a truth irreconcilable with the truth of their elders. And this is what the young wanted to see at the movies: actors who gave a face to their yearnings.

These films gave a decisive impulse to the New Hollywood. From now on, the studios would give young filmmakers a chance. And they knew how to use it; with Francis Ford Coppola, Brian De Palma, George Lucas, Steven Spielberg, Peter Bogdanovich, William Friedkin, Paul Schrader and Martin Scorsese, the 70s produced a generation of "child prodigies," who defined

a new kind of Hollywood cinema. These young movie-maniacs helped the American film industry to make an unexpected and lasting commercial comeback. For their films included some of the biggest box-office hits of the decade – *The Godfather*, (1972, p. 86; Part II, 1974, p. 150), *The Exorcist* (1973, p. 130), *Jaws* (1975, p. 172), *Close Encounters of the Third Kind* (1977, p. 272) and *Star Wars* (1977, p. 252).

Naturally, one has to be careful when comparing the *Wunderkinder* with European *auteurs* in the tradition of the *Nouvelle Vague*, but the influence of the latter on the New Hollywood is readily apparent. In the 70s, American directors enjoyed a stronger position than any of their predecessors since the days of Griffith – and this in a film industry characterized by specialization. The decade marked a highpoint of directorial independence. Having begun with the death of the old Dream Factory, it ended with the invention of the blockbuster: an "event-movie" swaddled in a tailor-made marketing strategy, with which today's Hollywood continues to rule the commercial cinema practically worldwide.

The Back Doors of Power

The most important American director of the decade is Francis Ford Coppola. He is also the one who most radically upheld his position as a "film author." As the first director of the New Hollywood, he scored a major triumph. *The Godfather* was an artistic and commercial success, and he even managed to

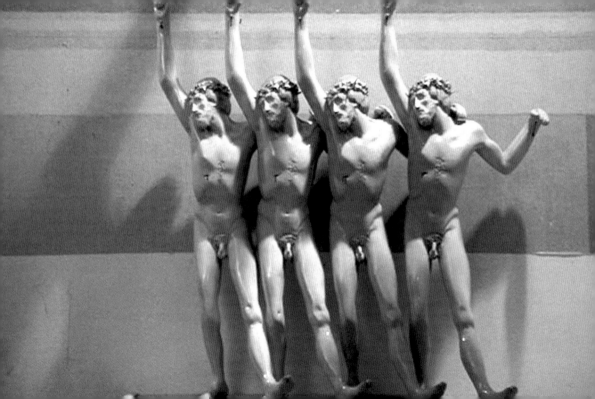

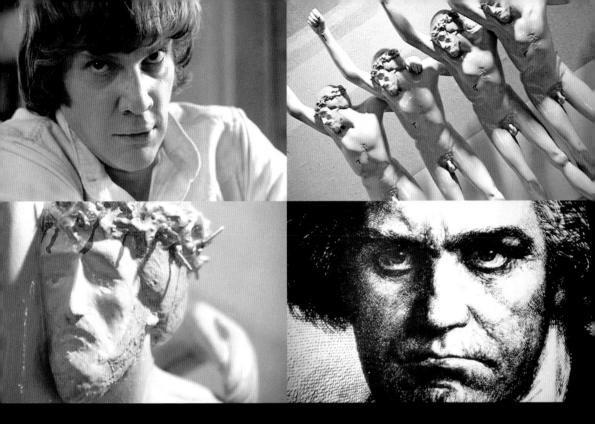

By contrast, Cimino's *The Deer Hunter* (1978, p. 282) was the source of considerable controversy, with the negative representation of the Vietcong arousing particular criticism. If truth be told, the film is completely uninterested in a balanced representation of events, and less interested in the conflict itself than in what the American film scholar Robin Wood called "the invasion of America by Vietnam" – the war's penetration of the American psyche. In Wood's reading of the film, Cimino is examining the myth of an ideal America at the moment of its dissolution. Vietnam initiated a process of increasing awareness, a terrible dawning. At the end of the film, the survivors join together in singing "God Bless America," and the song is heavy with grief. These people are in mourning, not just for their dead friend, but for a lost ideal.

The Comeback of the Classics

Following the lead of the French auteurs, young American cineasts discovered the great classics of U.S. cinema. For not a few of these new directors, the older movies were their declared models, and they paid tribute to them in their own films. Peter Bogdanovich began his career as a film journalist, interviewing Hollywood legends such as Orson Welles and John Ford. When he himself took up directing, most of his films were homages

to the Hollywood movies of the past. With *What's Up, Doc?* (1972), he attempted to create a screwball comedy *à la* Howard Hawks. "Reclaiming" such classic genres was typical of the "Wunderkinder." In this case, the result was a splendidly exuberant film-buff's jamboree, packed full of movie quotations and amusing nods to past classics. Nonetheless, the film worked even for those who were less in the know, partly thanks to the comic talent of Barbra Streisand, one of the top female stars of the 70s.

New York, New York (1977) was Martin Scorsese's extravagant attempt to revive interest in the musical. To evoke the Golden Age of the genre, he placed all his bets on the glamour and star quality of a Broadway icon: Liza Minnelli. Although the daughter of Vincente Minnelli and Judy Garland had received a lot of attention for her lead role in Bob Fosse's *Cabaret* (1972, p. 80), *New York, New York* failed to attract a big audience. Instead, moviegoers flocked to pop musicals like *Hair* (1978) and the tongue-in-cheek *The Rocky Horror Picture Show* (1975, p. 208). These were two films that achieved remarkable cult status – yet ultimately, they too were isolated, one-off hits.

Of course, Neo-Noirs such as *Taxi Driver* were also modeled on classic films of the past; yet they reveal much more than the cinematic preferences of their creators. In the pessimistic perspective of Film Noir, it's obvious that these filmmakers saw clear parallels to their own take on American reality. And so they didn't merely adopt the dark visual style of 40s and 50s thrillers; they also facilitated the comeback of a genre with a supremely skeptical outlook on social mechanisms: the detective film.

Roman Polanski's *Chinatown* (1974, p. 166) is a masterpiece of the genre, and one of the best films of the decade. The Polish-born director created a magnificent portrait of universal corruption and violence, while also managing to conjure up the glory that was Hollywood. Nonetheless, his film was much more than a mere homage, thanks not least to some fabulous actors. Faye Dunaway perfectly embodied the mysterious erotic allure of a 30s film vamp, without ever seeming like a mere ghost from movies past. Jack Nicholson's private detective was also far more than yet another Bogart clone: J. J. Gittes is an authentic figure, a tough little gumshoe made of flesh and blood, who maintains his credibility even with a plaster on his nose. For a moralist like Gittes, a sliced nostril is just another hazard that goes with the job.

The U.S. cinema of the 70s took a skeptical and pessimistic attitude to the myths of the nation, and this had its effect on the most American film genre of them all – the Western. John Ford, Howard Hawks and John Wayne all died within a few years, and these were the personalities who had stamped the genre for decades. Ever since the late 50s, a process of demystification had been at work; and now the *content* of the Western was also taken to its logical conclusion.

The classical Western had always taken an optimistic attitude to history and progress. Sam Peckinpah's *Pat Garrett and Billy the Kid* (1973) is a sorrowful elegy for the old Western, and a complete reversal of its basic worldview. As the film sees it, the growing influence of capital on social relations meant the end of the utopia of freedom. Individuals can only suc-

cumb and conform to a corrupt society, or else they are doomed to perish, like Billy the Kid. Kris Kristofferson gave Billy the aura of a hippie idol – and with the outlaw's demise, the film also buried the hopes and ideals of the Woodstock generation.

It was clear that Western heroes would no longer serve as the icons of reactionary America. Their successors were "urban cowboys" like the protagonist of Don Siegel's controversial *Dirty Harry* (1971, p. 48): Clint Eastwood plays a cynical cop who takes the law into his own hands – because the legal system only serves crooks – and who makes no bones about despising the democratic legitimation of power. When Dirty Harry Callahan has completed his mission by killing the psychopath, he gazes down on the floating corpse – and throws his police badge in the water.

The primordial American yearning for freedom and the open road were now better expressed in road movies such as *Easy Rider*, Monte Hellman's *Two-Lane Blacktop* (1971) or even star vehicles like *Smokey and the Bandit* (1977), featuring Burt Reynolds. But as demonstrated by Steven Spielberg's feature-film debut *Duel* (1971), even the endless highway offered no refuge from the paranoid nightmares of the 70s.

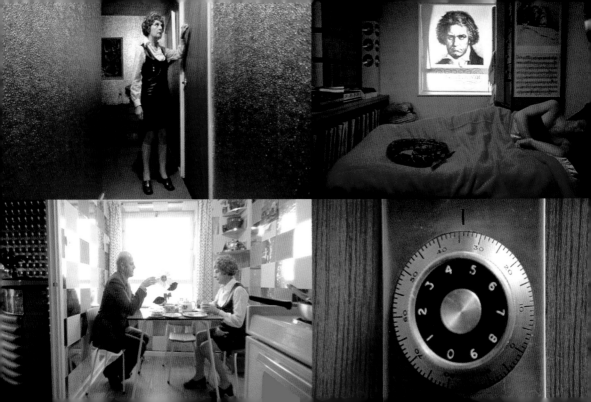

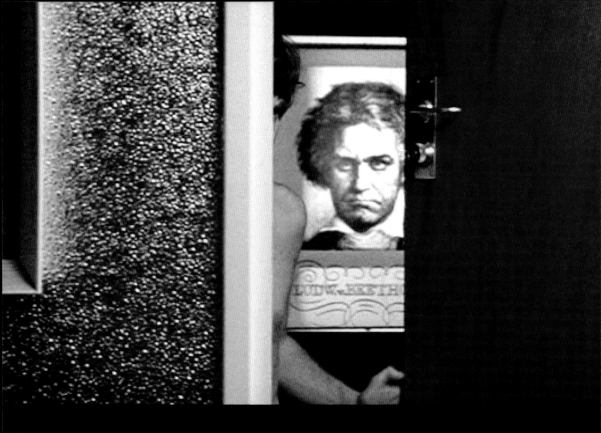

was certainly a trend towards stylization apparent in many Neo-Noirs, SF and horror films. Yet the realistic elements and faith in a good storyline were just as new, and more significant. Movies shot on location increasingly supplanted those made on studio sets. In the 70s, films were made in real streets, real backyards, and real apartments.

The recording technology too developed an unprecedented, dynamic mobility. Nervous hand cameras were soon practically standard, and opened up new frontiers, even for the commercial movie business. The Steadycam made it possible to film smooth pans and tracking shots without laying down cumbersome tracks; and for the simulation of amateur film sequences in *Mean Streets* and *Raging Bull*, Martin Scorsese even used an 8 mm camera. Clearly, many 1970s directors were looking for something closer to real life – which doesn't mean they were trying to slavishly reproduce the world around them. Though Coppola set up his cameras in the primeval jungle, what he produced was a war film that looked liked an acid trip: "This is not a movie about Vietnam. It is Vietnam."

In the 70s, it became clear at last that the old myths would no longer suffice. Vietnam and Watergate were only the most blatant symptoms justifying the terrible diagnosis of the decade's filmmakers: the Enlightenment had failed, and reports of humanity's progress had been premature. The American cinema of the period cast a strong light on the murky depths of American society. This was a country that felt recklessly secure in its possession of democracy and free speech. And the filmmakers were as skeptical about personal relationships as they were about politics. Predictions of sexual lib-

eration, apparently as much of a myth as the Enlightenment itself, remained stubbornly unfulfilled.

If we turn our thoughts once again to Kubrick's *A Clockwork Orange*, the prophetic quality of the film becomes clear. For the American director is questioning nothing less than the idea of a world without violence. By postulating a future in which there is nothing but oppression, revolt and opportunism, he is rejecting the utopia of a conflict-free society. In Kubrick's film, sadism and ignorance are more than merely "lapses" by an individual, a group, or an institution.

The film takes its leave of the idea that humanity is perfectible. If the cinema nonetheless remains an instrument of enlightenment, then the main reason is this: it forces us to undergo a paradoxical experience. For film can only retain its integrity by refusing to shield us from the irrational nature of the world. But it's not only the filmmakers' findings that undermine rationality. Our simple desire to *look* sometimes makes the movies seem more real us to us than our own lives. As Alex remarks during the therapy inflicted on him by Dr. Brodsky: "It's funny how the colors of the real world only seem really real when you viddy them on a screen."

Jürgen Müller / Jörn Hetebrügge

LOVE STORY

1970 - USA - 100 MIN. MELODRAMA, LOVE STORY

DIRECTOR ARTHUR HILLER (1923)
SCREENPLAY ERICH SEGAL, based on his novel of the same name DIRECTOR OF PHOTOGRAPHY DICK KRATINA EDITING ROBERT C. JONES
MUSIC FRANCIS LAI PRODUCTION HOWARD G. MINSKY for PARAMOUNT PICTURES.

STARRING ALI MACGRAW (Jenny Cavalleri), RYAN O'NEAL (Oliver Barrett IV), JOHN MARLEY (Phil Cavalleri), RAY MILLAND (Oliver Barrett III), KATHARINE BALFOUR (Mrs. Barrett), RUSSELL NYPE (Dean Thompson), SYDNEY WALKER (Dr. Shapely), ROBERT MODICA (Dr. Addison), WALKER DANIELS (Ray), TOMMY LEE JONES (Hank).

ACADEMY AWARDS 1970 OSCAR for BEST MUSIC (Francis Lai).

"Love means never having to say you're sorry."

"What can you say about a 25-year-old girl who died? That she was beautiful, and brilliant, that she loved Mozart and Bach. And the Beatles and me." Oliver Barrett (Ryan O'Neal) sits in New York's snow-covered Central Park and mourns the loss of his wife Jenny. Cut to a memory: Jenny (Ali MacGraw) is working the library checkout counter at Radcliffe, the prestigious women's college. Vivacious and argumentative, she's a vision of youth's limitless potential. Oliver, a student at Harvard University, the school's neighboring male counterpart, wants to borrow a book. The two quarrel, agree to go out for a cup of coffee and become a couple. Their relationship, however, is not without its hurdles. Oliver, or more accurately, Oliver Barrett IV, comes from a prominent Boston family and Oliver III (Ray Milland) has no intention of sitting back while his son marries the offspring of some Italian baker from

Rhode Island. Despite the objections, the young lovers wed, and Oliver's father all but disowns him. Jenny has, in the meantime, wrapped up her studies, and has to support the couple while Oliver finishes his degree. Struggling and in love, these are nonetheless happy times for the two of them, until the day when Jenny's doctor presents the newlyweds with some shattering news...

Love Story is a tale as immortal as its title suggests, and it ranks among Hollywood's most unforgettable boy-meets-girl sagas. Two people, whose feelings for one another overcome the greatest social obstacles, are forced to succumb to the will of Mother Nature. This is melodrama in its purest state. From its framing flashback to Francis Lai's painfully romantic Academy Award-winning score, the narrative makes no secret of this love story's in-

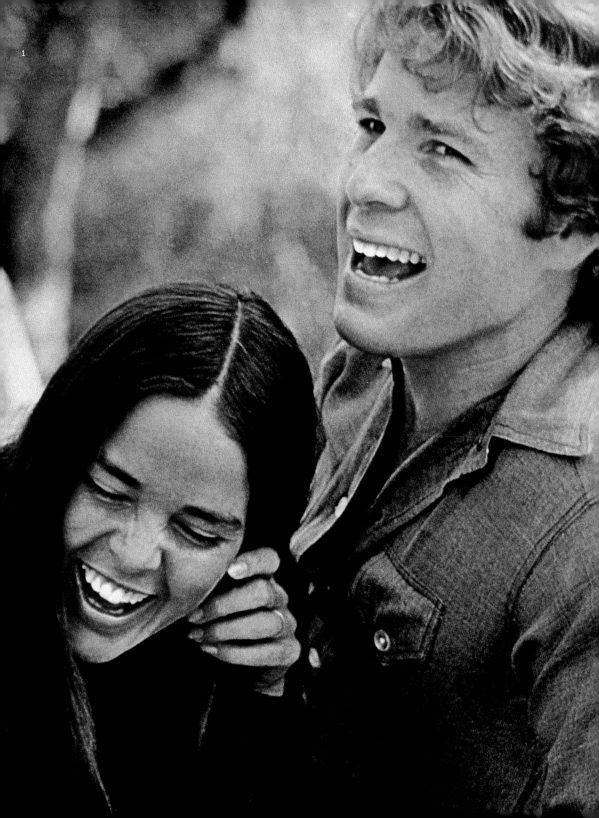

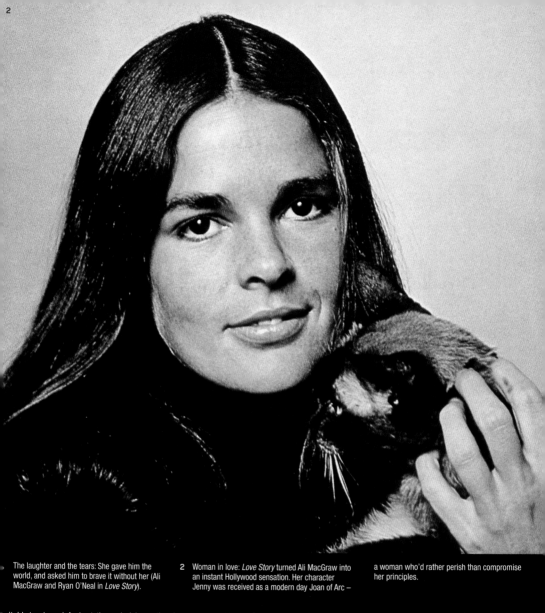

The laughter and the tears: She gave him the world, and asked him to brave it without her (Ali MacGraw and Ryan O'Neal in *Love Story*).

2 Woman in love: *Love Story* turned Ali MacGraw into an instant Hollywood sensation. Her character Jenny was received as a modern day Joan of Arc – a woman who'd rather perish than compromise her principles.

evitably tragic end. And yet, the underlying pathos is counteracted by the élan of the couple's fun-loving yet uncompromising relationship. Sarcasm and wit are the currency of regular communication, and Jenny never passes up an opportunity to tease Oliver for being the son of wealthy and influential parents, who have even lent their name to one of the university buildings. On one occasion she remarks: "Hey, I'm having coffee with a real Harvard building. You're Barrett Hall."

The fathers of the two main characters provide the film with two additional poles of opposition. Oliver III is a hard-headed businessman, who pre-fers the title of "Sir" to "father." His sole interest in Oliver IV revolves around the latter's professional success. Jenny's father, known to everyone including his daughter as Phil (John Marley), is quite the opposite. A man on his own, he embodies compassion, and treats his daughter as an equal. He may disagree with Jenny's decision to not have a church wedding, but he respects her wishes. The father figures emphasize the social conflicts inherent in the lovers' relationship, and the generation conflict effectively provides a second storyline. For besides being a picture about young paramours, it is also one of a son's emancipation from his father.

When the movie hit world screens in 1970, this mélange of romantic anguish and family drama accurately captured the zeitgeist of the youth protest movements and student riots of the late 60s. *Love Story* became an instant international sensation, raking in its entire production costs of 2.26 million dollars within three days of its U.S. premiere. Twelve weeks later, approximately 17 million Americans had seen the film. It received seven Oscar nominations for categories including direction, acting and best picture. Despite these accolades, the only win went to Francis Lai for his score. A sequel, *Oliver's Story*, came and went in 1978. It featured Ryan O'Neal as a young widower, trying to overcome his grief – aided by a woman who was very clearly *not* Ali MacGraw.

HJK

3 Out, out brief candle: Jenny and Oliver's romance is more than a tale full of sound and fury, signifying nothing.

4 Money can't buy everything: Oliver and his bride to be en route to meet Daddy Warbucks. However,

Jenny's not the one who'll be left a poor little orphan.

ALI MACGRAW

Love Story (1970) was not only an international blockbuster, it also marked Ali MacGraw's overnight rise to stardom. Born on April 1st, 1938, MacGraw had appeared in two previous films without generating much buzz. The daughter of visual artists, she was a scholar of art history before landing a job as an editorial staff assistant with *Harper's Bazaar* at the age of 22. This opened the door to a career in modeling, where she rapidly advanced to super model status and was crowned one of *the* faces by the very fashion magazine at which she had once held a desk job. MacGraw was cast in several commercials and debuted on the silver screen shortly thereafter in the 1968 production *A Lovely Way To Die* with Kirk Douglas. That year, she also appeared in Philip Roth's film *Goodbye, Columbus*. *Love Story* excluded, her most prominent role came with Sam Peckinpah's shoot'em-up action classic *The Getaway*, 1972, in which she plays Steve McQueen's wife. Life soon mirrored art and the leading couple wed, remaining married from 1973–78. Hollywood black sheep Peckinpah cast MacGraw in another of his pictures in 1978, this time as a resolute journalist in the trucker western *Convoy*, co-starring Kris Kristofferson. From there on in, it was a rarity to see Ali MacGraw on the big screen, and her career relocated to television with mini-series like *The Winds of War* (1983) and a recurring role on ABC's *Dynasty*. Nonetheless, this more recent fare hardly compares to her earlier work.

4

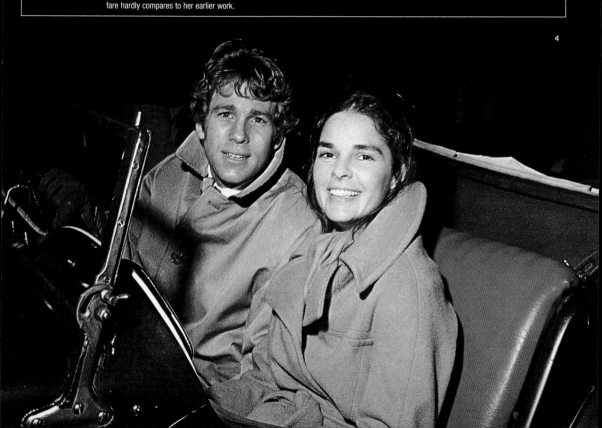

LITTLE BIG MAN

1970 - USA - 147 MIN. - WESTERN, LITERARY ADAPTATION

DIRECTOR Arthur Penn (*1922)
SCREENPLAY CALDER WILLINGHAM, based on the novel of the same name by THOMAS BERGER DIRECTOR OF PHOTOGRAPHY
HARRY STRADLING JR. EDITING DEDE ALLEN MUSIC JOHN HAMMOND PRODUCTION STUART MILLAR, ARTHUR PENN
for STOCKBRIDGE-HILLER PRODUCTIONS, CINEMA CENTER 100 PRODUCTIONS.

STARRING DUSTIN HOFFMAN (Jack Crabb), FAYE DUNAWAY (Mrs. Pendrake), CHIEF DAN GEORGE (Old Lodge Skins),
MARTIN BALSAM (Allardyce T. Merriweather), RICHARD MULLIGAN (General Custer), JEFF COREY (Wild Bill Hickok),
AIMY ECCLES (Sunshine), KELLY JEAN PETERS (Olga), CAROLE ANDROSKY (Caroline), ROBERT LITTLE STAR (Little Horse).

"It's a good day to die."

While *Little Big Man's* Allardyce T. Merriweather (Martin Balsam) may be nobody's fool, the miracle elixir salesman spills bits of wisdom like an Elizabethan court jester – and oh how telling they can be. Indeed, it is he who utters the picture's most resonating words, said in passing to the story's hero Jack Crabb (Dustin Hoffman), a white man raised by the Cheyenne. Expressing his "heartfelt" condolences, Merriweather lets Crabb know just how sorry he is that all that time with the Indians has gone to his head, remarking that "Chief Old Lodge Skins gave (him) a sense of moral order in the universe, when there just isn't any." At the time the film was produced, a great number of Americans would have agreed with him. For despite the increasing public insistence on a world order based on moral values, the American government's domestic and foreign policies bent on capital gains – even at the price of internal corruption or racism – were in direct contradiction to all of the "Great Society" doctrines of the late 60s.

It was a time of student riots and minority uprisings, of the equal rights movement and government brutality. And above all, it was the time of the Vietnam War. On the tip of everyone's tongue were issues like the U.S. Army's brutal slaughter of Vietnamese civilians at My Lai (made public while *Little Big Man* was still in production), conscientious objection (draft dodging, the hardliners called it), the fight for minority equal rights, and "free love" – the

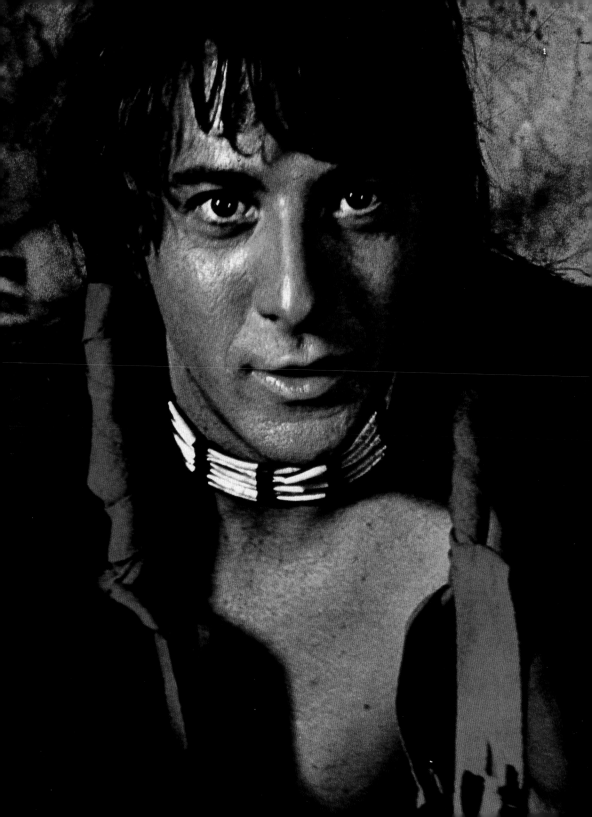

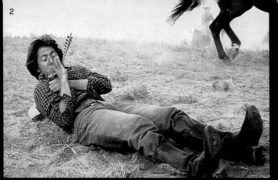

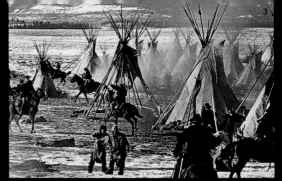

"In the long run, the winning thing about *Little Big Man* is its refusal to toe any line. It mocks the Western myth, as Arthur Penn has done before more seriously in *The Left Handed Gun*. It also has a tendency to gawp at history with something very like awe, while at the same time waxing satirical with a fitful kind of mirth that comes and goes." *Films & Filming*

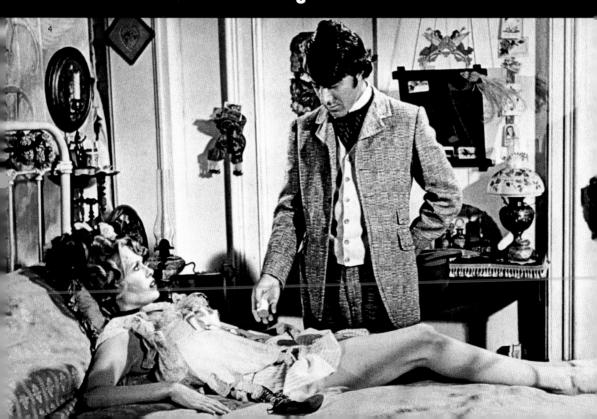

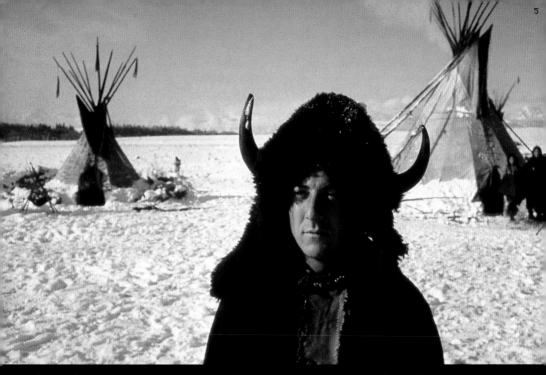

1 Little Tomahawk: Being raised by Indians has colored Jack Crabb's (Dustin Hoffman) take on life.

2 Politically neutral: Wild horses couldn't keep Jack away from the action – no matter whose side he happens to be fighting on.

3 Snow job: The American cavalry sweeps across the Cheyenne's land and leaves them to die in the merciless winter.

4 Poke her hontas: The preacher's wife (Faye Duna-way) wants to review the basics of sinning.

5 Cheyenne Viking: Jack braves new territory and boldly goes where no man has gone before. But is he man enough to tackle the needs of his wife and her squaw sisters?

expression of an attempted break with materialism. Director Arthur Penn and screenwriter Calder Willingham build on a great number of these topics for their depiction of the Cheyenne in *Little Big Man* (loosely based on Thomas Berger's 1964 novel of the same name). Here, no one thinks less of a man for not wishing to go to battle for his nation; according to the wise Cheyenne chief (Chief Dan George), individuals not willing to fight should simply stay home. Nor does anyone seem to be put off by the fact that one such Indian warrior is in the habit of sitting backwards on his horse and saying the opposite of what he means. Then there is a gay Indian who lives among the squaws and is as respected for his choice of lifestyle as the aforementioned pacifist. Even free love is an accepted part of the Cheyenne's way of life. Soon after Jack Crabb marries the young squaw Sunshine (Aimy Eccles), she selflessly entreats him to bed her three unattended sisters in their nuptial teepee; Jack, however, can barely muster up the strength required to satisfy his sister-in-laws.

It is therefore obvious that *Little Big Man* is neither meant to be seen as a painstaking reconstruction of the Wild West, nor – contrary to popular belief – a white-washed retelling of a past in which Native Americans are made to look morally superior. The picture is simply an allegory of 1960s society.

The Cheyenne, who define themselves as human beings, stand for the proponents of a just, modern utopia – an ideal plagued by the monstrous actions of the minions of the State.

For while *Little Big Man* portrays The Red Man with great compassion and a touch of irony, complete with an incident where the Cheyenne go to battle to beat some sense into their opponents, only to be shot and slaughtered, the White Men – whom Jack Crabb all meets twice – are caricatured as morally degenerate or completely neurotic. The preacher's wife, Mrs. Pendrake (Faye Dunaway), who wants to enlighten Jack with the Word of the Lord, turns out to be a bigoted hypocrite up to her chin in sin: when Jack meets her again she is on the payroll at a whorehouse. In the same vein, gunslinger Wild Bill Hickok (Jeff Corey) lets paranoia get the better of him and meets with a dishonorable demise, planting his chin in the toe of some cowboy's boot when he is hit down in a saloon by a crack shot kid. And then, of course, there's General Custer (Richard Mulligan), who takes the screen as a borderline insane, self-righteous narcissist. When, on the brink of the massacre at Little Big Horn, he indifferently gurgles and blabbers some nonsense to his troops about a glob of phlegm caught in his throat, we can't help but be reminded of the mad General Jack D. Ripper (Sterling Hayden) who laun

"One can easily see what attracted Penn to Berger's book: a *déraciné* hero zigzagging his way through America to find a home, the probing into the roots of American violence, and in particular the opportunity to confront the confusion of destructive, White Anglo-Saxon Protestant society with the organic culture of the Cheyenne, who call themselves 'the human beings.'" Sight and Sound

6 The soft-spoken carry big sticks: The Cheyenne on
 the freedom trail.

7 More than he can chew: Jack Crabb's stories
 about survival on the frontier are often tough to
 swallow.

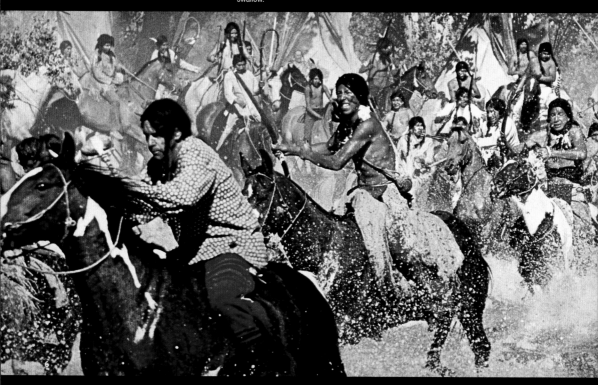

ches World War III in Stanley Kubrick's *Dr. Strangelove or: How I Learned to Stop Worrying and Love the Bomb* (1963).

Little Big Man's script was written in the literary tradition of the picaresque novel. The pure of heart anti-hero Jack Crabb relies on a bit of luck and healthy opportunism to cross the vast frontiers of time and space. Without batting an eye, he switches sides many times over, leading a ridiculously eventful and unsuccessful life that parodies the classic heroism of the Hollywood Western. A veritable contradiction in terms, Jack is an Indian warrior, the adopted son of a preacher, a gunslinger known as "The Soda Pop Kid," the respectable business colleague of a resolute Swedish wife, a drunkard, a trapper and last but not least a scout for General Custer. It is in this final

capacity that he dupes the bloodthirsty warmonger into leading his men to a valley where allied Indian forces are laying in wait. Custer, who has hired Jack to serve as his "negative barometer," follows the scout's instructions to the letter, thinking that he'll dodge any confrontation with the Native Americans by doing so. Needless to say, the general is headed for wholesale disaster. Jack, on the other hand, is the only White Man to come out of Little Big Horn unscathed and smelling like a rose. That, at least, is what he says in the 1950s at the age of 121 in an interview with an aspiring historian (William Hickey). It is a larger than life story preserved for posterity on tape – and as credible as any legend of the wild Wild West.

LP

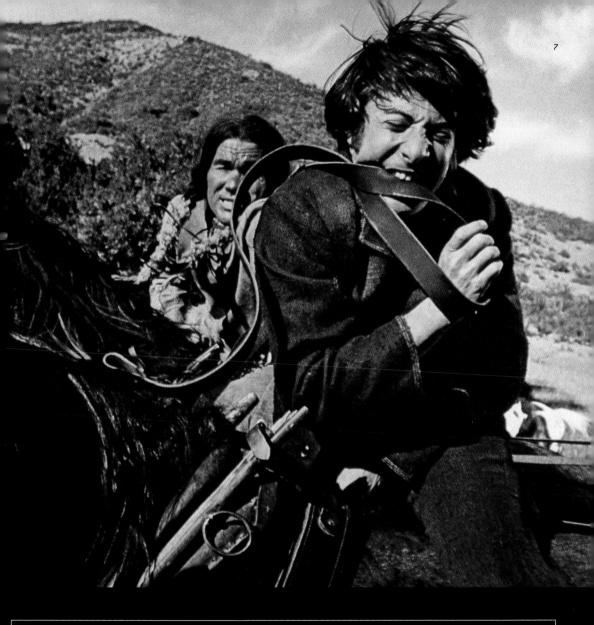

REVISIONIST WESTERN The first Revisionist Western dates back to William A. Wellman's anti-lynch picture *The Ox-Bow Incident* (1943), which put a new slant on a genre notorious for brazenly glorifying the spirit of a frontier pioneered exclusively by Whites. In the 1950s, similar undertakings revamped many of the archetypes prevalent in the Hollywood Western. The films of Anthony Mann and Budd Boetticher, to name but two, consistently feature neurotically flawed, wrathful heroes on the rampage.

Conversely, Native Americans began to emerge as three-dimensional characters in pictures like Delmer Daves' *Broken Arrow* (1950), and were no longer made out to be a mere impediment to the march of U. S. civilization. The critical examination of established Western legends in the 60s and 70s soon paved the way for films that totally ignored the norms of the genre. The Spaghetti Western became known for substituting fair play and golden idealism with cynicism and greed. Director Sam Peckinpah even displayed a taste for having his heroes do the unthinkable and shoot their enemies in the back. Still, the Revisionist Western cannot be categorized by a uniform style or subject: directors either tweak cinematic narratives, focus on an accurate historical portrayal of the period, or use the Wild West as a parable for the Vietnam War, as Robert Aldrich did in *Ulzana's Raid* (1972). But one thing is certain: the once pristine face of the Western acquired indelible scars that blocked any way back to the innocence of yore.

DEATH IN VENICE
Morte a Venezia

1970 - ITALY - 135 MIN. - LITERARY ADAPTATION, DRAMA

DIRECTOR LUCHINO VISCONTI (1906–1976)
SCREENPLAY LUCHINO VISCONTI, NICOLA BADALUCCO, based on the novella *DER TOD IN VENEDIG* by THOMAS MANN
DIRECTOR OF PHOTOGRAPHY PASQUALE DE SANTIS EDITING RUGGERO MASTROIANNI MUSIC GUSTAV MAHLER PRODUCTION LUCHINO VISCONTI for ALFA CINEMATOGRAFICA.

STARRING DIRK BOGARDE (Gustav von Aschenbach), SILVANA MANGANO (Tadzio's Mother), BJÖRN ANDRESEN (Tadzio), ROMOLO VALLI (Hotel Director), MARK BURNS (Alfred), MARISA BERENSON (Frau von Aschenbach), FRANCO FABRIZI (Hairdresser), ANTONIO APPICELLA (Vagabond), SERGIO GARFAGNOLI (Polish Boy), NORA RICCI (Gouvernante).

"Your music is stillborn."

Venice, in the early 20th century. Gustav von Aschenbach (Dirk Bogarde), an aging German composer, is visiting the city of canals, hoping to recover from a nervous breakdown. He moves into an exclusive hotel facing the beach, where his fellow guests include an aristocratic Polish lady (Silvana Mangano) with her children and servants. Aschenbach immediately notices her son Tadzio (Björn Andresen), a pale, slender boy with long blond hair. Soon, Aschenbach is so fascinated by this beautiful youth that his daily schedule is increasingly dominated by the need to observe him. This obsession leads to a resolve to make contact with the boy – despite the threat posed by the

cholera epidemic that is spreading through the city. Aschenbach ultimately succumbs to the disease and dies.

Few film adaptations of literary classics manage to surpass the original. Luchino Visconti's *Death in Venice* is one of the few exceptions, not least because the director refused to be intimidated by Thomas Mann's famous novella. His film version is strikingly different from the book, and he made these changes in order to realize his own cinematic vision.

In the course of his career, Visconti directed opera as well as films, and it shows. The importance of music to *Death in Venice* can be judged by the

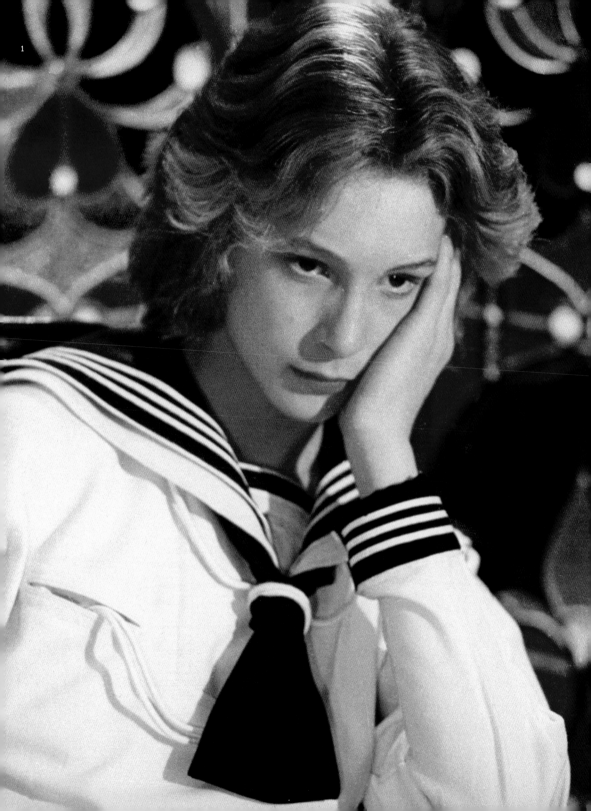

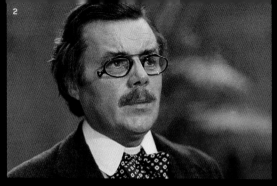

fact that Visconti made Aschenbach a composer; in Mann's novella, Aschenbach was a writer, though the character was in fact based on Gustav Mahler.

Mahler's music is of essential importance to the film. His Fifth Symphony is heard over the opening titles, and it accompanies Aschenbach's arrival in Venice on a steamship emerging into the light of dawn. This musical motif recurs throughout the film, and the elegiac gravity of the piece is mirrored in the almost lethargic rhythm of the images. The drama is contained, and develops, in a series of slow zooms and meticulous tracking shots that capture the morbid and sensual atmosphere of Venice, in the strong but subdued colors of the sultry summer and in the broad Cinemascope format. There is a remarkably serene quality to Visconti's film, strengthening the impact of the music, which is used very sparingly. The film has no narrator, Aschenbach is

"A film to be savored and one to be enjoyed and studied more than once." *Variety*

1 Angel of death: Frail aesthete Gustav von Aschenbach is overtaken by youth's fleeting beauty when he lays eyes on Tadzio (Björn Andresen).

2 Music to our ears: The role of composer Gustav von Aschenbach was the crescendo of Dirk Bogarde's acting career.

3 Eternal flame: Much like Visconti, Silvana Mangano's (left) film career rode the wave of postwar Italian neo-realism. She was one of the movement's shining stars.

4 Phoenix from the ashes: Visconti and cameraman Pasquale de Santis masterfully translate Thomas Mann's prose to the screen with sensuous visuals, gliding cinematography and seamless zoom-ins.

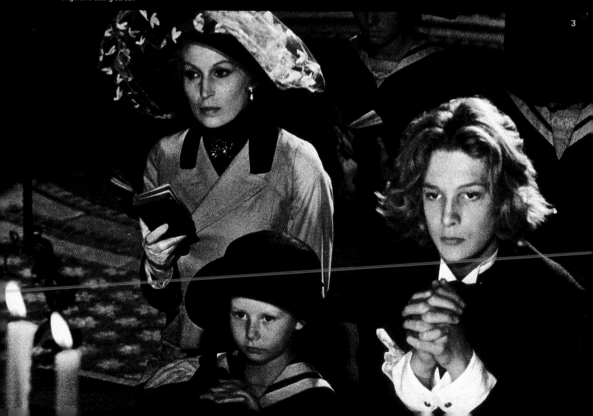

allowed no internal monologues, and indeed, no one says very much at all. Instead, the camera feels its way around the story discreetly, and Dirk Bogarde's expressive acting does the rest. Thomas Mann's polished descriptions and the fine irony of the text are perfectly translated into a purely visual language. Visconti traces the beginnings of Aschenbach's downfall in a series of flashbacks: the destruction of a happy family, sexual frustration and, above all, failure as an artist. In his ambition to express a pure, absolute beauty through his music, Aschenbach is not merely an anachronism; he is also in fatal rebellion against the claims of the body. When his friend Alfred (Mark Burns) insists on the dual nature of music, Aschenbach resists desperately. These are the moments in which Visconti interrupts the tranquil flow of his narrative and allows the past to erupt into the sluggish present like a fever-

ish memory. The lie that has ruled Aschenbach's life catches up with him in Venice: for in recognizing that Tadzio embodies both perfection *and* sensuality, the noble aesthete is thrown back upon his own physical desire, which is more clearly homosexual in Visconti than in Mann.

By the time Aschenbach realizes what's driving him, it's too late: he's an elderly man with a decaying body. With the bitterest of irony, Visconti shows us how the composer attempts to regain his youth in the hairdresser's salon. At the end of the film, a cadaverous Aschenbach lies slumped in his deckchair on the beach, with black hair-dye trickling down his sweat-soaked face. Tadzio, standing on the shore, turns towards him and points off into the distance: it's a last greeting from an angel of death.

JH

LUCHINO VISCONTI
(1906–1976)

He was the scion of a noble Italian family, and he described himself as a Marxist – though his politics didn't stop him enjoying the best that life had to offer. The apparently disparate sides of Luchino Visconti's personality left their traces in his filmography. After learning his trade with Jean Renoir, he made his directing debut while Mussolini's Fascist regime was still in power: the naturalistic style of *Obsession* (*Ossessione*, 1943) was the starting point for Italian *neorealismo*. Visconti's *The Earth Trembles* (*La terra trema*, 1948), the story of a fisherman exploited by wholesale merchants, is regarded as one of the masterpieces of the neorealist movement. His sympathy for ordinary people is also evident in later films: see *Rocco and His Brothers* (*Rocco e i suoi fratelli*, 1960), which shows the disintegration of a family that moves from southern Italy to Milan in search of work. With *Senso* (*Senso*, 1954) however, he created the first of the splendidly operatic color films that would dominate his later career. Of these major productions, many critics feel the best was *The Leopard* (*Il gattopardo*, 1963), based on a novel by Giuseppe Tomasi di Lampedusa. This spectacular epic about a family of Sicilian aristocrats in the 19th century won him the Golden Palm at Cannes and made him an international star director. He sustained his reputation with films such as *Death in Venice* (*Morte a Venezia*, 1970) and *Ludwig* (*Le Crépuscule des dieux*, 1972), the latter a biography of the eccentric King of Bavaria. In parallel to his work in the cinema, Visconti was also a successful theater and opera director. The career of Maria Callas was closely linked to his own.

STRAW DOGS

1971 - GREAT BRITAIN / USA - 118 MIN. - THRILLER

DIRECTOR SAM PECKINPAH (1926–1984)
SCREENPLAY DAVID ZELAG GOODMAN, SAM PECKINPAH, based on the novel *THE SIEGE OF TRENCHER'S FARM* by GORDON WILLIAMS DIRECTOR OF PHOTOGRAPHY JOHN COQUILLON EDITING PAUL DAVIES, TONY LAWSON, ROGER SPOTTISWOODE MUSIC JERRY FIELDING PRODUCTION DANIEL MELNICK for ABC PICTURES CORPORATION, AMERBROCO, TALENT ASSOCIATES LTD.

STARRING DUSTIN HOFFMAN (David Sumner), SUSAN GEORGE (Amy Sumner), PETER VAUGHAN (Tom Hedden), T. P. MCKENNA (Major John Scott), DEL HENNEY (Charlie Venner), JIM NORTON (Chris Cawsey), DONALD WEBSTER (Riddaway), KEN HUTCHISON (Norman Scutt), LEN JONES (Bobby Hedden), SALLY THOMSETT (Janice Hedden), ROBERT KEEGAN (Harry Ware), PETER ARNE (John Niles), DAVID WARNER (Henry Niles), CHERINA SCHAER (Louise Hood), COLIN WELLAND (Reverend).

"This is my house."

Young American mathematician David Sumner (Dustin Hoffman) has taken up residence with his wife Amy (Susan George) on an old farm in Cornwall, England. It is the house of Amy's parents, and David hopes to find peace and quiet for his work. But the opposite proves to be true. In the nearby village, the newcomers are greeted with suspicion. And the men whom David has hired to repair the garage roof of the farmhouse show their disdain for him with increasing audacity. David, who feels intellectually superior, tries to ignore this, as well as the growing dissatisfaction of his sensually lascivious wife, who is bored and feels bothered by the workers. But the tension gradually intensifies and ultimately the situation escalates.

After the frustrating bickering over *The Wild Bunch* (1969) – Warner Brothers released a heavily edited version – *Straw Dogs* presented Sam Peckinpah the welcome opportunity to shoot in Europe for the first time and more importantly, independence from the big Hollywood Studios. *Straw Dogs*, shot on location in the English countryside and in London's Twickenham Studios, was Peckinpah's first film outside of the Western genre. And perhaps it is this missing genre context that was one of the reasons why the violent scenes in *Straw Dogs* caused such unusually heavy indignation. Two scenes in particular provoked repugnance: Amy's rape by two villagers, which she seems to enjoy, and during which she is depicted anything but

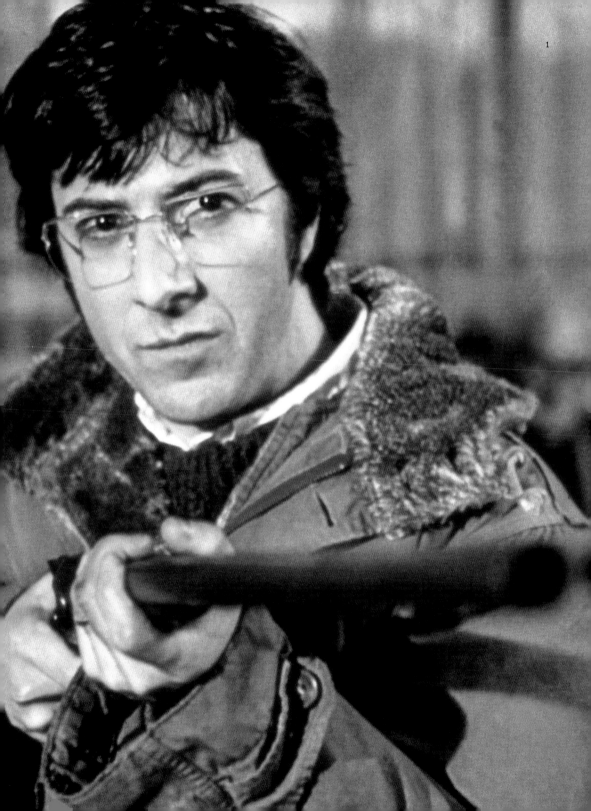

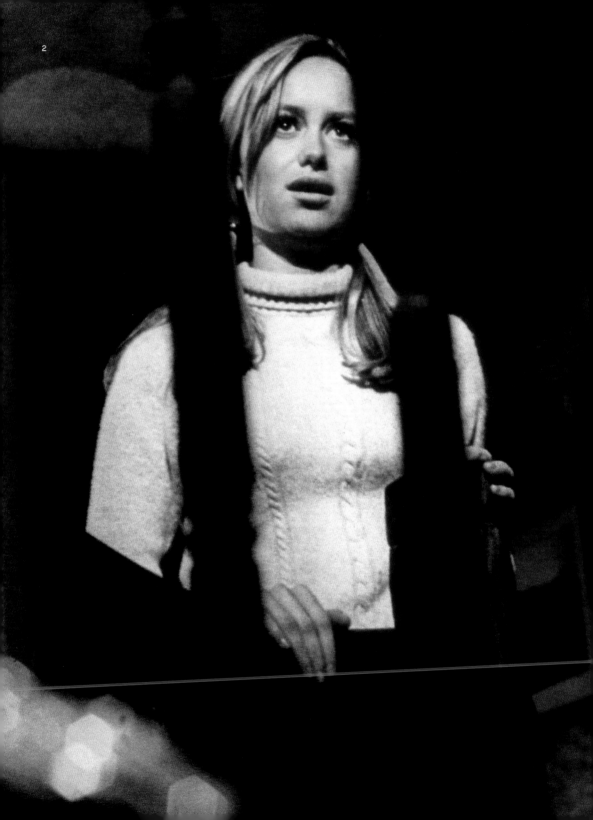

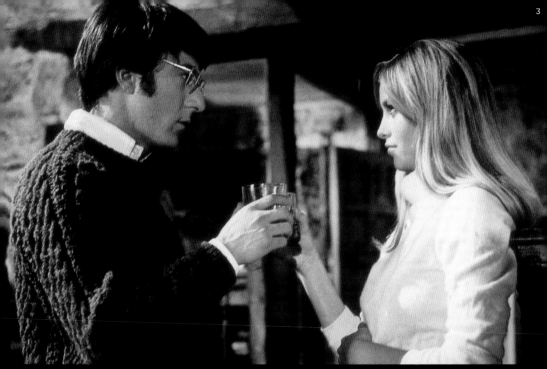

1 How low can we go? In Sam Peckinpah's films, civilization is a thin sheet of ice over an abyss of brutality.

2 It's a man's world: One of the few significant women in Peckinpah's films is Amy (Susan George), whose naive sensuality provokes an escalation of violence.

3 The odd couple. The marriage of David (Dustin Hoffman), a mathematician, and his sensual wife Amy is increasingly dogged by frustration.

"The film is a provocation and a diagnosis. It takes the hysterical debate about the portrayal of violence in the media to new heights, thus questioning its own right to exist. Withdrawal treatments of this kind are vitally necessary." *Die Zeit*

nnocently. The second, more controversial still, was the bloody finale. David, my and the feeble-minded Henry Niles (David Warner) barricade themselves om a fanatical mob in the farmhouse and kill off one besieger after another with shocking brutality. This showdown inspired several polemical attacks by critics who accused Peckinpah of propagating fascist violence.

Straw Dogs is doubtlessly a highly provocative and upsetting film. From he beginning, an atmosphere of oppressive violence looms over the bucolic etting and the apparent archaic simplicity of the villagers undeniably recalls

the notorious scenery of the Peckinpah Western. David, the rational man seems to be the diametric opposite of the locals, though he is in no way a sympathetic figure. Hoffman's character is a far cry from the endearing helplessness of his Benjamin Braddock in *The Graduate* (1967). Contrary to Amy, David seems unable to decode the behavioral language of the locals and attempts to cover up his insecurity with cowardly servility. His frustration that he is unable to implement his intellectual superiority against the aggres-sive physicality of the villagers is expressed instead in his degrading condi-

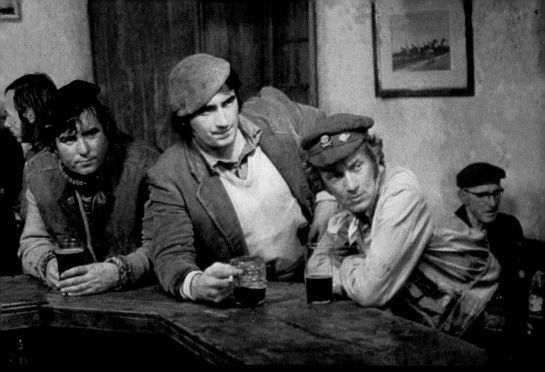

4 Trouble brewing: The village pub in *Straw Dogs* is strikingly reminiscent of the Western saloons in other Peckinpah films.

5 Scandal. The brutal rape scene met with particular outrage – and for Peckinpah, a full-scale offensive from the censors.

6 Home sweet home: David and Amy's lifestyle contrasts strongly with that of the rough and ready villagers.

"I can think of no other film which screws violence up into so tight a knot of terror that one begins to feel that civilization is crumbling before one's eyes." *Tom Milne*

scension toward Amy. The deep-seated violence that lies beneath this culti-vated form of cruelty comes to the surface when David finally throws his habitual reservation overboard and allows his shocking aggression to burst forth, which is all the more effective for spectators as this is what they expect from the locals. Here Peckinpah expresses the same deeply pessimistic view of civilization that is evident in his Westerns: every man, the film posits, is ca-pable of bestial atrocities when he finds himself in the relevant situation. The observation by some critics that this commentary represents emancipation for David Sumner, placing his eruption in a positive light, seems questionable at best. In the end, David drives through the night with Niles, the supposedly harmless village idiot. "I don't know my way home," says Niles. "That's okay," responds David, "I don't either."

5

JH

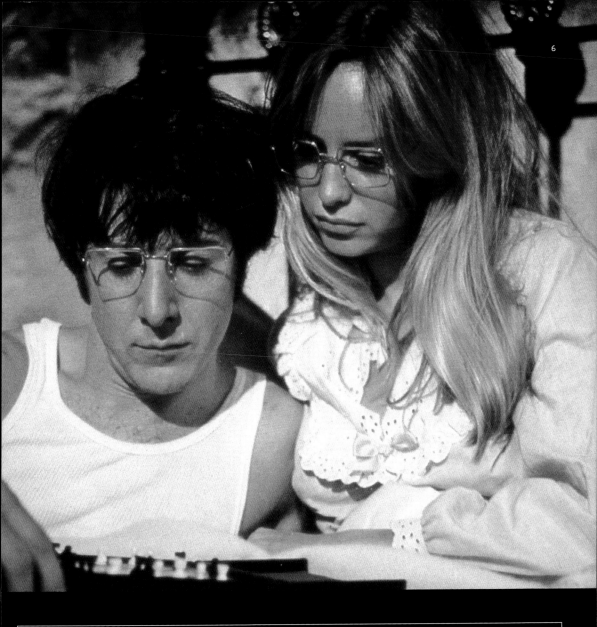

SAM PECKINPAH His rough manner was just as notorious as the violence in his films: Sam Peckinpah (born February 21, 1925 in Fresno, California, died December 28, 1984 in Inglewood, California) doubtlessly belongs to the most legendary Hollywood outsiders. After taking some acting courses, he began his career toward the beginning of the 1950s as a stage hand for television. Within a few years he rose to become the assistant for action specialist Don Siegel, and before long he was writing and dramatizing Western series for TV. And when the second-class script for the Western *The Deadly Companions* (1961) came across his desk, he took his chance without hesitation. His second feature film, *Ride the High Country* (1962), like most of his films a swan song to the old West, thrust him into the international limelight. But shortly thereafter, with his next project, the epic army Western *Major Dundee* (1964/65), Peckinpah's famed recurring problems with his producers began: the film was released in a heavily edited version. This fate also befell his subsequent film, *The Wild Bunch* (1969), considered his masterpiece, as well as his melancholic Western *Pat Garrett and Billy the Kid* (1973). After *The Wild Bunch* Peckinpah was repeatedly criticized for his extreme portrayal of violence, not least for *Straw Dogs* (1971), his first foray outside the Western format, which the critics blasted for its fascist undertones. Cynicism and pessimism aside, the fact that Sam Peckinpah was often able to reveal a tender depiction of the characters in his films – most notably in *The Ballad of Cable Hogue* (1970) and *Junior Bonner* (1972) – is seldom praised. Peckinpah is regarded as a brilliant stylist, though from the mid-70s onwards his films seldom achieved the same quality as his earlier works.

KLUTE

1971 - USA - 114 MIN. - THRILLER

DIRECTOR ALAN J. PAKULA (1928–1998)
SCREENPLAY ANDY LEWIS, DAVE LEWIS DIRECTOR OF PHOTOGRAPHY GORDON WILLIS EDITING CARL LERNER MUSIC MICHAEL SMALL
PRODUCTION ALAN J. PAKULA for WARNER BROS., GUS PRODUCTIONS.

STARRING JANE FONDA (Bree Daniels), DONALD SUTHERLAND (John Klute), CHARLES CIOFFI (Peter Cable), ROY SCHEIDER (Frank Ligourin), DOROTHY TRISTAN (Arlyn Page), RITA GAM (Trina), VIVIAN NATHAN (Psychiatrist), NATHAN GEORGE (Trask), MORRIS STRASSBERG (Mr. Goldfarb), BARRY SNIDER (Berger), ROBERT MILLI (Tom Gruneman).

ACADEMY AWARDS 1971 OSCAR for BEST ACTRESS (Jane Fonda).

"Tell me, Klute. Did we get you a little? Huh? Just a little bit? Us city folk? The sin, the glitter, the wickedness?"

A man has disappeared without trace… All efforts made at pinpointing the whereabouts of upstanding Pennsylvania family man Tom Gruneman (Robert Milli) have led nowhere. When the police declare the investigation closed, private detective and family friend, John Klute (Donald Sutherland), takes on the case.

He follows a lead to New York, as evidence suggests that Gruneman wrote obscene letters to call girl Bree Daniels (Jane Fonda) before he vanished. Klute tries to question the woman, but doesn't get very far. Highly suspicious of the snoop, Bree tells him to stick it to himself. Only after Klute taps her phone line and uses snippets of the conversations to pressure her does Bree agree to cooperate. Although she claims to have no recollection of Gruneman, she confides in Klute, telling him about an experience with a violent john – a dumper as she puts it – who might have something to do with a string of anonymous phone calls she has been receiving. Bree admits to being afraid, but finds her anxiety ridiculous. Klute, however, senses that Bree is truly in danger. His hunch is confirmed when one night he notices from inside Bree's apartment that the two of them are being watched.

Paranoia thrillers reached their zenith in the USA of the 70s. Vietnam and Watergate devastated the nation. The malignant state of emergency and the American people's growing distrust of the Nixon administration were magnified in films like Francis Ford Coppola's *The Conversation* (1974), Sydney Pollack's *Three Days of the Condor* (1975) along with Alan J. Pakula's so-called paranoia trilogy, which included *Klute* (1971) *The Parallax View* (1974) and *All the President's Men* (1976).

In *Klute*, Pakula paints a portrait of a relentless, invisible menace. Even during the picture's prolog, the seed of anxiety begins to take root, as the camera reveals a tape-recorder picking up the conversation at a serene holiday dinner at the Grunemans. The oppressive atmosphere gains momentum, eventually engulfing the entire film. Surveillance equipment seems to be planted in every crevice, in a private sphere wholly unprotected from unknown predators. The piece's shadowy images, lacking both depth and sharpness, seem to come from a hidden camera. The tinny audio track has a bugged sounding quality to it, giving us the impression that even life's most intimate moments do not go unobserved. Pakula thus forces his audience

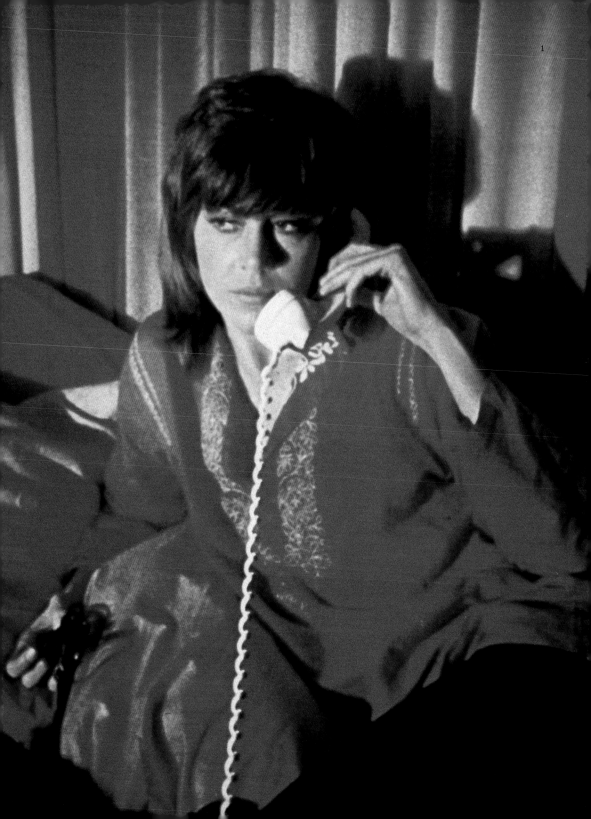

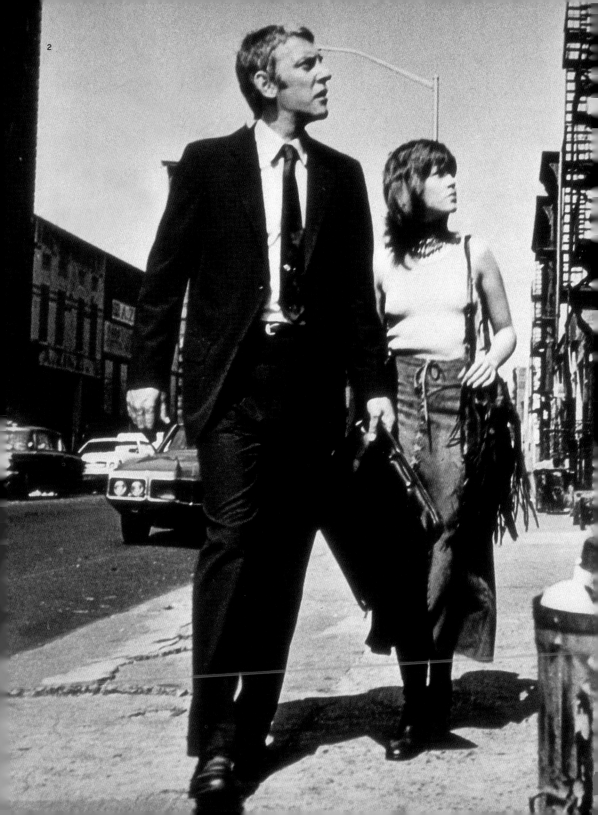

Jane Fonda dominates the film from her first to her last appearance. In a brilliant performance that almost bursts the confines of the character she plays, she combines subtle expressiveness with intelligence and feminine self-assurance. Yet she also shows the suffering and uncertainty of a lonely human being." *Stuttgarter Zeitung*

into the role of a conscious voyeur, an impression accentuated by frequent switches back and forth between the maniac's diabolical mousetrap and Bree's suffocating frenzy. The audience is left squirming in their seats, gasping as terror encroaches upon them. Pakula's direction suggests that the imminent danger he depicts is more than just a story, but a universal threat that extends far beyond the confines of his film.

Klute is, nonetheless, much more than just an example of a masterfully executed, claustrophobic thriller. Pakula's film is also a complex portrait of a woman. Contrary to what one might assume from both the film's title and premise, it is not the investigator who serves as this film's centerpiece but Bree Daniels. This can be attributed, without question, to Jane Fonda's incom-

parable, Oscar-winning performance. She portrays Bree as a prostitute but avoids the clichés. Neither the moral wreck, nor the hooker with a heart of gold, she is a young woman shielding herself behind a harsh and cynical suit of armor. Alone in the world, she has no illusions about the fickleness and ego-centrism of human nature. The wary Bree is a woman full of contradictions who attempts to assert herself in a hostile, male-dominated society. Her greatest aspiration is to become an actress, claiming that her performance as a call girl already proves that that she ranks among the world's greatest. At the time, in the early days of the so-called New Hollywood, this assertion was no gentle poke at the chauvinist female images dominating the contemporary American cinema. It was nothing less than a slap in the face. JB

1 Fond of Jane: In the early 70s, Jane Fonda was the premier personality among America's female movie stars. She was awarded her first Oscar for her role as call girl Bree Daniels in *Klute*.

2 Not just film partners: Jane Fonda and Donald Sutherland made the most of their fame and worked together to oppose America's military intervention in Vietnam.

3 Getting past their inhibitions (Donald Sutherland): *Klute* made a clean break with the clichés of the genre.

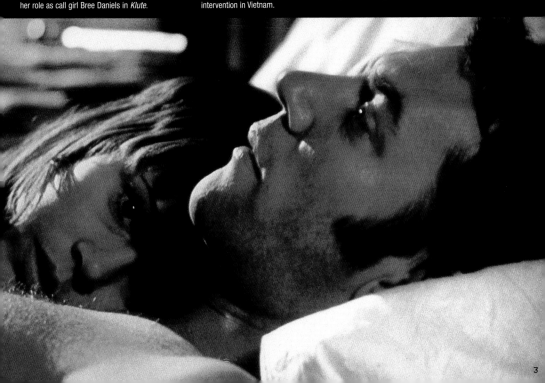

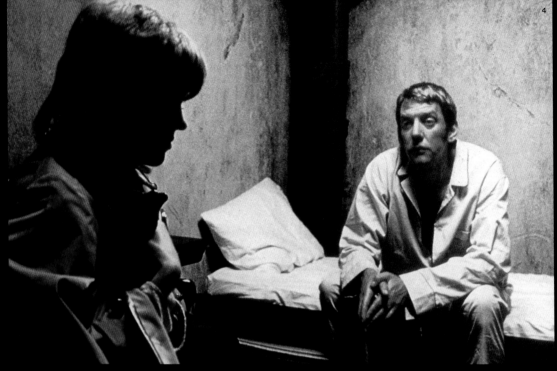

4 All talk? Bree mistrusts the world around her –
 and she doesn't find it easy to open up to Klute.

5 A girl about town: The title "Klute" is misleading:
 Jane Fonda is clearly the central focus of the film.
 Her performance made Alan J. Pakula's thriller

one of the most gripping and sensitive portraits
of a woman in 70s cinema.

"This film belongs to Jane Fonda. She portrays a prostitute who is both the classic victim and the captain of her fate."

James Monaco, in: American Film Now

JANE FONDA	Prior to her 1960 screen debut in Joshua Logan's *Tall Story*, Jane Fonda (born December 21, 1937 in New York), daughter of Hollywood legend Henry Fonda, had already worked as both a fashion model and theatrical actress. She also successfully completed her formal studies at the Lee Strasberg Actor's Studio prior to her film career. Initially, Jane Fonda appeared in a number of romantic comedies. In the mid-60s, the young ingénue went to France – to "discover herself" as she put it – where she met her husband Roger Vadim, starring in several of his pictures, most notably *Barbarella: Queen of the Galaxy* (1968). Following her return to the United States, she garnered her first Academy Award nomination for her performance in Sydney Pollack's *They Shoot Horses, Don't They?* (1969). In 1972, Jane Fonda was recognized with the Best Actress Oscar for her stunning portrayal of a Manhattan call girl in Alan J. Pakula's thriller *Klute* (1971). In the years that followed, she used her fame and status to aid the human rights crusade. Fonda was a strongly opposed to the Vietnam War and the climax of her involvement in the anti-war effort took place when she visited American POWs in North Vietnam. Only towards the end of the 1970s did Jane Fonda begin to focus on her film career again, winning her second Best Actress Oscar for her role as a woman who volunteers at the local veterans' hospital in Hal Ashby's *Coming Home* (1978). Three further Academy Award nominations promptly followed. Ms. Fonda's career took yet another surprising turn in the 1980s, when she started her decade long reign as the nation's most prominent fitness guru thanks to her best selling series of workout videos. In 1989, she took a leave of absence from film and married media mogul Ted Turner two years later. They recently divorced.

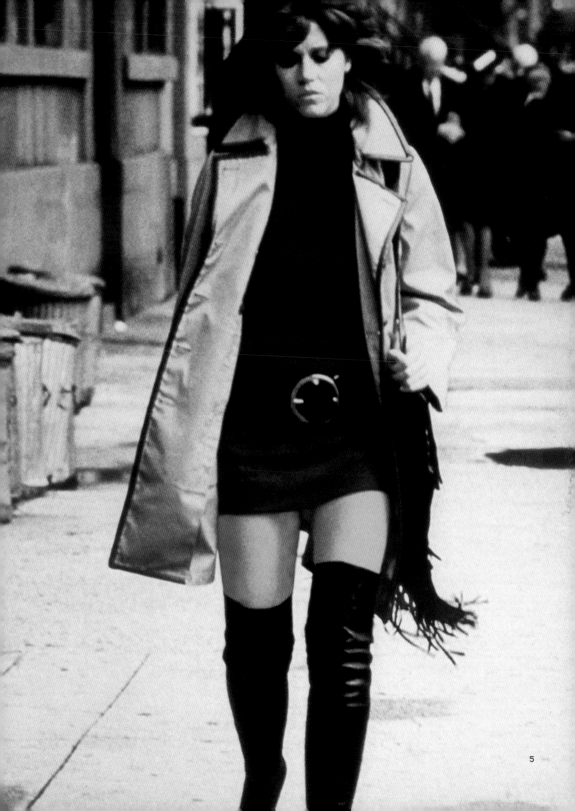

DIRTY HARRY

1971 - USA - 102 MIN. - THRILLER

DIRECTOR DON SIEGEL (1912–1991)
SCREENPLAY HARRY JULIAN FINK, RITA M. FINK, DEAN REISNER DIRECTOR OF PHOTOGRAPHY BRUCE SURTEES EDITING CARL PINGITORE
MUSIC LALO SCHIFRIN PRODUCTION DON SIEGEL for THE MALPASO COMPANY, WARNER BROS.

STARRING CLINT EASTWOOD ("Dirty" Harry Callahan), HARRY GUARDINO (Bressler), RENI SANTONI (Chico Gonzalez),
JOHN VERNON (Mayor), ANDREW ROBINSON (Scorpio, the Killer), JOHN LARCH (Chief), JOHN MITCHUM (Frank DiGiorgio),
MAE MERCER (Mrs. Russell), LYN EDGINGTON (Norma), JOSEF SOMMER (Rothko).

"I think he's got a point."

A killer lurks on the rooftops of San Francisco. A young woman becomes his first victim. Sensuously following her movements through his telescopic lens, he watches her rise from her lounge chair on the top of a high-rise across the way and dive elegantly into a pool. The killer lets her swim a few laps, and then squeezes the trigger. The clear water in the light-blue pool turns dark red and the girl momentarily flails about, and then dies in a thick cloud of her own blood.

Some time later, police inspector Harry Callahan (Clint Eastwood) scrutinizes the crime scene from the killer's perspective – clearly a voyeuristic spot. But it is all too apparent that what had once been a pleasure in watching has now become a pleasure in killing. And the killer has just one objective: at the scene of the crime, Callahan finds a note from the mysterious man, who calls himself Scorpio (Andrew Robinson). If he does not receive $100,000 he will continue to kill one person a day – anyone from a "Catholic priest," to a "Nigger." The mayor (John Vernon) wants to agree to the demands. Callahan's advice, however, is to investigate and search for the suspect without further delay. Experience tells him that Scorpio will most definitely kill again – for the sheer fun of it. Callahan's prophecy turns out to be correct. Intensified surveillance of the high-rise buildings, including helicopter sorties, does not stop Scorpio from his murder spree. Soon, Callahan sets a trap for the killer and Scorpio is just a few steps away. But he eludes capture by shooting indiscriminately and killing a police officer.

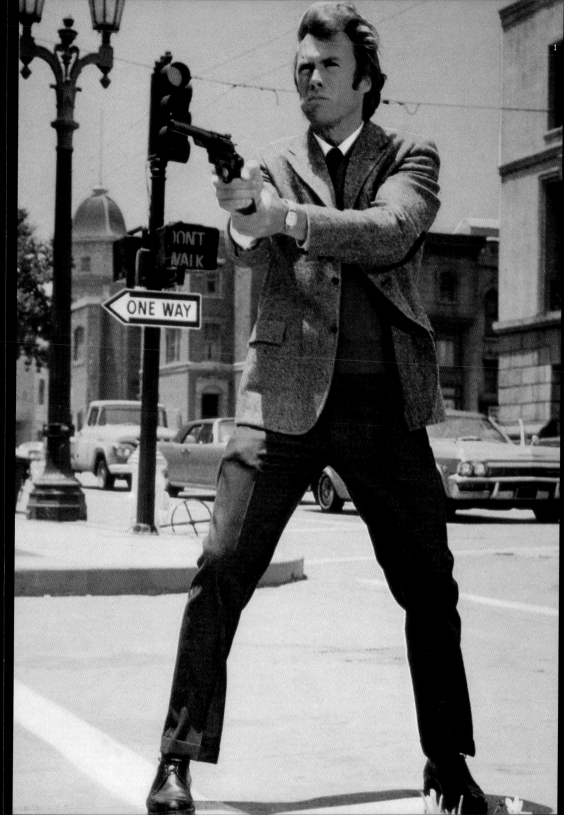

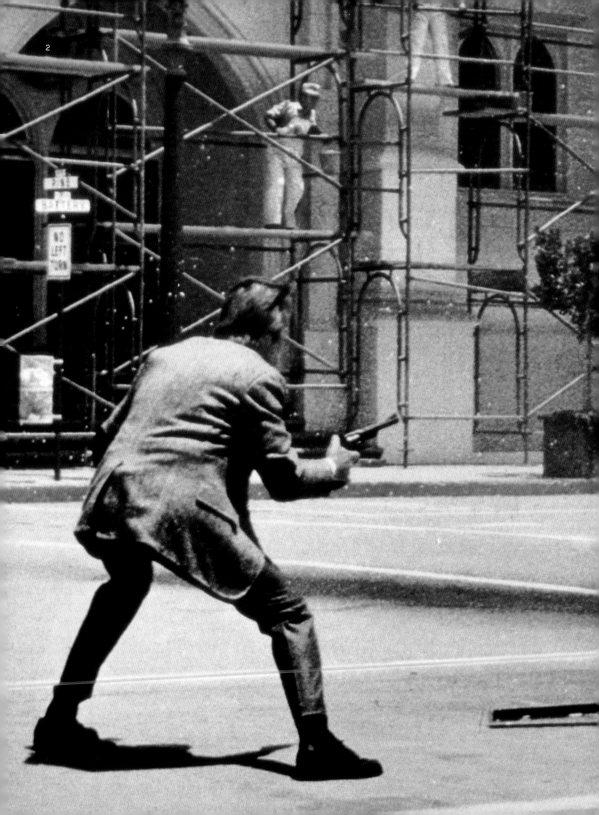

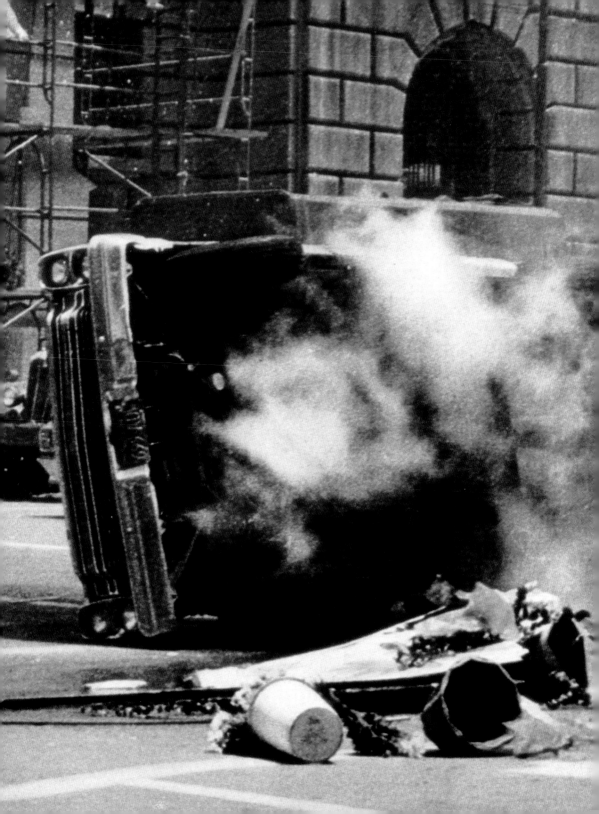

"As suspense craftsmanship, the picture is trim, brutal, and exciting; it was directed in the sleekest style by the veteran urban-action director Don Siegel, and Lalo Schifrin's pulsating, jazzy electronic trickery drives the picture forward."

The New Yorker

LALO SCHIFRIN

Composer and director Lalo Schifrin, born in Buenos Aires in 1932, fundamentally shaped the sound of the 60s and 70s. His themes are immediately recognizable and consistently contemporary. The recognizable melody from *Bullitt* (1968) was used again decades later in a commercial, and the robust title music from the TV series *Mission: Impossible* (1966–1973) was rerecorded and used in 1988 for the new episodes of the series, as well as for the subsequent movie versions with Tom Cruise (1996, 2000). Schifrin's name is closely associated with Clint Eastwood's movies, which made him a regular composer for Don Siegel's police films like *Coogan's Bluff* (1968) and the *Dirty Harry* series (1971, 1973, 1983, 1988), with the exception of *Dirty Harry III – The Enforcer* (1976). A further classic is Schifrin's musical contribution to the Bruce Lee film *Enter the Dragon* (1973), its gentle grooves and symphonic jazz enriched by influences from the Far East.

Lalo Schifrin is a classically trained conductor. In Buenos Aires he studied with Enrique Barenboim, in Paris with Olivier Messiaen. But the gifted musical scholar fell out of favor with Messiaen because of his nightly appearances in Paris jazz clubs. He did this not only to earn money for his studies, but out of his passion for the music of Thelonious Monk and Art Tatum.

He studied both classical music and jazz simultaneously, and this mixture heavily influenced his later work for the cinema, which in addition to the typical Schifrin sound, also includes chamber music soundtracks like the one from Mark Rydell's D. H. Lawrence adaptation *The Fox* (1967).

SHAFT

1971 - USA - 100 MIN. - DETECTIVE FILM, THRILLER

DIRECTOR GORDON PARKS (*1912)
SCREENPLAY ERNEST TIDYMAN, JOHN D. F. BLACK, based on the novel of the same name by ERNEST TIDYMAN
DIRECTOR OF PHOTOGRAPHY URS FURRER EDITING HUGH A. ROBERTSON MUSIC ISAAC HAYES PRODUCTION JOEL FREEMAN for SHAFT
PRODUCTIONS LTD., MGM.

STARRING RICHARD ROUNDTREE (John Shaft), MOSES GUNN (Bumpy Jonas), CHARLES CIOFFI (Vic Androzzi),
CHRISTOPHER ST. JOHN (Ben Buford), GWENN MITCHELL (Ellie Moore), LAWRENCE PRESSMAN (Sergeant Tom
Hannon), VICTOR ARNOLD (Charlie), SHERRI BREWER (Marcy), REX ROBBINS (Rollie), CAMILLE YARBROUGH
(Diana Greene).

ACADEMY AWARDS 1971 OSCAR for BEST SONG: "THEME FROM SHAFT" (Isaac Hayes).

"He's a complicated man, no one understands him but his woman."

Now and again, a film comes along that strikes the nerve of its age with instinctive certainty. *Shaft*, developed as a technically simple, low-budget project with neither expensive stars nor a renowned director, became the surprise hit of 1971 and saved MGM Studios from looming bankruptcy. With *Shaft*, the multi-talented Gordon Parks Sr., a photographer, novelist, composer, and director, developed a unique language of images still referred to in the iconography of today's rap videos. And John Shaft (Richard Roundtree) became the embodiment of black self-confidence – at least for black males.

The first images of the film, underscored by Isaac Hayes' explosively sizzling title theme, immediately signal a character who follows his own rules. The camera aptly captures John Shaft as he emerges from a subway station – the depths of the underworld in more ways than one – and enters the lively scenery in and around New York's Times Square. He weaves through the traffic, lean, black, and self-confident. The themes of the opening sequence are sustained – protagonist John Shaft does not knuckle under to

anyone – white cops or black drug gangsters. He sympathizes with a militant black organization and refuses to tolerate demands made on him. He cannot be assigned to any form of male organization, instead enjoying the adulation of women, a privilege he savors to its fullest extent. But his sensually charged relationships have no master-slave dimension to them.

Even Bumpy Jonas (Moses Gunn), the black underworld boss who controls Harlem, must accept that Shaft is a truly independent character; one of Bumpy's handymen who is sent out with an associate to escort Shaft back to his boss doesn't survive the incursion. But Bumpy wants to avoid a quarrel at all costs, as he is pursuing a personal matter. Accordingly, he makes an exception to the norm, visiting Shaft in his office. He even sheds a few crocodile tears when he reveals that his daughter Marcy (Sherri Brewer) has been kidnapped. Shaft is to bring her back safely – and money is no object.

Shaft's investigations take him all through Harlem, through the milieu of hobos, pickpockets, and small-time crooks. He is searching for Ben Buford

Shaft is the first picture to show a black man who leads a life free of racial torment. He is black and proud of it, but not obsessed with it…"

1 Neighborhood watch: Ben Buford (Christopher St. John), leader of a black gang, supports Shaft in his investigations.

2 Movin' in on his turf: Bumpy Jonas (Moses Gunn) is king of the Harlem underworld – and white gangsters want what he's got.

3 Solid as a rock: John Shaft (Richard Roundtree) is his own man, and he won't knuckle under to the cops or the gangsters.

4 Outsourcing: The syndicate has flown in killers from elsewhere – and they take their work seriously.

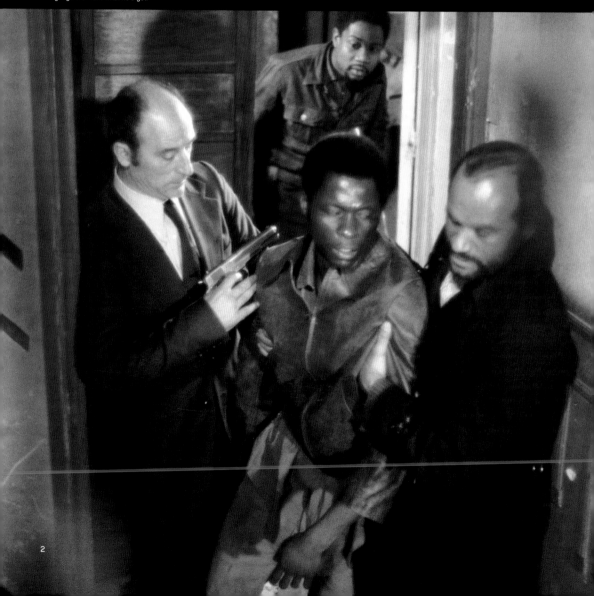

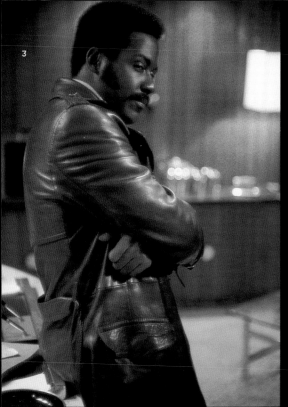

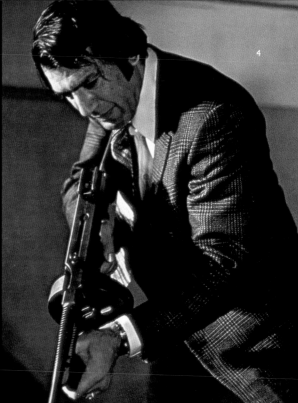

ISAAC HAYES The suspense-filled title track, perfectly fitting John Shaft's first appearance in the film (*Shaft*, 1971), immediately caught audiences in its spell. It was the work of Isaac Hayes, one of the most reliable hit makers of the preceding decade. In collaboration with songwriter David Porter, the autodidact wrote and produced a handful of successful songs for the Memphis-based Stax-Volt label, including "Soul Man," "Hold On, I'm Coming," "B-A-B-Y," and many more. Most of the tunes were performed by the soul duo Sam & Dave.

Only in 1967 did Hayes try his luck as a solo artist, and he soon created his own brand of symphonic soul, with a grand orchestra and an eccentric stage show. This was the determining sound of the double album *Shaft* Soundtrack. His enigmatic, physically driven appearances destined Hayes for a film career. Initially he appeared in *Shaft*-inspired "Blaxploitation" films like Duccio Tessari's *Three Tough Guys* (*Uomini duri*, 1973), and Jonathan Kaplan's *Truck Turner* (1974), naturally composing the music for the soundtracks as well. In later years, he appeared in films like John Carpenter's *Escape from New York* (1981) and Keenan Ivory Wayans' "Blaxploitation" parody, *I'm Gonna Git You Sucka* (1988), among several others. He made a guest appearance in the television series *The Rockford Files* (1974–1980) in 1977 with his occasional musical partner, Dionne Warwick.

(Christopher St. John), an earlier companion who is now the leader of a militant civil rights group. Shaft eventually meets him at a conspiratorial gathering. But their conversation is interrupted by an arson attack in which most of Ben's men are killed. Shaft pulls Buford from the danger zone and brings him to safety at a friend's house. It soon becomes clear that the Mafia is behind the attack, as well as the kidnapping, which was carried out in an attempt to force Bumpy from his territory. Shaft demands financial retribution for the death of Ben's men from Bumpy, who withheld the genuine background of the kidnapping from him. Bumpy pays up and Ben agrees to aid Shaft in the liberation mission.

Marcy is holed up in a small hotel guarded by numerous thugs. Shaft comes up with a spectacular rescue plan: while Ben's men act as hotel per-

sonnel and neutralize the guards, he will let himself down from the roof with a rope and jump through the closed window, directly into the gangsters' room.

Shaft is driven by the visual talents of long-time *Life* photographer, Gordon Parks, whose son Gordon Parks Jr. also delivered a black cinema sensation with *Superfly* (1972) before dying in 1979 in a plane crash. With cool images from wintry New York, specifically the sequences of Harlem at night, Parks Sr. gave the film an almost documentary-like veneer. This partially harsh realism is intensified by Isaac Hayes' soundtrack, which ranges from rebellious funk to atmospheric ballads. Just like the film, the theme song also had a sequel: Isaac Hayes' band, the Bar-Kays recorded the piece "The Son of Shaft," which was used in the concert film *Wattstax* (1972). HK

A CLOCKWORK ORANGE

1971 - GREAT BRITAIN - 137 MIN. - LITERARY ADAPTATION, THRILLER

DIRECTOR STANLEY KUBRICK (1928–1999)

SCREENPLAY STANLEY KUBRICK, based on the novel of the same name by ANTHONY BURGESS DIRECTOR OF PHOTOGRAPHY JOHN ALCOTT EDITING BILL BUTLER MUSIC WALTER CARLOS PRODUCTION STANLEY KUBRICK for POLARIS PRODUCTIONS, HAWK FILMS LTD., WARNER BROS.

STARRING MALCOLM MCDOWELL (Alex), PATRICK MAGEE (Frank Alexander), MICHAEL BATES (Chief Guard Barnes), WARREN CLARKE (Dim), JOHN CLIVE (Stage Actor), PAUL FARRELL (Tramp), ADRIENNE CORRI (Mrs. Alexander), CARL DUERING (Doktor Brodsky), CLIVE FRANCIS (Joe), MICHAEL GOVER (Prison Governor), MIRIAM KARLIN (Miss Weatherly).

"Viddy well, little brother, viddy well."

A Clockwork Orange was banned in England until Stanley Kubrick's death in 1999. The director himself had withdrawn it in 1974, and the motivation for his self-censorship remains obscure. Perhaps he had simply grown tired of being blamed for glorifying violence, but it's possible he had actually been threatened. This is not as outlandish a suggestion as it may seem, for the film had occasioned a great deal of heated debate. No film before *A Clockwork Orange* had depicted violence in such an aestheticized manner, and with such a laconic refusal to justify itself. The critics accused Kubrick not merely of fomenting an appetite for extreme brutality, but of failing to challenge or even question that appetite. The violence on screen, they felt, was crying out to be imitated in real life. But Kubrick is no moralist, and no psychologist either; he doesn't explain what he shows. The audience is forced to decide for itself what it wants to see in his film, and the price we pay for this freedom includes accepting the risk that Nazi skinheads will love it.

Black bowler and bovver boots, white shirt and pants, tastefully topped off with an eyecatching, fortified codpiece: this is the uniform of Alex (Mal-

colm McDowell) and his Droogs, a teenage gang in constant search of some real "horrorshow" action. On a particularly enjoyable night out, they start off with a few drinks in the Korova Milkbar before going on to kick a drunken bum to pulp, indulge in a rumble with a rival gang, and play "road hogs" in a stolen car. Having warmed up, they proceed to break into the country house of a successful author and take turns at raping his wife, making very sure that the elderly writer – bound and gagged – gets a first-class view of her lengthy ordeal. Back at the bar, "feeling a bit shagged and fagged and fashed," they chill out with a "moloko plus" (milk with a little something added) before heading "bedways."

It's not so much the brutality that makes *A Clockwork Orange* such a haunting experience: it's the choreography. Alex above all, adoring fan of Ludwig Van, celebrates and savors his own "appearances" like works of performance art. In the writer's villa, he parodies Gene Kelly in "Singin' In The Rain," keeping time to the music with a series of kicks to his victim's guts. In contrast to his three mates, who expect to pick up some booty on their raids, he has

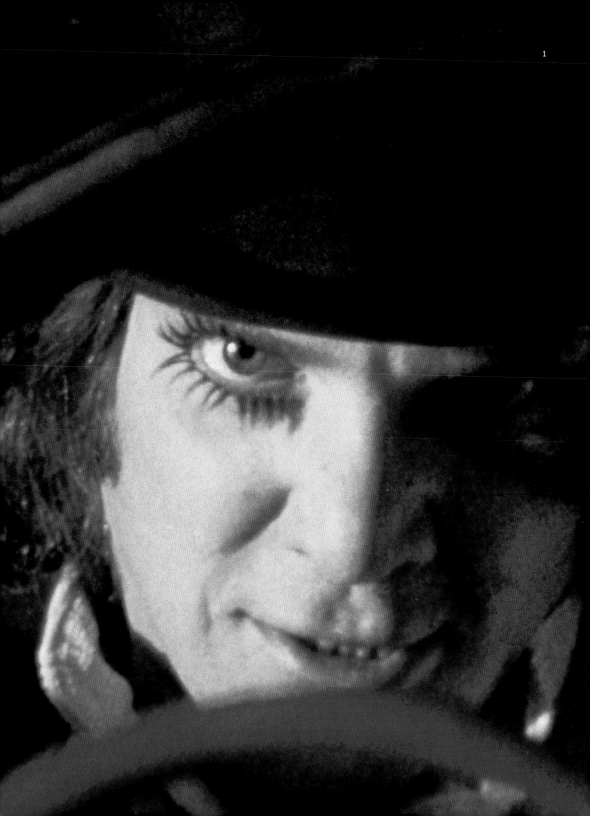

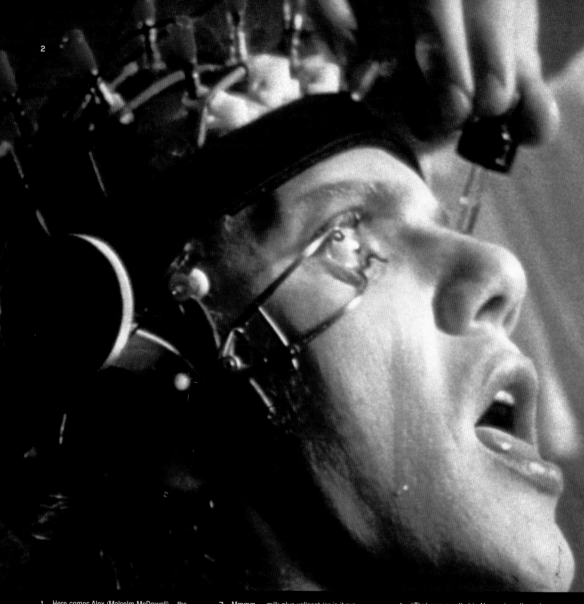

1 Here comes Alex (Malcolm McDowell) – the personification of brutality.

2 Doomed to look: Alex undergoes the Ludovico therapy.

3 Mmmm… milk plus vellocet (or is it syn-themesc?): Dim (Warren Clarke) tanks up for a night of the old ultra-violence.

4 "That was me, that is Alex and my three droogs, that is Pete, Georgie and Dim. And we sat in the Korova Milkbar, trying to make up our razudoks what to do with the evening."

"In my opinion, Kubrick has made a movie that exploits only the mystery and variety of human conduct. And because it refuses to use the emotions conventionally, demanding instead that we keep a constant, intellectual grip on things, it's a most unusual – and disorienting – movie experience."
The New York Times

them up. This will turn out to be a fateful difference of opinion. For later, when Alex inadvertently kills a woman with an *objet d'art* (a giant phallus), his disgruntled and mutinous droogs smash a bottle in his face and leave him to be found by the police. He is sentenced to 14 years in jail, but thanks to a new resocialization program and a revolutionary therapeutic technique, he is granted an early release. From now on, Alex will be violently sick whenever he's tempted to indulge in "a bit of the old ultra-violence." But though he can't hurt a fly, his past is inescapable: the world is full of people who suffered under his rule, and who will now exact revenge on their helpless ex-tormentor.

A Clockwork Orange is a complex discourse on the connections between violence, aesthetics and the media. The film gives no answers, it

MALCOLM MCDOWELL *A Clockwork Orange* (1971) would not have been made without him. For Stanley Kubrick, Alex simply had to be Malcolm McDowell. At that time, the 27-year-old had almost nothing to show for himself. He had just made his very first major film, the impressive *If...* (1968), set in an English boarding school and directed by Lindsay Anderson. But Kubrick was convinced of the qualities of the young, unknown actor, for he saw in him the human being in a natural state. And so Malcolm McDowell became a star. His instant success was also a kind of curse, for his face came to stand for everything evil, incalculable and dangerous, and he has rarely been permitted to play anything but the villain.

Born in Leeds in 1943, McDowell worked as a coffee salesman before going to drama school in London. Later, he acted with the Royal Shakespeare Company. After *A Clockwork Orange*, he went on to make two more films with Lindsay Anderson, both of them intelligent satires: *O Lucky Man!* (1973) and *Britannia Hospital* (1982). In 1979, he caused another stir, this time as the notorious dictator in Tinto Brass' controversial *Caligula*. He then disappeared from view, showing up almost only in B-movies, although he did have some interesting supporting roles in movies such as Paul Schrader's *Cat People* (1982). In the 90s, however, MacDowell was a very busy man, making around 50 appearances in movies or TV series, for example in *Star Trek: Generations* (1994), where he faced off Captains Kirk and Picard, and in Paul McGuigan's *Gangster No. 1* (2000).

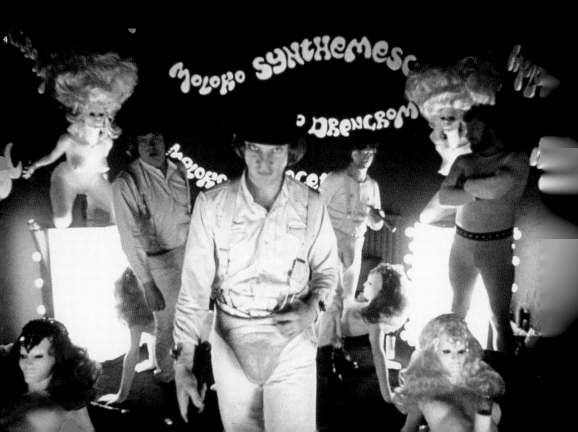

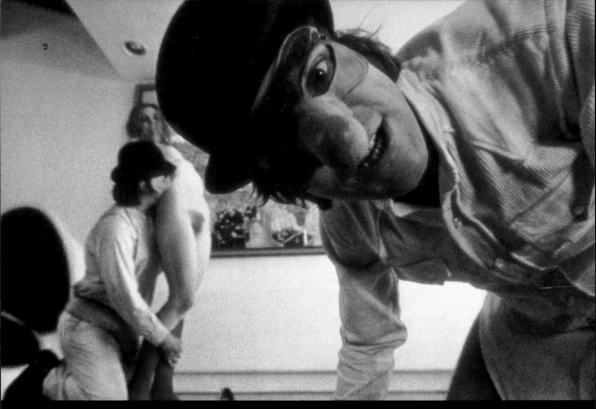

5 "A truly Satanic cinematic satire, made with almost unimaginable perfection," said *Der Spiegel*. In this scene, Kubrick himself operated the hand-held camera.

6 The writer Alexander (Patrick Magee), a victim of Alex and his droogs. But he'll wreak his revenge.

7 Pop art: Alex batters a woman to death with a giant phallus.

merely asks questions, and it calls some assumptions into doubt: for example, that violence in the cinema will inevitably lead to violence in the world. Alex's therapy consists of forced viewings of brutal films. The longer he's bound to his seat with his eyes propped open, the worse he feels – an effect reinforced by the drug he's been given. Alex the Doer is transformed into Alex the Watcher. For the former hoodlum, it's a terrible torture; for the average moviegoer, it's a regular delight: to become a mere seeing eye, with no obligation to act; to watch, entranced, happily "glued to the seat." Kubrick almost literally pulls the audience into the film. Alex often looks straight into the camera, apparently addressing the spectators. Before he rapes the writer's wife, he kneels down before her on the floor: "Viddy well," he says to the captive woman, and to the captivated audience in the argot of the droogs: "take a good look." The real scandal of *A Clockwork Orange* is that we catch ourselves looking forward with excitement to whatever is going to come next. It's not what Kubrick shows us that shocks, but how we react as spectators, fascinated by a masterly and unforgettable film. NM

"Objectively, it has to be said that there has seldom been a film of such assured technical brilliance" *Der Tagesspiegel*

THE FRENCH CONNECTION

1971 - USA - 104 MIN. - POLICE FILM

DIRECTOR WILLIAM FRIEDKIN (*1939)
SCREENPLAY ERNEST TIDYMAN, based on a work of non-fiction by ROBIN MOORE DIRECTOR OF PHOTOGRAPHY OWEN ROIZMAN
EDITING GERALD B. GREENBERG MUSIC DON ELLIS PRODUCTION PHILIP D'ANTONI for D'ANTONI PRODUCTIONS, 20TH CENTURY FOX FILM CORPORATION.

STARRING GENE HACKMAN (Detective Jimmy "Popeye" Doyle), ROY SCHEIDER (Detective Buddy "Cloudy" Russo), FERNANDO REY (Alain Charnier), TONY LO BIANCO (Sal Boca), MARCEL BOZZUFFI (Pierre Nicoli), FRÉDÉRIC DE PASQUALE (Henri Devereaux), BILL HICKMAN (Bill Mulderig), ANN REBBOT (Mrs. Marie Charnier), HAROLD GARY (Joel Weinstock), ARLENE FARBER (Angie Boca), EDDIE EGAN (Commander Walt Simonson), SONNY GROSSO (Bill Klein).

ACADEMY AWARDS 1971 OSCARS for BEST PICTURE (Philip D'Antoni), BEST DIRECTOR (William Friedkin), BEST ACTOR (Gene Hackman), BEST ADAPTED SCREENPLAY (Ernest Tidyman), and BEST FILM EDITING (Gerald B. Greenberg).

"It's like a desert full of junkies out there!"

"Today's world will brand him a racist," said director William Friedkin of the *French Connection's* singleminded protagonist, Jimmy "Popeye" Doyle (Gene Hackman). As it turned out, the Academy of Motion Picture Arts and Sciences was not only impressed with the then unknown Hackman, honoring his performance with an Oscar, but with the provocative Friedkin himself (*The Exorcist*, 1973). *The French Connection* swept the major categories of that year's award ceremonies, taking a total of five accolades, and making the then 32-year-old Friedkin the youngest person in Academy Award history to receive the Best Director Oscar, a distinction he still holds.

Even without a female lead in its cast, everything magically clicked into place for this picture. As the posters rightly said of its hero, "Doyle is bad news but a good cop." The role itself was based on New York police officer Eddie Egan, a detective in the narcotics bureau, whom the film promotes to Division Commander. In 1962, Egan and his partner Sonny Grosso (the Buddy Russo character played by Roy Scheider) stumbled onto the trail of an astounding 112-pound heroin sale and busted the deal after weeks of fieldwork. With this landmark victory in law enforcement, *The French Connection's* story was born.

Hanging out at an Eastside bar after work, "Popeye" and "Cloudy" notice suspiciously large sums of money being flashed by crooked playboy Sal Boca (Tony Lo Bianco), and on a long shot decide to tail him through the icy winter night. At about 7 o'clock in the morning, they witness a drug drop at a corner store that soon puts them in hot pursuit of French drug boss Alain Charnier (Fernando Rey). With the help of French actor Henri Devereaux (Frédéric de Pasquale), Charnier intends to flood the practically bone dry New York drug market – a plan Doyle and Russo will stop at nothing to foil.

No one is willing to believe the allegations of the two cops and with good reason. Not only does the fanatic Doyle have a reputation that precedes him among the city's scum, but his dubious crime fighting methods have also tarnished his name among fellow officers and superiors. This, however, all proves of no consequence when the two detectives locate Devereaux's car, which seems to be peculiarly overweight...

Despite or because of his do-or-die work ethic, the Popeye Doyle character presents a striking alternative to the orthodox police officer. He is cynical, brutal and utterly impetuous. In his fervor, he has been known to wage personal wars against corruption, even sacrificing the life of a fellow cop in the process.

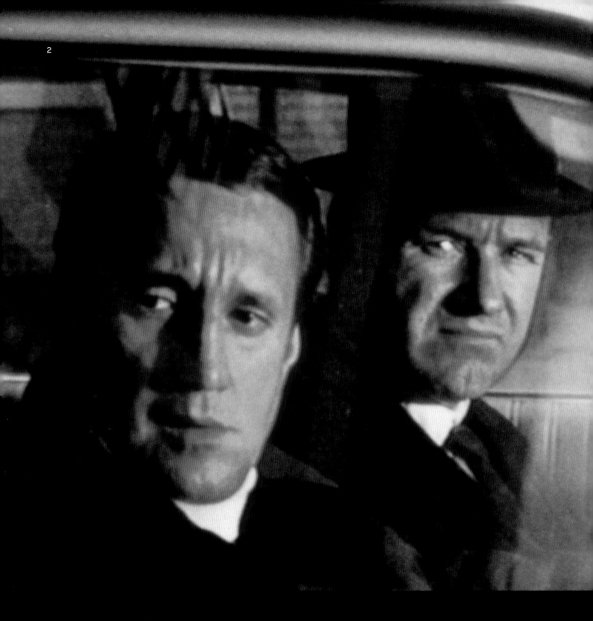

In the spirit of Egan and Grosso's 'round the clock shadowing, director Friedkin relentlessly accompanied these two great policemen on their beat for several weeks. The dialog of the two leading actors stems in part from genuine cop conversations and slang. Even the legendary line, "Did you ever pick your feet in Poughkeepsie?" were the words the real life Egan uttered during his interrogation to get the suspect to give himself away.

Such fastidious details made for one of the bleakest, most deliciously pessimistic police capers of all time. The shoot took place on location during the harsh New York winter, forcing both cast and crew to battle against often sub-zero temperatures. Much of the energy that sparks the film to life is the result of brilliant improvisation. Cinematographer Owen Roizman went to great lengths to ensure that the film would look 100% realistic and have an almost documentary feel. Actors and camera crew regularly rehearsed separately from one another to give the visuals an added sense of naturalism. The result is that the camera often seems to have been in the right place at the right time by pure coincidence.

To make the sequence underneath the tracks of the elevated train as convincing as possible (a scene many still consider the greatest cinematic car chase of all time), Friedkin and his team decided to violate traffic laws rather than prearrange to have the street blocked off. Thus the 90-mph visuals caught on film were actually shot in the middle of usual city traffic. Friedkin's ballsy bit of gambling certainly paid off, undeniably one upping the

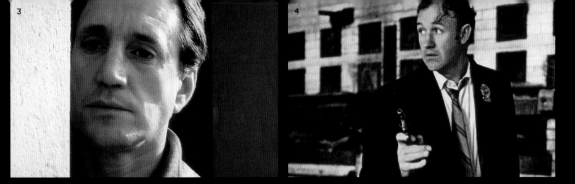

"If you start counting 'movie moments' in *The French Connection*, you'll have to stop by about number eight – it's simply impossible to keep up." *steadycam*

1 Gene Hackman's Popeye Doyle is a bull on a rampage, whose ruthless and unconventional methods aggravate cops and underworld kings alike.

2 Tough as nails: with a bit of persistence and sheer luck, the two cops pick up on the trail of the drugs ring.

3 Doyle's partner Buddy Russo (Roy Scheider) is his last loyal ally. Both characters were based on real-life policemen.

4 No thinking cap no dice: Popeye Doyle seems naked without his pork-pie hat.

5 The law is down and dirty, while evil smells like a rose.

classic chase scene in *Bullitt* (1968) with Steve McQueen, which had held the "all time best" title before *The French Connection* hit the screen. While the film can still pride itself on the effectiveness of its intentionally raw look – the result of painstaking efforts to wipe all traces of artistry from the visuals – the piece surprisingly ends with an almost surreal sequence. We watch as a forlorn Doyle stumbles aimlessly into the darkness, until he disappears completely. A lone shot is suddenly heard, but we are left with no answers as to who plugged whom or why. It is an intriguingly obscure conclusion that even goes unexplained in the 1975 John Frankenheimer sequel *The French Connection II*, a piece that would prove to be yet another undisputed milestone in police drama.

SH

"Many things I experienced close up as a child went into *The French Connection*. I knew how policemen deal with one another."

William Friedkin

6　The gangster (Fernando Rey) and his henchman (Marcel Bozzuffi) check out the lie of the land.

7　Stopped short: After the obligatory showdown, director William Friedkin surprises his audience with an abrupt ending.

8　Huffing and puffing: One of the most spectacular chases in film history leaves Doyle *a bout de souffle*. The words on the steps show Friedkin's instinct for irony.

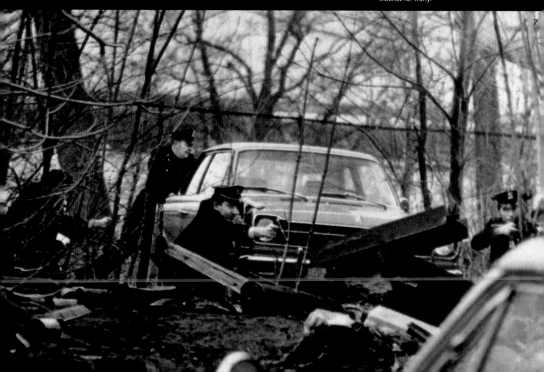

NO FUME

SI

**RUNNING ON EMPTY –
THE BIG SCREEN CHASE**

Movies are movement by definition. It is therefore only fitting that the so-called "chase" is one of the most beloved silver screen phenomena. Several films throughout cinematic history from *M* (1931), *The Sugarland Express* (1974) to *The Fugitive* (1993) and beyond are basically tributes to this

FELLINI'S ROMA
Roma

1971 - ITALY / FRANCE - 128 MIN. - GROTESQUE

DIRECTOR FEDERICO FELLINI (1920–1993)
SCREENPLAY FEDERICO FELLINI, BERNARDINO ZAPPONI DIRECTOR OF PHOTOGRAPHY GIUSEPPE ROTUNNO EDITING RUGGERO MASTROIANNI
MUSIC NINO ROTA PRODUCTION TURI VASILE for ULTRA FILM, LES PRODUCTIONS ARTISTES ASSOCIÉS, PRODUZIONI EUROPEE
ASSOCIATI.

STARRING PETER GONZALES (Fellini as an 18-year-old), FIONA FLORENCE (Young Prostitute), PIA DE DOSES (Princess
Domitilla), MARNE MAITLAND (Engineer) RENATO GIOVANNOLI (Cardinal Ottaviani), STEFANO MAYORE (Fellini as a Child),
ELISA MAINARDI (Pharmacist's Wife), GALLIANO SBARRA (Compère), ANNA MAGNANI (Herself) GORE VIDAL (Himself).

"It's the stench of the ages!"

"The unusual, the mysterious, is right there before us. You only have to look closely to find the terror and beauty in everyday life." Thus spake Federico Fellini after completing his film *La dolce vita* (1959/60). The implication was clear: sedentary and immobile, he had no need to travel to distant countries in order to create exotic films. Ten years later, he furnished the proof: *Fellini's Roma* is an affectionate portrait of a city that's populated by the strangest of people – at least in Fellini's eyes. He sees Rome as a baroque construction where history, culture, religion and voluptuous life meet and mix unceasingly.

Fellini's Roma needs no dramatic storyline and has only one protagonist: Fellini himself. In a series of episodes, he tells how he dreamt as a child of the alluring city, and how he arrived there as a young man in 1939. He tells of his first evening in the metropolis, stepping off the train at Roma Termini, finding a seat in a crowded trattoria, standing in line at a shabby bordello. Fellini jumps to and fro between past and present, battles his way through the packed streets with a camera team in tow, visits a cacophonous wartime theater, hangs out with the hippies on the Spanish Steps, sits in an air-raid shelter and meets a German girl.

In Fellini's vision, Rome is an organic entity. At a dinner party, someone quotes a Roman proverb: "As you eat, so will you shit." The people are vulgar, obstreperous, argumentative, noisy. They smoke, they sweat, their children piss on the floor of the theater, and they only ever appear *en masse*: in the young Fellini's apartment house, there are an incredible number of subtenants; people push for room at the dinner table, gobbling snails and

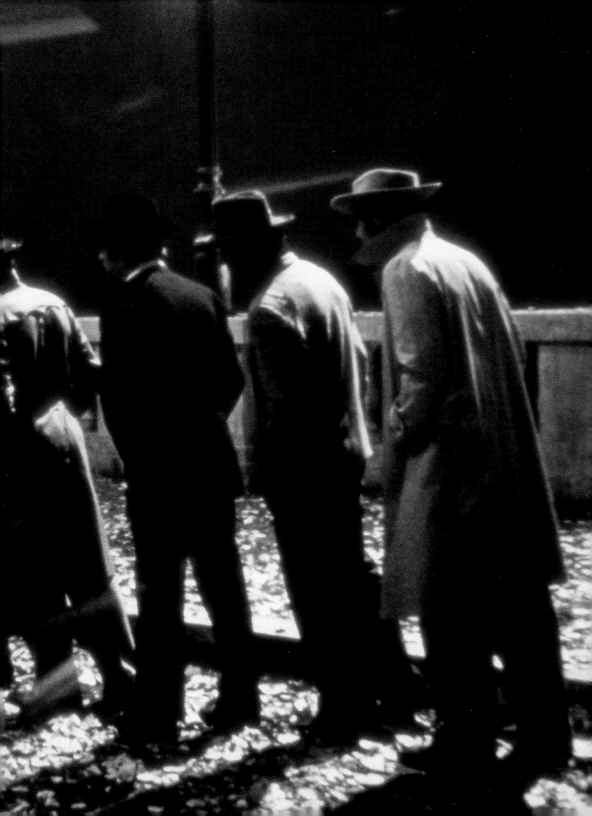

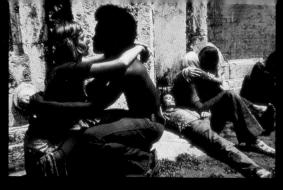

tripe. The hippies, playing love games, practically tie themselves in knots. There's no such thing as privacy, everyone takes part in everyone else's life. The streets of Rome, says the narrator, are like corridors, and the public squares are living rooms.

The Rome we see here is so idealized that Fellini could find it only in the studio. Thus, he had an entire stretch of the Via Albalonga rebuilt in Cinecittà, including the trams. The real Rome appears only occasionally, above all at the end, as the camera accompanies a horde of bikers on their night journey through the city.

In one scene, the camera goes underground to film the building of the subway. Like a monstrous worm, the drill bores through the entrails of the city. The engineer explains that Rome was built in eight layers, and that a

"As Rome to Fellini, so Dublin to Joyce, Cologne to Heinrich Böll and Turin to Pavese... but it's hard to think of another film director as close to a city, a country, an ever-present locus of lived experience, as Fellini is to Rome." *Frankfurter Rundschau*

1 Basking in the cinema: Country boy Fellini first discovered Rome at the movies.

2 Lining up for a rendezvous with the wife of the provincial pharmacist. "She's worse than Messalina," say the local men.

3 Puppy love: Young people on the Spanish Steps cast Fellini's mind back to the days when love was something shameful and furtive banished to brothels or public toilets.

4 Fellini's assembly of the weird and the wonderful. He had originally planned several more city scenes, including a soccer match between Lazio and AS Rome.

5 Running wild: Fellini said Rome was an ideal breeding ground for the imagination. Rome is the perfect mother, indifferent, "with too many children to waste time on you personally."

burial chamber has just been discovered in the fifth layer. Suddenly, they're up against another hollow space; the drill breaks through the wall to reveal an ancient Roman villa – there are mosaics in the untouched baths, and stunningly beautiful frescos. Abruptly, the paintings on the walls begin to fade and crumble to dust; they cannot survive contact with the air of the outside world. What fascinates Fellini is the clash of opposites in Rome: antiquity and modernity, the old and the new; how the past permeates the present, and how partial destruction is sometimes necessary to ensure the survival of the total organism called Rome.

Fellini cuts into the body of the city and takes a look beneath its surface; but he cannot grasp Rome as a whole. It never stops changing, said Fellini after filming: "This city is like a woman. You think you've had her, undressed her, heard her moan… but then you see her again a week later, and you see that she's nothing like the woman you thought you had possessed. In short, I still have the desire to make a film, another film, about Rome." Things turned out differently, though. In his next film, *Amarcord* (1973), Fellini revisited the scene of his childhood: Rimini.

NM

THE CITY IN FILM As the modern city was undergoing radical change, thanks to electricity, tramlines and the separation of life and work, film was discovering its language: montage. The cut from one shot to another, the change of viewpoint and camera-angle – these resemble a streetcar journey through the city, with ever-changing views of narrow streets, tall buildings, strange faces, shop windows swooping past, and sudden, spacious squares. City and film are interdependent. In the early days of the medium, no one could understand an edited film unless he had experienced the city.

In the earliest films, the city was not merely a backdrop to the story; it was the story itself. The Berlin films made by the Brothers Skladanowsky in 1896 record the street life on Alexanderplatz or on the boulevard Unter den Linden. Since then, the image of the city in film has gone through several transformations. It has been shown as a brutal counterpart to the idyllic natural world, as in Friedrich Wilhelm Murnau's *City Girl* (1929/30), as a place of historical memory, as in Wim Wenders' *Wings of Desire* (*Der Himmel über Berlin / Les Ailes du désir*, 1987) or as a configuration of neon lights and shopping malls, as in *Fallen Angels* (*Duo luo tian shi*, 1995) by Wong Kar-wai. And – at regular intervals – there have been declarations of love to one city or another, as in *Manhattan* (1979) by Woody Allen or *Fellini's Roma* (*Roma*, 1971).

HAROLD AND MAUDE

1971 - USA - 91 MIN. - TRAGICOMEDY, SATIRE

DIRECTOR HAL ASHBY (1929–1988)
SCREENPLAY COLIN HIGGINS, based on his novel of the same name DIRECTOR OF PHOTOGRAPHY JOHN A. ALONZO EDITING WILLIAM A. SAWYER, EDWARD WARSCHILKA MUSIC CAT STEVENS PRODUCTION CHARLES MULVEHILL, COLIN HIGGINS, MILDRED LEWIS for PARAMOUNT PICTURES.

STARRING BUD CORT (Harold Chasen), RUTH GORDON (Maude), VIVIAN PICKLES (Mrs. Chasen), CYRIL CUSACK (Glaucus), CHARLES TYNER (Uncle Victor), ELLEN GEER (Sunshine Doré), ERIC CHRISTMAS (Priest), G. WOOD (Psychiatrist), JUDY ENGLES (Candy Gulf), SHARI SUMMERS (Edith Phern).

"What kind of flower would you like to be?"

When *Harold and Maude* hit American theaters in 1971, the off-beat love story about a stoic sixteen-year-old boy and an eighty-year-old woman flopped at the box office. It was not until 1979, when the picture was re-released, that it triumphed with audiences. Looking back, it makes perfect sense. How could a nation who had elected the staunchly conservative Nixon as its president embrace a tender, anarchic comedy, in which figures of authority like police officers, soldiers and members of the church get the proverbial "pie in the face," and where material wealth is not depicted as the pot of gold at the end of the rainbow. As Harold's home life shows us, money is arguably the root of spiritual barrenness. All the more reason why the movie spoke to so many individuals worldwide, capturing the hearts of younger audiences in particular, who felt so boxed in by the social conventions of the era. As Cat Steven's ballad inspiringly echoes throughout the film, "You can do what you want," and "If you want to be free, be free."

Yet *Harold and Maude* is much more than a love story. At heart, the film is also a social satire, a coming-of-age movie and a black comedy. Director Hal Ashby suavely negotiates the tightrope between the private and political arena, comedy and sentimentality, between the grotesque and the banal.

The story starts off macabre. Harold Chasen (Bud Cort), a young man from a wealthy family, turns on the phonograph, lights a candle, steps up onto a chair – and hangs himself. Moments later, his mother (Vivian Pickles) enters the room and seems completely unaffected by the event. She cancels an appointment at the hair dresser's and exits the room after informing Harold that dinner will be served promptly at eight.

Harold's staged "suicides" (there will be more of them to come as the film progresses) function as a sort of ritual, an utterly twisted and failed attempt at communicating with his mother. For the scenes between Harold and Mrs. Chasen all follow the same pattern. She throws an endless barrage of nonsense at Harold while he says stands there silently. When he does respond to her on occasion, it's simply water off a duck's back.

The Chasens live on a lavish estate, which director Hal Ashby plays up with long shots to accentuate its larger-than-life quality. Its rooms, on the other hand, are dark and oppressive and cage Harold in just as much as his wardrobe, exclusively made up of pressed suits and ties. Harold's body language is stiff and clumsy and his facial expressions appear to be frozen from ear to ear.

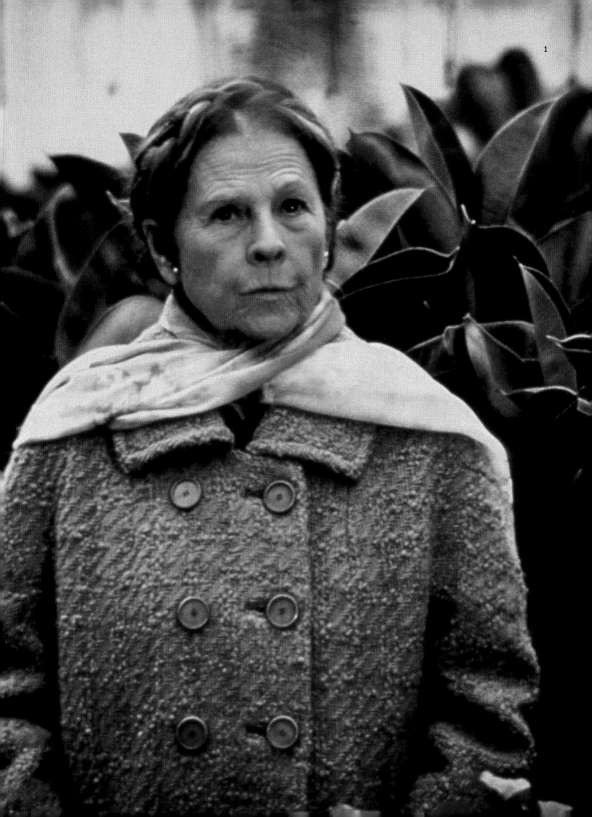

Harold and Maude is a poeticized slice of American life, in which automobile graveyards, garbage dumps, slums and junkyards are all awakened to new life. The film is a ballad, an allegory of life and death – in which life is ultimately triumphant." *Frankfurter Allgemeine Zeitung*

1 80 years old and still going strong: Maude (Ruth Gordon) is ready for anything.

2 Crying bloody murder: Harold's (Bud Cort) form of protest against his ice mama throws even house guests for a fatal loop.

3 A shared hobby: Visiting the funerals of strangers. Maude approaches Harold.

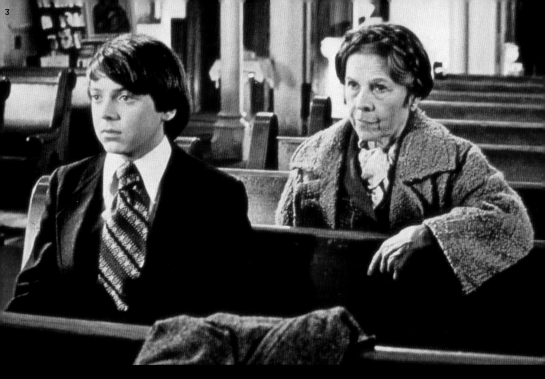

Harold is the polar opposite of Maude (Ruth Gordon). The two of them meet one day while partaking in their shared hobby. Both routinely attend the funerals of people they don't know. Brassy to the core and a fireball of energy, the eighty-year-old Maude is always on the move. She likes getting around by car, stealing one right after another and recklessly zooming around the bends.

Maude's youthfulness is so convincing (she puts the moves on Harold during a funeral service) that their putative misalliance never seems awkward. Indeed, the ones we want to shake our heads at are those who are so vehemently opposed to their relationship.

Harold awakens to life when Maude literally shoves him into motion. She encourages him to sing and dance, gives him a banjo and implores him to somersault whenever the spirit so moves him. After all, there's something new to be tried everyday, she insists.

Another saying Maude lives by is that you should never stop moving. Never commit to anything too long because you just might get stuck in a rut. In the end, it is the living world that she no longer wants to commit to and resolutely brings her own life to a close on her eightieth birthday. Harold is left, yet again, without someone to share his thoughts with, but he has learned from Maude's example. Ashby revisits the suicide theme one last time in the film's closing sequence as we watch Harold's Jaguar, which he has converted into a hearse, race along the coast and plummet off a cliff. With an upward swoop of the camera we see Harold still atop the hill exuding life and playing that banjo Maude gave him. LP

RUTH GORDON When Ruth Gordon won an Oscar at the age of 72 for her delightfully sinister supporting performance in *Rosemary's Baby* (1968), her amusing remark "I can't tell you how encouraging a thing like this is" nicely summed up the energy and optimism she displayed over a then 50-year career, which had begun with a 1915 stage debut as Peter Pan. The legendary actress soon landed bit parts in silent movies, but remained true to the stage for the next 25 years. Reaching the upper echelons of Broadway fame, she first made her way to Hollywood in the early 1940s. Tinseltown readily supplied Gordon with character and supporting roles in films like *Dr. Ehrlich's Magic Bullet / The Story of Dr. Ehrlich's Magic Bullet* (1939/40) and the celebrated wartime drama *Action in the North Atlantic* (1943).

Her career quickly took a new turn after she entered into her second marriage in 1942 with actor/director Garson Kanin. Together with Kanin, she wrote screenplays, many of which were filmed by George Cukor. These included the Katharine Hepburn / Spencer Tracy comedies *Adam's Rib* (1949) and *Pat and Mike* (1952), as well as the Judy Holliday films *The Marrying Kind* (1952) and *It Should Happen to You* (1954). Gordon's script for *The Actress* (1953) was based on her autobiographical stage play "Years Ago" and deals with her years as an adolescent when she decided to work in the theater despite her father's vehement disapproval. Her career experienced a miraculous renaissance in the mid-1960s: she won the above-mentioned Oscar, became a cult icon with *Harold and Maude* (1971) and proceeded to work right up to the end of her life in film and television. In 1985, the world said goodbye to the great Ruth Gordon.

CABARET

ttttttt

1972 - USA - 124 MIN. - LITERARY ADAPTATION, DRAMA, MUSICAL

DIRECTOR BOB FOSSE (1927–1987)
SCREENPLAY JAY PRESSON ALLEN, based on the Broadway musical of the same name by JOE MASTEROFF, JOHN KANDER and FRED EBB, the drama *I AM A CAMERA* by JOHN VAN DRUTEN, and the collection of short stories *THE BERLIN STORIES* by CHRISTOPHER ISHERWOOD **DIRECTOR OF PHOTOGRAPHY** GEOFFREY UNSWORTH **EDITING** DAVID BRETHERTON **MUSIC** JOHN KANDER, RALPH BURNS **PRODUCTION** CY FEUER for ABC CIRCLE FILMS, AMERICAN BROADCASTING COMPANY.

STARRING LIZA MINNELLI (Sally Bowles), MICHAEL YORK (Brian Roberts), HELMUT GRIEM (Maximilian von Heune), JOEL GREY (Master of Ceremonies), FRITZ WEPPER (Fritz Wendel), MARISA BERENSON (Natalia Landauer), ELISABETH NEUMANN-VIERTEL (Fräulein Schneider), HELEN VITA (Fräulein Kost), SIGRID VON RICHTHOFEN (Fräulein Mayr), GERD VESPERMANN (Bobby).

ACADEMY AWARDS 1972 OSCARS for BEST DIRECTOR (Bob Fosse), BEST ACTRESS (Liza Minnelli), BEST SUPPORTING ACTOR (Joel Grey), BEST CINEMATOGRAPHY (Geoffrey Unsworth), BEST MUSIC (Ralph Burns), BEST FILM EDITING (David Bretherton), BEST ART DIRECTION (Rolf Zehetbauer, Hans Jürgen Keibach, Herbert Strabel), and BEST SOUND (Robert Knudson).

"Divine decadence, darling!"

Berlin 1931. Despite a severe economic crisis, the German metropolis is determinedly cosmopolitan and exudes sensuality. Leave your worries at the door and come on into the Kit Kat Club, a dazzling night club where evening after evening an enthusiastic emcee greets you in three languages: "Willkommen, Bienvenue, Welcome!" His diabolically painted white face is reflected on the shimmering stage. And like a funhouse mirror, the film presents the cabaret to movie audiences as a caricature of the outside world. "Life is a cabaret!" exclaims Liza Minelli in an unforgettable song that is meant to be taken at face value.

Like so many other foreigners, British student Brian (Michael York) feels drawn to this thriving urban center. Arriving at a boarding house, he quickly makes the acquaintance of American Sally Bowles (Liza Minnelli), who works as a singer at the Kit Kat Club and dreams of making it big one day as a movie star. She's not only willing to capitalize on her charisma to get there, but will

readily exploit her body too if need be. Sexually uninhibited with a taste for luxury, Sally is a hedonistic modern whose deep-seated, hidden desire is to find true happiness. Beneath her decadent exterior we are shown more and more of the childish, vulnerable woman she really is. Brian, who at first seems immune to her erotic advances, eventually falls madly in love with her. It is a happy romance until the wealthy, young and rather attractive Baron Max von Heune (Helmut Griem) enters their world. Sally, mesmerized by his charms and riches, becomes more impractically minded with each passing day. Brian is jealous and turned on at the same time. Their love triangle is only spoken of in jest initially, but it soon becomes reality. Both of them have slept with the affluent Baron, and Sally, it turns out, is pregnant. While Sally and Brian are busy tackling their personal catastrophes, the Nazis take to the streets of Berlin in preparation for their rise to power. It seems the couple's lifestyle is doomed, for the epidemic of fascism spreading throughout the

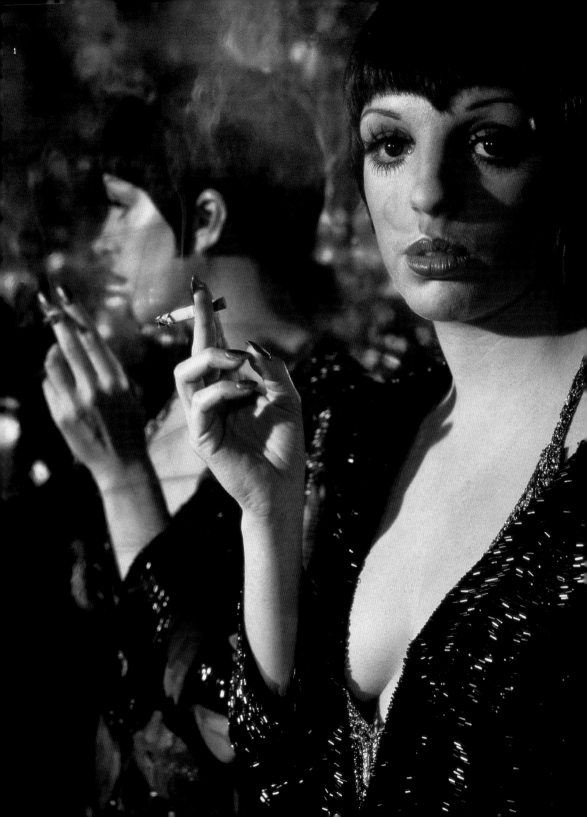

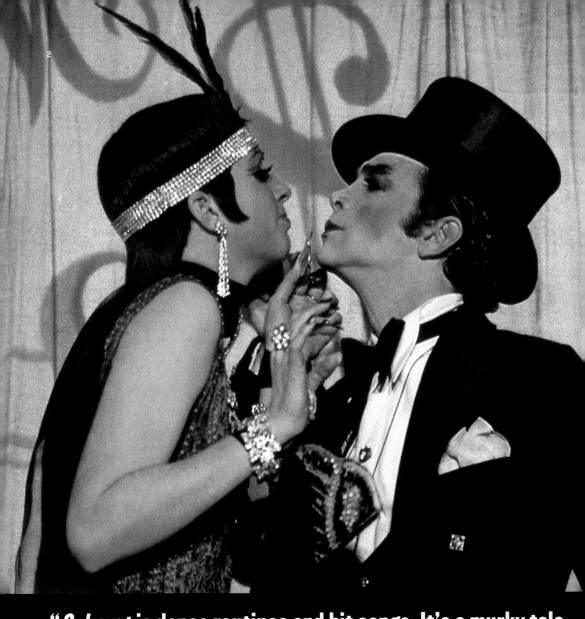

"*Cabaret* is dance routines and hit songs. It's a murky tale inspired by the novels of Christopher Isherwood. It's the myth of 30s Berlin. And above all, it's Bob Fosse. He has a marvelous grasp of the world of cabaret, its pathos and its poetry; fleeting, illusory, and poignantly authentic." *Le Monde*

nation seeks to extinguish all that is urban and modern. In its place, the Nazi movement prescribes conservative and provincial values for the German people. Brian decides to return to England. Sally, however, stays on in Berlin to try her luck at acting.

 Cabaret was one of last great Hollywood musicals. (Eat your heart out *Chicago*! [2002]) It was awarded an astounding eight Oscars at the Academy Awards. The movie version was based on John Kander and Fred Ebb's Broadway musical, which premiered in 1966. This, likewise, drew heavily from the short stories "The Last of Mr. Morris" and "Goodbye to Berlin" by Christopher Isherwood, which were published in a volume entitled *The Berlin Stories*. Unlike the majority of Hollywood musicals, such as *An Ameri-*

can in Paris (1951) or *Singin' in the Rain* (1952) there is nothing anachronistic about *Cabaret* even today. This is due to its songs, as popular as those of Kurt Weill's *Three Penny Opera* (*Dreigroschenoper*), and to the then 25-year-old Liza Minnelli, whose image is more intrinsically linked to *Cabaret* than almost any other actress' has ever been to a single production. Yet above all else, it is the film's narrative structure that plays the decisive role in its timelessness. Deviating from the traditional Hollywood musical format, *Cabaret* markedly separates its musical numbers from its plot. In other words, none of the characters in the film burst into song for no given reason. Instead, director and choreographer Bob Fosse brilliantly lets the stage acts at the nightclub serve as commentary on both the surrounding political situation

1 Cigarette, lipstick and a voice that won't quit:
 The role of Sally Bowles made Liza Minelli an
 international superstar.

2 "Life is a cabaret:" The stage as a world of
 entertainment and politics.

3 A pink-tinted love triangle: Only later does Sally
 discover that Brian (Michael York) and Maximilian
 (Helmut Griem) have been playing house.

4 Babe in the woods: When Brian comes to Berlin,
 he's a shy young writer. Sally's attempts to seduce
 him are initially unsuccessful.

"*Cabaret* may make a star out of Miss Minnelli, but it will be remembered as a chilling mosaic of another era's frightening life-style." *Films in Review*

LIZA MINNELLI The extent to which her image was shaped by one single film is itself a Hollywood phenomenon. Her belting voice and touching yet extravagant flair breathed so much life into *Cabaret's* (1972) nightclub singer Sally Bowles that from then on world audiences viewed Liza Minnelli as virtually inseparable from the role she had played. The daughter of Hollywood legend Judy Garland and director Vincente Minnelli was literally born into show business in 1946. She made her first appearance in front of a Hollywood camera when she was just two years old. Be it on Broadway, in film, in TV movies or in the music industry, her work has always met with instant success. She received a Tony in 1965 for her performance in the Broadway musical *Flora, the Red Menace*. Her first Oscar nomination came for her portrayal of the eccentric Pookie in *The Sterile Cuckoo* (1969). Another nomination followed in 1970 for Otto Preminger's *Tell Me That You Love Me, Junie Moon*, and in 1973 she won the Best Actress Academy Award for *Cabaret*. She became more popular with audiences than ever before, and in 1972, NBC aired the award winning television special *Liza with A Z*. Liza Minnelli, who describes herself as both "hopeful and cynical," is a star to this day, even though not all her films are smash hits. She collaborated with her father Vincente Minnelli on *A Matter of Time / Nina* (1976). Images of her superstar mother, who died in 1969, pop up in many of her movies, including Stanley Donen's *Lucky Lady* (1975) and most prominently in Martin Scorsese's musical drama *New York, New York* (1977). She experienced one of her greatest commercial successes in 1981 with *Arthur*. Shortly thereafter, her film career started to dry up. She disappeared completely from the public eye for several years. Alcohol and prescription drug addictions contributed to her personal downfall. In 1984 she sought professional help. She staged a comeback in 1985 in the form of an NBC made for TV movie *A Time to Live*, winning the Golden Globe for her performance. She then went on a star-studded tour at the end of the 80s with Frank Sinatra and Sammy Davis Jr. and even recorded a single with the Pet Shop Boys entitled "Losing My Mind" that reached number six on the U.K. charts. In 1997, Liza Minnelli was celebrated on Broadway in Blake Edwards' "Victor/Victoria," yet another great comeback after a twelve-year absence.

5 Tomorrow belongs to… whom? It remains unclear how fascism will change Sally's wild and extravagant lifestyle.

6 Mirror, mirror on the wall, *Cabaret* was Liza's best picture of all.

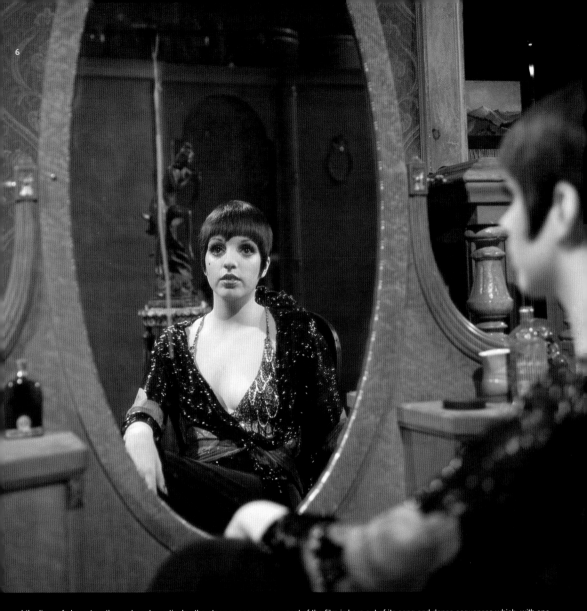

and the lives of characters themselves. In particular, the stage appearances of the emcee (Joel Grey), whose character doesn't exist within the framework of the plot outside the nightclub, do a poignant job of this. Plot elements and musical numbers are occasionally brought together through the ironic use of parallel montage. Such is the case when a scene of a staged Bavarian folk-dance is cut between rapidly appearing images of Nazis brutally beating up the Kit Kat's manager elsewhere. This sequence feeds violence into the musical number and choreography into the street fight. *Cabaret*, with its strikingly dark palette, is highly reminiscent of the 1920s, as is the music inspired by Kurt Weill and Fosse's stylized dance numbers, which clearly draw from that era's expressionist tradition. Commendably, it does this with-

pact of the film is born out of its song and dance sequences which, with one exception, all take place on stage. The only time we witness music outside the cabaret setting is when a young blond boy begins to sing what is meant to sound like a traditional German folk song at a beer garden. We just see his face at first, but soon the camera pulls back to show us his swastika arm-band. One beer garden patron after the next joins in his chant. The rhythm of the piece transforms into a military march and by the end, all have their hands extended in a Hitler salute. It may sound ludicrous, but at the time of the picture's European premiere, this scene was to be cut out for German audiences. Only after a number of critics were up in arms about the decision, was the sequence restored.

DIRECTOR FRANCIS FORD COPPOLA (*1939)
SCREENPLAY FRANCIS FORD COPPOLA, MARIO PUZO, based on his novel of the same name **DIRECTOR OF PHOTOGRAPHY** GORDON WILLIS
EDITING MARC LAUB, BARBARA MARKS, WILLIAM REYNOLDS, MURRAY SOLOMON, PETER ZINNER **MUSIC** NINO ROTA
PRODUCTION ALBERT S. RUDDY for PARAMOUNT PICTURES.

STARRING MARLON BRANDO (Don Vito Corleone), AL PACINO (Michael Corleone), DIANE KEATON (Kay Adams), ROBERT DUVALL (Tom Hagen), JAMES CAAN (Santino "Sonny" Corleone), JOHN CAZALE (Frederico "Fredo" Corleone), RICHARD S. CASTELLANO (Peter Clemenza), STERLING HAYDEN (Captain McCluskey), TALIA SHIRE (Constanzia "Connie" Corleone-Rizzi), JOHN MARLEY (Jack Woltz), RICHARD CONTE (Don Emilio Barzini), AL LETTIERI (Virgil Sollozzo), AL MARTINO (Johnny Fantane), GIANNI RUSSO (Carlo Rizzi), SIMONETTA STEFANELLI (Appollonia Vitelli-Corleone).

ACADEMY AWARDS 1972 OSCARS for BEST FILM (Albert S. Ruddy), BEST ACTOR (Marlon Brando), and BEST SCREENPLAY (Mario Puzo, Francis Ford Coppola).

"I'll make him an offer he can't refuse."

The unmentionable words are never heard. No one dares speak of the "Mafia" or the "Cosa Nostra" in this film, despite the fact that it tells a tale whose roots are at the heart of organized crime. The contents are categorized by another word: family. "It's a novel about a family, and not about crime," said its author, Mario Puzo. Francis Ford Coppola initially rejected the offer to direct the film after reading the book over-hastily and dismissing it as just another Mafia-vehicle. He eventually changed his mind for a number of reasons, principally because he discovered the family aspect of the story and was fascinated by it.

It is no coincidence that the film begins and ends with traditional family celebrations – a wedding and a baptism. The marriage of Connie Corleone (Talia Shire) and Carlo Rizzi (Gianni Russo) is the occasion for an enchanting celebration. An orchestra plays in the Corleone's garden, filled with a mass of dancing guests. Feasting and joking, children run wild and glasses are repeatedly raised to toast the bride. During the festivities, FBI agents mill outside the gates of the villa and scrawl down license plate numbers of the guests. The father of the bride, Vito Corleone (Marlon Brando) is one of the five Dons of the Italian community in the New York area and the guest

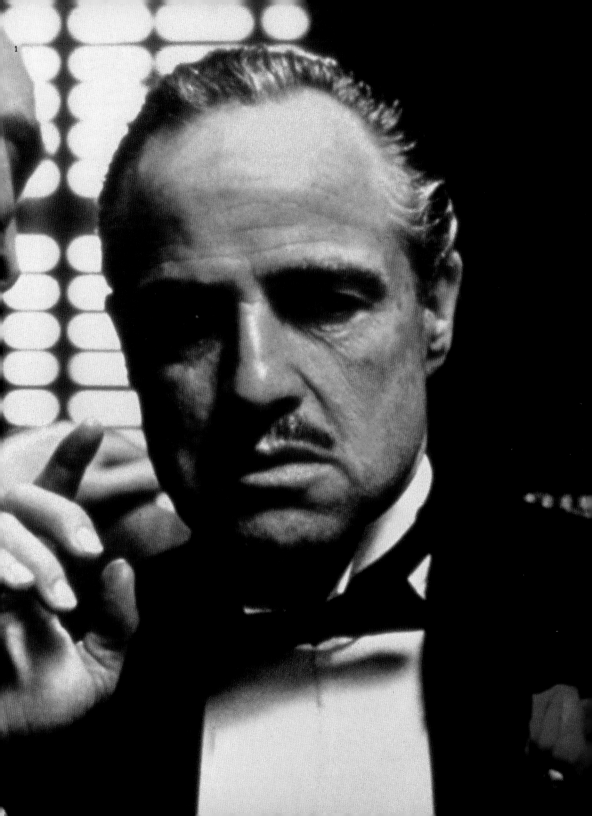

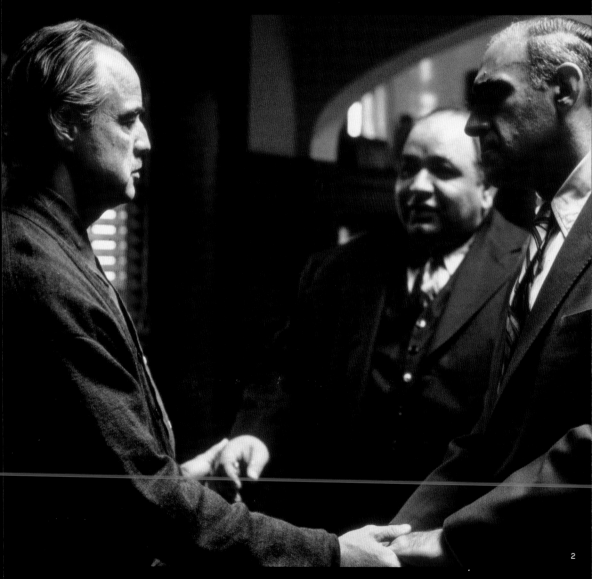

"Like practically no other Hollywood film of recent years, the tale of the New York Mafia clan Corleone reflects the divisions, the compulsions and the fears afflicting American society. Damaged by Vietnam and shaken by a profound crisis of faith in the nation, America's hallowed norms of good and evil are looking more beleaguered than ever." *Kölner Stadt-Anzeiger*

2

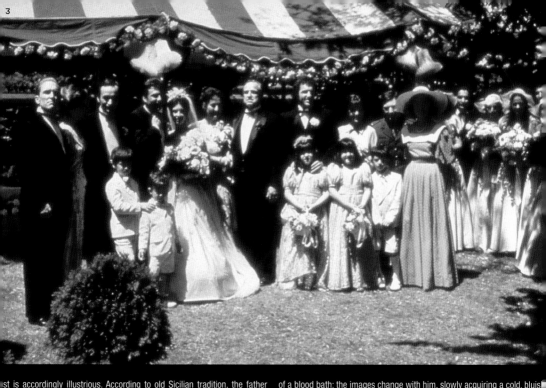

st is accordingly illustrious. According to old Sicilian tradition, the father of the bride cannot refuse any favor on his daughter's wedding day. Surrounded by his sons and confidants he aristocratically sits in his darkened reception room, glowing in a golden brown light, the perfect expression of dignity and power. He patronizingly receives the supplicants, listens to their dilemmas, accepts congratulations, and basks in the respect offered from all sides.

Like every scene with Marlon Brando in the role of the Godfather Vito Corleone, these scenes are filled with warmth. The colors fade when his son Michael (Al Pacino) flees to the family's ancestral home in sunny Sicily after committing two murders. Later Michael, who once strived for an honorable life and distanced himself from his family, will become the ringleader

of a blood bath: the images change with him, slowly acquiring a cold, bluish tinge.

The cause of the violent clash is Vito Corleone's decision to deny his backing to Virgil Sollozzo's (Al Lettieri) plans to branch out in the drug dealing business. Vito's temperamental son Sonny (James Caan) seems to disagree with his father, which inspires Sollozzo to try and topple the patriarch. Five shots bring Corleone down, but the old tiger survives. Michael, who to this point has held himself out of the family business, is shaken. His outsider role makes him seem unsuspicious, and he is therefore sent to the negotiation table. Michael promptly uses the opportunity to murder both Sollozzo and the corrupt police captain McCluskey (Sterling Hayden), and flees to Sicily. His unsuspecting girlfriend Kay (Diane Keaton) remains behind.

1 A man that won't take "no" for an answer: Marlon Brando takes life in stride as Don Corleone.

2 In sickness and in health: Making a deal with Don Corleone is more than a business transaction – it's a life-long bond.

3 One wedding for fifty funerals: *The Godfather* opens with the Corleone family renewing its vows, whilst Carlo (Gianni Russo) and Connie (Talia Shire) take theirs.

MARLON BRANDO Among the many curiosities surrounding the legendary *The Godfather* (1972) is that its success sprung from a series of coincidences and imponderables. Mario Puzo was unhappy writing the screenplay, Francis Ford Coppola initially didn't want to direct the film, and the studio had problems with the choice of the male lead. At this time, Marlon Brando was at a low point in his career, which began in the 1940s in the theaters of New York City. In 1947, his portrayal of Stanley Kowalski in *A Streetcar Named Desire* was a triumph and in 1951 he played the character in Elia Kazan's film adaptation. Schooled in "method acting," Brando graduated to Hollywood big-time – four Oscar nominations in a row speak for themselves. Initially he was repeatedly cast as the youthful rebel, but he soon proved his versatility in costume films and musicals. In the 1960s, his notorious moodiness and a string of flops caused him to fall from grace with Hollywood producers. In 1972 he made his comeback with *The Godfather* and *The Last Tango in Paris* (*Ultimo tango a Parigi / Le Dernier Tango à Paris*), receiving Oscar nominations for both films. Though he was awarded the Oscar for his role as Vito Corleone in *The Godfather*, he refused to accept it for political reasons.

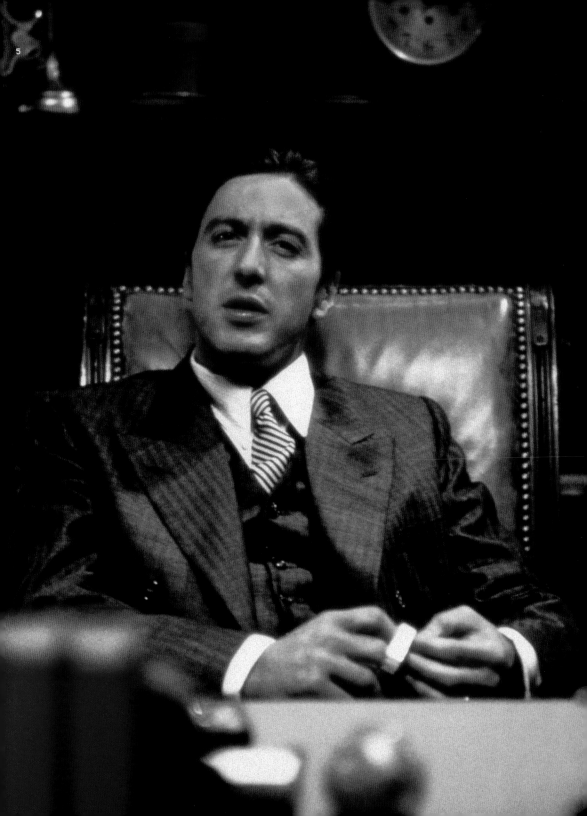

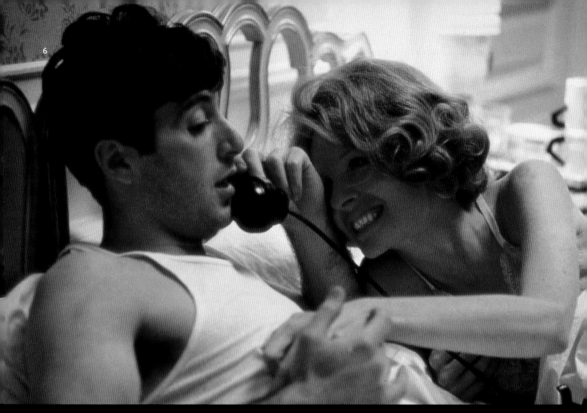

4 European vacation: A hunted man, Michael Corleone (Al Pacino) decides it's time to go back to his roots.

5 Like father like son: After some initial stumbling, Michael learns how to fill his father's shoes.

6 Deadlock: Michael Corleone and bride-to-be Kate (Diane Keaton).

7 The emissary wore black: Michael holds out a Sicilian olive branch to Virgil Sollozzo (Al Lettieri).

8 When in Rome: During his time in Sicily, Michael fares the local cuisine and develops a taste for Appollonia (Simonetta Stefanelli).

"And all the while, we think we're watching a Mafia crime story; but we're actually watching one of the great American family melodramas." *The Austin Chronicle*

7

In Sicily, Michael's hardening process continues. He falls in love and – with old-fashioned etiquette – asks the bride's father permission for his daughter's hand. But the long arm of vengeance stretches to Italy – his young wife, Appollonia is killed in a car bomb that was meant for Michael. In New York, the war between the families rages on. Michael's brother Sonny is the next victim. The slowly recovering Vito Corleone is devastated, but forgoes his right to vengeance in an attempt to put an end to the killing. Michael returns to the United States. He marries Kay, who has become a teacher. Michael, whose eyes now have a cold, hard expression, knows that the old feud is not over. He plans a large liberating coup. While he is in church at his nephew's baptism, and is solemnly named as the child's godfather, the enemies of the Corleones are killed off one

In scene after scene — the long wedding sequence,
John Marley's bloody discovery in his bed, Pacino
nervously smoothing down his hair before a restaurant
massacre, the godfather's collapse in a garden —
Coppola crafted an enduring, undisputed masterpiece."

San Francisco Chronicle

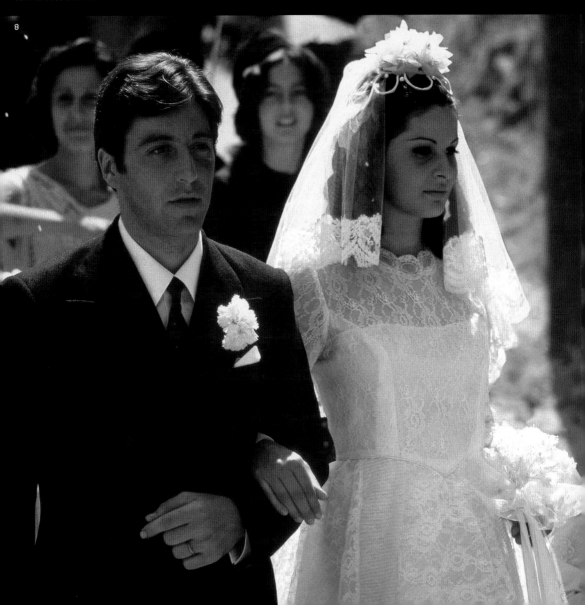

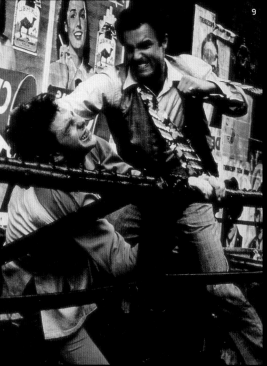

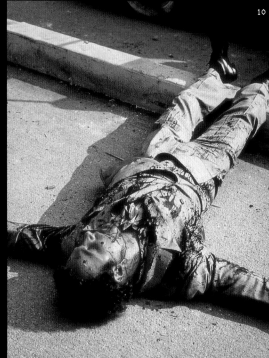

9　Big brother: When Carlo makes putty of wife Connie, Sonny puts a little love in his heart.

10　Gone with the wind: Sonny Corleone (James Caan) walks into a trap and goes up in smoke.

11　Paying the piper: An attempt to rescue sister Connie from a violent marriage proves more dangerous than Sonny had imagined...

"Cast and designed to perfection, this epic pastiche of 40s and 50s crime movies is as rich in images of idyllic family life as it is in brutal effects." *Der Spiegel*

by one. Among them is Connie's husband Carlo, who lured Sonny into a deadly trap.

Connie has become a nervous wreck and Kay begins to ask critical questions. Michael coldly denies responsibility and Kay is forced to experience her utter exclusion from the male circle. Before the doors close in front of her, she sees her husband, the new Don, Michael graciously receive the best wishes of his confidants and associates.

The film stands out for its clever dramatization of the balance of power enjoyed by Vito Corleone and his successor, Michael, as well as its scenes of heavy violence, such as the severed horse's head in film producer Jack Woltz's bed, Sonny's bullet-riddled body, or the gunshot through the lens of casino owner Moe Green's glasses. The brilliant finale has an Old Testament-like intensity about it. But these drastic images are mere moments compared

to the extensive family scenes. The business activities of the Corleones, which include murder and extortion, invariably take place outside the inner circle – they often follow car rides and trips, literally at a distance from the family core. This distance represents a lack of protection – the attempted hit on Vito Corleone occurs when he spontaneously stops to buy fruit from a street vendor, and hothead Sonny is killed when he leaves the family fortress with too great haste.

In a poignant reversal, Michael Corleone, the initially modern man, is unable to escape the chains of his family. Though he always considered himself an independent individual, he becomes a victim of the family tradition, a marionette whose strings are moved by the hands of fate, a metaphor the image on the book cover and film poster captures with perfection.

HK

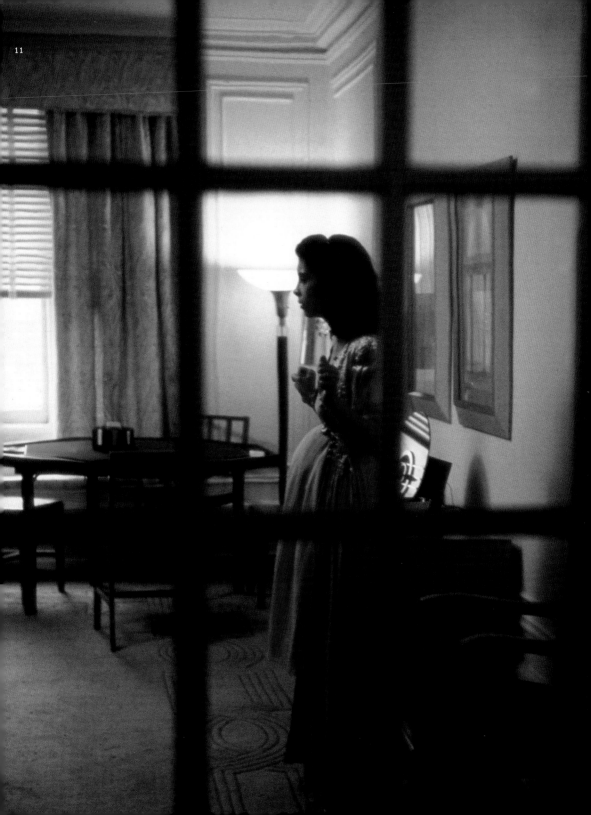

THE DISCREET CHARM OF THE BOURGEOISIE

Le Charme discret de la bourgeoisie

1972 - FRANCE - 102 MIN. - SOCIAL GROTESQUE

DIRECTOR LUIS BUÑUEL (1900–1983)
SCREENPLAY LUIS BUÑUEL, JEAN-CLAUDE CARRIÈRE DIRECTOR OF PHOTOGRAPHY EDMOND RICHARD EDITING HÉLÈNE PLEMIANNIKOV
MUSIC GUY VILLETTE PRODUCTION SERGE SILBERMAN for GREENWICH FILM PRODUCTIONS.

STARRING FERNANDO REY (Rafaele Costa, Ambassador of Miranda), PAUL FRANKEUR (Monsieur Thévenot), DELPHINE SEYRIG (Madame Thévenot), BULLE OGIER (Florence), STÉPHANE AUDRAN (Madame Sénéchal), JEAN-PIERRE CASSEL (Monsieur Sénéchal), MILENA VUKOTIC (Ines, the Maid), JULIEN BERTHEAU (Bishop Dufour), CLAUDE PIÉPLU (Colonel), MICHEL PICCOLI (Minister).

ACADEMY AWARDS 1972 OSCAR for BEST FOREIGN FILM.

"There's nothing like a martini, especially when it's dry!"

An anecdote from Oscars Night, 1972, encapsulates the spirit of this film. When Luis Buñuel's movie was officially nominated, the 72-year-old Surrealist and scourge of the bourgeoisie made a statement to Mexican journalists: he was quite sure, he announced, that he would indeed be awarded the Oscar; after all, he insisted, he'd forked out the 25,000 dollars demanded for the prize – and though Americans might have their faults, they could always be relied on to keep their word… The story hit the press, and all hell broke loose in Hollywood. Buñuel's producer, Serge Silbermann, had his work cut out pouring oil on the troubled waters. When *The Discreet Charm of the Bourgeoisie* actually went on to win the Academy Award for the Best Foreign Film, Buñuel smugly told anyone who'd listen: "The Americans

may have their faults – but you can always count on them to keep their word."

In his last film but three, the Old Master unleashed the beast of surrealism once more. This time, however, the result was less visually disturbing than the early masterpiece *An Andalusian Dog* (*Un chien andalou*, 1929), made in collaboration with Salvador Dalí. After years of struggle and exile, in his hard-boiled but still vital old age, Buñuel no longer had any need to prove his credentials as an anarchic, subversive, and unconventional artist. And though one might complain that the film has no plot, that its characters are as lifeless as marionettes, or that they're forced to caper through an all-too-theatrical set, this kind of criticism simply fails to recognize the film's truly

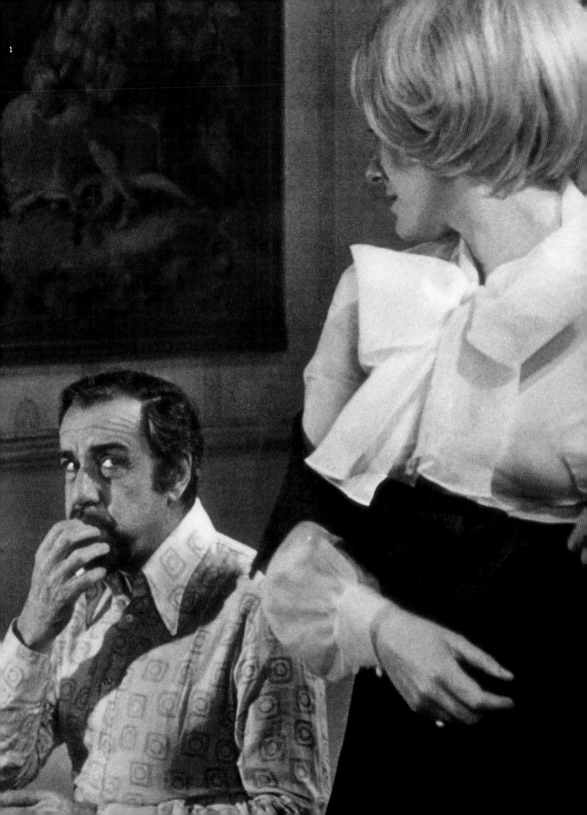

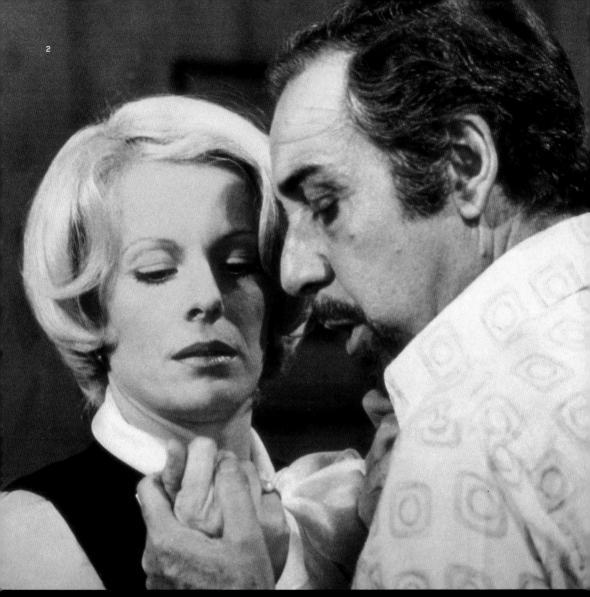

1 The Mirandan ambassador (Fernando Rey) is a connoisseur of good food. Madame Thévenot (Delphine Seyrig) admires his excellent taste.

2 The more unattainable the goal, the more authoritative the moral law, the more unsus-pecting the husband… the more desire grows.

3 Everybody's nightmare: Suddenly on stage without a line in your head.

revolutionary quality, as a grotesque cinematic carnival of bourgeois ideals, values and clichés.

The story is easily summarized: six *grands bourgeois* are doing their damnedest to meet for an exquisitely cultivated evening meal – but something or other keeps stopping them from doing so. Either they mysteriously get the dates mixed up, or they're inconvenienced by a sudden death in the restaurant. So they try again; and this time, a squad of paratroopers burst into the house in order to carry out a maneuver. The would-be diners persist undeterred; and just as they've all taken their places and lifted their

cutlery, they realize they're on a theater stage; the chicken is made of rubber the audience are booing, and the actors appear to have forgotten thei lines…

This last scene is not the only one that turns out to have been dream by one of the protagonists. Various other nightmares disturb the diners whose faultlessly polite but utterly trivial activity seems destined to peter ou in one dead end after another. On one occasion, a dream within a dream leads to yet another dream. As the film proceeds, it becomes increasingly clear to the audience that they can rely on nothing they are shown. Reality

"The title's complacent *grandezza* not only characterizes the bourgeoisie itself, but the visual style of the film, and Bunuel's analytical approach. No other director treats his characters with such distance and apparent passivity (or indifference); and none grants them such unconditional freedom to act according to the milieu or the atmosphere they happen to inhabit – to be new and different in each scene." *Die Zeit*

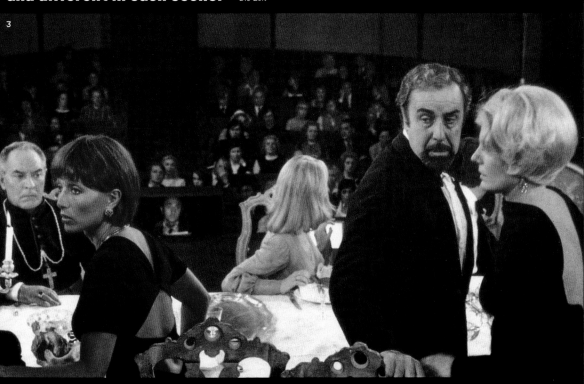

3

FERNANDO REY

He turned up in so many films that almost everyone must have seen him sometime – possibly without even noticing it, for his appearances were sometimes fleeting (though always worthwhile). In the 80s, he appeared in so many movies that one critic dared call him "a prop." His filmography comprises around 200 films.

Yet for all that, the Spaniard Fernando Rey (1917–1994) is best known and best loved for his performances in a handful of films by his friend Luis Buñuel, as well as for his major roles in *The French Connection I* and *II* (1971/1975). In the latter movies, he played a sophisticated French drugs czar who's pursued obsessively by a tough, streetwise New York detective (Gene Hackman). The chase scene in the subway is unforgettable: when Rey, the man with the elegant walking-stick and the perfectly-manicured beard, waves nonchalantly as his train draws away from his frustrated nemesis on the platform, it's surely one of the great moments in movie history. Only Rey could have embodied this figure in all its rich ambiguity: gallant and decadent, cultivated and greedy – a memorably nuanced characterization.

His great career with the exiled Spaniard Buñuel began in Mexico with *Viridiana* (1961). There followed *Tristana* (1969/70), *The Discreet Charm of the Bourgeoisie* (*Le Charme discret de la bourgeoisie*, 1972) and *That Obscure Object of Desire* (*Cet obscur objet du désir*, 1977), Buñuel's last film. Though it may be hard to believe, Buñuel discovered Rey when he was playing the part of a corpse; the director was simply blown away by the actor's "expressive power." An encounter of crucial – indeed vital – importance to both…

and illusion dissolve and merge into a new actuality, a surreal cinematic universe. Yet however bizarre the events that invade their lives, these six ladies and gentlemen never lose their cool, persevering heroically with their cultivated poses and their gestures of hypocritical friendliness. Quite literally, they never lose face; for when all they have is a succession of masks for every social eventuality, there's no face left to lose.

However elegantly the table is set, it's a uniquely hot, dry and spicy meal that Buñuel serves up to his audience, and it's not for tender palates (though he does include an excellent recipe for an extra dry Martini). In fact, the guests at this dinner table are so wonderfully adroit in their blasé bitchiness that it's hard not to end up liking them a little. The subtle pleasure of *schadenfreude* is something one could quite easily acquire a taste for.　　SR

"You may note that I haven't really tried to say what the film is about, what it means. And the reason for that is that I don't know. But, I don't really care, either. A poem should not mean, but be, said someone, and if there was a film poem, this is it."

Guardian Weekly

4　Opportunity grabs: While the party is hiding from terrorists, the ambassador gets what he can.

5　Topsy-turvy: The dead hold a wake while the living sleep. Buñuel adopted and adapted the principles of Carnival.

6　Absolution: A bishop with a shotgun (Julien Bertheau) executes his father's murderer during Confession.

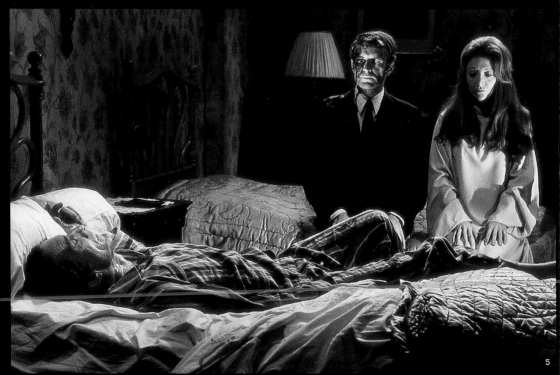

5

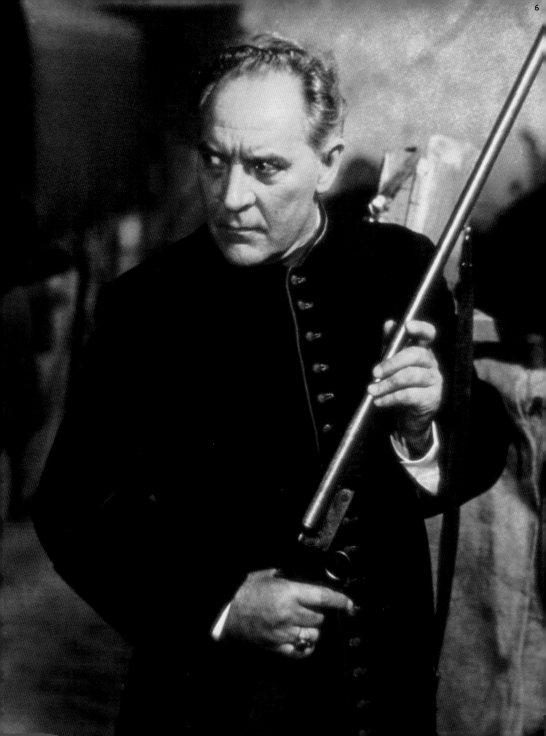

SOLARIS
Solyaris

1972 - USSR - 167 MIN. - SCIENCE FICTION

DIRECTOR ANDREI TARKOVSKY (1932–1986)
SCREENPLAY FRIEDRICH GORENSTEIN, ANDREI TARKOVSKY, based on the novel of the same name by STANISLAW LEM
DIRECTOR OF PHOTOGRAPHY VADIM YUSOV EDITING LJUDMILA FEYGINOVA MUSIC EDWARD ARTEMYEV, JOHANN SEBASTIAN BACH
PRODUCTION VIACHESLAV TARASOV for MOSFILM.

STARRING NATALYA BONDARCHUK (Hari), DONATAS BANIONIS (Kris Kelvin), NIKOLAI GRINKO (Kris's Father), YURI JÄRVET (Snaut), ANATOLI SOLONITSYN (Sartorius), VLADISLAV DVORZHETSKI (Berton), SOS SARKISSIAN (Gibarjan), OLGA BARNET (Kris's Mother), TAMARA OGORODNIKOVA (Aunt Anna), YULIAN SEMYONOV (Chairman at Scientific Conference).

IFF CANNES 1972 GRAND PRIZE OF THE JURY (Andrei Tarkovsky).

"We are dealing with the limits of human understanding."

Based on a novel by Stanislaw Lem, this is a film that takes on some very big issues: the nature of self-awareness, knowledge and perception. In an era of space epics that were strong on special effects but weak on content – from *Star Wars* (1977) to *Star Wars: Episode V – The Empire Strikes Back* (1980) – *Solaris* reminds us that the science-fiction genre has its roots in philosophical speculation. And the film begins like a poetic alternative to its high-tech rivals.

Its opening shots are long and slow, idyllic images of the natural world: grass waving softly in the waters of a lake, trees, fog, a solitary horse. In the background, we hear birdsong, frogs croaking, and the soft rustle of flowing water. From beginning to end, *Solaris* maintains this meditative tempo, and it's one of the film's great strengths. With a confidently minimalist use of

cinematic means, Tarkovsky presents a maximum of disturbing effects. The world he creates is a kind of Utopia; highly idiosyncratic, familiar and yet strange. But Tarkovsky is in any case only marginally interested in doing justice to the conventions of the SF film. Indeed, his almost provocative refusal to serve up the special effects expected of the genre gives him more space to follow the development of the characters as they travel in search of themselves. Their story is told with the greatest of care.

The center of attention is the psychologist Kris Kelvin (Donatas Banionis). His task is to examine the crew of a space station in orbit around the planet Solaris, and to find out the reasons for their strange behavior. Before he departs from the Earth, however, he has to order his personal affairs, which means, above all, his relationship with his father (Nikolai Grinko).

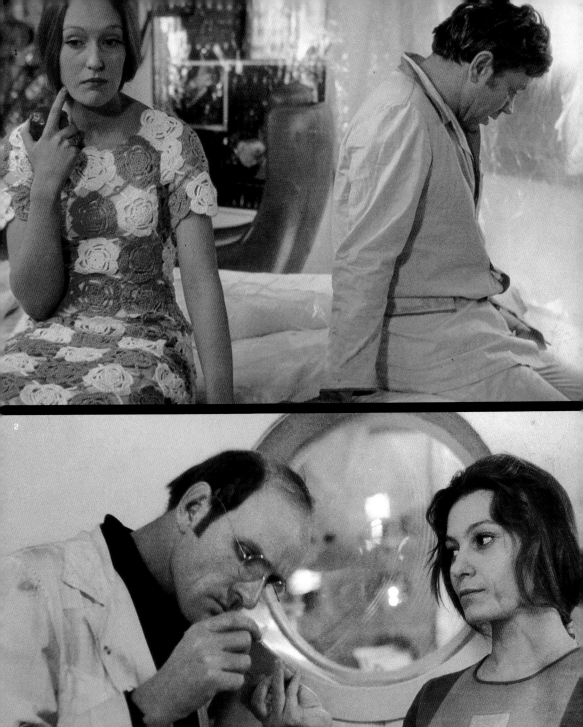

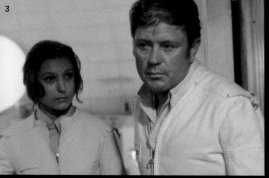

This is a subject Tarkovsky returns to in each of his films. Kelvin's melancholy farewell is overshadowed by the still-raw memory of his wife Hari, who took her own life.

Against this background, the voyage to the space station seems like a welcome departure to a new life. On arriving, Kelvin finds the two astronauts Snaut (Yuri Järvet) and Sartorius (Anatoli Solonitsyn) in a strangely nervous and preoccupied state. Their peculiar behavior appears to have something to do with the ocean of Solaris, whose biostreams are somehow affecting the psychic wellbeing of the crew. It becomes apparent that the planet itself is capable of turning private thoughts and wishes into three-dimensional reality. Kelvin himself is not spared the experience. Soon, he is faced with a materialized copy of his wife Hari (Natalya Bondarchuk). He is drawn into

"The seething planet, turbulent metaphor as much for an imperfect deity as for the psychoanalyst's couch, provides what the men come to recognize as a mirror of themselves, reflecting with inescapable clarity the faults which caused the errors now incarnate before them." *Sight and Sound*

1 In bed with the blues: Color symbolism and religious imagery brighten up the ether of *Solaris*.

2 Scent of a woman: "Humanized" memory Hari (Natalya Bondartschuk) proves little more than a hatful of hollow.

3 Always on my mind: Despite all attempts to stifle the memories of his mistress, Hari lives on.

4 Through the looking glass: Hari realizes that her identity is a sham.

5 Mind scrambler: Snaut (Juri Järvet) and Sartorius have already grasped Hari's implications for future galactic travelers.

a series of mysterious encounters with this phantom creature – and confronted with the power of his own memories.

Like the astronaut Bowman in Stanley Kubrick's *2001: A Space Odyssey* (1968), Kelvin in *Solaris* ultimately attains a new level of consciousness. In many science fiction movies, outer space is the scene of conquest, of battles for new territory. In *2001* and *Solaris*, by contrast, infinite and apparently empty space provides an opportunity for evolution, for a growth in knowledge and self-awareness. Vast, obscure and barely explored, space is also a metaphor for the human race, a stranger to itself and to its own history, despite all the progress of technology. Thematically, however, *2001* takes a broader view, examining the development of humankind as a whole; in

Solaris, Tarkovsky is interested primarily in the individual, his unique subjectivity and personal history. The form chosen is a kind of filmic contemplation that forgoes fast cutting in favor of poetic images, long takes, and faces absorbed in thought, thus granting us some deep insights into the characters' mental states and private spiritual landscapes. What we see is the process of reflection given cinematic form; and, above all, given time to develop. If the methods seem unusual for a science fiction film, they are more than adequate to the director's theme. The film is powerfully poetic, and its melancholy atmosphere of loneliness and silence constitutes an invitation to the spectator: to follow Kris Kelvin on his Utopian search for the unknown self. BR

SCIENCE FICTION Since the 20s, the term has served as a collective name for films and books that speculate on technological developments in fantastic future worlds. The first science fiction film appeared as early as 1902: Georges Méliès' *Journey to the Moon* (*Le Voyage dans la lune*), based on motifs from Jules Verne and H. G. Wells. While the set design and visual aesthetics of Fritz Lang's *Metropolis* (1926) formed a kind of stylistic prototype still imitated today, science fiction only achieved real popularity in the 50s, with films such as *The Thing From Another World* (1951) and *The War of the Worlds* (1953). The SF film appears to have no difficulty in formulating social and technical utopias, even when these are very far removed from the moviegoers' daily experience. A number of different strategies are available: the *Star Wars* saga (five episodes between 1977 and 2002) was just one example of an elaborate spectacle driven by special-effects technology; the *Alien* series (1979–97) showed how horror elements could be integrated; and *Blade Runner* (1982) picked up on the tradition of 40s Film Noir. As a rule, all these variants combine a vision of the human future with a scenario of existential threat. The philosophical content varies. In recent times, the genre has experienced a revival, with the satirical *Men in Black* (1997) and *The Matrix* (1999), which owes a lot to comics. The dramatic development of digital animation technology has produced a new "somatic cinema," whose sensuous and physical qualities could barely have been imagined even a few years ago. Films like *Solaris* (*Solyaris*, 1972) however, make it painfully clear that these technical advances have so far only been possible at the expense of real content.

LAST TANGO IN PARIS
Ultimo tango a Parigi / Le Dernier Tango à Paris

1972 - ITALY / FRANCE - 136 MIN. - DRAMA

DIRECTOR BERNARDO BERTOLUCCI (*1941)
SCREENPLAY BERNARDO BERTOLUCCI, FRANCO ARCALLI DIRECTOR OF PHOTOGRAPHY VITTORIO STORARO EDITING FRANCO ARCALLI,
ROBERTO PERPIGNANI MUSIC GATO BARBIERI PRODUCTION ALBERTO GRIMALDI for LES PRODUCTIONS ARTISTES ASSOCIÉS,
PRODUZIONI EUROPEE ASSOCIATI.

STARRING MARLON BRANDO (Paul), MARIA SCHNEIDER (Jeanne), JEAN-PIERRE LÉAUD (Tom), MASSIMO GIROTTI (Marcel),
VERONICA LAZAR (Rosa), MARIA MICHI (Rosa's Mother), GIOVANNA GALLETTI (Prostitute), GITT MAGRINI (Jeanne's
Mother), CATHERINE ALLÉGRET (Catherine), CATHERINE BREILLAT (Mouchette).

"How do you like your hero?
Over easy or sunny side up?"

The camera swoops down on a man, before encircling him with the fast, aggressive movements of a tango dancer. The man (Marlon Brando) is standing under a métro bridge in Paris, and he's screaming. His name is Paul and his wife has just committed suicide. In the distance, we see the shadowy figure of a young woman (Maria Schneider). She approaches, passes Paul, and turns to look at him once more. These two will meet again. In an empty apartment, their first sexual contact takes place within minutes – no holds barred. The couple are in flight from themselves. Estranged from their lives, enclosed in a barely furnished room and surrounded by diffuse sunlight, they meet to adopt the original male and female roles: Adam and Eve. Neither knows the other's name nor anything of their life outside the apartment, for what goes on beyond these walls is of no significance. Their relationship can only exist in the hermetic world of the apartment, in which all social links are erased. Paul is a hotelier and a vagabond, whose life has fallen apart since the death of his wife. It's he who makes the rules, though his bourgeois 20-year-old lover Jeanne adopts them with increasing alacrity. In the end, though, it's Paul who shatters this artificial unity against Jeanne's will. He moves out of the flat and announces his desire to marry her; but Jeanne cannot countenance a bourgeois alliance with the man she refers to, disrespectfully as maître d'hôtel. The iron rule remains: no names. As events draw

towards the climax, he bursts into her apartment and demands to know her name. She's holding a gun in her hand, in self-defense; and as she fulfills his request, the gun goes off. It's impossible to say what killed him – the weapon or the word.

In the early 70s, few films aroused as much attention as Bertolucci's Last Tango in Paris. In New York, Pauline Kael celebrated Last Tango as a work that had "altered the face of an art form;" in Italy, the movie caused uproar. Bertolucci was only 32 when he made Last Tango, and it was already his sixth film. Though he had become world-famous with 1900 (Novecento), his epic of the Italian century, Ultimo tango a Parigi was eventually banned in his home country. It was the graphic sex scenes that caused all the trouble, for they went far beyond anything ever seen in mainstream cinema and were accused of being pornographic. Yet the censors felt provoked not only by the copulating couple (who are, incidentally, never seen naked) and the spectacular body of Maria Schneider (at that time, a young and unknown actress). They were equally offended by the film's fundamentally nihilistic attitude and its openly stated fantasies of degradation. The movie was a product of its period: without the climate of sexual liberation at the start of the 70s, a film like Last Tango in Paris would have been as unthinkable as Liliana Cavani's The Night Porter (Il portiere di notte, 1974) or Pasolini's

Arabian Nights (*Il fiore delle mille e una notte*, 1974). Since the 70s, we have grown accustomed to provocation as an artistic principle. It's the film's aesthetic qualities that impress us today. The pictorial composition, the light, the camerawork and the editing create a wholly unique atmosphere and provide the actors with the framework they require – especially Marlon Brando. Bertolucci's cameraman Vittorio Storaro had a huge influence on the director's visual style. The artfully lit interiors, the variations in focal depth and the precisely calculated camera movements combine to evoke the atmosphere that made the film so famous: a continual oscillation between sexual tension, power fantasies and sheer hopelessness. This effect is reinforced by Franco Arcalli's montage, with its often bewildering suspension of spatial logic, and the music of Gato Barbieri, till then known only as a composer for B-movies.

With admirable skill, Bertolucci weaves together three narrative threads. There's the story of Paul, mourning his dead wife and hunting for the traces of her suicide in his strange, labyrinthine hotel. There's the story of Jeanne, whose life we see filtered through the camera of her fiancé Tom (Jean-Pierre Léaud) as material for a TV documentary entitled "The Portrait of a Young Girl." This film-within-the-film is a parody of *cinéma vérité*; while Tom believes he's portraying the real Jeanne, all he can produce is a string of tired clichés. And finally we have the story of Paul *and* Jeanne, another manifestation of the old dream of innocence regained, of a new self beyond economic status, culture or civilization. The scene in which the couple sit naked on the bed has since become famous. Their bodies are bathed in warm, yellow light, and they converse only in sounds, in a series of grunts and chirrups. For

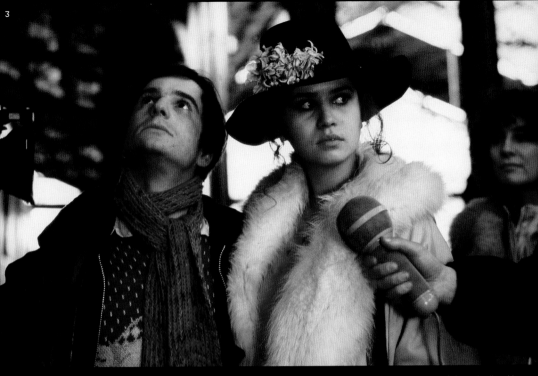

1 Alone at last: After his wife's suicide, Paul (Marlon Brando) escapes to the confines of an empty apartment. Jeanne (Maria Schneider) soon follows suit.

2 It takes two to tango… Paul and Jeanne dance to a different tune.

3 If only they knew the real me: The spectator can only see Jeanne through her fiancé's camera.

4 Sex among strangers: A desperate attempt to return to the arms of innocence.

"This must be the most powerfully erotic movie ever made, and it may turn out to be the most liberating movie ever made, and so it's probably only natural that an audience, anticipating a voluptuous feast from the man who made *The Conformist* and confronted with the unexpected sexuality, and the new realism it requires of the actors, should go into shock. Bertolucci and Brando have altered the face of an art form. Who was prepared for that?" *Pauline Kael*

language is civilization, words petrify social relationships, and these are the very things the two deeply different protagonists are seeking to escape in the secret world of the apartment. Yet this Garden of Eden, as a refuge from civilization, is also a place in which the rules of civilized behavior seem to have lost their normative force. Here, violence, raw sex and obscene fantasies can achieve expression, as putative manifestations of a non-social way of being.

The film is permeated by an existential despair that evokes the world of Francis Bacon. Not only does the film open with two Bacon paintings; Bertolucci also imitates the colors and compositional techniques of the artist, with shots framed in arches and faces filmed through a sheet of glass, shifting and dissolving their contours. **KK**

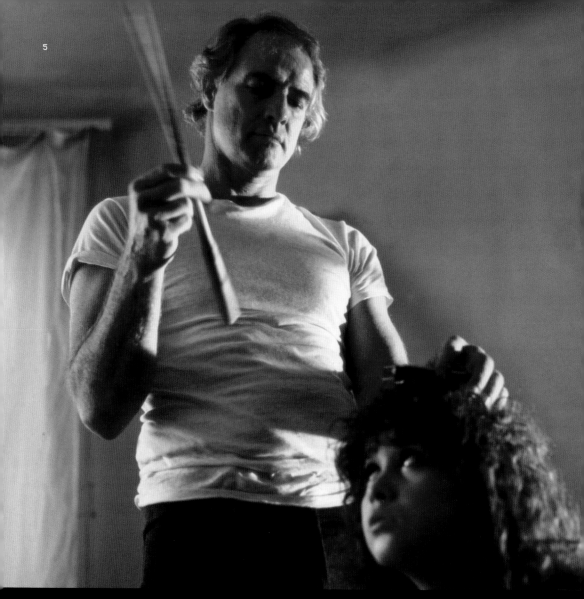

"*Tango's* explosive impact will demonstrate to a wide public what many film buffs already know: that Bertolucci, 31, is Italy's most gifted director in the generation after Fellini and Antonioni, and one of the most gifted younger directors on the world scene." *Time Magazine*

BERNARDO BERTOLUCCI Alongside Godard, Antonioni and Chabrol, the Italian director Bernardo Bertolucci is regarded as one of the last survivors of the European film avant-garde. He alone, however, managed to introduce the aesthetics of the *cinéma des auteurs* into the cinematic mainstream. Indeed, his films were often astonishingly popular, not least the multiple Oscar-winner *The Last Emperor* (1987). Influenced by the theories of Freud and Marx as well as by artists as diverse as Francis Bacon and Giuseppe Verdi, Bertolucci is a great political filmmaker *and* an outstanding visual stylist. His best film is widely agreed to be *The Conformist* (*Il conformista / Le Conformiste*, 1970), a tale of guilt and political entanglement in the fascist Italy of the 1930s. The film was adapted from a novel by Alberto Moravia.

Bertolucci was born in Parma in 1941, and made his directing debut at the age of 21 with *La Commare secca*, based on a short story by Pier Paolo Pasolini. He went on to work with Pasolini as an assistant director on *Accattone* (1961), before achieving international recognition with his own film,

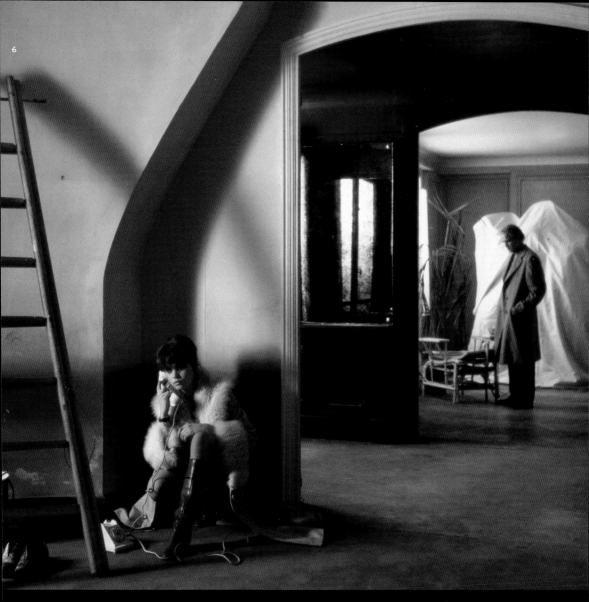

6

5 *A Streetcar Named Desire* (revisited): Domestic
violence behind closed doors.

6 Empty chairs and empty tables: Vittorio Storaro's
camera captures the character's inner isolation.

Before the Revolution (*Prima della rivoluzione*, 1963–64). Other works of the 60s include *the new yorker* (*Love and Anger*, 1969) and *Partner* (1968*)*, a homage to the French *Nouvelle Vague*. The scandal caused by *Last Tango in Paris* (*Ultimo tango a Parigi / Le Dernier Tango à Paris*) brought him unheard-of success, but the film was banned in Italy and the country's authorities even stripped the director of his right to vote.
Bertolucci's cinematic trademarks include a highly developed epic narrative style and a sophisticated delight in visual imagery. In the 70s, he consolidated his reputation as a director of high-quality films with *1900* (*Novecento*, 1975/76) and *La Luna* (1979). With *Stealing Beauty* (*Io ballo da sola / Beauté volée*), a film set in Tuscany, he made his cinematic return to Italy; but only since *Besieged / L'assedio* (1998), the story of an Englishman and an African woman in Rome, has he been fully accepted back in his native land. He made *Paradiso e inferno* in 1999 before his latest film in English, *Heaven and Hell* (2001).

DIRECTOR TERRENCE MALICK (*1943)
SCREENPLAY TERRENCE MALICK DIRECTOR OF PHOTOGRAPHY BRIAN PROBYN, TAK FUJIMOTO, STEVAN LARNER EDITING ROBERT ESTRIN
MUSIC GEORGE ALICESON TIPTON, GUNILD KEETMAN, JAMES TAYLOR, CARL ORFF, NAT KING COLE, ERIK SATIE
PRODUCTION TERRENCE MALICK for PRESSMAN-WILLIAMS, BADLANDS COMPANY.

STARRING MARTIN SHEEN (Kit), SISSY SPACEK (Holly), WARREN OATES (Holly's Father), JOHN CARTER (Rich Man), RAMON BIERI (Cato), ALAN VINT (Deputy), GARY LITTLEJOHN (Sheriff), BRYAN MONTGOMERY (Boy), GAIL THRELKELD (Girl), CHARLES FITZPATRICK (Salesman).

"He wanted to die with me and I dreamed of being lost forever in his arms."

Fifteen-year-old Holly (Sissy Spacek) has grown up without a mother and whiles away the hours playing in her backyard. Kit (Martin Sheen) is 25 and works as a garbage man in Fort Dupree, a middle-of-nowhere town in South Dakota. When the two of them lay eyes on each other, it's love at first sight. Holly's father (Warren Oates) forbids her from associating with Kit, but to no avail. One thing leads to another and Kit ends up shooting Holly's father dead, sending the couple on an outlandish escapade in the great American frontier. They flee to the Montana Badlands, committing three more murders en route.

In their isolation, they revert to an archaic hunter-gatherer way of life, until they are finally discovered…

The work of filmmaker Terrence Malick is surrounded by legends. He directed two films in the 70s, *Badlands* and *Days of Heaven* (1978), and then disappeared from the scene until 1998 when he re-emerged behind the camera with the critically acclaimed *The Thin Red Line*. His first feature film, *Badlands,* marked an astounding debut. Malick's story of two star-crossed loners is a stunningly aesthetic ballad. From the sleepy town to the abandoned,

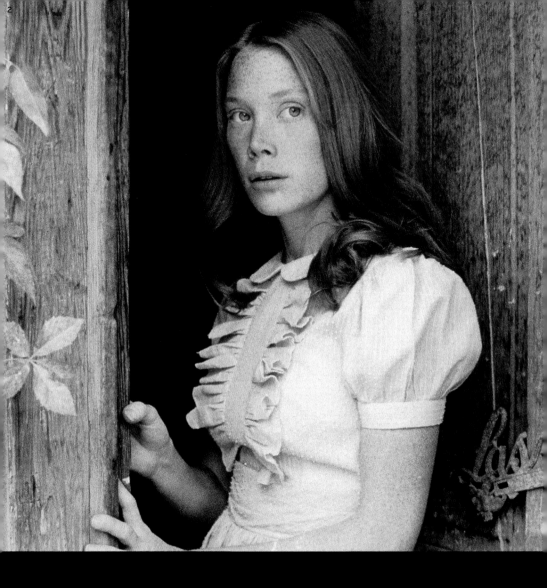

virtually endless expanses of land, right through the sanctuary of the wilderness, the scenes unfold in a blanket of golden sunlight. The film is a homage to the landscape of the region, showered in a melange of heat and dust. Malick employed the services of three cinematographers to realize his vision. His imagery is underscored, not by country music, but rather by the simple yet soothing xylophone sounds of Carl Orff's "Musica Poetica."

As luxuriously as the film exhibits its landscape, so it laconically tells the protagonists' story. *Badlands* is coldly distant in the depiction of its subject matter and avoids the psychological. The film is based on the true story

of "Mad Dog Killer" Charles Starkweather, a nineteen-year-old who alongside his fourteen-year-old girlfriend, Carol Ann Fugate, went on a killing rampage that left Carol's father and several others dead. Charles and Carol, according to the tale, were regular kids and not psychopaths. Malick's central characters too, are seemingly ordinary people, even when, for the most part, the appear apathetic and caught up in their own world, far from reality.

Holly looks like a little girl when we see her playing in the backyard wearing shorts and a T-shirt. Her one genuine interest is her love for movie magazines. We watch as she plows through one after the other. They infiltrate

1 Say say, oh, playmate: Volatile lovers Holly (Sissy Spacek) and Kit (Martin Sheen) are either a pair of innocents or a pair of fools.

2 Tess of the D'Urbervilles: "Holly is an unformed character, willing to be led in any direction, by anyone who pays attention to her." (*Guide for the Film Fanatic*)

3 Runaway train: He came from the wrong side of the tracks and decided to stay there.

"The couple has often been compared with Bonnie and Clyde, but Malick had something else in mind – these young rebels are too undeveloped, too emotionally immature to know how to approach each other sexually." *San Francisco Chronicle*

her language, as we hear in the off-camera narratives in which she tells us of her life with Kit. After her mother's death, her father even views her as the "little stranger he found in his house" and Kit as the kid from "the wrong side of the tracks."

To Holly, Kit is a projection of her own desires, an image come to life right out of her magazines. He is thin, muscular, wears white Ts, blue jeans and smokes. Naturally, she immediately sees him as James Dean. At one point, Kit actually takes on Dean's classic stance from *Giant* (1956), with a rifle mounted square across his shoulders. He and Holly are creatures who

know nothing of responsibility. They commit their bloody deeds as if they were a game, absent of emotion or compassion. The dead are no more real to Holly than the people she reads about in her Hollywood journals. She often appears more gruesome in her childlike inability to reflect than Kit, whose attempts at emulating James Dean are at times almost endearing. Simply stated, they are two overgrown children, who – for a while – are free to kill in cold blood. Who knows. Maybe it was the director's intention to paint an ironic portrait of the silver screen serial killer, a trend that took off in Holly-wood following this production. HJK

5

"The more I looked at people the more I hated them, because I knowed there wasn't any place for me with the kind of people I knowed."

Motion Picture Guide

4 Living off the land: Kit and Holly return to primordial life in the Badlands of Montana.

5 End of the line: Taken into custody by the authorities, Kit and Holly learn that all good things must come to an end.

6 Field of dreams: *The Badlands* ballad celebrates the virgin frontier.

6

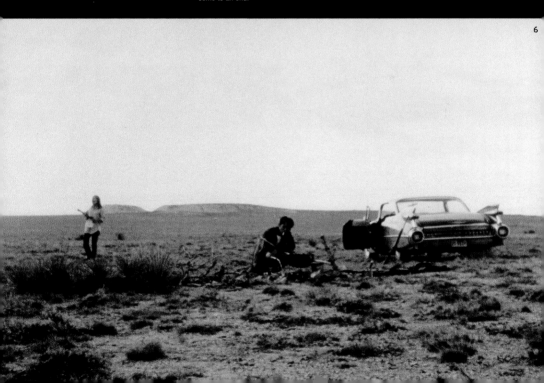

ENTER THE DRAGON

1973 - USA / HONG KONG - 99 MIN. - EASTERN, MARTIAL ARTS FILM, ACTION FILM

DIRECTOR ROBERT CLOUSE (1928–1997)
SCREENPLAY MICHAEL ALLIN DIRECTOR OF PHOTOGRAPHY GIL HUBBS EDITING KURT HIRSCHLER, GEORGE WATTERS MUSIC LALO SCHIFRIN
PRODUCTION FRED WEINTRAUB, PAUL M. HELLER, LEONARDO HO, BRUCE LEE for WARNER BROS., CONCORDE PRODUCTIONS INC., SEQUOIA PRODUCTIONS.

STARRING BRUCE LEE (Lee), JOHN SAXON (Roper), SHIH KIEN (Han), JIM KELLY (Williams), AHNA CAPRI (Tania), BOB WALL (Oharra), YANG SZE (Bolo), ANGELA MAO YING (Su Lin), BETTY CHUNG (Mei Ling), PETER ARCHER (Parsons).

"You have offended my family, and you have offended a Shaolin temple."

Lee (Bruce Lee) is a Shaolin Monk and a masterful kung fu fighter. A British secret agent comes to him with a mission: Lee is to enter a martial arts tournament held every three years by a man named Han (Shih Kien). Han deals in drugs and girls and lives on an island in the middle of the Chinese Sea that he has converted into a fortress. Entering the tournament is the only way to gain access to the island, and Lee has to use this opportunity to gather evidence against the gangster. He has a personal interest in the matter — Han's sidekick Oharra (Bob Wall) caused the death of Lee's sister.

Cornered by Oharra, she committed suicide to prevent herself from being raped. Lee accepts the mission. Among the men accompanying Lee to the tournament are two Americans: white trash gambler Roper (John Saxon), and a black playboy named Williams (Jim Kelly). Both men are first-rate fighters.

Enter the Dragon was the fourth and final completed film starring Bruce Lee, who died in 1973. It was also the first Hollywood film to feature a protagonist of Chinese origin. Producer Fred Weintraub saw Bruce Lee in Hong

1 The man of Shaolin: A master of mental and physical discipline, Lee (Bruce Lee) is a monk, kung fu fighter and irresistible sex symbol.

2 Hugh Hefner of Hong Kong: With an unlimited supply of drugs and human sex toys, Han lives like a king on his own island paradise.

3 The main event: From his island fortress in the Chinese Sea, the treacherous Han dreams up a tournament to determine the world's best fighter.

"Unlike his rivals, Lee, the actor, exploits his sexuality, stripping off his shirt to reveal his rippling muscles, posing for battle with legs spread."

Guide for the Film Fanatic

BRUCE LEE

It could be said that Bruce Lee (*1940 in San Francisco) inherited his success. Or at least that it was written in his birth certificate: Lee Jun Fan, his Chinese name, means "achieves success abroad." His success story did begin away from America – in Hong Kong. Lee initially appeared in a handful of U.S. television series like *The Green Hornet* (1966–67). The international breakthrough – his ascendancy from martial arts instructor and philosophy student to cult star was only achieved upon his return to Hong Kong. There he took over the lead role in martial arts films like *The Big Boss* (*Tang shan da xiong*, 1971) and *Fist of Fury* (*Jing wu men*, 1972). After differences of opinion with director Lo Wei, Lee began to direct himself. With *Way of the Dragon* (*Meng long guojiang*, 1972) he purposely set his sights on the world market. He switched the setting of the story from Hong Kong to Rome and chose the American martial arts sportsman and future action film star Chuck Norris as his opponent. Lee's next directorial project was to be *Game of Death*, but the postponed filming of *Enter the Dragon* (1973) caused a conflict, and his sudden death prevented the film from being finished. Four years after Lee's death, a film was made and subsequently released using a body double and the ten minutes of fight footage from *Game of Death* (*Si wang ju ju*, 1977). After his death, copycats sought to profit from Lee's success, producing films with such no-names as Bruce Li or Bruce Le, none of whom came anywhere close to the style and flair of the icon they imitated.

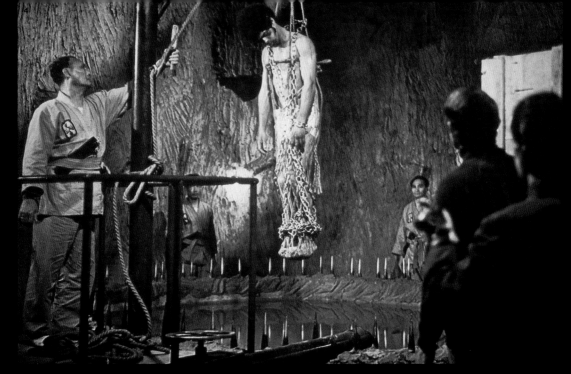

4 Last rites: African-American Williams (Jim Kelly) is lynched soon after discovering the villain's secret lair.

5 Get those legs up there! Han (Shih Kien), with a prosthetic right hand, and kung fu legend Lee (left) fight to the death in the final battle.

6 She comes with the room: Upon their arrival, contestants of the Han's island "World's Greatest Fighter Showdown" will receive a complimentary fruit basket and a voucher for a 15-min. warm welcome.

"During a fight scene, Lee performed a flying kick so fast it couldn't be captured on film at 24 frames a second. The cameraman had to film the sequence in slow motion to get it look like it wasn't faked." *Motion Picture Guide*

Kong and was so impressed he immediately decided to produce a film with Lee in the United States. Bruce Lee was the unquestionable star of the film, choreographing the fight sequences and supposedly also revising the script. *Enter the Dragon* is a true Bruce Lee film – a star vehicle for the action virtuoso. The film is full of the ingredients of the American films of its time: cool chick-magnets who drink and gamble, a funky seventies soundtrack by Lalo Schifrin, which sometimes sounds like the title theme of the television series *Mission: Impossible* (1966–1973), and a plot that employs all the successful concepts and themes of the spy movie genre.

The rudiments of the story are strongly reminiscent of *Dr. No* (1962), the first Bond film, with a megalomaniac gangster who has barricaded himself in a fortress-like island full of underground corridors and laboratories.

lofeld, 007's adversary, the villain Han even has a white long-haired
ut the charm of the film lies less in the story than in the fight se-
es. It begins with a battle in Lee's monastery (his sparring partner is
ure director and actor Sammo Hung, a companion of Jackie Chan, who
f worked as a stuntman in the film). The additional fights – with Roper,
ns, and Lee – occur on the island and each fight trumps the previous
r choreographic spectaculars. Adhering to the rules of the genre, the
ncludes with the fight between the main adversaries, Lee and Han. The
o end all fights is made all the more astonishing by Han's prosthetic
and, fitted with sharp blades in place of fingers. The showdown is a
of martial acrobatics and is unrivaled for its visual ingenuity, not least

Lee and Han are not only fighting against one another. Both are hard-
pressed to actually locate their adversary, and are required to separate the
physical opponent from his mirror image, adding a game of perception to
the dazzling fight choreography. This final scene and its theme – true and
illusory enemies – echoes a scene early on in the film where a priest explains
to Lee, "The enemy is only an illusion; the real enemy lies within oneself."
Supposedly Bruce Lee wrote this scene himself, but unfortunately it is absent
from the international version of the film, and only preserved in the Chinese
version. *Enter the Dragon* was released in the summer of 1973 in the United
States, and in Hong Kong in October of the same year. Bruce Lee did not live
to see the premiere, dying on July 20, 1973 from the effects of a brain edema

DIRECTOR FRANKLIN J. SCHAFFNER (1920–1989)
SCREENPLAY DALTON TRUMBO, LORENZO SEMPLE JR., based on the novel of the same name by HENRI CHARRIÈRE
DIRECTOR OF PHOTOGRAPHY FRED J. KOENEKAMP EDITING ROBERT SWINK MUSIC JERRY GOLDSMITH PRODUCTION ROBERT DORFMANN,
FRANKLIN J. SCHAFFNER for ALLIED ARTISTS PICTURES CORPORATION, CORONA-GENERAL, SOLAR PRODUCTIONS.

STARRING STEVE MCQUEEN (Papillon), DUSTIN HOFFMAN (Louis Dega), DON GORDON (Julot), ANTHONY ZERBE (Toussaint),
ROBERT DEMAN (Maturette), VICTOR JORY (Aboriginal Chief), WOODROW PARFREY (Clusiot), BILL MUMY (Lariot),
GEORGE COULOURIS (Doktor Chatal), BARBARA MORRISON (Oberin).

"If I stay here in this place, I'll die."

Henri Charrière's autobiographical novel *Papillon* appeared in 1968 and became an international bestseller. It describes the experiences of a man who succeeds in escaping from a prison colony in French Guyana. Because of the book's numerous contradictions and inconsistencies, many critics immediately cast doubt on the authenticity of the events it describes. Eyewitnesses confirmed that it gave a truthful representation of the cruel methods used in the colony (which no longer exists), but they criticized the way Charrière had taken the experiences of other prisoners and presented them as his own. Nonetheless, the book's gripping descriptions of desperate escape attempts and sheer density of detail were a goldmine for a Hollywood scriptwriter. The result was a box-office smash, a prison film in an exotic setting with two mega-stars in the leading roles.

Papillon (Steve McQueen), a French safecracker, acquired his nickname thanks to the butterfly tattooed on his chest. In 1931, despite being innocent of the murder he was accused of, he was sentenced to life imprisonment on Devil's Island. Among the others sent down is the weedy accountant and counterfeiter Dega (Dustin Hoffman). During their passage to South America, Dega fears for his life. He has a small fortune in cash concealed in his own back passage, and he has good reason to fear he'll be butchered for the money. Papillon makes a deal with Dega: he'll protect him, and in return Dega will finance his escape. On their arrival in the colony, the two prisoners are assigned to work in the swamps. After Papillon prevents a warder from beating his friend to death, Dega feels deeply indebted to the hard-bitten jailbird. But "Papi's" hasty escape attempt ends in failure: quickly recaptured, he is sentenced to two years in solitary confinement. Even in his isolation, however, he still retains tenuous contact to Dega. The latter has bribed his way into a more pleasant job in prison administration, and he provides Papillon with a secret supply of coconuts – an essential supplement to the foul prison rations, which barely ensure survival. When this illegal food bonus is discovered, Papillon's punishment is draconian: he is placed on half-rations and confined for years to a darkened cell. Yet he still holds his tongue and refuses to betray Dega. Years later, the two meet once again in the prison colony; on Papillon's next escape attempt, Dega will accompany him.

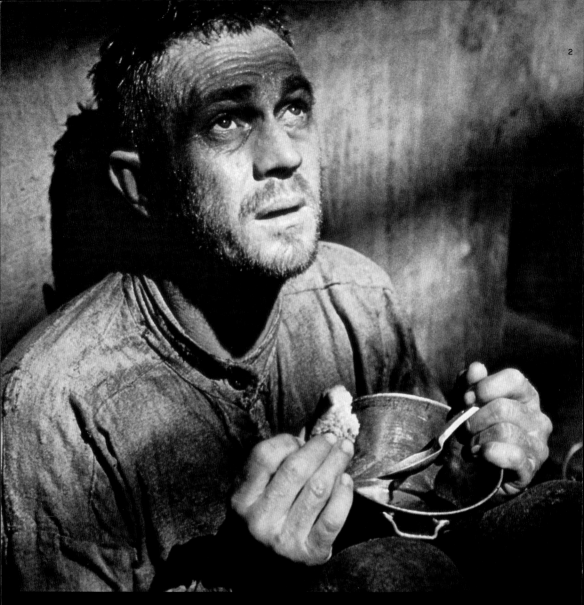

"We're something, aren't we? The only animals that shove things up their ass for survival." *Film quote: Papillon*

1 Do not pass go: Forger Louis Dega (Dustin Hoffman) has seen better days. The prison camp in French Guayana is hell on earth.

2 Iron will: Even half rations and total isolation can't break his spirit: Papillon (Steve McQueen).

3 Breaking out of solitary: Though known for playing loners and individualists – in *Papillon*, Hoffman's brilliance lies in his on-screen friendship with Steve McQueen.

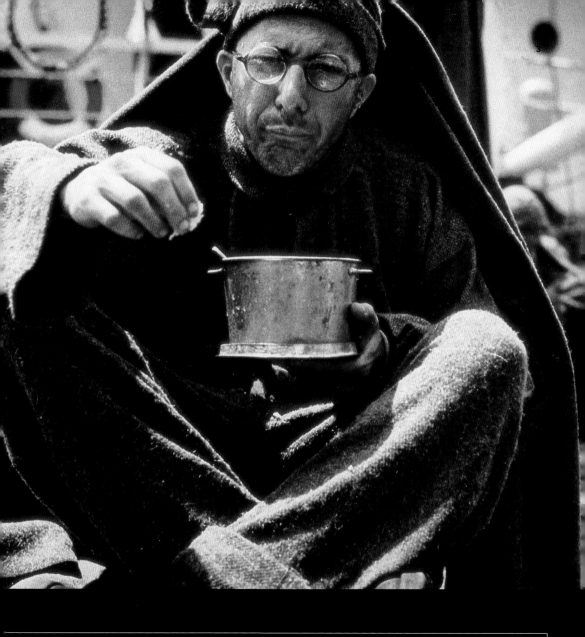

"France has written you off – so forget France and get your clothes on." In the opening sequence of *Papillon* (1973), these words are spoken by an

Papillon inevitably refers us to old movies rather than to reality. Audiences whose expectations do not exceed their grasp will find it a much more comfortable vehicle for escape than any that McQueen & Co. discover on location." *Time Magazine*

4 No girls allowed: Homosexuality is another theme examined in this "men's film." *Papillon* features only two small speaking parts for women.

5 Epic grandeur: Director Franklin J. Schaffner demonstrates the same masterful ease with crowd scenes and intimate dialogues alike.

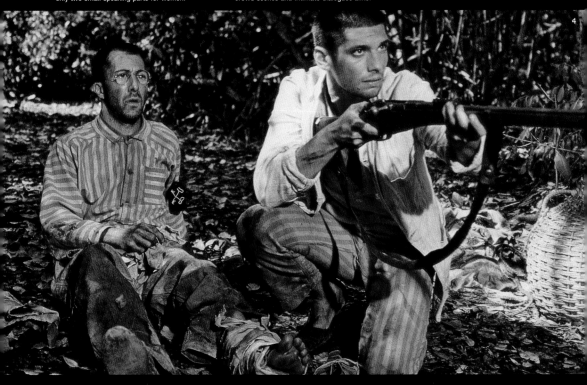

Papillon tells the story of an unusual male friendship, marked by kindness and strong fellow feeling. More than once, Dega uses the following words to Papillon: "My thoughts are with you." It's an expression of deeply felt sympathy that sums up their remarkable bond.

Director Franklin J. Schaffner had already enjoyed success with *Planet of the Apes* (1968) and the Oscar-winning *Patton* (1969). In *Papillon*, he accomplishes a delicate balancing act, combining a realistic portrayal of monstrous prison conditions with some very funny moments. When Dega and "Papi" are sent off to retrieve a shot crocodile from the swamp, we witness a slapstick scene, for it turns out that the animal is still far from dead. Even their escape constitutes a kind of comic relief: while the prison orchestra plays marching tunes for the ladies and gents of the French colony, the two

jailbirds struggle like Keystone Cops to scale a very high wall. Gallows humor indeed, bitter and funny in equal measure.

The film derives its power from many unforgettable moments that demonstrate the leading character's impressive will to survive. We see him stave off starvation in his darkened cell by catching centipedes and roaches; taking a draw from the cigar of a leper who could help him escape from the island; and leaping into the sea from the clifftops – a tiny figure against a huge background, an individual victorious against an inhuman, implacable system.

Despite all the sadistic warders and the fugitives wading through swamps, *Papillon* has more to offer than the usual prison-film clichés. Schaffner had always been interested in connecting the history of cinem:

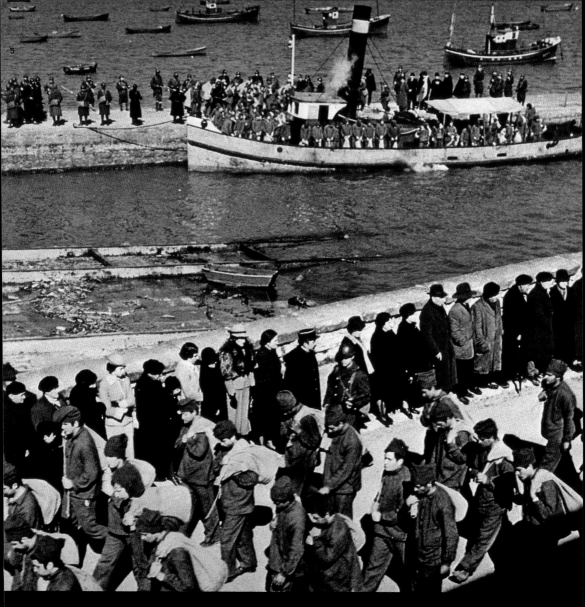

itself to the historical and political events depicted in his films. In his study of the last Russian royal family, for example (*Nicholas and Alexandra*, 1971), his treatment of the crowd scenes draws on techniques of montage deployed by Sergej M. Eisenstein in *Strike* (*Statschka*, 1924) and *October* (*Oktjabr*, 1927). In *Papillon*, the characterization of the main figure constitutes an equally artful symbiosis between film history and history *per se*. It's no accident, for example, that "Papi," who spends 14 years in jail, bears more than a passing resemblance to another famous cinematic jailbird. In *A Man Escaped* (*Un condamné à mort s'est échappé / Le vent souffle où il veut*, 1956), Robert Bresson depicts the captivity and flight of a resistance fighter in occupied France during WW II. This film was also based on factual reports; and like Papillon, Bresson's protagonist is obsessed with escaping. Both characters

are driven by a yearning for freedom that expresses itself in untiring resistance, and each of them is prepared to risk death rather than submit to oppression. Schaffner's composer Jerry Goldsmith reinforced this link by taking his inspiration from the French music of the period. Papillon's "French" leitmotif dominates the film's soundscape, and we hear it for the last time after his successful flight: a musical bond between the exiled hero and his distant home country. The despised prisoner of Devil's Island and the heroes of the French resistance share more than their nationality. Thus the music in Schaffner's film is not a merely decorative "quotation;" it adds a dimension beyond Charrière's book and provides an original and illuminating insight into cinematic history.

DG

DIRECTOR WILLIAM FRIEDKIN (*1939)

SCREENPLAY WILLIAM PETER BLATTY, based on his novel of the same name **DIRECTOR OF PHOTOGRAPHY** OWEN ROIZMAN, BILLY WILLIAMS

MUSIC JACK NITZSCHE, KRZYSZTOF PENDERECKI **EDITING** NORMAN GAY, EVAN LOTTMAN, BUD SMITH **PRODUCTION** WILLIAM PETER BLATTY for WARNER BROS., HOYA PRODUCTIONS.

STARRING ELLEN BURSTYN (Chris MacNeil), MAX VON SYDOW (Father Merrin), LEE J. COBB (Lieutenant Kinderman), LINDA BLAIR (Regan MacNeil), KITTY WINN (Sharon Spencer), JASON MILLER (Father Damien Karras), JACK MACGOWRAN (Burke Dennings), REVEREND WILLIAM O'MALLEY (Father Dyer), BARTON HEYMAN (Dr. Klein), PETER MASTERSON (Barringer).

ACADEMY AWARDS 1973 OSCARS for BEST ADAPTED SCREENPLAY (William Peter Blatty), and BEST SOUND (Robert Knudson, Christopher Newman).

"What an excellent day for an exorcism."

Evil neither stems from a dark abyss nor from a cosmic realm. It neither limits its dominion to dark shadows and blind alleys, nor does it attack in the form of a werewolf that can be slain with a silver bullet. When we are struck by the fear that without warning, something horrific could infiltrate our lives and turn our precious little worlds on their heads, perhaps we are tuning into something very real and tangible. Maybe evil has already made a nest for itself, where we'd least expect it. Namely, in our most intimate surroundings.

Although this is the central topic of the story involving American actress Chris MacNeil (Ellen Burstyn), whose twelve-year-old daughter Regan (Linda Blair) is transformed into the Antichrist before her very eyes, *The Exorcist* director William Friedkin opens his film with far off images of the Middle East. It is on an archaeological dig in Iraq that Father Merrin (Max von Sydow) unearths several ancient artifacts that send him into a state of panic, including decapitated statue heads and a most unnerving amulet.

The ensuing scenes, in which pure evil appears to take possession of Merrin's entire environment, are among the picture's most powerful. The vacant and yet piercing stares of the locals, the hammering of the blacksmiths that Merrin confuses with the sound of his own racing heart and a clock that stops cold are just a few of the images that contribute to the audience's visceral incorporation of the imminent danger.

When, at the end of this sequence, Merrin sits directly across from a statue of an ominous demon with rabid dogs running rampant at its feet, the essence of the story becomes clear. According to the director, the film is "a Christian parable about the eternal struggle between good and evil."

Cut to "Georgetown." The on-screen caption and the bird's eye view of the city evoke a deceptive picture of order and distanced safety. Friedkin referred to the fade-in technique he often used as the "Means of luring the audience onto the wrong track." Nonetheless, the peace of Georgetown's idyllic autumn and the illusion of the stable family unit fall like a house of cards after one of the Jesuit priests from the university, Father Karras (Jason Miller) breaks down and admits that he has "lost faith." With these words, something wicked this way comes.

It comes in the form of an appalling, disfigured little girl spewing out profanities and blaspheming uncontrollably. Wretched displays of gasping, choking and shrieking are let loose on the audio track, accompanied by a visual deluge of regurgitated green mucus. Never before and never since for that matter, has a director been so intent on terrorizing his audience. At the time of its release, screenings often had spectators vomiting in the aisles, fainting and breaking into hysterics. This highly provocative work even made movie critic Roger Ebert question his faith in humanity, asking whether "people (are) so numb that they need movies of this intensity in order to feel anything at all?"

The intoxicating shock value of the gore can make one overlook the masterful web of allusions, contrasts, analogies and sociopolitical arguments

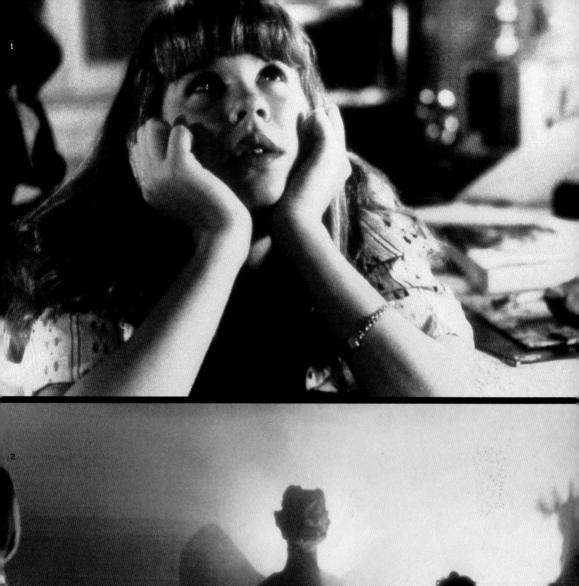
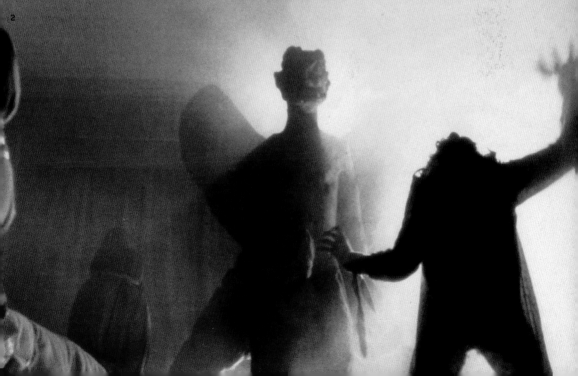

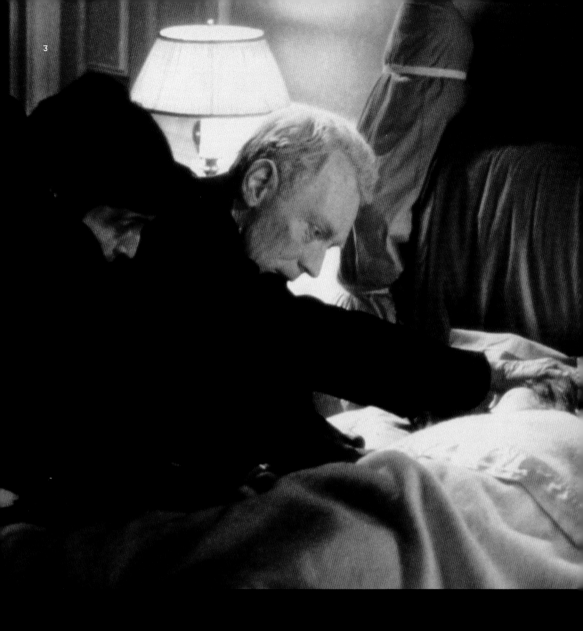

Friedkin has woven here. One example of this intricate layering can be witnessed when Regan forms a clay model of a bird with wings that recall those of the demonic statue in the Iraq sequence. Later on, Lieutenant Kinderman (Lee J. Cobb), assigned to investigate the mysterious death of Chris' close friend, finds yet another clay object at the scene of the crime. It is the pagan counterpart to the crucifix, which Chris recently discovered in her daughter's bed.

The way in which the film attempts to diagnose the cause of Regan's possession is also worthy of close examination. The arrogance of the doctors, Chris' outbursts of rage, her friend Burke's alcoholism, the burden of guilt Father Karras feels towards his dead mother are all signs that the source of

evil could be human. Karras' work as a psychologist for the university's Jesuit community makes him doubt God's existence, providing the audience with another possible clue to the origin of Regan's infection. Other events, including the Jesuit priest who comes across a defiled statue in the chapel, but doesn't acknowledge the Madonna as he enters, also point to lack of faith as a contributory.

All these factors are devices Friedkin uses to vary the film's underlying principle mentioned in the opening paragraph. Namely, that evil lurks in everyday life and even in our very hearts. In this respect, it is not a battle with the devil that Carras ends up winning. It's a battle with his own self. SH

The Exorcist makes no sense, but if you want to be shaken, it will scare the hell out of you."

The New Republic

1 That little devil: Regan (Linda Blair) is about to have a religious experience.

2 Satanic verses: The Prince of Darkness moves in mysterious ways.

3 Who's been sleeping in my bed? Father Damien Karras (Jason Miller) suppresses his doubts and aids Father Merrin (Max von Sydow) in the ancient exorcism.

4 That thing upstairs is not my daughter: Actress Chris MacNeil (Ellen Burstyn) wants to be a good mother to Regan, but Dr. Spock never said anything about spitting up pea soup.

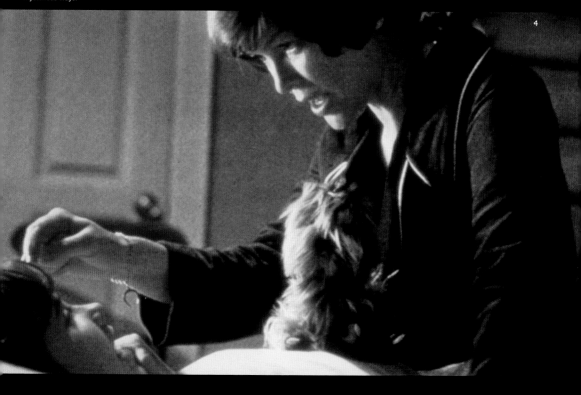

4

SUBLIMINAL MESSAGES At the speed of 24 frames per second in film and 30 NTSC frames per

AMERICAN GRAFFITI

1973 - USA - 110 MIN. - COMEDY

DIRECTOR GEORGE LUCAS (*1944)
SCREENPLAY GEORGE LUCAS, GLORIA KATZ, WILLARD HUYCK DIRECTOR OF PHOTOGRAPHY RON EVESLAGE, JAN D'ALQUEN
EDITING VERNA FIELDS, MARCIA LUCAS MUSIC BUDDY HOLLY, CHUCK BERRY, BOOKER T. JONES PRODUCTION FRANCIS FORD
COPPOLA for THE COPPOLA COMPANY, LUCASFILM LTD., UNIVERSAL PICTURES.

STARRING RICHARD DREYFUSS (Curt Henderson), RON HOWARD (Steve Bolander), PAUL LE MAT (John Milner),
CHARLES MARTIN SMITH (Terry Fields), CINDY WILLIAMS (Laurie Henderson), CANDY CLARK (Debbie Dunham),
MACKENZIE PHILLIPS (Carol), WOLFMAN JACK (XERB Disc Jockey), HARRISON FORD (Bob Falfa), BO HOPKINS
(Joe Young).

"Hey, is this what they call copping a feel?"

Not on your life, sister! The only reason John (Paul Le Mat), the reigning king of the road this side of the Sierra Nevada, presses Carol's (Mackenzie Phillips) face into his lap is out of sheer embarrassment to be seen with a thirteen-year-old while cruising the streets. As far as he's concerned, the kid just got into his roadster by mistake. Be that as it may, young Carol's somewhat naive question pricelessly captures the spirit of 1962, the year in which George Lucas' bittersweet adolescent comedy takes place. *American Graffiti* tells of the last days of teenage innocence, both for the protagonists, who are fresh out of high school and uncertain about what to do next, as well as for the era's way of life in general. For within the coming two years, American president John F. Kennedy will be assassinated and the nation will enter the Vietnam War.

The film tells the story of one night in the life of four adolescents grow-ing up in sleepy Modesto, California. Curt (Richard Dreyfuss) and Steve (Ron Howard) have both won college scholarships and are scheduled to leave in the morning. Steve is starry-eyed and hopeful for the future, while Curt is still contemplating whether he'd be better off spending another year in his comfortable surroundings. Terry (Charles Martin Smith) is younger than the other two. A clutzy dork, he wears a pair of two-inch thick, horn-rimmed glasses, trying his damnedest to emulate the older guys where women and booze are concerned, but failing miserably. John is a bit older than the rest of the troop and drives around town in a suped-up 1932 Ford Deuce coupe. As far as cars go, John is the undisputed cock of the walk, although the "cool rider" title is beginning to sound a little stale. He eventually admits being jealous of Curt for being able to escape their hometown, a chance he'll never get…

American Graffiti was produced with a budget of 750 thousand dollars and raked in a total of 55 million at the box office. Its enormous appeal then, as now, was its ability to reconstruct a beloved era in recent American his-

1 Everything is copasetic: Drive-in restaurants and bubbly car hops light up main street.

2 Out of my dreams and into my car: Candy Clark as Debbie Dunham, impressed by an Impala.

3 American Bandstand: Live rock 'n' roll at the high school ball.

4 Speed demon: John Milner (Paul Le Mat) sets off on the open road to nowhere.

"This superb and singular film catches not only the charm and tribal energy of the teen-age 1950s but also the listlessness and the resignation that underscored it all, like an incessant bass line in one of the rock-'n'-roll songs of the period." *Time Magazine*

tory. It was a time of carefree better days, of gigantic street intersections, drive-in restaurants with carhops, jacked up hot rods in illegal drag races, school dances where bands still performed live and radio disc jockey Wolfman Jack's legendary rock 'n' roll broadcast.

Nonetheless, as nostalgic as the story reads, its episodic structure is rooted in the cinematic techniques of the 1970s. Without the use of transitions, director Lucas, who said most of the story was autobiographically inspired, flips back and forth between the separate storylines of the protagonists. Lucas blends comedy and suspense with melodrama, capturing that

interplay of boredom and forced excitement that characterized small town America. Curt frantically searches for a dreamy blonde woman (most likely a prostitute) he saw at a traffic light driving past him in a Thunderbird and gets mixed up with a group of punks known as the "Pharaohs." The gang of ruffians seem to pose a real danger at first, but what starts off threatening has an undeniably humorous outcome. Steve, on the other hand, fights with his girlfriend Laurie (Cindy Williams) the entire evening about his going away. Terry, who was lent Steve's 1958 Impala, picks up cute blonde Debbie (Candy Clark), and takes her on a scenic trip full of ludicrous mishaps. Then there's

John, who just can't seem to rid himself of that pesky Carol. Not that he minds as much as he claims. When it comes down to it, he kind of likes the little chatterbox. Intentionally directionless, the plot never reaches a clear climax (even John's drag race against Falfa (Harrison Ford) is just one of many episodes), mirroring the characters' own disorientation. These are, after all, kids who don't really know what they want yet. The film concludes with Curt going away to college and Steve remaining home. Captions, serving as the movie's epilog, inform us of what destiny has in store for these boys later in life. Curt becomes a writer and Steve an insurance salesman. John dies in a car accident at the hands of a drunk driver and Terry is killed in Vietnam. And thus the age of innocence, when everything was copasetic, has come to an irreversible close. LP

GEORGE LUCAS George Lucas is among the most commercially successful filmmakers alive today. His personal fortune alone is estimated at two billion dollars. In the grand scheme of things, Lucas' work as a director accounts for just a small part of his many diverse activities (over the last thirty years he has only actually directed five films himself). Primarily, Lucas has devoted himself to producing, writing and running his personal film "empire," which houses the well-known and phenomenally successful special effects company, Industrial Light and Magic (a part of Lucas Digital). After studying at the University of Southern California Film School and directing a wide range of short films, Lucas made the acquaintance of Francis Ford Coppola in 1967, and worked as his assistant for some time. It was Coppola, in fact, who helped Lucas produce his first full-length feature film, the sci-fi story *THX 1138* (1970). *American Graffiti* (1973), however, proved to be Lucas' first commercial success. He, of course, turned around significantly more profits in 1977 with the first installment of the *Star Wars* Saga (1977, 1980, 1983, 1999, 2002). Lucas directed this first picture in the series himself, but then the filmmaker loved and scorned for his perfectionism began to focus exclusively on writing and producing. In the mid 90s, the original *Star Wars* Trilogy was re-released in theaters, this time featuring new digital effects. Lucas reclaimed his seat in the director's chair for the long-awaited prequels *Star Wars: Episode I – The Phantom Menace* (1999) and *Star Wars: Episode II – Attack of the Clones* (2002), which followed shortly thereafter. Although both films were box-office sensations, they won the approval of few critics.

4

THE STING

1973 - USA - 129 MIN. - GANGSTER FILM, COMEDY

DIRECTOR GEORGE ROY HILL (1922–2002)
SCREENPLAY DAVID S. WARD DIRECTOR OF PHOTOGRAPHY ROBERT SURTEES EDITING WILLIAM REYNOLDS MUSIC SCOTT JOPLIN, MARVIN
HAMLISCH PRODUCTION TONY BILL, JULIA PHILLIPS, MICHAEL PHILLIPS, RICHARD D. ZANUCK for UNIVERSAL PICTURES.

STARRING PAUL NEWMAN (Henry Gondorff), ROBERT REDFORD (Johnny Hooker), ROBERT SHAW (Doyle Lonnegan),
CHARLES DURNING (Lieutenant William Snyder), RAY WALSTON (J. J. Singleton), EILEEN BRENNAN (Billie), HAROLD
GOULD (Kid Twist), JOHN HEFFERNAN (Eddie Niles), DANA ELCAR (F.B.I. Special Agent Polk), ROBERT EARL JONES (Luther
Coleman).

ACADEMY AWARDS 1973 OSCARS for BEST FILM (Tony Bill, Julia Phillips, Michael Phillips), BEST DIRECTOR (George Roy Hill),
BEST SCREENPLAY (David S. Ward), BEST FILM EDITING (William Reynolds), BEST MUSIC (Marvin Hamlisch), BEST ART
DIRECTION (Henry Bumstead, James Payne), and BEST COSTUMES (Edith Head).

"What was I supposed to do – call him for cheating better than me?"

Joliet, Illinois, 1936. Con men Hooker (Robert Redford) and Luther (Robert Earl Jones) pull off a lucrative street swindle. But they don't suspect that the money they've stolen belongs to notorious gangster boss Doyle Lonnegan (Robert Shaw), who immediately sets a killer on the trail of the two crooks. After Luther is cold-bloodedly murdered, Hooker flees to Chicago, leaving behind the corrupt cop, Snyder (Charles Durning), who is also after him. He goes into hiding with Gondorff (Paul Newman), an old con man buddy of Luther's whose heyday is long past and who, in an attempt to stay out of trouble with the FBI, has settled down comfortably with brothel owner Billie (Eileen Brennan). But Hooker's determination to avenge Luther's death breathes new life into Gondorff. The two piece together a band of old associates and hatch a refined plan to swindle Lonnegan out of a half a million bucks.

The Sting is a phenomenon. A charmingly lightweight movie about gangsters and swindlers in 1930s Chicago, it was the clear winner at the Oscars and became one of the biggest box office smashes of the decade. Created by an independent production team, the film was a triumph for New Hollywood, though it showed that the methods of old Hollywood could still function provided well-known elements were rearranged. The producers built upon the successful trio from the Western Butch Cassidy and the Sundance Kid (1969), casting Robert Redford and Paul Newman in starring roles, and hiring George Roy Hill to direct the project. They also correctly guessed that film audiences of the 1970s would be very receptive to nostalgic films. Accordingly, the squalor of the Depression of the 1930s is hardly noticeable in The Sting. From the very beginning when the characters are introduced

1 Shall I frisk ya? Although *The Sting* itself raked in a slew of Oscars, heartthrob Robert Redford only won the laurels of adoring fans.

2 "Reunited, and it feels so good!" Five years after riding off into the sunset, Butch and Sundance met up again in the Depression Era, striking box-office gold again.

3 Pick a card, any card… A tribute to con artistry that examines the tricks of the trade.

"Two of Hollywood's dream men form this genial marriage of criminal minds: Paul Newman, the mature senior partner, is unbeatably dashing; and in Robert Redford, the dream factory's latest young hero, he's found an ideal foil and accomplice."

Stuttgarter Zeitung

one realizes that what lies ahead is pure film fantasy, not an attempt at reconstructing the past. And sure enough, George Roy Hill's film is unadulterated and highly entertaining fiction, in which a perfect mix between historic and historicized set pieces is achieved: Scott Joplin's Ragtime piano, though from the 1920s, brings a sleight of hand and levity to the film that corresponds marvelously with the actions of the actors. Antique segment titles and the use of the fade-out further strengthen the tongue-in-cheek charm of the mischievous swindle. And the pleasant retro-look reminiscent of the color

films of the late 1940s, with which camera veteran Robert Surtees impressively refines the studio set, exudes the faded luster of the "good old times," a feeling that was not present in the harsh underworld dramas of the 1930s, the heyday of Warner Brothers' classic gangster films.

The Sting also mirrors the enthusiasm of filmmaking itself in the playful accentuation of its dramatization. It succeeds in reflecting the love of performance, deception and manipulation that drive the central characters, and around which the entire plot revolves. No one can resist this virus;

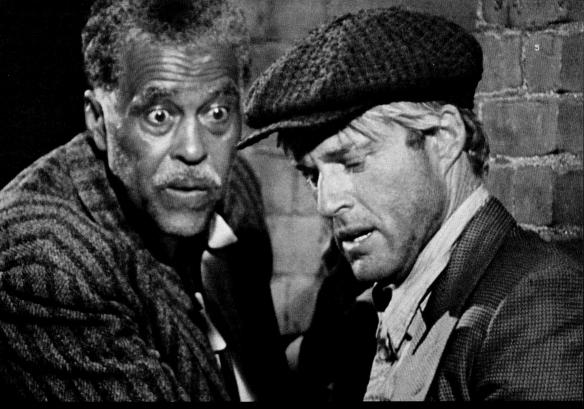

4 Blue eyes: Our, baby's got 'em and does he ever 5 The way we weren't: Redford makes misery and
 know it! Paul Newman has become as synonymous poverty look stylish and divine.
 with Hollywood as that famous sign atop the hill.

"How long has it been since you exited from a movie theatre smiling and just plain feeling good?" *Films in Review*

even the seemingly vice-free Lonnegan is ensnared by Gondorff in a round of poker. Needless to say, the cards are marked. As appropriate vengeance however, Gondorff & Co. find this action far too mundane. Instead, the plan is to get Lonnegan to place and subsequently lose a fortune on a horserace – in a fabricated betting office created just for this purpose. The action is without a doubt a masterpiece of deception and a challenge for true pros. Consequently, like in so many American films, the charm of *The Sting* lies in the pleasure of watching shrewd specialists at work. It is a pleasure that does not limit itself merely to the plot, but expands to the unmistakably brilliant performance of the entire film team – the actors, the cameraman, the art director, the author, and the director. *The Sting* is enthralling thanks to the professionalism of its entire crew. Hill's tour de force is a film by and about people who are clearly in supreme command of their craft – the craft of illusion. JH

ROBERT SURTEES Robert Surtees (1906–1985) was one of the most famous of all American cameramen. He came to Hollywood in 1927, at the time of the introduction of the "talkie," and began his career as a camera assistant, initially at Universal and then later at both Warner Brothers and MGM. During these years, Surtees assisted Joseph Ruttenberg and Gregg Toland, the legendary master of focal depth, among others. Surtees graduated to head cameraman in the early 1940s and in subsequent years he developed into one of the most versatile and sought-after technicians in his field, as well as one of the most honored. Over the course of his 50-year career, Surtees was awarded an Academy Award on three separate occasions – for the color photography of *King Solomon's Mines* (1950) and *Ben-Hur* (1959), as well as for the black and white film *The Bad and the Beautiful* (1952). He received 13 further Oscar nominations, in 1967 and 1971 for two films simultaneously. Robert Surtees was one of the few camera virtuosos of the studio system who were also able to collaborate with young directors of New Hollywood, including Peter Bogdanovich in *The Last Picture Show* (1971) and Mike Nichols in *The Graduate* (1967). Surtees' son, Bruce, followed in the footsteps of his father. He is best known as Clint Eastwood's favorite director of photography.

MY NAME IS NOBODY
Il mio nome è Nessuno

1973 - ITALY / FRANCE / FGR - 117 MIN. - SPAGHETTI WESTERN, SPOOF

DIRECTOR TONINO VALERII (*1934)
SCREENPLAY SERGIO LEONE, ERNESTO GASTALDI, FULVIO MORSELLA DIRECTOR OF PHOTOGRAPHY ARMANDO NANNUZZI, GIUSEPPE RUZZOLINI EDITING NINO BARAGLI MUSIC ENNIO MORRICONE PRODUCTION FULVIO MORSELLA for RAFRAN CINEMATOGRAFICA, RIALTO FILM, LES PRODUCTIONS JACQUES LEITIENNE, LA SOCIETE IMP EX CI, LA SOCIETE ALCINTER.

STARRING TERENCE HILL (Nobody), HENRY FONDA (Jack Beauregard), JEAN MARTIN (Sullivan), REMUS PEETS (Biggun), PIERO LULLI (Sceriffo), GEOFFREY LEWIS (Band Leader), R. G. ARMSTRONG (John), NEIL SUMMERS (Squirrel), ULRICH MÜLLER (Dirty Joe), LEO GORDON (Red).

"A hero must die – it has to be so."

Three sinister figures ride into town. Dogs make themselves scarce and the townspeople stay in their houses. The trio make their way to the barber shop. They have no intention of harming the barber. They simply "borrow" his shop and his apron, posing as assistants in the hope of bumping off the next customer, gunslinger Jack Beauregard (Henry Fonda). But he smells a rat, shoves his revolver into an extremely sensitive spot of the fake barber's anatomy and survives the cut-throat razor. At the end of the film, the gunslinger's successor will also sit down in a barber's chair, and he too will know how to protect himself – just like Beauregard, but even more brazenly.

My Name is Nobody tells of a changing of the guard. With this brilliant prelude, an old gunslinger is introduced – a man who trusts his hunches and is quick with his pistol, but who's now tired and ready to hang up his gun. He's waiting for a ship to take him to Europe so he can retire. "Do you know anyone who can draw faster," asks the barber's son after Beauregard has done away with the three sinister characters. "Nobody," says the father. And Nobody (Terence Hill) soon appears. He is to become *the* new gunslinger.

He's just as quick on the draw as Beauregard, and just as cheeky. A fan of the old gunslinger, he can recount all of his "heroic deeds." Nobody wants Beauregard to retire into the history books so he can take his place. He helps matters along, by arranging a showdown between his idol and the so-called "Wild Bunch," a group of 150 men who are "as good as 1,000…"

The beginning of the film is pure "Leone" – a sweeping paraphrase of Sergio Leone's masterpiece *Once Upon a Time in the West* (*C'era una volta il West*, 1969). Just like in the old Leone Westerns, Ennio Morricone composed the music, and like in *Once Upon a Time in the West*, each character gets a personal melody. Nobody gets the cheerful title song; the "Wild Bunch" get a piece with more than a passing resemblance to Wagner's "Ride of the Valkyrie." Sergio Leone was both executive producer and co-author, and his one-time assistant Tonino Valerii directed the film. *My Name is Nobody* pays its respects to the Spaghetti Western, and is packed with countless little homages to the Hollywood Western. The "Wild Bunch" is clearly named after Sam Peckinpah's classic *The Wild Bunch*

(1969), and their appearance recalls the troops from Sam Fuller's *Fort Guns* (1957).

The film becomes a parody through the Terence Hill character, Nobody. He has a comedic streak and goes as far as to face his adversary on the fair ground. He is silly, perpetually cracks corny jokes, and has none of the tragic honor typical of the classic gunslinger. This aspect makes the film a kind of late Western – the time of the great tragic heroes is over and the new gun slinger is a clown. The film also tells of the ritual of legend building in the West. It depicts the writing of history, so to speak, while it is happening. While Beauregard shoots up the "Wild Bunch," the camera, in a kind of fast for ward, continually blends book illustrations into the frame that capture the events and will finally turn the old gunslinger into a Western myth. HJ

"For me, the interesting thing about *My Name is Nobody* was that it confronts a myth with the negation of a myth." *Sergio Leone*

1 Nobody knows the trouble I've seen: Rootin' tootin' gunslinger Nobody (Terence Hill) isn't afraid of anything, except maybe gingivitis.

2 This chilli ain't made in NYC: Scooping up a hearty portion of Western-style beans right out of the pan.

3 See no evil, see no nothin': Nobody has planned out the showdown for his true hero, Jack Beauregard (Henry Fonda, in the distance).

4 Before you can say Jack Robinson: Nobody's West may not be as wild as it once was, but it sure is as dangerous.

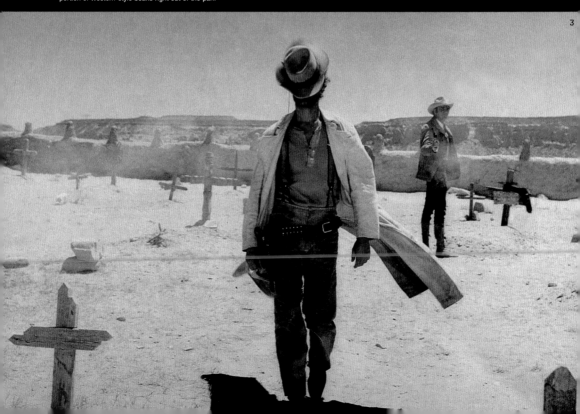

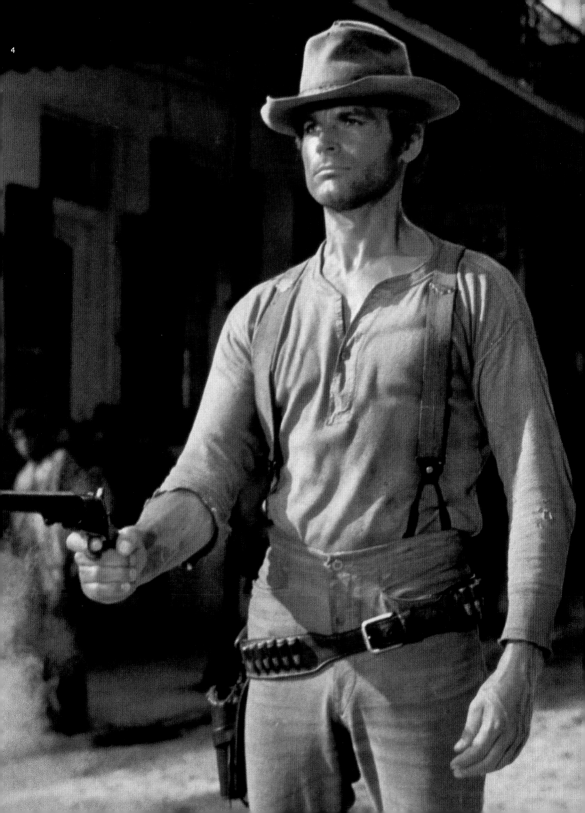

5 Basket of goodies: Jack Beauregard may be getting on in years, but he still ain't afraid of no big bad wolf. Is he?

6 Retirement community: Beauregard wants to quit while the going's still good…

7 … but to no avail: As Nobody puts it "A good exit is sometimes trickier than a grand entrance."

TERENCE HILL Blond hair and bright blue eyes are the distinguishing characteristics of Terence Hill (*29.3.1939 in Venice). Toward the beginning of his career, however, he had dark hair and appeared under his given name, Mario Girotti. As a twelve-year-old he was discovered by director Dino Risi, and for years played supporting roles in countless films, among them such differing projects as the Karl May adaptation *Winnetou II* (*Vinetu II*, 1964) and Luchino Visconti's masterpiece, *The Leopard* (*Il gattopardo*, 1963). In 1967 he became the blond Terrence Hill and appeared for the first time with the colleague at whose side he was to become famous – Bud Spencer (née Carlo Pedersoli). With *Dio perdona… Io no!*, a long collaboration began, which was to make Spencer and Hill famous as the wisecracking pugnacious duo. Many of these films (for example *Lo chiamavano Trinità*, 1970) are parodies of Spaghetti Westerns and were more successful than Leone's serious films. "Leone deserved artistic revenge," commented *Nobody* director Tonino Valerii. "If Terence Hill poked fun at the Spaghetti Western, he should be given an appropriate punishment – he should be the adversary of the most legendary Western actor (Henry Fonda) and he should acknowledge his own nothingness, which is where the title, *My Name is Nobody* (*Il mio nome è Nessuno*, 1973), comes from." Terence Hill remained true to the Western parody later as well – at the beginning of the 1990s he appeared in film adaptations of the comic book cowboy, *Lucky Luke* (1990, 1991, 1992), several of which he also directed.

7

"He totes his saddle on his shoulder like a pair of wings, punching and shooting his way through the West right there with the best of 'em."

film-dienst

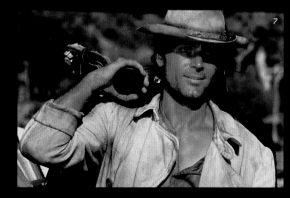

THE GODFATHER – PART II

†††††

1974 - USA - 200 MIN. - GANGSTER FILM, DRAMA

DIRECTOR FRANCIS FORD COPPOLA (*1939)
SCREENPLAY FRANCIS FORD COPPOLA, MARIO PUZO, based on his novel *THE GODFATHER* **DIRECTOR OF PHOTOGRAPHY** GORDON WILLIS **EDITING** BARRY MALKIN, RICHARD MARKS, PETER ZINNER **MUSIC** NINO ROTA, CARMINE COPPOLA **PRODUCTION** FRANCIS FORD COPPOLA for THE COPPOLA COMPANY, PARAMOUNT PICTURES.

STARRING AL PACINO (Michael Corleone), ROBERT DUVALL (Tom Hagen), ROBERT DE NIRO (Vito Corleone), DIANE KEATON (Kay Adams-Corleone), JOHN CAZALE (Frederico "Fredo" Corleone), TALIA SHIRE (Constanzia "Connie" Corleone-Johnson), LEE STRASBERG (Hyman Roth), MICHAEL V. GAZZO (Frankie Pentangeli), G. D. SPRADLIN (Senator Pat Geary), RICHARD BRIGHT (Al Neri), ORESTE BALDINI (Young Vito Corleone), GASTONE MOSHIN (Don Fanucci).

ACADEMY AWARDS 1974 OSCARS for BEST FILM (Francis Ford Coppola, Gray Frederickson, Fred Roos), BEST DIRECTOR (Francis Ford Coppola), BEST SUPPORTING ACTOR (Robert De Niro), BEST ADAPTED SCREENPLAY (Francis Ford Coppola, Mario Puzo), BEST MUSIC (Nino Rota, Carmine Coppola), and BEST SET DESIGN (Dean Tavoularis, Angelo P. Graham, George R. Nelson).

> ## "There are many things my father taught me here in this room.
> ## He taught me: keep your friends close, but your enemies closer."

Francis Ford Coppola's film epic *The Godfather – Part II* forms a narrative frame around its predecessor, *The Godfather* (1972), one of the most successful films of the 1970s. With part two of the story of the rise and fall of a New York Mafia family, Coppola achieved much more than just a continuation of the first film. He made a self-contained masterpiece that was awarded six Oscars and which, according to many critics, even surpassed its predecessor in several ways.

In *The Godfather – Part II*, two narrative strands unfold in parallel. The first strand begins in Sicily at the dawn of the twentieth century: the young Vito Andolini (Oreste Baldini) from the village Corleone is the only member of his family to survive the Mafia's wholesale extinction of his clan. Friends of the family place him on a boat to America – his chance of survival. Arriving on Ellis Island in New York, Vito, whom the immigration officials have given the surname Corleone, looks at the Statue of Liberty through the barred window in the quarantine station. Shimmering in the sunlight, it embodies the American Dream shared by the immigrants. Years later, when the adult Vito (now played by Robert De Niro) has his own family, he initially tries to make his way by honorable jobs in New

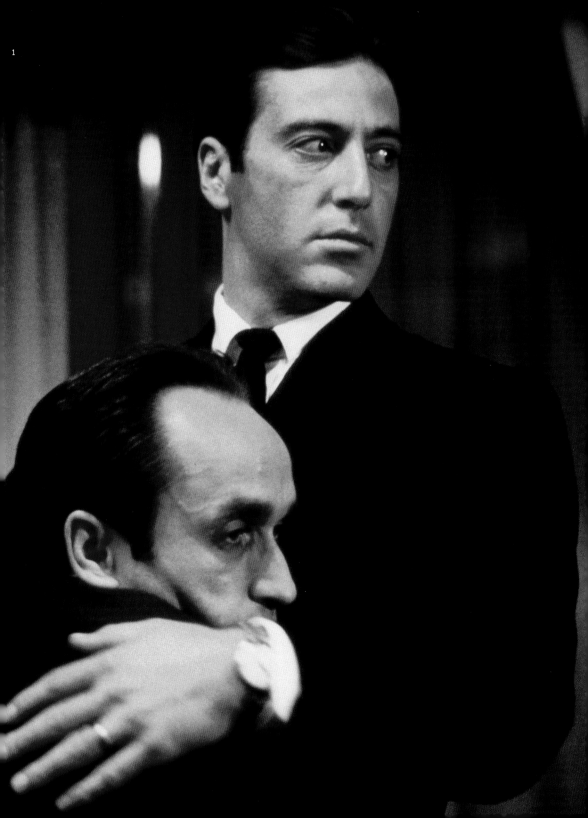

"This is a bicentennial picture that doesn't insult the intelligence. It's an epic vision of the corruption of America. (...) Within a scene Coppola is controlled and unhurried, yet he has a gift for igniting narrative, and the exploding effects keep accumulating. About midway, I began to feel that the film was expanding in my head like a soft bullet." *The New Yorker*

York's immigrant quarter, Little Italy. But even there, the Mafia has already struck powerful roots. Vito's rise to "Godfather" only begins after he successfully defends himself against the money-hungry Don Fanucci (Gastone Moshin).

The second narrative level picks up the story in 1958, a few years after the end of the first film. Vito Corleone's son Michael (Al Pacino), who has run the family business since his father's death, now lives in Lake Tahoe, Nevada, where he is attempting to legitimize and legalize his activities in Las Vegas. He is also beginning to expand them to Miami and Cuba with the help of the gangster Hyman Roth (Lee Strasberg). Michael has adopted

the business principles of his father. One of them is "the family..." Another is "Keep your friends close..."

Family members and business partners assemble at a large celebration that Michael arranges for his son's Communion. While the guests celebrate outside, Michael holds court in his shadowy study and greets the members of "the family." Here it becomes apparent that Michael's enemies really do stand closer than he himself believed. Michael, consummate briber of high-profile politicians and head of a family business that "is more powerful than U.S. Steel," as he will later say, is forced to watch as his attempts to hold the family together do nothing but destroy it.

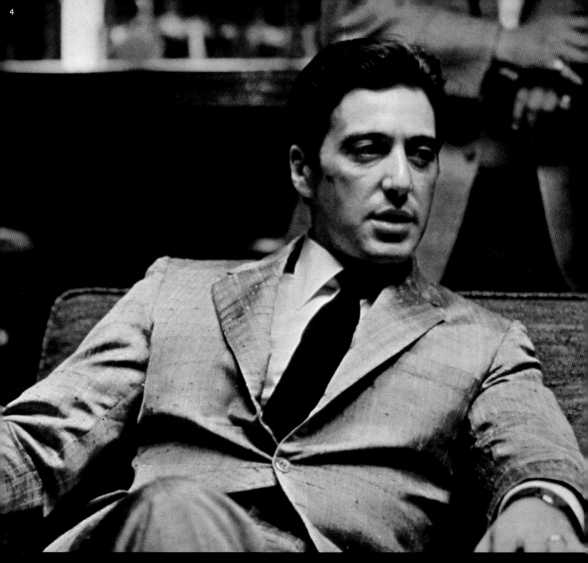

1 Put your head on my shoulder: The role of Michael
 Corleone turned Al Pacino (pictured here with
 John Cazale) into a Hollywood headliner, who was
 soon renowned for his bravado performances in
 the most unconventional of movies.

2 The actor's studio: Still willing to hit below the
 belt, legendary acting coach Lee Strasberg (left)
 appears in *The Godfather – Part II* as gangster
 Hyman Roth.

3 Let's get one thing straight… Al Pacino doesn't
 have to beat a brilliant performance out of Robert
 Duvall.

4 Italian made and tailored: Michael Corleone
 stylishly epitomized the crassest side of American
 individuality.

At the end of the film – his wife, Kay (Diane Keaton) has long since left him – we see Michael Corleone sitting in the garden, alone with his memories and seething with hate. Moments before, during his mother's wake, he gave the order to kill his own brother, Fredo (John Cazale), who like so many others, has betrayed him. The autumn leaves fall from the trees, and through Al Pacino's eyes we stare directly into "the heart of darkness."

Coppola's sequel contrasts the personalities of father and son, weaving a tale of morals, trust, and loyalty, betrayal, and vengeance. Vito is a respectable "paisan" from Sicily whose surroundings force him to adapt to the criminal lifestyle. He becomes powerful by earning the respect and trust of his friends. His son Michael is born into the Mafia and as the Don, must learn how to deal with the responsibility that has been handed

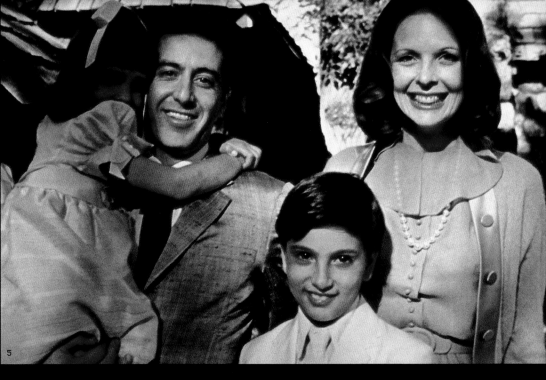

5

down and the power that comes with it. He trusts no one and even makes enemies within the family. But different as the two men are, their stories resemble each other in the fact that both must discover what it means to be a gangster.

The Godfather – Part II is a modern classic. This is predominantly thanks to Francis Ford Coppola, who in continuing the saga accepted a difficult task and rose to the occasion. He was assisted by an eminent ensemble of actors led by Al Pacino and Robert De Niro. De Niro was awarded an Oscar for his performance. Al Pacino shows that the Michael Corleone of The Godfather has become an entirely different person – a self-righteous man who harshly and bitterly attempts to achieve his objectives. Robert De Niro on the other hand is a young embodiment of Marlon Brando, in everything from his manner to the coarse, subdued voice. The meandering story, with its multiple tangents, also gives the other characters significant space: John Cazale in his Cain-role as Michael's humiliated brother, Talia Shire as Michael's sister, Connie, the black sheep of the family (she was also nominated for an Oscar), and Robert Duvall, who once again plays the loyal family attorney, Tom Hagen.

The historic décor and costumes are meticulously exact, and the camera work of Gordon Willis – who filmed both the first and later the last part of the trilogy – captures the transformation of the family by switching from sepia-colored tones (in the flashbacks) to more sinister hues for the present day. After the success of The Godfather, which he assumed as a commissioned work, Coppola was able to secure full control over the second film. And it shows: The Godfather – Part II is quieter, more emotional, and more sinister than the first part. It is more authentic. It is Coppola. APO

LEE STRASBERG An actor, director, theater director, and drama teacher, Lee Strasberg was born on November 17, 1901 in the Austro-Hungarian town of Budzanow, which is now in the Ukraine. In 1909 he came to New York with his parents. In 1930 he founded the Moscow Artist Theater which influenced the critical Group Theater with Harold Clurman and Clifford Odets. Here he began to realize his idea of theater acting, in which "emotional memory" plays a central role and the actors don't fake emotions, but rather identify with the character's emotions.

At the beginning of the 40s Strasberg traveled to Hollywood to learn the art of filmmaking. But he was unable to make it as a director, and was convinced by Elia Kazan in 1948 to assume the artistic direction of the Actors Studio in New York, which was founded in 1947. He served as artistic director from 1951 until his death in 1982. He is considered one of the most important acting teachers in the world, and his "method" is still taught at theater schools. The stars he taught include Marlon Brando, James Dean, Steve McQueen, Dustin Hoffman, Robert De Niro, Jack Nicholson, Jane Fonda, Anne Bancroft, Ellen Burstyn, Al Pacino, Harvey Keitel, Marilyn Monroe, and many others.

Strasberg gave acting lessons, but also appeared in film roles. His portrayal of Hyman Roth in Francis Ford Coppola's The Godfather – Part II (1974) earned him a 1975 Oscar Nomination as best supporting actor. Lee Strasberg died in February 1982.

"I don't feel I have to wipe everybody out, Tom. Just my enemies."

Film quote: Michael Corleone

5 A chicken in every pot and a car in every garage: On occasion, the all-American Corleone family also sports a horse in every bed.

6 Calling the shots: Michael Corleone can tell you firsthand, it doesn't matter how you walk as long as you carry a big stick.

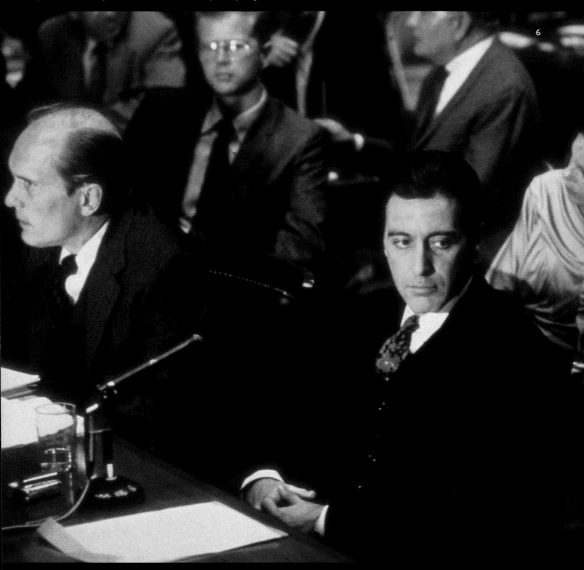

6

THE GREAT GATSBY

1974 - USA - 144 MIN. - LITERARY ADAPTATION, DRAMA

DIRECTOR JACK CLAYTON (1921–1995)
SCREENPLAY FRANCIS FORD COPPOLA, based on the novel of the same name by F. SCOTT FITZGERALD DIRECTOR OF PHOTOGRAPHY DOUGLAS SLOCOMBE EDITING TOM PRIESTLEY MUSIC NELSON RIDDLE PRODUCTION DAVID MERRICK for NEWDON PRODUCTIONS, PARAMOUNT PICTURES.

STARRING ROBERT REDFORD (Jay Gatsby), MIA FARROW (Daisy Buchanan), BRUCE DERN (Tom Buchanan), KAREN BLACK (Myrtle Wilson), SCOTT WILSON (George Wilson), SAM WATERSTON (Nick Carraway), LOIS CHILES (Jordan Baker), HOWARD DA SILVA (Wolfsheim), ROBERTS BLOSSOM (Mr. Gatz), EDWARD HERRMANN (Klipspringer).

ACADEMY AWARDS 1974 OSCAR for BEST MUSIC (Nelson Riddle), and BEST COSTUMES (Theoni V. Aldredge).

"Rich girls don't marry poor boys."

No one knows for sure who Jay Gatsby really is. Nick Carraway (Sam Waterston), a New York stockbroker, has been hearing the most incredible rumors about the new resident on the island of West Egg. Allegedly, he's earned his money on the black market and someone has even died at his hand. One thing's for sure: Gatsby (Robert Redford) has amassed an insurmountable fortune. He lives in a mansion that eclipses the rest of the affluent city's visible wealth, and has gone so far as to build a fun park on the grounds of his estate. Nick looks on as countless cars pull up for his extravagant parties night after night, where guests dance the Charleston, drink champagne and have a wild time until sunrise. We have arrived in the Roaring Twenties, the Jazz Age, an era wedged between the First World War and the onset of the Great Depression in 1929. British director Jack Clayton, whose previous films *Room at the Top* (1959) and *The Innocents* (1961) had met with success, pulled out all the stops to assure that his big screen interpretation of F. Scott Fitzgerald's 1925 classic novel, *The Great Gatsby*, would perfectly recapture the fashion, atmosphere and intricacies of the age. The pastel gowns are hypnotically elegant, and the classic roadsters a monument to bygone decadence. Riding the wave of 1970s period pieces, *The Great Gatsby* is a full-fledged study in nostalgia. Despite this, a misleading advertising campaign that marketed the piece as a great romance meant that film's reception was disappointing. The screenplay, written by Francis Ford Coppola, who enjoyed a tremendous triumph that same year with *The Godfather – Part II* (1974), can also be cited as somewhat problematic. Although it largely remained true to Fitzgerald's book, it proved impossible to bring his literary devices to life on screen. Thus, as with many adaptations of great works of literature, there are moments that take on both a shallow and artificial tone. Previous attempts to turn the book into a movie had met with a similar fate, including a silent version from 1926 and a better-known 1949 movie with Alan Ladd in the title role.

As in the novel, we are soon able to see past the alluring façade that is Jay Gatsby to the broken man beyond. He is someone who has allowed an impossible dream to trap him in the past. Nick quickly discovers that Gatsby throws his parties for the sole purpose of winning the affections of Nick's cousin Daisy (Mia Farrow), who has held his heart for years. She is married to a man named Tom Buchanan (Bruce Dern), and the two of them live with their young daughter in the neighboring town of East Egg. Unlike West Egg, this

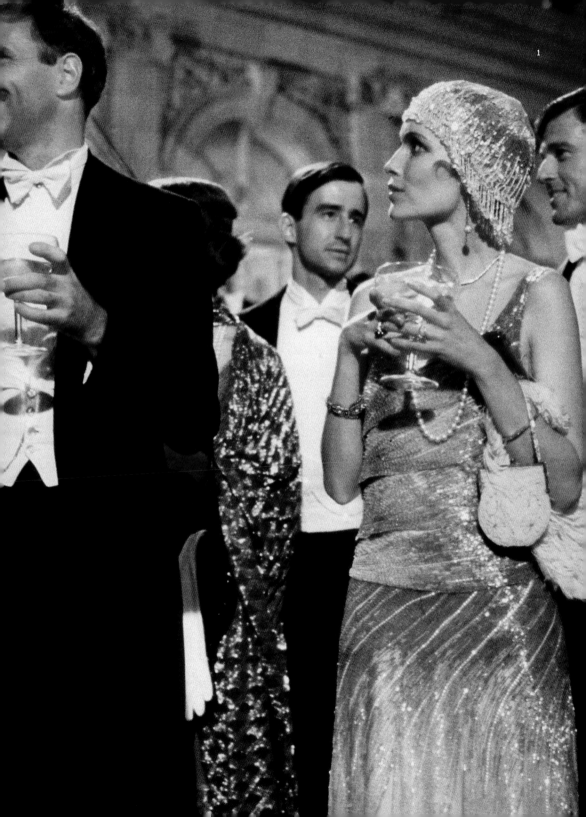

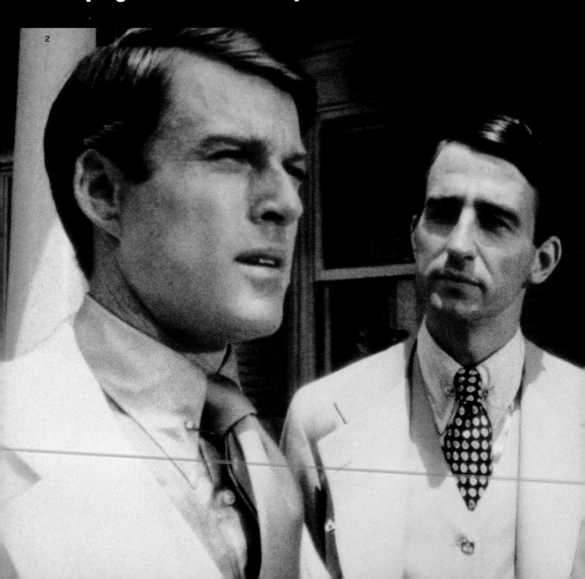

The aim was to capture the spirit of the book, Fitzgerald's masterly evocation of the lifestyle of the rich and famous in the Roaring Twenties. And indeed, the formula romance + nostalgia + advertising campaign does seem to equal success." *Berliner Morgenpost*

2

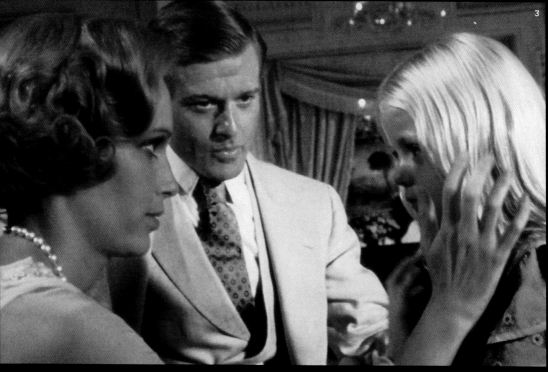

1 Bathtub gin and all that jazz: The film is a loving reconstruction of the fashions and frolics of the Roaring Twenties.

2 One-track mind: Jay Gatsby (Robert Redford) is haunted by the dream of winning back his first love.

3 Roses are red and Jordan is blue: Francis Ford Coppola's script stays true to the novel, but its depth is inevitably lost.

community represents old money and establishment. It has been eight years since Gatsby last saw Daisy; he was an army officer with no money at the time, and she was a poor little rich girl. His accumulated mountain of status and collateral exists for the sole purpose of sweeping Daisy off her feet and winning her back.

Everything seems to go according to plan. After an arranged rendezvous at Nick's residence, the two lovers get to know each other a bit better. Daisy is bowled over by the opulence of Gatsby's palatial manor, whose

neoclassical grandeur seems incomprehensible even for the world of multimillionaires. The plot soon unfolds into a love affair marked by exaggerated romantic conventions and "Vaseline lens" visuals, which prove as grating as Daisy's neurotic behavior. The audience is torn between wondering whether they are watching a farce or simply a world that is "genuinely" as far removed from the realities of ordinary life as is humanly imaginable. It is a dimension that appears even more sensational when compared to the downtrodden, suburban street where impecunious auto-body shop

MIA FARROW Many consider her to be one of the few great actresses of 1970s New Hollywood. Others see her as a frail crybaby. Perhaps a telling choice of words as actress Mia Farrow's rise to international stardom came with the 1968 picture *Rosemary's Baby*, about a child bride's devastating pregnancy. Farrow was born in 1945 in Los Angeles to actress Maureen O'Sullivan, famous for playing the role of Jane throughout the 1930s in the Tarzan movies, and director John Farrow. She began her acting career in the 1960s on the TV soap opera *Peyton Place* (1964–69). After the success of *Rosemary's Baby* she was offered a large number of promising roles, playing that same year in *Secret Ceremony*. In 1972, she appeared at the side of Jean-Paul Belmondo in *Docteur Popaul*. Other highlights include her 1974 performance opposite Robert Redford in *The Great Gatsby* and a 1978 all-star film adaptation of Agatha Christie's *Death on the Nile*.

A long-standing personal and professional relationship with Woody Allen burgeoned in 1982 when she was cast in his picture, *A Midsummer Night's Sex Comedy*. The once wife of both legendary entertainer Frank Sinatra and composer/conductor André Previn became Allen's favorite leading actress and companion of many years. Over the course of twelve years she performed exclusively in Allen's productions, playing the fragile yet sprightly woman in numerous pieces like *Zelig* (1983), *Broadway Danny Rose* (1983–84), *The Purple Rose of Cairo* (1985), considered by many to be Allen's masterpiece, *Hannah and Her Sisters*, (1985), *September* (1987) and *Alice* (1990). The couple split up in 1992 when it became clear that Allen was having an affair with Farrow's adopted Korean daughter, Soon Yi. After the mudslinging of the public scandal subsided, Farrow began to work again in film and television. In 1994 she stood before the camera in *Widows' Peak* and *Miami Rhapsody*. Mia Farrow is the mother of 13 children, nine of which she adopted. She is also the author of the 1997 autobiography *What Falls Away*.

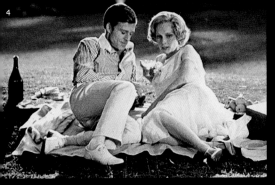

"The film is faithful to the letter of F. Scott Fitzgerald's novel but entirely misses its spirit. Much of Fitzgerald's prose has been preserved, especially in Nick Carraway's narration, but it only gives the film a stilted, stuffy tone that is reinforced by the dialogue. Fitzgerald wrote dialogue to be read, not said; and the Coppola screenplay (much rejuggled by Director Clayton) treats Fitzgerald's lines with untoward reverence. When Daisy sighs, 'We were so close in our month of love,' she sounds like a kid in creative-writing course reading her first story loud." *Time Magazine*

4 Daisy, Daisy give me your answer do… Gatsby has found the love of his life (Mia Farrow) again.

5 Suddenly last summer: Gatsby shortly before his violent death.

6 A race to the finish: Gatsby's car symbolizes wealth and freedom, but in the end it costs him his life.

7 All that glitters is not gold: Mia Farrow and Robert Redford of *Butch Cassidy and the Sundance Kid* fame.

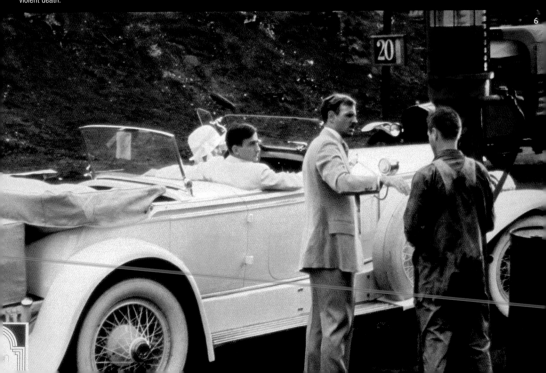

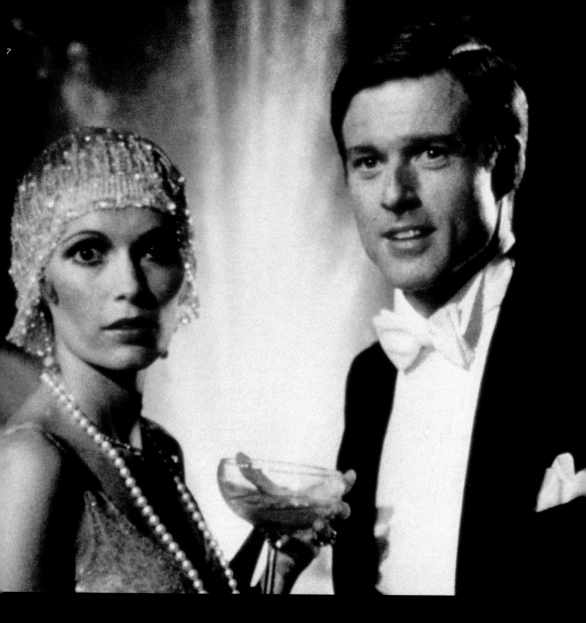

wner George Wilson (Scott Wilson) lives with his wife Myrtle (Karen Black). he ominous eyes of Dr. T.J. Eckleburg on a local billboard watch over this owhere town and serve as one of the film's most evident symbols. This is world sucked dry of color, providing a sharp contrast to the rainbow world f the two Eggs. Myrtle is Tom Buchanan's mistress and like Jay Gatsby, opes to gain access to a new social stratum via her lucrative liaison. Both f these hopefuls are left hung out to dry. Not only does Tom soon find ut that Gatsby has indeed, as accused, made a killing in the illegal alcohol ade, but it also becomes clear that Daisy has no intention of leaving er husband. Shortly after this shattering revelation, Myrtle meets an un- ely demise when Gatsby unintentionally hits her with his car. In a wild act

of desperation, Wilson shoots Gatsby and then himself, leaving the two men dead.

Both the movie and the book equate Gatsby's personal desires with those inherent in the American Dream. Nevertheless, everything that Daisy represents to this social climber is rooted in the past. Likewise, the American Dream itself is deemed to be a concept that only exists in nostalgic reveries. Several generations separate the time between the mass European exodus to the western shores of the New World and the 1920s, and in *Gatsby*, we bear witness to an opposing trend within the United States. Here, characters from "western" cities like Detroit are returning to the East Coast. For Gatsby, the movement is a harrowing reverse that signals his undoing.

KK

THE PASSENGER (AKA PROFESSION: REPORTER)

Professione: reporter / Profession: Reporter

1974 - ITALY / FRANCE / SPAIN / USA - 125 MIN. - DRAMA

DIRECTOR MICHELANGELO ANTONIONI (*1912)
SCREENPLAY MARK PEPLOE, PETER WOLLEN, MICHELANGELO ANTONIONI DIRECTOR OF PHOTOGRAPHY LUCIANO TOVOLI
EDITING MICHELANGELO ANTONIONI, FRANCO ARCALLI MUSIC IVAN VANDOR PRODUCTION CARLO PONTI for CIPI
CINEMATOGRAFICA S. A., COMPAGNIA CINEMATOGRAFICA CHAMPION, LES FILMS CONCORDIA, MGM.

STARRING JACK NICHOLSON (David Locke), MARIA SCHNEIDER (The Girl), IAN HENDRY (Martin Knight), JENNY
RUNACRE (Rachel Locke), CHUCK MULVEHILL (Robertson), STEVEN BERKOFF (Stephen), AMBROISE BIA (Achebe),
JOSÉ MARÍA CAFFAREL (Hotel Owner), ÁNGEL DEL POZO (Police Inspector), MANFRED SPIES (Stranger).

"People disappear every day." – "Every time they leave the room."

"No family, no friends – just a couple of obligations and a weak heart." This is how the arms dealer Robertson (Chuck Mulvehill) sums up his life. British journalist David Locke (Jack Nicholson) encounters his compatriot in a hotel in the middle of the Sahara desert, and a few hours later, he finds him dead in his room.

With hardly a second thought, Locke assumes the dead man's identity – partly for professional reasons, and partly (as the viewer gradually discovers) because he has become as estranged from his own life as from his profession as a war reporter. The ink isn't dry on the famous journalist's obituaries before Locke has arranged to meet with Robertson's contractors – a group of African freedom fighters. Clearly, Robertson had believed in what he was doing; and as conviction is precisely what Locke's life has been lacking, he uses the dead man's calendar to pick up where Robertson had left off.

It seems, at first, that the change of identity has gone off without a hitch. Soon, however, there's a bunch of people pursuing the imposter: Not just Robertson's business partners, but his enemies too; and – last, not least – the "widow" of David Locke … In flight from his own past and another man's future, the journalist is clearly in mortal danger.

Locke is joined by a young student (Maria Schneider), who is fascinated by his radical self-erasure and "rebirth." Yet he knows he'll have to come clean eventually, and his attempts to evade his pursuers are half-hearted. The journey ends in a Spanish no-man's-land, a kind of wilderness like the African desert in which it began.

For director Michelangelo Antonioni, the thriller plot of The Passenger is a vehicle for reflections on human identity. From the bits and pieces available to him, Locke tries desperately to reconstruct Robertson's life, but the attempt ends in failure. The arms dealer remains a phantom, for Robertson has no reality apart from the complex network of relationships that constitute his unique existence.

Even in his new identity, Locke falls victim to the contradictions inherent in his own profession. Antonioni shows us the journalist as a man doomed to passivity, even in his most active moments. Fragments of interviews from Locke's journalistic past reveal the roots of his crisis. Whether hi

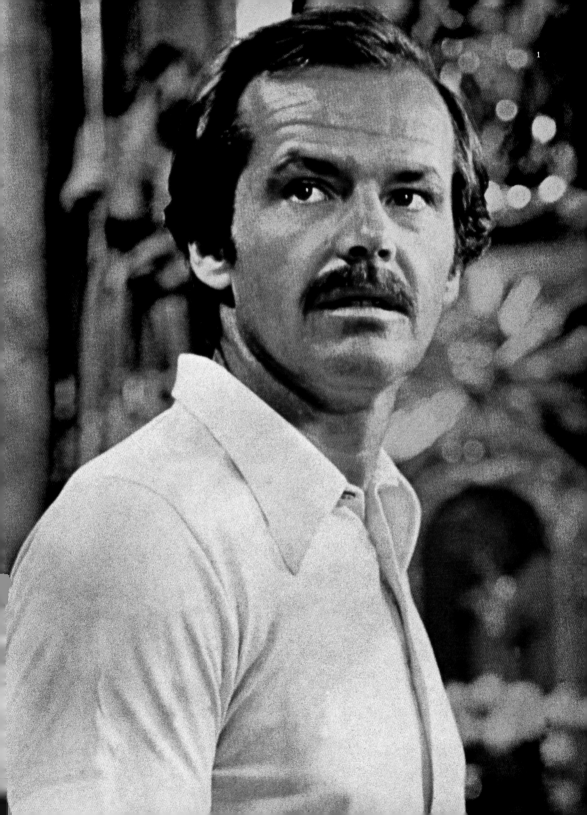

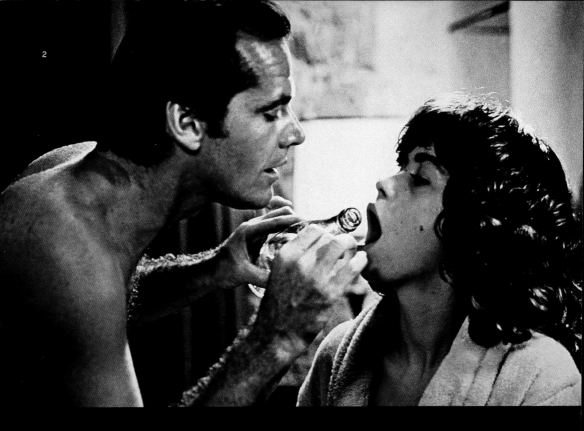

"I don't have anything to say but perhaps something to show."

Michelangelo Antonioni, in: The Architecture of Vision. Writings and Interviews on Cinema

MICHELANGELO ANTONIONI Antonioni was born in Ferrara in 1912. He began his career as a writer of short stories and as a contributor to the Italian film journal *Cinema*, the cradle of neorealism. After making several short documentaries, Antonioni retreated from the view that the cinema should serve a political agenda, and his first feature, *Story of a Love Affair* (*Cronaca di un amore*, 1950) broke with conventional narrative techniques. Until the mid-60s, Antonioni's great theme was "the sickness of feelings," depicted in films such as *The Night* (*La notte*, 1960), *The Eclipse* (*L'eclisse*, 1962) and *Red Desert* (*Il deserto rosso*, 1964). In his later works, *Blow Up* (1966), *Zabriskie Point* (1969) and *The Passenger* (*Professione: reporter / Profession: Reporter*, 1974), he examined the emotional and existential rootlessness of modern humanity. These films also express Antonioni's distrust of superficial appearances. To him, the essential nature of a thing is forever hidden beneath its visible surface, and no image or representation can alter this fact. In Antonioni's work, landscapes, buildings, gestures and sounds are the symbols of interior realities; he creates what has been termed a "dramaturgy of the fragmentary," where "the form swallows the content." (Thomas Christen in *du* Magazin 11/1995). At times, his style is almost mannered, perhaps too much in love with effects. Yet his considered use of technical means – like the slow-motion explosion in *Zabriskie Point* or the closing sequence of *The Passenger* – stands in striking contrast to his intuitive working methods, exemplified by his frequent changes to the dialog during filming. Unlike most of his Italian or American counterparts, Antonioni seems to approach his subjects tentatively, watchfully, as if waiting for an opening, a way into their deeper meaning. As he put it himself: "I know what I have to do. Not what I mean."

1 Lost for words. As gunrunner Robertson, David
Locke (Jack Nicholson) loses his grip on reality.

2 Who did you say you were? Despite their
unbridled intimacy, Locke and his nameless
companion (Maria Schneider) never really
get close.

3 One corpse and a fake ID: Locke is surprised
how easy it is to become someone else.

4 Ticket to ride: On the road to nowhere, in flight
from the unknown.

subject was a magician or a dictator, the actual person, the real significance, always remained hidden. What we see is what we get, but we only ever see what we want to see – or the little we're shown.

In a sense Locke is the director's alter ego, for he too is lumbered with perceivable reality, the only material available to him. As the plot dissolves into a plethora of locations and narrative levels, *The Passenger* emerges as a thesis on the possibility or impossibility of visual representation per se. A recurring metaphor: doors and windows that reveal only a portion of the past or the present. Whatever the image, the camera lingers a little longer than necessary, as if waiting for the magical moment when the visible world will finally yield up its secrets.

The seven-minute final sequence is a final reminder that we wait in vain for revelation. Locke is recumbent on his bed in a hotel room, but the camera-angle makes him invisible to the audience; through the window, we see the village square, and the bullring beyond it; a car drives past; a boy throws rocks at a beggar; and the girl converses with various people. In the midst of these barely decipherable details, the true drama remains hidden, indicated only by the vague sound of a single shot. The camera passes through the barred window, describes a broad curve around the square and comes back round to gaze through the window once more: At the end of his aimless journey, David Locke has arrived at the only inevitable destination. SH

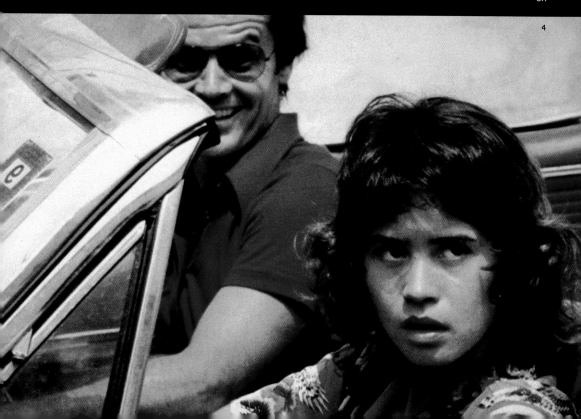

CHINATOWN

1974 - USA - 131 MIN. - DETECTIVE FILM, DRAMA

DIRECTOR ROMAN POLANSKI (*1933)
SCREENPLAY ROBERT TOWNE **DIRECTOR OF PHOTOGRAPHY** JOHN A. ALONZO **EDITING** SAM O'STEEN **MUSIC** JERRY GOLDSMITH
PRODUCTION ROBERT EVANS for LONG ROAD, PENTHOUSE, PARAMOUNT PICTURES.

STARRING JACK NICHOLSON (J. J. "Jake" Gittes), FAYE DUNAWAY (Evelyn Cross Mulwray), JOHN HUSTON (Noah Cross), PERRY LOPEZ (LAPD Lieutenant Lou Escobar), JOHN HILLERMAN (Russ Yelburton), DARRELL ZWERLING (Hollis I. Mulwray), DIANE LADD (Ida Sessions), ROY JENSON (Claude Mulvihill), ROMAN POLANSKI (Man with the knife), RICHARD BAKALYAN (LAPD Detective Loach).

ACADEMY AWARDS 1974 OSCAR for BEST ORIGINAL SCREENPLAY (Robert Towne).

"I'm just a snoop."

Los Angeles, 1937. When private detective J. J. Gittes (Jack Nicholson) is hired to keep tabs on an unfaithful husband, he assumes it's going to be just another routine job. But the investigation takes an unexpected turn. The guy he's been keeping an eye on, a high-ranking official for the city's water and power department is bumped off. His attractive widow Evelyn (Faye Dunaway) retains Gittes' services to find out whodunit. Before he knows it, Gittes stumbles unexpectedly onto a foul smelling real estate scheme, and soon finds himself entangled in one sordid affair after another. Gittes has several bloody run-ins with thugs determined to put an end to his work on the case, and uncovers clues pointing to the involvement of influential power-players in the sinister dealings. Even Gittes' alluring employer Evelyn seems to know more about the matter than she's letting on…

Chinatown is considered by many film critics to be not only one of the greatest films of the 70s, but of all time. How the movie came to be illustrates, like so many other similar moments in Hollywood history, that masterpieces can still be born within the framework of the imperious big studios. Chinatown was simply one of those rare instances when the perfect combination of people came together at just the right time. Jack Nicholson who, at the time was not a solid "A list" star, brought prominent "script doctor" Robert Towne on board the project to write the screenplay. When he got wind of the project, Robert Evans, who was head of production at Paramount, wanted to try his hand at producing a film himself. He finalized an agreement with the writer and actor and secured Roman Polanski, with whom he had collaborated previously on Rosemary's Baby (1968), as the picture's director. (Understandably, Polanski had been working in his native Europe following the brutal death of his wife Sharon Tate [1943–1969] in their Los Angeles home.) When Faye Dunaway was cast as the female lead, yet another not quite famous personality was added to the mix. As one might expect, the shoot was not exactly plain sailing. Evans dubbed the verbal fireworks between Towne and Polanski, "World War III." The problem probably had something to do with the fact that this was first project Polanski directed without writing himself. The product was, nonetheless, an inter-

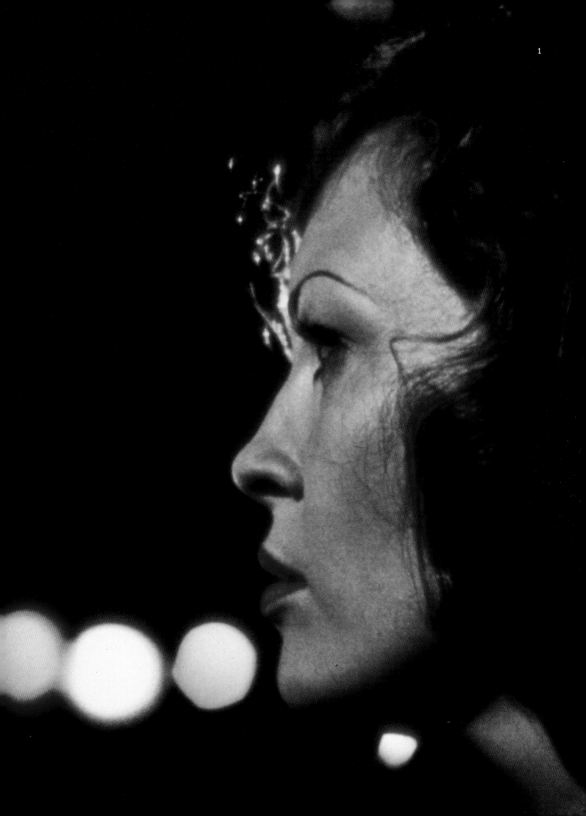

Chinatown was seen as a Neo-Noir when it was released – an update on an old genre. Now years have passed and film history blurs a little, and it seems to settle easily beside the original noirs. That is a compliment." *Chicago Sun-Times*

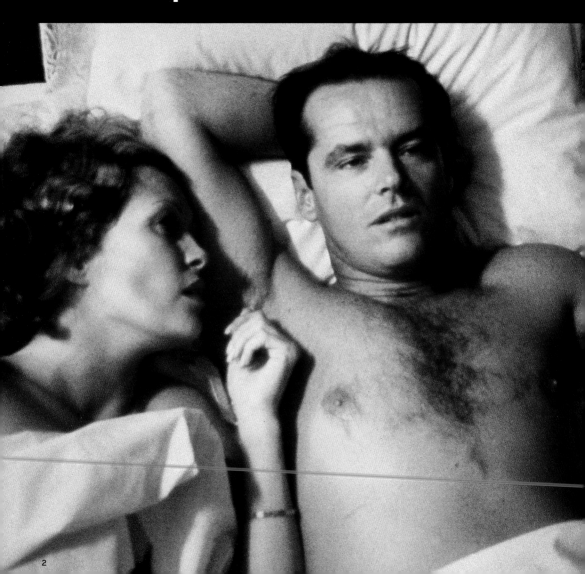

Portrait of a lady: Femme fatale Evelyn (Faye Dunaway) awakens men's dreams and inspires them to action.

In her clutches: The private eye (Jack Nicholson) has lost all professional distance from his seductive client.

Masterful execution: Veteran director John Huston plays a brutal patriarch who holds all the cards.

Mack the knife: Polanski in a striking cameo as the "nose-slitter."

3

tional smash. *Chinatown* reeled in a total of eleven Oscar nominations, though Robert Towne was the sole person who ended up taking a statuette me.

Yet what makes *Chinatown* truly fascinating, and the reason it attained its instant status as an uncontested masterpiece, is by and large the film's grace in evoking the Golden Age of 1930s–1940s Hollywood, without losing itself in the nostalgia of the era or turning the production into just another stiffly stylized homage. Naturally, Polanski's film draws heavily on classic Bogart characters like detective Philip Marlowe from Howard Hawks' *The Big Sleep* (1946) or his more cynical counterpart Sam Spade from *The Maltese Falcon* (1941), directed by Hollywood legend John Huston. Huston himself plays a pivotal role in *Chinatown* as a ruthless and sickeningly senti-

mental patriarch, who seems to be the key to the entire mystery. Unlike Bogart, Nicholson's character is only capable of being a limited hero. Although J. J. "Jake" Gittes is a likeable, small-time snoop, with a weakness for smutty jokes, the charming sheister fails miserably as a moralist and suffers terribly as a result. The scene featuring Polanski as a gangster who slits open Nicholson's nose is absolutely priceless. The Gittes character also lacks the romantic potential of a Bogart hero. Gittes doesn't embody desires, instead he falters on them. Yet his greatest weakness is Chinatown, the place where his career as a cop came to an end and a synonym for all the irresistible, exotic dangers of the urban jungle. This same sweet taboo seems to echo in Faye Dunaway's character. In the end, Chinatown presents Gittes with a double-edged defeat. Although Towne had originally written a happy

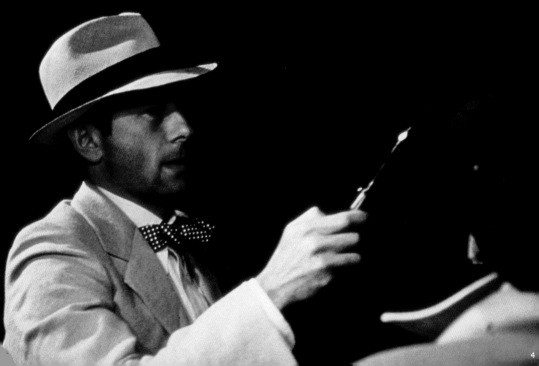

4

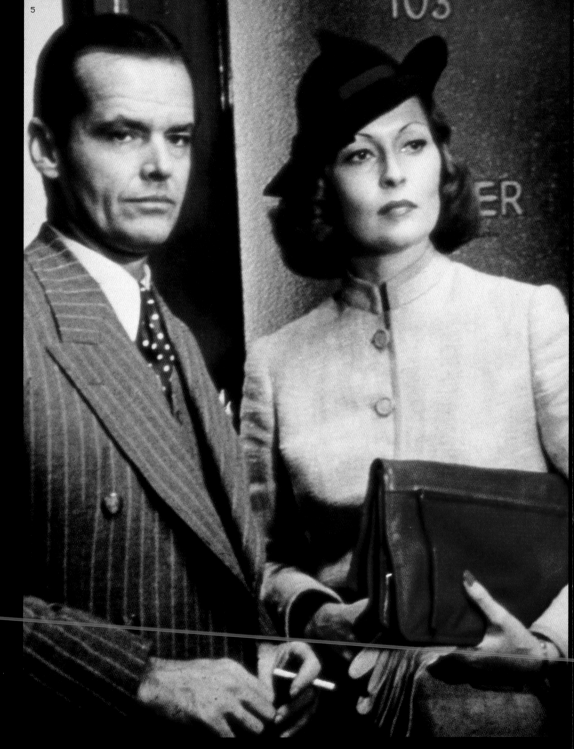

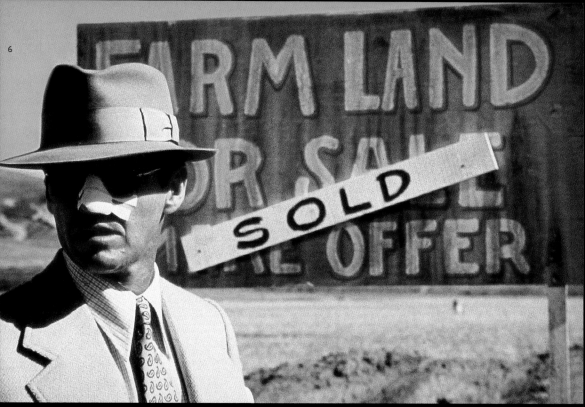

6

5 Just the facts Ma'am: *Chinatown* evokes classic Hollywood cinema without ever romanticizing it.

6 Still nosing around: J. J. Gittes (Jack Nicholson), bloody but unbowed.

ending, the film's final sequence, which just screams Polanski, sees Gittes inadvertently aiding the forces of evil and losing the love of his life at the same time.

Another great accomplishment of the piece is Polanski and cinematographer John A. Alonzo's triumph in achieving the impact of a black and white Film Noir piece with brilliant color photography. It is uncanny how little the city feels like a movie lot and how convincing the topography looks. Unlike in so many other so-called revisionist noir films, in *Chinatown*, L. A. is not a black, smoldering hell's kitchen but rather a vast, often sunny countryside metropolis still in the early stages of development. The imagery lets the viewer sense that the city and its surrounding valleys exist in spite of the imposing

desert. We are also made aware of the colossal pipeline, supplying the city with water, its artificial lifeblood. Water is, in fact, the major resource being manipulated in the story's diabolical real estate venture, a scandal with genuine historical roots in the region. Robert Towne based his screenplay on nonfictional accounts dating back to early 20th century Southern California. It was a time when the foundations for the future riches of the world's movie capital were in construction. The location was chosen primarily on account of the area's year-round sun, ideal for filming, and its affordable purchase price. The boom ushered in a wave of land speculators, corruption and violence. It is a grim bit of Earth that the City of Angels and Hollywood rests upon. A tale that unfolds in *Chinatown*. JH

ROBERT EVANS Robert Evans (born 1930 in New York), is one of New Hollywood's most illustrious personalities and got his start performing in film at the age of 14. His big break into the business came when actress Norma Shearer, widow of legendary Hollywood tycoon, Irving Thalberg, insisted that Evans play her husband in the *Man of a Thousand Faces* (1957). Dissatisfied with the state of his acting career, he began to work as a freelance producer, without ever producing a single picture, and eventually signed a contract with Paramount in 1965. In the blink of an eye, Evans climbed the rungs of the corporate ladder and emerged as the studio's head of production. He was able to bring the old "mountain" back to its state of former glory as a major studio by taking on a number of blockbuster projects such as *Rosemary's Baby* (1968), *Love Story* (1970), *The Godfather* (1972), *The Godfather – Part II* (1974) and *Chinatown* (1974).
Chinatown marked the first time Evans was able to realize his long harbored ambition of producing a film himself, which garnered him an Academy Award nomination for Best Picture. He left Paramount shortly thereafter to produce film independently, working on films like *Marathon Man* (1976) and *Black Sunday* (1977). These productions were, however, less popular at the box office. In 1984, Evans made headlines for his involvement in the *The Cotton Club* (1984), which not only bombed, but also entangled him in disastrous private scandals. As a result, Evans disappeared from the scene completely for several years. He returned to the business in 1990 with *The Two Jakes*, a further instalment of *Chinatown*, also starring Jack Nicholson. Evans published a book entitled *The Kid Stays in the Picture* (1994) about his personal life story, a constant target of media attention since his start in Hollywood. This gripping autobiography was made into a documentary film in 2002 under the same title.

JAWS

1975 - USA - 124 MIN. - THRILLER, HORROR FILM

DIRECTOR STEVEN SPIELBERG (*1947)
SCREENPLAY CARL GOTTLIEB, PETER BENCHLEY, based on his novel of the same name **DIRECTOR OF PHOTOGRAPHY** BILL BUTLER
EDITING VERNA FIELDS **MUSIC** JOHN WILLIAMS **PRODUCTION** RICHARD D. ZANUCK, DAVID BROWN for ZANUCK/BROWN
PRODUCTIONS, UNIVERSAL PICTURES.

STARRING ROY SCHEIDER (Police Chief Martin Brody), ROBERT SHAW (Quint), RICHARD DREYFUSS (Matt Hooper),
MURRAY HAMILTON (Mayor Larry Vaughn), LORRAINE GARY (Ellen Brody), CARL GOTTLIEB (Ben Meadows),
JEFFREY KRAMER (Lenny Hendricks), SUSAN BACKLINIE (Chrissie), CHRIS REBELLO (Mike Brody), JAY MELLO
(Sean Brody).

ACADEMY AWARDS 1975 OSCARS for BEST FILM EDITING (Verna Fields), BEST MUSIC (John Williams), and BEST SOUND
(Robert L. Hoyt, Roger Herman Jr., Earl Mabery, John R. Carter).

"You're gonna need a bigger boat."

A hot summer night, a beach party, a little too much red wine, and some teenage sex is just the stuff Hollywood horror films are made of. While her drunken companion sleeps off his hangover on the beach, young Chrissie (Susan Backlinie) takes a midnight dip in the water and is torn to pieces by a shark. The fact that the monster with the dead eyes cynically emerges in innocent white from the depths of the water makes it all the more threatening. The shark – the fear and guilt in all of us – awakens our prehistoric terror of the incomprehensible, the truly wild. It is evil incarnate.

But in the small American beach town ironically named Amity, nobody wants to hear about the threat to a safe world and free market economy, least of all from the mouth of visiting New York cop Martin Brody (Roy Scheider) who, to cap it all, is afraid of the water.

Accordingly, the authorities, in the form of the mayor Larry Vaughn (Murray Hamilton), and the profit and pleasure-seeking public win out over Brody, who wants to close the beaches in light of the menacing danger. It comes as no surprise that the town has a new victim the very next day.

A reward of $3,000 for the capture of the shark incites hunting fever in Amity, and the gawking mob on the pier is duly presented with a dead shark. But it is quickly determined that the captured shark can't possibly be the feared killer: upon cutting open its stomach they find a few small fish, a tin can, and a license plate from Louisiana.

It is a motley trio that sets out to capture the beast – a water-shy policeman, a "rich college boy" named Matt Hooper (Richard Dreyfuss), and

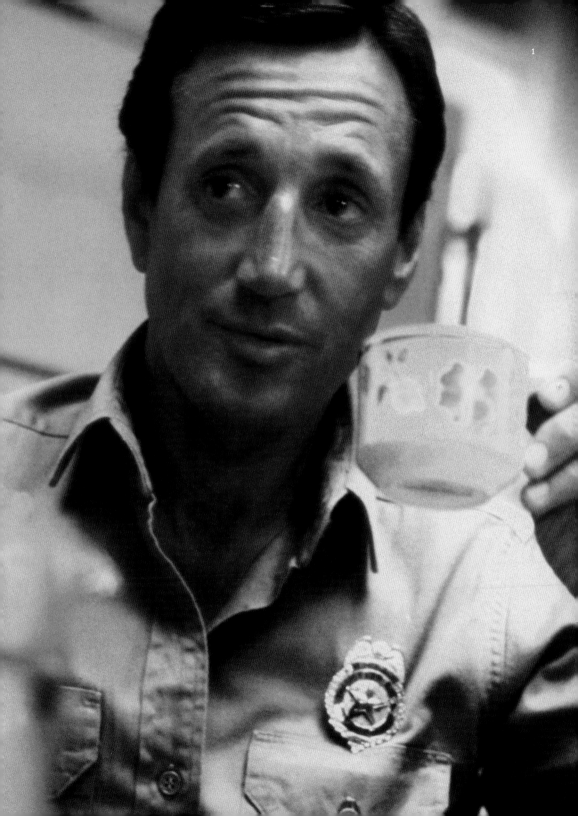

"If *Jaws* was a kind of skeleton key to the angst of the 70s, from the puritanical fear of sex to the war in Vietnam, then its heroes were models of America's wounded masculinity, who meet and join to face a test of character."

Georg Seeßlen

3

1 Baywatch: Police Chief Martin Brody (Roy Scheider) is fighting nature, the ignorance of those he's trying to protect and his own fears.

2 Beach, blanket, bloodbath: Beautiful Chrissie (Susan Backlinie) is the shark's first victim.

3 Smile for the camera: Three separate models, each seven yards long and weighing over a ton, brought the monster to life. The film crew dubbed the shark "Bruce" – after Steven Spielberg's lawyer.

shark hunting Vietnam veteran Quint (Robert Shaw), a modern Captain Ahab who unsuccessfully attempts to disguise a wounded psyche with a façade of disgust for everything around him. For each of the three men, the shark hunt also turns into a search for their true selves.

The unmistakably sexual aspect of the story of the unnamed monster – a terrifying mixture of phallus and vagina – which afflicts the home and the family has often been pointed out. But *Jaws* is also a film about human fears and character flaws, the overcoming of which gives birth to heroes. That

the story also tells of the capitalistic, self-endangering society, of patriotic America, of mass hysteria, guilt, atonement, and the sacrifice of the individual for the good of the whole is proof of Spielberg's ability to give a simple story plausible readings on multiple levels.

But let's not forget that *Jaws* is one of the most nerve-wracking thrillers of all time. When Spielberg explains that during the filming he felt as if he could direct the audience with an electric cattle prod, it speaks volumes about the cold precision with which, supported by an exceptionally sugges-

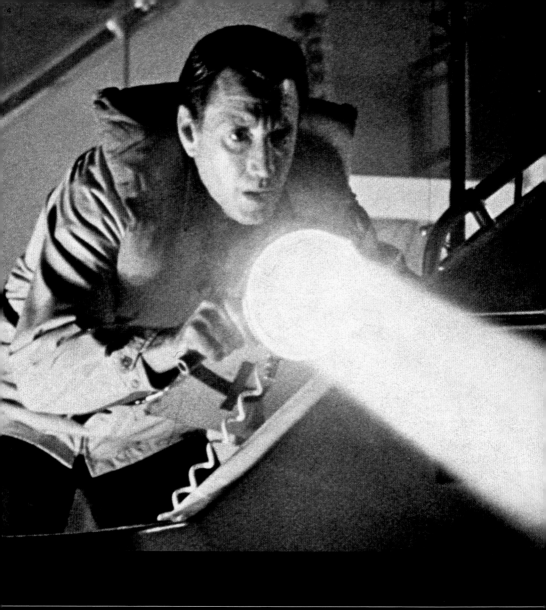

THE END OF ARTIFICIAL CREATURES

"Compressors, tanks, winches, pneumatic hoses, welding torches, blow lamps, rigging, generators, copper, iron, and steel wire, plastic material, electric motors, crammers, hydraulic presses" – just some of the trappings required to make "Bruce," as the film team christened the model of the white shark, come alive. In his book, "The Jaws Log," co-screenwriter Carl Gottlieb tells of the immense problems encountered trying to simulate real-life shark attacks with a life-sized model (because actually Bruce was made of three different models). Shooting was repeatedly interrupted by technical problems, most memorably when they first put Bruce in the water, only to see him sink like a stone. The hiring of long-retired Hollywood veteran Robert A. Mattey, creator of the special effects for Disney's *Marry Poppins* (1964) and countless other films, makes it clear that the mid-70s marked the end of conventionally created film monsters. "Bruce" was one of the last of his kind and craftsmen like Bob Mattey were increasingly relieved by computer programmers. Spielberg proved his ability to incorporate their work into his projects in 1981 with *Raiders of the Lost Ark*, in which entire sequences were created with the help of computer animation.

"If Spielberg's favorite location is the suburbs, *Jaws* shows suburbanites on vacation."

Chicago Sun-Times

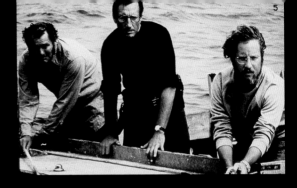

...ve soundtrack, he was able to raise the tension and lower it again, all in preparation for the next dramatic highlight.

Just one example of Spielberg's virtuoso story-telling technique is the scene in which the men show one another their scars under deck. In the middle of the scene, the audience is told the story of the *ISS Indianapolis*, the boat with which the Hiroshima bomb was transported to the Pacific. Under fire from Japanese submarines, the crew threw themselves into the ocean and the majority of them were eaten by sharks.

During this sequence, which is actually quite humorous, Spielberg and his authors succeed in setting a counterpoint even before the appearance of the shark illustrates the terror of the story. Quint's tale contains a political dimension. Ultimately, this scene also reveals something about story-telling itself – reality catches you up in a flash. Right when Quint and Hooper attempt to stem their apprehension with loud song, Mr. Spielberg is right there with his electric shocker.

SH

4 Brody's scared of water, but he's about to undergo some shock therapy...

5 Rub a dub dub, three men in a tub: *Jaws* is also a parable about social conflicts in the USA.

6 Shark fin soup: Evil feeds on ignorance and Americans.

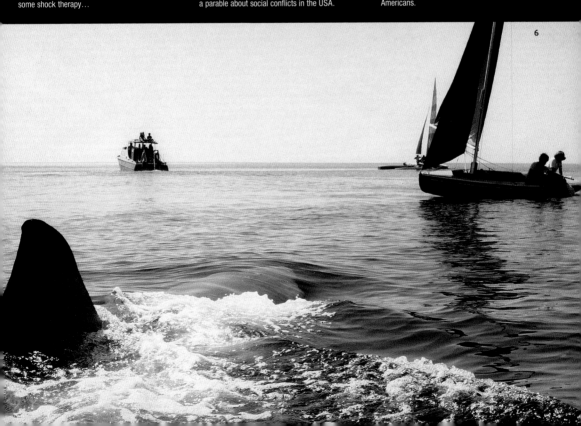

ONE FLEW OVER THE CUCKOO'S NEST

1975 - USA - 134 MIN. - DRAMA, LITERARY ADAPTATION

DIRECTOR MILOŠ FORMAN (*1932)
SCREENPLAY LAWRENCE HAUBEN, BO GOLDMAN, based on the novel of the same name by KEN KESEY and a play by DALE WASSERMAN DIRECTOR OF PHOTOGRAPHY HASKELL WEXLER, WILLIAM A. FRAKER, BILL BUTLER EDITING LYNZEE KLINGMAN, SHELDON KAHN, RICHARD CHEW (Supervising editor) MUSIC JACK NITZSCHE PRODUCTION SAUL ZAENTZ, MICHAEL DOUGLAS for FANTASY FILMS, N. V. ZVALUW.

STARRING JACK NICHOLSON (Randle Patrick McMurphy), LOUISE FLETCHER (Nurse Mildred Ratched), WILLIAM REDFIELD (Harding), BRAD DOURIF (Billy Bibbit), WILL SAMPSON (Chief Bromden), DANNY DEVITO (Martini), MICHAEL BERRYMAN (Ellis), PETER BROCCO (Colonel Matterson), DEAN R. BROOKS (Doctor John Spivey), ALONZO BROWN (Miller).

ACADEMY AWARDS 1975 OSCARS for BEST PICTURE (Saul Zaentz, Michael Douglas), BEST DIRECTOR (Miloš Forman), BEST ACTOR (Jack Nicholson), BEST ACTRESS (Louise Fletcher), and BEST ADAPTED SCREENPLAY (Lawrence Hauben, Bo Goldman).

"But I tried didn't I? Goddammit, at least I did that!"

The movie's opening shot evokes an image of paradise lost. Rolling hills are reflected in the glistening water by the rising sun, as a peaceful melody drifts through the air. The last shot is equally utopian. Chief Bromden (Will Sampson), a mountain of a man resident at the psychiatric rehabilitation facility tucked away in this picturesque countryside, wrenches a colossal marble bathroom fixture from its anchored position, hurls it through a window and embarks on the road to freedom. What director Miloš Forman manages to pack into the action that takes place between these two points is a mesmerizing parable about both the urge to capitulate and an ideological system that seeks to crush the individual at any cost. The tale is ingeniously coated in a tragicomic drama about life, death and the state of vegetative indifference exhibited by the residents of an insane asylum.

But all that is about the last thing assault and statutory rape convict, Randle P. McMurphy (Jack Nicholson) has on his mind when he first arrives at the sterile building with barred windows for clinical observation. To McMurphy, the facility serves as a promising alternative to the hard labor he'd be subjected to at the state penitentiary. This is, of course, precisely why higher authorities suspect him of faking his mental ailments. It soon becomes evident that McMurphy is the sole person at the institution still possessing enough fantasy and initiative to combat the current reign of deadening boredom. His opposition comes in the form of the austere head nurse, Mildred Ratched (Louise Fletcher), who has made it her life mission to suck the marrow out of any bit of excitement within the ward in order to assure her patients' eternal sedation. McMurphy, however, slowly undermines her authority. He begins to question trivialities as well as the inalterable daily schedule by instigating "harmless" acts of defiance, even managing to get the patients to sneak out of the clinic and treat them to a fishing trip. Although McMurphy's actions infuse the sequestered men with newfound self-esteem, Nurse Ratched's festering anger reveals her personal disdain for anything other than the prescribed routine. She of course defends the

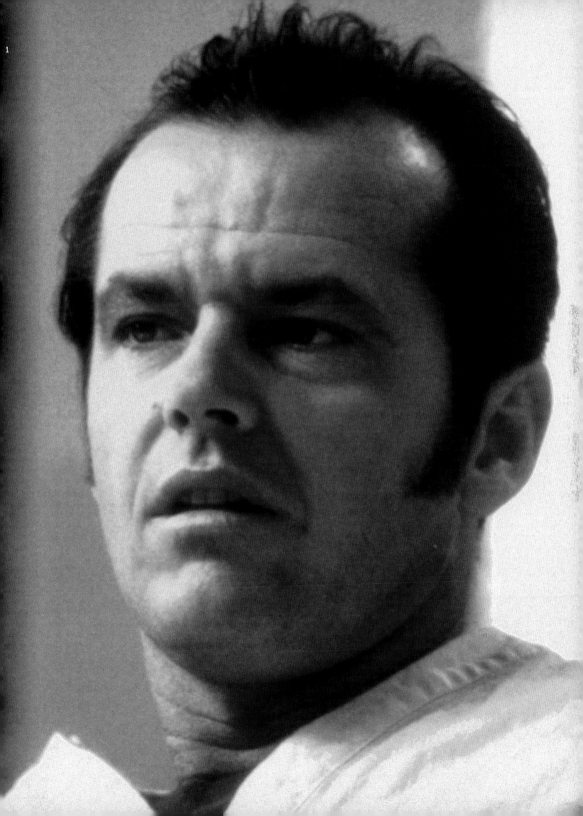

1 It's your move: Randle P. Murphy (Jack Nicholson) thinks he's in a game – and he thinks he can win.

2 Leading by example: Randle is the hero of the other patients in the psychiatric ward.

3 Shake, rattle and roll: Randle encourages his fellow patients to take control of their lives.

> **"*One flew over the Cuckoo's Nest* is a powerful, smashingly effective movie – not a great movie but one that will probably stir audiences' emotions and join the ranks of such pop-mythology films as *The Wild One*, *Rebel without a Cause* and *Easy Rider*."**
>
> *The New Yorker*

prevailing order by enforcing a strict, borderline totalitarian regime rooted in pseudo-democratic doctrines.

To take the film as a critique of modern psychiatric medicine is to misinterpret it. Director Forman has clearly made an attempt at a more monumental allegory about the power structures at play in modern society. Among the poignant final scenes in *One Flew Over the Cuckoo's Nest* is the moment when we discover that the majority of patients at the clinic are there of their own volition. In other words, they have all willingly acquiesced to the tyranny and perpetual humiliation. The counterpoint to this mentality manifests itself in McMurphy's reticence to resign himself to such blind compliance. One of the few actually incarcerated hospital inhabitants, the unforgettable words he utters, following his failed attempt at dislodging a marble bathroom fixture sum up the plea of Forman's picture: "But I tried didn't I? Goddammit, at least I did that!" Tragically, McMurphy never internalizes the extreme gravity of

Wily, devious and even lecherous at times, Jack Nicholson still possesses all the qualities required to portray characters driven by animal instincts rather than intellect. His caustic mimicry, gestures and trademark sneer vitalize rebels (*One Flew Over the Cuckoo's Nest*, 1975), psychopaths (*The Shining*, 1980), career killers (*Prizzi's Honor*, 1985) and hardboiled P.I.s alike (*Chinatown*, 1974; *The Two Jakes*, 1990). Some might even regard the sinister, eternally grinning "Joker" in Tim Burton's *Batman* (1988) as the culminating fusion of his classic roles. Hard to believe that for many years it seemed that the movie star born in Neptune, New Jersey in 1937 was not destined to make it big as an actor. In the late 1950s, he joined the team of legendary exploitation film director/producer Roger Corman, performing bit roles in his horror flicks and wannabe rockumentaries, as well as writing screenplays. His screenwriting credits include Monte Hellman's Western *Ride in the Whirlwind* (1965) and Corman's exploration in LSD entitled *The Trip* (1967). The turning point in his career came with his role as a perpetually inebriated lawyer in *Easy Rider* (1969). Dennis Hopper's drama about the disappearance of the American Dream quickly attained cult status and earned Nicholson his first of many Oscar nods. His rise to superstardom reached its inevitable height in the 1970s. Among his many credits and honors, Nicholson has been awarded three Oscars, not to mention the projects he has directed himself. Still very much alive in the business, his more recent movies often feature him as stubborn, eccentric types. These parts attest to Nicholson's immense popularity and continuing role as one of Hollywood's all-time favorite actors.

3

his own predicament and continues to gamble in a poker game where no one can afford to bluff. At one point he is presented with a *deus ex machina* in the form of an open window offering escape. The camera holds its focus on McMurphy's face for some time before a cunning grin finally unfolds across his lips. He will stay and continue on with the "game."

Be that as it may, his tournament is over before he even realizes it. The burgeoning self-confidence and associated mental resilience demonstrated in the wisecracks of the patients cause the hospital staff to implement more drastic physical and psychological measures. The film concludes with a "pacified" McMurphy, who was subjected to a lobotomy, being put out of his misery by his friend, the chief. It is this character who continues what McMurphy has set into motion.

"The 'cuckoo's nest' described by Forman is our very own nest. It's the world we poor lunatics live in, subjected to the bureau-cratic rule of one set of oppressors and the economic pressure of another; forever chasing the promise of happiness, which here appears in the guise of liberty – but always obliged to swallow Miss Ratched's bitter little pills." *Le Monde*

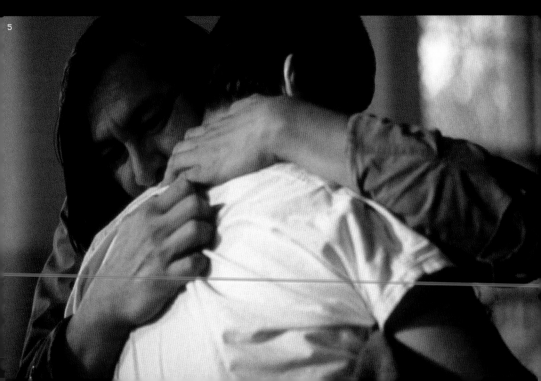

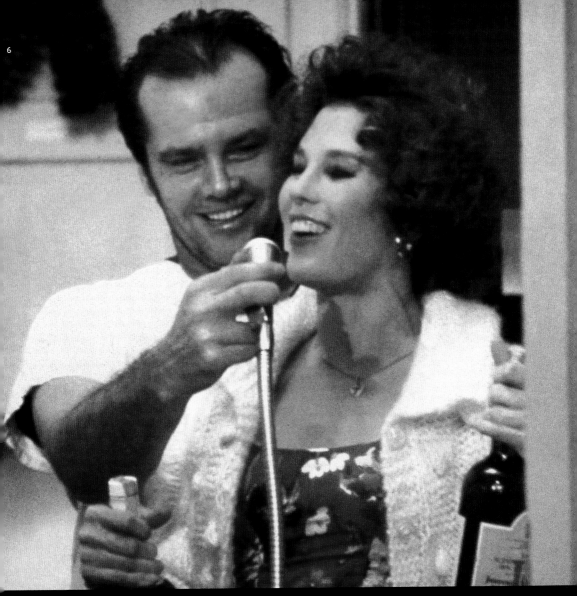

4 First Lady of a mock-democracy: Nurse Ratched (Louise Fletcher) brings the patients to their knees.

5 Born free: "Chief" Bromden carries on the torch when he flies the coop.

6 Sex, drugs and fishing trips: There's nothing Dionysian Randle enjoys catching more than some female tail.

Miloš Forman earned his reputation in Hollywood as the most influential Czech "new wave" import in the 1960s with his sarcastic reflections on everyday life. Although Ken Kesey's novel, on which the screen adaptation is based, is told from the perspective of the mute Native American, McMurphy served as the perfect vehicle for Forman to express his personal cinematic interests and set of reccurring themes. The director transforms the story into a lighter satire, whose socio-political potential takes a slight backseat to the entertainment value, allowing the piece to soar to stunningly beautiful heights. The actual directing in *One Flew Over the Cuckoo's Nest* is primarily evidenced in the world-class acting led by an energized Nicholson, his antithesis, the insidiously pleasant Louise Fletcher, and Will Sampson's gut-wrenching stoicism. Yet, it's not enough to speak of Sampson's Bromden character solely in these terms, for it is he who will undergo the most dramatic metamorphosis. From the ashes of his self-imposed silent retreat and symbolic emasculation arises a true warrior, who lets the eternal flame borne by McMurphy burn on inside him.

DIRECTOR ROBERT ALTMAN (*1925)

SCREENPLAY JOAN TEWKESBURY **DIRECTOR OF PHOTOGRAPHY** PAUL LOHMANN **EDITING** SIDNEY LEVIN, DENNIS M. HILL **MUSIC** RICHARD BASKIN
PRODUCTION ROBERT ALTMAN for AMERICAN BROADCASTING COMPANY, PARAMOUNT PICTURES.

STARRING HENRY GIBSON (Haven Hamilton), LILY TOMLIN (Linnea Reese), BARBARA BAXLEY (Lady Pearl), NED BEATTY
(Delbert Reese), KAREN BLACK (Connie White), RONEE BLAKLEY (Barbara Jean), TOMMY BROWN (Timothy Brown),
KEITH CARRADINE (Tom Frank), GERALDINE CHAPLIN (Opal), SHELLEY DUVALL (L. A. Joan), SCOTT GLENN (Glenn Kelly),
JEFF GOLDBLUM (Tricycle Man), BARBARA HARRIS (Albuquerque), MICHAEL MURPHY (John Triplette), GWEN WELLES
(Sueleen Gay), KEENAN WYNN (Mr. Green).

ACADEMY AWARDS 1975 OSCAR for BEST ORIGINAL SONG: "I'M EASY" (Keith Carradine).

"Cut your hair. You don't belong in Nashville!"

"We must be doing something right to last 200 years," sings country music legend Haven Hamilton (Henry Gibson) as the band strikes up in *Nashville*. The picture is Robert Altman's opus, commemorating and investigating a country on the verge of its bicentennial. Rather than setting the film in the nation's capital, Altman travels to the Tennessee heartland where politics and country music are presented on the same ticket.

Music reverberates through this city swarming with singers and entertainment hopefuls. King of the scene is Haven Hamilton himself. The showman, a charismatic public speaker who radiates a political and evangelistic fervor, invariably appears in shimmering white suits. Nashville's reigning queen – also partial to white and curiously reminiscent of the great Loretta Lynn – is the mentally unstable Barbara Jean (Ronee Blakley), who returns to the city after a mourned absence only to collapse at her first public appearance. Other colorful characters among the performers we encounter include folk singer guitarist Tom Frank (Keith Carradine), as well as black country western star Tommy Brown (Timothy Brown), who some accuse of selling out to the white-run industry. We also meet an eclectic assortment of "undiscovered" talent like tone-deaf waitress Sueleen Gay (Gwen Welles), who is manipulated into putting on a strip tease for a drooling male voting contingent at an event promoting the fictitious third party presidential candidate Hal Phillip Walker.

Walker's booming campaign slogans and promises are as ubiquitous in this town as the deluge of country music. Despite the country music capital's traditional neutrality regarding partisan politics, the Walker team tries to win Haven's allegiance with the promise of a governor's seat. The candidate him-

self, who remains unseen throughout the entire film, spreads his gospel from the megaphone of his campaign, pitching a platform that swears to throw all lawyers out of congress and not allow tax-exemptions for churches. One of his most poignant slogans demands "new roots for the nation." These solutions appeal to the common man's sensibility concerning life, liberty and the pursuit of happiness. In this respect, they are not at all unlike the clichés proposed by country music. This backroads world seems, for the most part, to be dominated by surface appearances that allow it to block out all political realities. Yet there are instances where we witness characters like Haven's mistress and personal manager Lady Pearl (Barbara Baxley) contemplating some of the nation's all too fresh political wounds. Pearl, for one, harps on about the excruciating pain she still suffers as a result of the numerous tragedies associated with the democratic "Kennedy boys." Similar isolated sentiments throughout the film foretell an inevitable catastrophe – similar to the Kennedy assassinations – that will strike the crystal tower of country music.

Aside from this, political scandals like the Vietnam War and Watergate only subtly manifest themselves as an occasional song lyric or at the most the lone soldier character just returned from the recently ended war. Ironically enough, Altman filmed the scene in the legendary Grand Ole Opry on the day President Nixon resigned from office.

Nashville is unique in that it offers no true main characters to its audience, presenting them instead with 24 more or less equally important human portraits. Of course, director Altman has proven himself time and again to be a master at negotiating this feat while still captivating his viewers

very step of the way. Nashville tells no single story, but unfolds as a tapestry made up of many intimate vignettes that are free of formal endings and beginnings. The stories are interwoven with concert scenes and visual tableaux of mass audiences, creating a documentary film effect not unlike an in-depth TV news report. The actors, all of whom, other than David Peel and Ronee Blakley, had no prior experience with country music, were provided with a forum for total improvisation. Part of the idea was not only to get the cast to sing, but to have them write the picture's songs themselves, an effort to which almost everyone contributed. Keith Carradine was even awarded the Best Song Oscar for his.

There are but two times when the entire cast, and in effect the Nashville world, assembles in this picture, both of which end in violence and illustrate

"*Nashville* seems like a gigantic live broadcast, with 24 hidden cameras and a virtuoso at the control panel." Peter W. Jansen and Wolfram Schütte

1 Press pass: Opal (Geraldine Chaplin) does some undercover investigating for what she claims is the BBC, but nobody seems interested in her professional credentials…

2 Let me entertain you! Waitress Sueleen Gay (Gwen Welles) wants to be a singer, but the presidential election just might strip her of her dreams.

3 Ain't never been grander! Joan (Shelley Duvall) enjoying a faerie tale theatre production of "Hee-Haw.

4 Harpo rides easy: There's just no telling where that tricycle guy (Jeff Goldblum) and his bag of tricks will show up next.

4

> "It is a musical, it is a political parable, it is a docudrama about the Nashville scene. But more than anything else, it is a tender poem to the wounded and the sad." *Chicago Sun-Times*

5 Just a good ol' boy: Recording artist and country legend Haven Hamilton (Henry Gibson) belts out a ballad commemorating the nation's bicentennial.

6 Together in harmony: Nashville locals break out in song for any occasion, be it a weekend road-show or the homecoming of country queen Barbara Jean.

7 I'm Easy: Singer, songwriter Tom Frank (Keith Carradine) spends significantly more time in bed than he does on stage.

8 Stars and Stripes Forever: Connie White (Karen Black) is sick of playing second fiddle to country queen Barbara Jean.

ROBERT ALTMAN

The engineer of the ensemble film deftly balanced 24 characters in *Nashville* (1975) and doubled that number for his next picture *A Wedding* (1978). Always innovative, Robert Altman (*1925) came up with a new mode of recording capable of picking up the overlapping dialog of his many protagonists. He furthered the brand of storytelling he coined in the 1970s with such works as the screen adaptation of Raymond Carver's *Short Cuts* (1993) and the British social drama/mystery *Gosford Park* (2001). These enormous ensemble productions are social portraitures that showcase specific cross-sections from literally all walks of life. Altman is a master of conveying the dreams, fears and propaganda of whichever group of people he chooses to examine, always breaking through their façades. In his scathing war comedy *M*A*S*H* (1969), he does his best to annihilate all romantic notions of combat. In *The Player* (1992), he makes out that the world of behind-the-scenes Hollywood is a veritable lion's den. Altman's career began in television, but he quickly switched to film. His projects have spanned an astoundingly wide range of genres and topics, including a wintertime Western (*McCabe & Mrs. Miller*, 1971), a political drama about Richard Nixon (*Secret Honor*, 1984), a comedy about haute couture (*Prêt-à-Porter*, 1994), a live action comic strip (*Popeye*, 1980), plays (*Fool for Love*, 1985) and even a John Grisham novel (*The Gingerbread Man*, 1997). The work of this great social satirist and critic is traditionally more widely hailed in Europe than in his United States homeland. A large number of his pictures have flopped in Hollywood and – despite numerous nominations – he has yet to win an Oscar. The flipside of this are the top European honors he has received such as the Golden Palm in Cannes for *M*A*S*H*, the Golden Lion in Venice for *Short Cuts* and the honorary lifetime achievement award at the Berlin International Film Festival in 2002.

how twisted American values can be. The first instance follows a welcome reception for Barbara Jean where mass traffic spirals into a "Dukes of Hazzard" style freeway collision. None of the protagonists is wounded or incites injury. Yet their completely unfazed response, behaving as if they had simply been going for a ride on the bumper cars at the fair, is what is so disconcerting. The second occasion takes place during the finale at a packed concert and political rally for Walker that resembles a patriotic summer picnic. As Barbara Jean is about to exit the stage, gunfire sounds and both she and

Haven are hit. We are led to believe that the queen of country music has been fatally injured, as the grazed Haven fanatically insists that the concert continue, handing the microphone to Albuquerque (Barbara Harris), a strung out hopeful. By the grace of God, she is phenomenal and the crowd instantly forgets the blood bath they just witnessed, joining the new star in an uplifting yet ominous song, whose bittersweet words close the film: "You may say that I ain't free, but it don't worry me."

SUPERVIXENS

1975 - USA - 106 MIN. - SEX FILM

DIRECTOR RUSS MEYER (*1922)

SCREENPLAY RUSS MEYER DIRECTOR OF PHOTOGRAPHY RUSS MEYER EDITING RUSS MEYER MUSIC WILLIAM LOOSE PRODUCTION RUSS MEYER for RM FILMS INTERNATIONAL, SEPTEMBER 19.

STARRING SHARI EUBANK (Super Angel Turner / Super Vixen), CHARLES PITTS (Clint Ramsey), USCHI DIGARD (Super Soul), HENRY ROWLAND (Martin Bormann), CHARLES NAPIER (Harry Sledge), Christy Hartburg (Super Lorna), SHARON KELLY (Super Cherry), JOHN LAZAR (Carl McKinny), STUART LANCASTER (Lute), DEBORAH MCGUIRE (Super Elua).

"I ask myself if the fucking he has is worth the fucking he gets."

They go by the names of Super Angel, Super Lorna, Super Soul and Super Cherry. The world they live in is a strange and mysterious place tucked away in the Arizona desert. If you saw them there you'd think you were looking at a Hustler magazine company picnic at the Duckberg junkyard. These blessed ladies have two striking traits in common. These would, of course, be their blinding set of knock-out melons and a bleeding thirst for good old-fashioned love making. Such a pity that the male element in Meyer's sexual Disneyland is either malevolent, as dumb as they come, or – brace yourselves ladies and gentlemen – cursed with impotence.

The big exception to these atypical archetypal masculine zeroes stomping about Meyer's playground is the simpleminded, honest, Joe character that

takes the form of Clint Ramsey (Charles Pitts). He's the type of guy who wants nothing more from life than a nice cold beer and a bit of peace and quiet. Clint also happens to possess the skills required to survive this starts with 'f' and rhymes with 'duck' fantasia. The man knows how to repair a car and carries around a monkey wrench you wouldn't want anywhere near your virgin daughters. A guy like this doesn't really need anything more than a gas station, a burger joint and a fine woman like Super Angel (Shari Eubank) to make him happy. She herself could personally while away the livelong day just in bed, getting all revved up for her beau.

However, this missy is a she-devil, who isn't about to let anything, not even a man's career, stand between her and her incessant box-spring mat-

"Russ Meyer was telling fairytales, in which voyeuristic pleasure was coupled with a cynical take on a seemingly atomized society."

little out of hand and the ensuing rampage sees a car pulverized to smithereens as well as the intervention of law enforcement officer Harry Sledge (Charles Napier), who steps in and beats some good sense into Clint with his nightstick.

Logically, this rough and tough Dirty Harry soon tries to fill the out of commission Clint's place in the sack with the relentless Angel. Harry, nonetheless, makes the mistake of working a double shift that nearly drives him over the edge. Angel reacts to his crude display of neglect by giving the cop a piece of her mind. He snaps and Angel meets with a gruesome demise. The murder is immediately pinned on Clint, who decides to make himself scarce and heads for the endless highway.

"Super Vixen – voluptuous, pure, good, totally giving, self-sacrificing."

Russ Meyer

1 What beautiful eyes she has… and as long as the men are willing and able, the Supervixens keep smilin'.

2 It's a full moon tonight: Russ Meyer documents a solar eclipse.

3 Climb every mountain! Conquer every peak!

4 Let's get physical! Super Angel (Shari Eubank) puts poor Clint (Charles Pitts) to eternal booty camp.

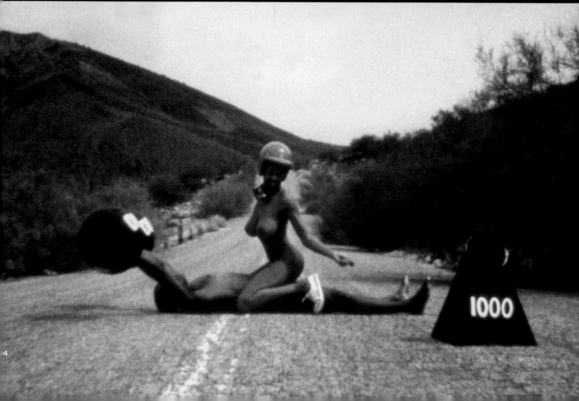

What lies ahead are more filling stations, a whole new bunch of wa... characters and countless supervixens waiting to lure the sexually sp... hitchhiker from one fiasco to the next. Along his road odyssey, he pulls i... "Super Vixen's Oasis" and discovers a pit-stop paradise with a trusty gas line pump, deluxe cheeseburgers and double-D cups. It would seem that t... greater world order has been completely restored as, low and behold, Sup... Vixen is the spitting image of Super Vixen (Shari Eubank in a double ro... Unfortunately, where there are angels, there are sure to be devils close... and that rotten ol' Harry is itching to stick sweet sucker Clint with a few lo... of TNT.

Don't be fooled by the half baked plotline. Russ Meyer is no storytel... His tempest of banged up lead, naked flesh and German military marches a... visions of the apocalypse to an American audience. Yet while this Baroq... surreal panorama is the distilled essence of bad taste, the raw worldvie... presents is precisely what attests to the filmmaker's great love for his fell... man.

Russ Meyer's specialty is his knack for sexually charging every cam... shot. Drawing liquid from a tap or even preparing eggs sunny side up su... denly becomes a blatantly obscene act. Perhaps it is therefore only fitti... that this "culmination of all wet dreams" reads like a children's birthday pa... for grownups, as do all Meyer's productions.

Frequenters of the "Internet Movie Data Base" will find the most o... target description of the legend that has become known as Russ Meyer. "(H... creates his own world in his movies and invites you to visit. And while I m... not want to live there, I sure do like to visit!"

"Too much for most men, too much for one movie."

U.S. commercial for the movie

RUSS MEYER

In the earlier years of his career, the Oakland, California native born in 1922, worked as a wartime reporter in Europe and a Playboy centerfol... photographer for the magazine's initial issues. Clearly, these occupations served as preliminary training for the body of work filmmaker Russ Meye... would eventually produce. His directorial debut came in 1959 with his rather mild nudie *The Immoral Mr. Teas*. The picture netted over a millio... dollars for Meyer and provided him with a foundation for all his subsequent self-financed, self-produced, self-written and self-shot big screen flicks... As a German advertising slogan once put it, "there's always something to see in a Russ Meyer movie." Leading ladies with busts of intergalacti... proportion became the calling card of his production company, RM Films International. For audiences seeking "a more classical Meyer aesthetic,... the works of his black and white period including *Lorna* (1964), *Mudhoney*, (1965), *Motor Psycho* (1965) and *Faster, Pussycat! Kill! Kill!* (1966) ar... highly recommended. *Mudhoney* is by far the picture that the Fellini of the celluloid sex genre endowed with the most artistic merit. After th... disproportionate success of *Vixen!* (1968), the bust sizes of his featured females underwent a dramatic inflation, the humor raunched up a notc... and the film plots slimmed down significantly. *Megavixens / Cherry, Harry and Raquel!* (1969) was followed by *Beyond the Valley of the Dolls* (1970... *Supervixens* (1975) and his biggest commercial hit *Beneath the Valley of the Ultra-Vixens* (1979). The laurel wreaths won by the hardcore por... industry in the 1980s put an end to his career. The gregarious showman has produced both a film autobiography (*The Breast of Russ Meyer*) a... well as a written one (*A Clean Breast*). Today, the pioneer of sexploitation's professional life consists primarily of actively promoting and reissuin... his canon of work.

TAXI DRIVER

1975 - USA - 113 MIN. - DRAMA

DIRECTOR MARTIN SCORSESE (*1942)

SCREENPLAY PAUL SCHRADER **DIRECTOR OF PHOTOGRAPHY** MICHAEL CHAPMAN **EDITING** TOM ROLF, MELVIN SHAPIRO, MARCIA LUCAS (Editing Supervisor) **MUSIC** BERNARD HERRMANN **PRODUCTION** JULIA PHILLIPS, MICHAEL PHILLIPS for BILL/PHILLIPS, COLUMBIA PICTURES CORPORATION.

STARRING ROBERT DE NIRO (Travis Bickle), CYBILL SHEPHERD (Betsy), JODIE FOSTER (Iris), HARVEY KEITEL (Sport), ALBERT BROOKS (Tom), PETER BOYLE (Wizard), MARTIN SCORSESE (Passenger), STEVEN PRINCE (Andy the Gun Dealer), DIAHNNE ABBOTT (Candy Saleswoman), VICTOR ARGO (Melio).

IFF CANNES 1976 GOLDEN PALM for BEST FILM (Martin Scorsese).

"You talkin' to me?"

The restless, metallic strokes of the musical theme in the opening sequence say it all: this film is a threat. A rising steam cloud hangs over the street and covers the screen in white. As if out of nowhere, a yellow cab penetrates the eerie wall of steam and smoke, gliding through in slow motion. The background music abruptly ends atonally; the ethereal taxi disappears, the cloud closing up behind it. Two dark eyes appear in close up, accompanied by a gentle jazz theme. In the flickering light of the colorful street lamps they wander from side to side, as if observing the surroundings. They are the eyes of Travis Bickle (Robert De Niro), a New York taxi driver who will become an avenging angel.

Even at the premiere in 1976, *Taxi Driver* split the critics. Some saw the main character as a disturbed soul who revels in his role as savior of a young prostitute, for whom he kills three shady characters in an excessively bloody rampage, an act for which the press fetes him as a hero. Others looked more closely and detected a skillfully stylized film language in the melancho[...] images and a common urban sociopath behind the figure of the madma[...] Travis Bickle: "On every street, in every city, there's a nobody who dreams [...] being somebody," reads one of the film posters.

Travis can't sleep at night. To earn a few cents he becomes a ta[...] driver. He'll drive anytime and anywhere, he says in his interview. He w[...] even enter the neighborhoods his colleagues avoid at all costs – the dis[...] tricts with either too little or too much light, in which street gangs loite[...] around and teenage prostitutes wait for punters under bright neon light[...] Travis is given the job. He and his taxi become one and the catastrophe take[...] its course.

Like Travis, the audience gazes out of the driving taxi into the nigh[...] Rarely was New York depicted as impressively. The camera style switche[...] between half-documentary and subjective takes. Bernard Herrmann's suc[...]

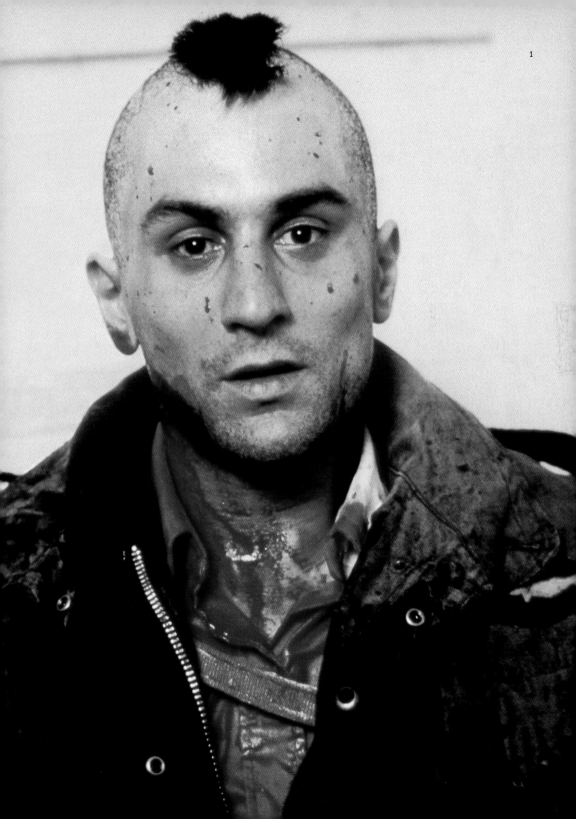

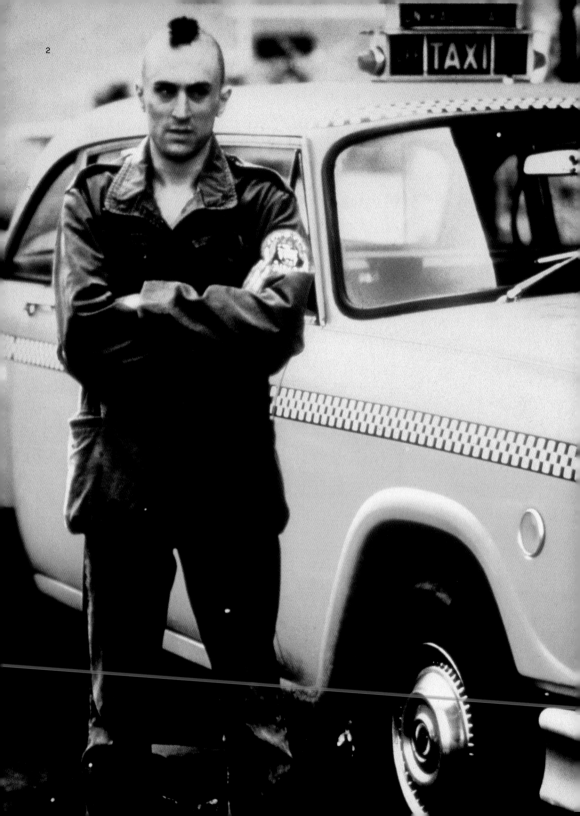

gestive music, which accompanies the film, lends it an acoustic structure, creating a unique combination of image and sound. The taxi driving becomes nothing less than a metaphor of film.

Travis' attempt to build a romantic relationship with campaign assistant Betsy (Cybill Shepherd) fails. He can neither express himself, nor his feelings, which is why in the end he turns to the gun. Isolated and aimless, he wanders through the city. Travis' story resembles the yellow taxi cab that sliced through the cloud of smoke in the opening sequence. He too emerges out of nowhere, briefly appears in the night light of the city, and vanishes again into nothingness.

Travis is no hero, even if many applauded the brutal rampage at the premiere. Violence is naturally an important theme of the film, but the vio-

1 Robert De Niro in *The Last of the Mohicans?* Call central casting, quick!

2 Soldier of fortune at a buck a mile: Ex-Marine Travis Bickle, at war with New York.

3 Talk to the hand: Travis helps stamp out violent crime.

4 This screen ain't big enough for the two of us: Both pimp (Harvey Keitel) and taxi driver are used to getting their own way.

"Martin Scorsese's *Taxi Driver* is a homage to home from a homeless man; a New York Western, with a midnight cowboy cruising the canyons in a shabby yellow cab." *Der Spiegel*

"An utterly strange, disturbing, alarming and fascinating film. Syncretic and glamorous, it is a lurking reptile that changes color like a chameleon; a synthetic amalgam of conflicting influences, tendencies and meta-physical ambitions, raised to the power of a myth: comical, edgy, hysterical."

Frankfurter Rundschau

5 Jodie Foster as the child prostitute, Iris. Nonethe-less, it was Foster's older sister who stood in as her body double for the more mature shots.

6 The facts of life: On tonight's episode, Mrs. Garrett tells Tootie what men really want.

7 Remember the Alamo: Election campaigner Betsy (Cybill Shepherd) is the object of Travis's desire.

BERNARD HERRMANN He made a guest appearance in Hitchcock's *The Man Who Knew Too Much* (1956) as the conductor on the podium of the London Symphony, practically playing himself. He also wrote the music for the film. Born in New York on June 29, 1911, it was Bernard Herrmann who gave a number of film classics the final push towards immortality. He began working for radio, and then moved on to film, collaborating with Alfred Hitchcock, Orson Welles, François Truffaut, Brian De Palma, and Martin Scorsese to name but a few. He gave films like *Vertigo* (1958), *Psycho* (1960), *North by Northwest* (1959), *Citizen Kane* (1941), *The Magnificent Ambersons* (1942), *Fahrenheit 451* (1966), and *Taxi Driver* (1975) an unmistakable musical face, an aura of tonality. No one used the orchestra as eclectically Herrmann. He could make it sound conservative and classical, or send it into strange tonal regions in which the strings, accompanied by sonorous, dark horns, imitated the sounds of swinging metal wires.
Herrmann was fascinated by the sinister romantic literature of the Brontë sisters and by Melville's *Moby Dick*. The sea with its elemental force was an inspiration for the scores of his compositions. He could hear and compose the rising and falling of deep waters. Herrmann was not an affable man, perhaps because he was too much of an artist. He was known for his irascible and perverse behavior. He fell out of favor with Hitchcock during work on *Torn Curtain* (1966). He remained an artist through and through while working on his last soundtrack. He finished it on the day before his death on December 24, 1975. It was the music to *Taxi Driver*.

lence is not merely physical, but social. Travis embodies a person who has lost himself in the big city. Robert De Niro gave this type a face and an un-mistakable body.

Scorsese is known for creating his films on paper. He draws them like sketches in a storyboard, and time and again he shows that images are his true language. The screenplay was the work of Paul Schrader, and marked the first close collaboration between two film-obsessed men. The scene in which Travis stands before the mirror shirtless, clutching his revolver and picks a fight with himself is unforgettable: "You talkin' to me? Well I'm the only one here. Who do you think you're talking to?" The scene has been cited over and over, but the original remains unattainable. It is a modern classic.

SR

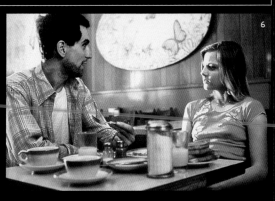

6

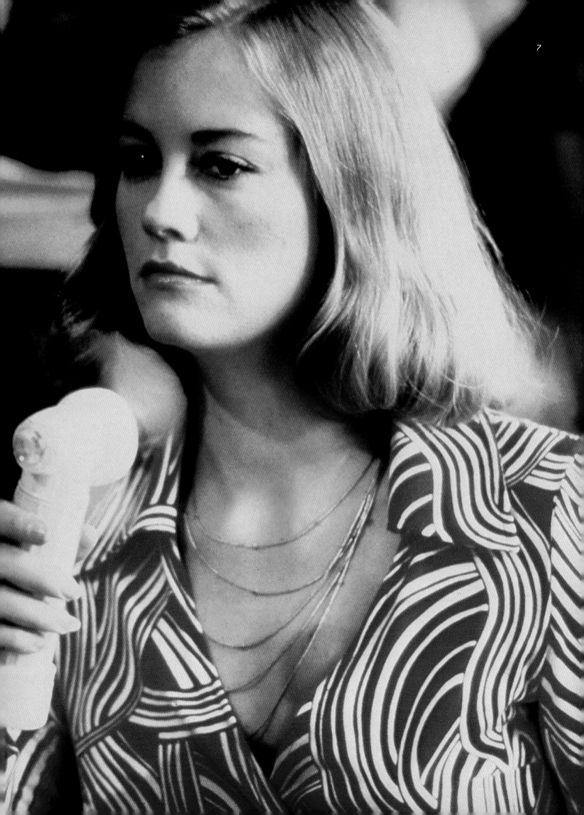

BARRY LYNDON

1975 - GREAT BRITAIN - 184 MIN. - LITERARY ADAPTATION, HISTORICAL FILM

DIRECTOR STANLEY KUBRICK (1928–1999)
SCREENPLAY STANLEY KUBRICK, based on the novel of the same name by WILLIAM MAKEPEACE THACKERAY DIRECTOR OF PHOTOGRAPHY JOHN ALCOTT EDITING TONY LAWSON MUSIC LEONARD ROSENMAN, JOHANN SEBASTIAN BACH, WOLFGANG AMADEUS MOZART, FRANZ SCHUBERT, GEORG FRIEDRICH HÄNDEL, ANTONIO VIVALDI PRODUCTION STANLEY KUBRICK for HAWK FILMS, PEREGRINE.

STARRING RYAN O'NEAL (Barry Lyndon/Redmond Barry), MARISA BERENSON (Lady Lyndon), HARDY KRÜGER (Captain Potzdorf), PATRICK MAGEE (Chevalier de Balibari), STEVEN BERKOFF (Lord Ludd), GAY HAMILTON (Nora Brady), MARIE KEAN (Barry's Mother), DIANA KÖRNER (Lieschen), MURRAY MELVIN (Reverend Runt), FRANK MIDDLEMASS (Sir Charles Reginald Lyndon).

ACADEMY AWARDS 1975 OSCARS for BEST CINEMATOGRAPHY (John Alcott), BEST ADAPTED SCORE (Leonard Rosenman), BEST ART DIRECTION (Ken Adam, Roy Walker, Vernon Dixon), and BEST COSTUMES (Ulla-Britt Söderlund, Milena Canonero).

> *"It was in the reign of George III that the aforesaid personages lived and quarreled; good or bad, handsome or ugly, rich or poor, they are all equal now."*

If Redmond Barry (Ryan O'Neal) hadn't fallen in love with his cousin (Gay Hamilton), his life might have been very different. As it happened, however, he had to fight a duel with an army officer who'd been promised the young lady's hand in marriage. And if Barry hadn't shot the officer, he wouldn't have had to flee his home village in Ireland; which is why he ended up fighting his way across Europe, first in the service of the British army, then for the Prussians. Barry's life is not in his own hands. Yet those who control him also help him, inadvertently, to climb the career ladder to a fairly dizzying height.

He has a talent for being in the right place at the right time. As a reward for saving a high-ranking officer on the battlefield, he is given a position with the Berlin police. Ordered to spy on an Irish aristocrat, he reveals the plot to his compatriot – who repays the compliment by teaching him the tricks of his trade. Barry learns the craft of card playing and becomes a familiar face at the royal courts of Europe. When he has acquired everything but a good name and a wife, he meets Lady Lyndon (Marisa Berenson). The marriage brings him money, land and property, but he squanders it all. At the end of the

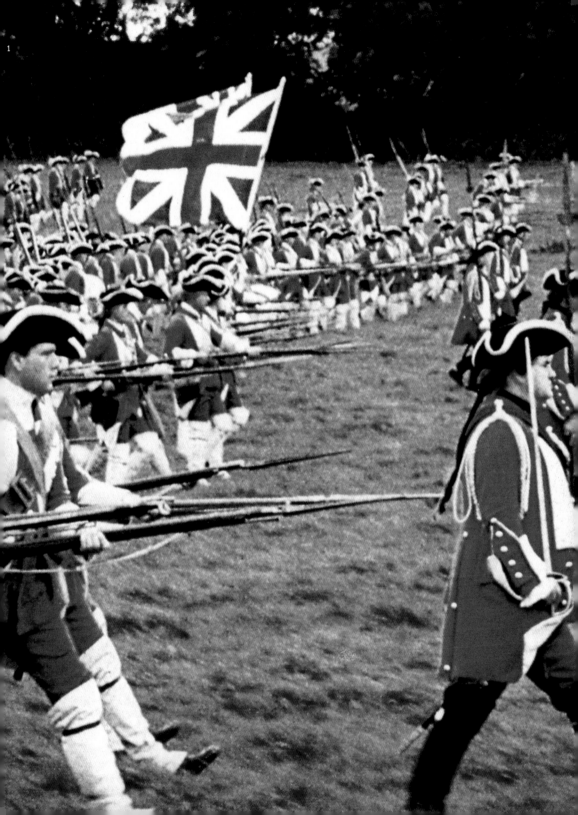

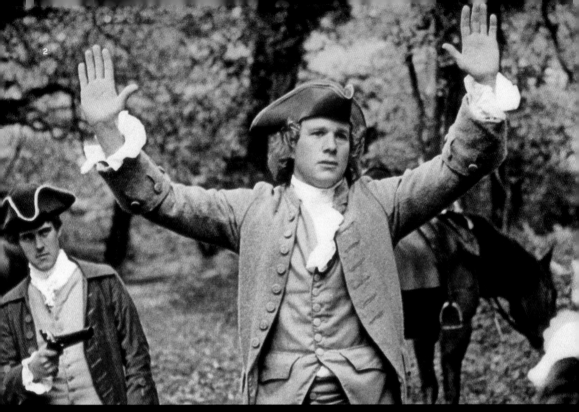

1 His troops go marching on: Kubrick based his film on the Thackeray novel, *The Luck of Barry Lyndon* (1844), but replaced the boastful first-person narrator with an omniscient commentator.

2 Take me, I'm yours: Barry Lyndon (Ryan O'Neil) enlists with the armed forces after losing his horse and his money.

"*Barry Lyndon* is not a warm film – Kubrick's never are – but it is so glorious to look at, so intelligent in its conception and execution, that one comes to respond to it on Kubrick's terms, which severely avoid obvious laughs and sentiment with the exception of two or three scenes." *The New York Times*

film, Barry is more or less back where he started: at a gambling table, but now minus his leg, his son, his wife, and his fortune.

We witness the rise and fall of an opportunist, filmed in breathtaking images. *Barry Lyndon* is a visual masterpiece, perhaps the most beautiful movie ever made. To see it in the cinema is like taking a walk through a gallery filled with works by Gainsborough and Reynolds. Few directors have ever composed a film with such care: each shot resembles an oil painting, and the colors are unparalleled in their intensity. The second half of the 18th

century has probably never been resurrected in such detail. *Barry Lyndon* is the ultimate historical epic. In most costume dramas, the characters carry the cloaks and daggers of olden days, but their manners and morals are those of the 20th century. *Barry Lyndon* creates its own world: here, the past is indeed another country, gone for ever yet still alive; and the first half of the film, especially, is notable for its quiet wit.

In creating a film that resembles a series of tableaux, Stanley Kubrick has chosen a form that fits the content: superficiality and the power of the

image in an ossified society. One of his main formal techniques is a gradually retreating camera, a kind of reverse zoom effect, as if the viewer were observing a detail of the picture before walking back slowly to gain an impression of the whole. Only a few times does the camera actually move through the pictorial space: namely, whenever the film is dealing not with gestures and rituals, but with the naked struggle for existence. Examples include barry's boxing match with the strongest man in the unit, or the company's march into the muzzle flash from the muskets of the French army.

In the final shot, the date "1789" appears. Before this time, the ideal of individuality had not yet developed; clothing, for example, was merely an indication of social status, and not an expression of personality. Like a peacock spreading its tail, the army officer puts on his uniform: his rank

PAINTING AND FILM The beginnings of film are inseparable from the photography and literature of the 19th century. Yet the medium is most intimately related to painting. Even in the earliest days, filmmakers, like painters, frequently thematised their own work, the processes of creation, and the cinematic medium itself. The very first filmmakers, for example, appeared in front of their own cameras in slyly self-referential slapstick scenes.

Time and again, directors have taken their cue from painting, and not (as one might expect) from the more closely related medium of photography. In *Barry Lyndon* (1975), for example, Stanley Kubrick created scenes that seemed like paintings come alive, like *tableaux vivants*, an aristocratic pastime popular in the 18th century (described, for example, by Goethe in his novel *Elective Affinities*). In *Passion* (1982), Jean-Luc Godard made even more direct use of the Old Masters as an example and inspiration.

In turn, the invention of motion pictures had its effect on painting. First photography, then film robbed the medium of its previous task – or freed it from the burden – of providing a close approximation of external reality. The painters went on to develop new formal languages, such as Cubism and Futurism. Some film directors also paint: David Lynch, Federico Fellini and Akira Kurosawa are examples that come to mind.

3 Location scout: Kubrick found most of the untouched landscapes he needed in Ireland, but several scenes were shot in Great Britain and the East German city of Potsdam.

4 Going to great lengths: For Kubrick's painstaking reconstruction of the 18th century, the costumes alone took almost a year and a half. Bob Mackie was unfortunately unavailable.

5

"Kubrick's latest is, however, extremely beautiful. It is not only the superb photography that delights the eye. Most remarkable is the atmospheric composition of scene after scene, which reflects the golden glow and subtle moods of a Reynolds canvas. Eighteenth-century Ireland and Germany seem to live again."

Herald Tribune

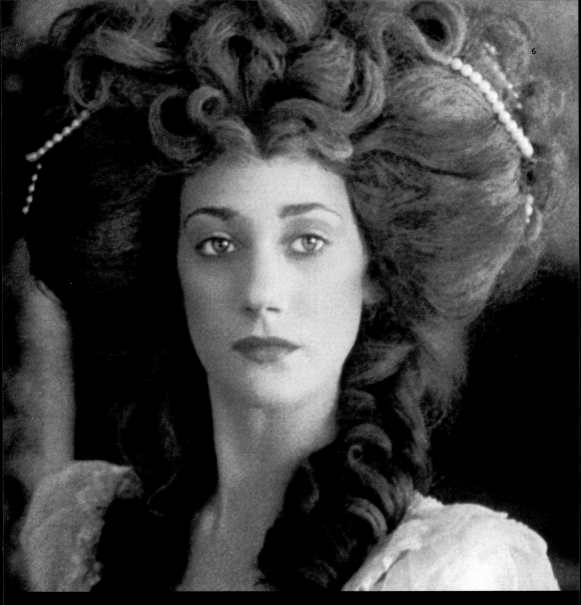

5 A discerning eye: Though Kubrick's film might appear cold and forbidding, Scorsese described it as one of the most soulful he had ever seen.

6 We have lift off! Kubrick filmed the interiors without artificial light, using a fast lens specially manufactured for NASA satellite photography.

Lady Lyndon's (Marisa Berenson) hairstylist demanded it.

– and his wallet – is enough to ensure he will win the hand of Barry's cousin. From now on, Barry will single-mindedly pursue his goal: riches and reputation. Yet although he will eventually marry the beautiful Lady Lyndon, the off-screen narrator informs us that his wife was of no more importance to him than the carpets and paintings that formed the backdrop to his life.

A duel sends him on his way to wealth and fame, and a duel throws him back out of it again. At the end, Barry is standing in a barn, face-to-face with his own stepson. Kubrick devoted six minutes to this showdown, and it has the sober quality of a ritual. Yet we suddenly realize how terrified the stepson is, as he vomits for fear of his life. It's a moment of naked and public emotion that Barry would never permit himself. But his time has now passed: there's no place left in the world for fellows like him. He probably went back to Ireland, declares the narrator; but it's said he turned up in Europe again – as a gambler. This time, however, without success.

NM

THE ROCKY HORROR PICTURE SHOW

1975 - USA - 100 MIN. - MUSICAL, SPOOF

DIRECTOR JIM SHARMAN (*1945)
SCREENPLAY RICHARD O'BRIEN, JIM SHARMAN, based on the stage play "THE ROCKY HORROR SHOW" by RICHARD O'BRIEN
DIRECTOR OF PHOTOGRAPHY PETER SUSCHITZKY EDITING GRAEME CLIFFORD MUSIC RICHARD O'BRIEN, RICHARD HARTLEY
PRODUCTION MICHAEL WHITE for 20TH CENTURY FOX.

STARRING TIM CURRY (Frank N. Furter), SUSAN SARANDON (Janet Weiss), BARRY BOSTWICK (Brad Majors), RICHARD O'BRIEN (Riff Raff), PATRICIA QUINN (Magenta), NELL CAMPBELL (Columbia), JONATHAN ADAMS (Doctor Everett Von Scott), PETER HINWOOD (Rocky), MEAT LOAF (Eddie), CHARLES GRAY (Criminologist).

"In just seven days, I can make you a man!"

If indeed the *Rocky Horror Picture Show* continues to glow in the minds of world audiences to this day, be assured that film critics of the time had little to do with lighting its eternal flame. Quite the contrary, my pretties. When the movie was beamed down to terrestrial theaters in 1975, the scathing verdict of these professional jurists was unanimous – the celluloid version was nothing more than a sorry adaptation of the London underground stage's surprise hit. According to the reviews, this fine specimen of big screen meningitis belly-flopped between gratuitous displays of histrionics and flawlessly unamusing musical numbers, which managed to completely obscure what little plot its 100 minutes had to offer. The outcome seemed clear. The film was doomed to the depths of oblivion in the vaulted hell of some dark, damp film archiving facility. At most, it would be a poor excuse for a footnote in camp and trash history.

Then something miraculous happened. During *Rocky's* midnight showing at the 8th Street Playhouse in New York, the owner of the movie house began to rant and rave at the screen (allegedly he shouted at Janet, "buy an umbrella, you cheap bitch!"). His words infected the audience and the ball was set rolling, with comments flowing like the downpour of rain. Spectators returned in droves armed with an ample supply of rice and water guns. This time, they were ready to take part in the wedding and the storm, dropping

their ironic commentary with increased fanaticism. The enthusiasm climaxed with moviegoers dressing up like their favorite characters, be it Frank N. Furter, Riff Raff or Magenta. The complacent, passive undertaking of watching a film became an interactive black mass. The picture itself was transformed into a blank canvas onto which both the uninhibited and party crazed could project their most irreverent whims and fancies. Out of the reels of a reproducible mass commodity, indistinguishable in both shape and content, a unique happening was born. No two showings of *The Rocky Horror Picture Show* were fundamentally identical and no action set in stone. The hierarchical fabric of active and passive parties, whether filmmaker and spectator, or producer and consumer had begun to unravel.

The plot is indeed no more than a light and simple catalyst for the piece's music and spoof aesthetic. Newly engaged lovebirds Brad (Barry Bostwick) and Janet (Susan Sarandon) motor their way to the former's mentor, Dr. Scott (Jonathan Adams). The young killjoy is set on sharing his future plans with the good doctor and getting his blessing. A flat tire and a thunderstorm force the two wholesome (in the biblical sense) Midwesterners to seek help at an old, ominous castle. What awaits them is a colorful cult of creepy-crawlies, who have all gathered to honor the groundbreaking achievements of Dr. Frank N. Furter (Tim Curry), one very "sweet transvestite from trans-

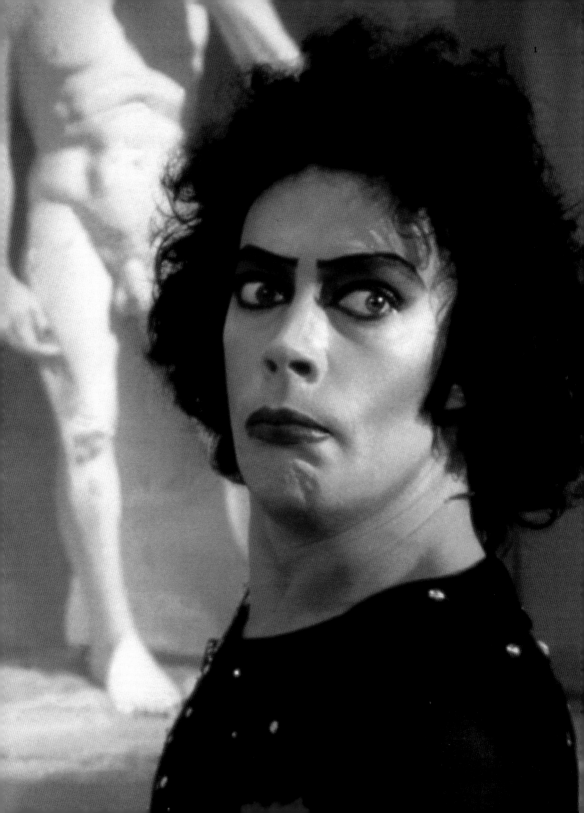

sexual Transylvania. A hunchback butler, a nymphomaniac chambermaid, an inorganically generated He-Man, a frozen solid rock star and even D... Scott himself all serve as indicators that this may be an eclectic conventi... of intergalactic proportion. This proves to be the case when Brad and Jan... realize that they have stumbled upon alien life forms who are avidly studyin... human sexual behavior.

This *Men in Black* style scenario under an altogether different astrolog... ical sign never strays from the universe of cinema and communicates i... story through pointedly self-conscious movie references. As the sumptuou... larger than life lips vocalize to us during the film's opening number *Scienc... Fiction Double Feature*, the entire picture is little more than one colossal trib... ute to the horror and sci-fi classics of the 1950s. *Rocky* fills its loins with th...

"Overall most of the jokes that might have seemed jolly fun on stage now appear obvious and even flat. The sparkle's gone." *Variety*

1 Full package and a strand of pearls: Tim Curry as the irreverent Dr. Frank N. Furter.

2 It's a boy! But in just seven days, Dr. Frankenfurter will make a man out of his well-endowed baby.

3 Heart attack: Frank N. Furter catches Rocky (Peter Hinwood) playing doctor with Janet Weiss (Susan Sarandon).

4 Dancing queens...

5 ... go cool in the pool.

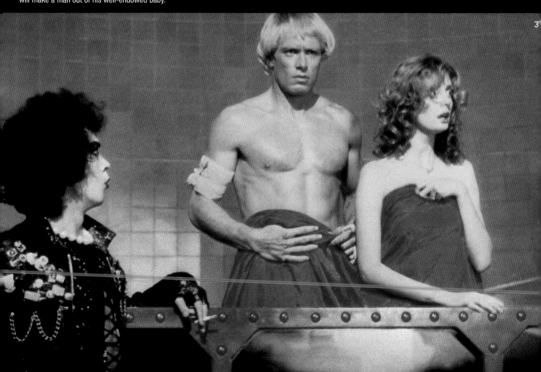

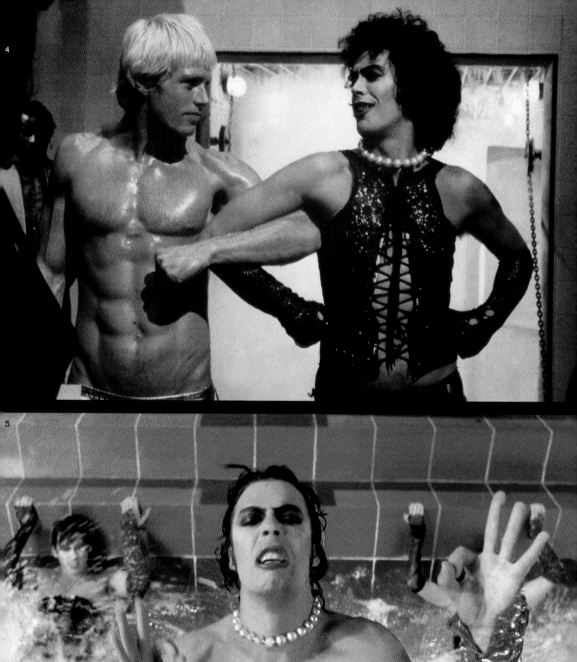

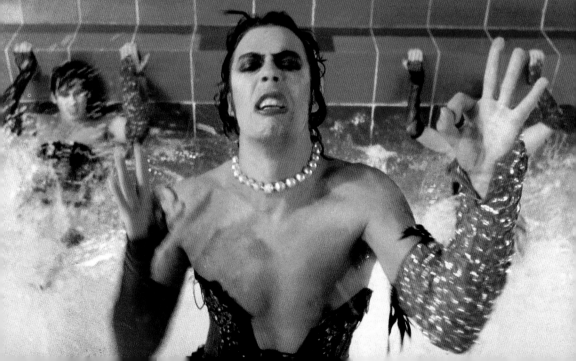

"But the greatest 'frisson' that *The Rocky Horror Picture Show* has to offer is that it was shot at Bray Studios, site of the decline and fall of Hammer horrors. It's ironically fitting that this bizarre, ill-conceived hybrid should be dancing on the grave of the real British B-movie tradition." *Monthly Film Bulletin*

6 Space oddity: When Metropolis meets King Kong at the film's conclusion, Magenta (Patricia Quinn) and brother Riff-Raff try to cut through the standing ovation.

7 Torn curtain: Furter and Brad sail to distant shores.

8 Blame it on the bossa nova: Riff Raff leads the castle guests in a most peculiar space conga line. Richard O'Brien, a writer of the stage version, joins in on the "Time Warp."

THE CULT CLASSIC The more often and more liberally a term is used, the harder it becomes to define. Its semantic essence diminishes with each extension of its meaning. The catchphrase, "cult film" fell victim to the grand mechanisms of movie marketing long ago. How else can one understand the unscrupulous efforts of distributors to deem *American Pie 2* (2001) and dozens of other pictures like it cult classics even prior to their initial release. Back when it was coined to refer to film, "cult" designated a specific audience reaction, which took the form of an actual "cult following" associated with the film. Whether *Blues Brothers* (1980) inspired costume parties, *Rocky Horror Picture Show* (1975) mayhem, or the *Once Upon a Time in the West* (*C'era una volta il West*, 1969) long duster coat fad, it was the audience's enthusiasm to integrate aspects of these pieces into their pop culture at large that made these pieces attain cult status.

The 1990s were particularly adroit at recognizing the promotional potential of a "cult classic" and proceeded to plant certain contrived elements in actual films and introduce lines of merchandise to accompany theatrical releases. Quentin Tarantino proved he had a remarkable knack for this sort of "cultification" by including some of the most memorable dialog from *Pulp Fiction* (1994) as bonus material on the film's soundtrack album. In no time flat, lines like "I love you, honeybunny, I love you, pumpkin," and "Zed's dead" were being chanted by addicted and adoring fans.

innuendoes and themes that once breathed life into the genre, managing to play up their original implications while making them relevant to the context of 1975. The film sends its own decade's sensibilities on a collision course with uptight, Cold War propriety. It thus paints a glaring portrait of revolution that has micromanaged its front to sexual fulfillment.

Taking all this into consideration, the film not only echoes in our hearts as a rich ode to bygone Hollywood with rock songs that have made history in their own right, but also marks the dawn of a new era in what an audience understands to be its role. Motion pictures ceased to solely exist as entities of passive consumption ever since. The door was now wide open to spectators getting up and playing along, reassessing the on-screen action and introducing elements of the piece into their own lives. MH

8

1900
NOVECENTO

1975/76 - FRANCE / ITALY / FRG - 318 MIN. - HISTORICAL FILM, EPIC

DIRECTOR BERNARDO BERTOLUCCI (*1941)
SCREENPLAY FRANCO ARCALLI, BERNARDO BERTOLUCCI, GIUSEPPE BERTOLUCCI **DIRECTOR OF PHOTOGRAPHY** VITTORIO STORARO
EDITING FRANCO ARCALLI **MUSIC** ENNIO MORRICONE **PRODUCTION** ALBERTO GRIMALDI for ARTÉMIS PRODUCTIONS, PRODUZIONI EUROPEE ASSOCIATI, LES PRODUCTIONS ARTISTES ASSOCIÉS.

STARRING GÉRARD DEPARDIEU (Olmo Dalco), ROBERT DE NIRO (Alfredo Berlinghieri Jr.), BURT LANCASTER (Alfredo Berlinghieri Sr.), STERLING HAYDEN (Leo Dalco), DOMINIQUE SANDA (Ada Fiastri Paulhan), DONALD SUTHERLAND (Attila), LAURA BETTI (Regina), WERNER BRUHNS (Ottavio Berlinghieri), STEFANIA CASINI (Neve), ROMOLO VALLI (Giovanni), ANNA HENKEL (Anita).

"There are no more masters."

Novecento – Twentieth Century – is the actual title of this mammoth project, an opulent epic covering five decades of Italian history, focusing on the lives of three generations whose tales are told in parallel. The year 1900 merely marks the connection to the previous century, which witnessed the emergence of one of the great modern ideas: that life in its totality might be encapsulated in a philosophical system or a work of art. It's an ambition shared by the film itself; and the theory of history as the story of class struggle and social conflict has clearly had a profound influence on Bernardo Bertolucci.

On a country estate in Emilia Romagna at the turn of the century, two baby boys are born on the same day: Alfredo, the grandson of the landowner Alfredo Berlinghieri (Burt Lancaster), is heir to the estate; Olmo, the fatherless grandson of the peasant Leo Dalco (Sterling Hayden), inherits the work. Having shared a childhood, they will grow up to confront one another as class enemies. Yet despite his clear sympathy for the oppressed workers, the artist

Bertolucci is no proponent of the primacy of politics. On the contrary: from the faces and landscapes of Northern Italy, he creates a panorama of rural life, assigning each of the four periods depicted – pre-Great War, postwar, fascism and liberation – to a season of the year: Summer, Fall, Winter, and Spring respectively. It's a subtle tribute to the composer Giuseppe Verdi, like Bertolucci a native of the province of Parma, for despite the lamenting of the harlequin in the film's opening scenes, Italy's national composer is far from dead. The film holds only superficially to the facts of recorded history, such as the great land-laborers' strike of 1908: it impresses, above all, as a kind of allegorical opera. Whether red flags are flying or fascist battalions marching through the streets, the choreographed masses have the power of operatic choirs, accompanied by Ennio Morricone's music and Bertolucci's Italian delight in pathos.

From beginning to end, the symbolic imagery of this baroque magnum opus is dominated not only by the colors of the earth and the changing light

2

"This $8 million epic, Bertolucci's first effort since *Last Tango in Paris*, is a fabulous wreck. Abundantly flawed, maddeningly simple-minded, *1900* nonetheless possesses more brute force than any other film since Coppola's similarly operatic *Godfather II*. If Bertolucci irritates as much as he dazzles, he never bores: his extravagant failure has greater staying power than most other directors' triumphs." *Time Magazine*

1 Animal attraction: The beautiful and unconventional Ada (Dominique Sanda) is married to young Alfredo. But then what's fidelity if you can have Olmo?

2 Gone to the dogs: Padrone Alfredo Berlinghieri (Burt Lancaster) is an Italian landowner of the old school – and now, he's an anachronism.

3 A finger in every pie: The meddlesome schoolteacher Anita (Anna Henkel) becomes Olmo's wife.

4 The Age of Reason: The new master Giovanni Berlinghieri (Romolo Valli) organizes the estate on more economic lines.

"The land needs the people! The soil will rot without them! But who needs the *padrone*?"

Film quote: Voices from the crowd

of the sun, but also by blood, dung, and filth. There is nothing nostalgic in Bertolucci's depiction of the merciless suppression of serfs by their masters. Alfredo Sr. makes a quick departure: the Italian rural aristocracy, so splendidly embodied by Burt Lancaster in Visconti's *The Leopard* (*Il gattopardo*, 1963), expires in a cowstall. The old man's son employs the methods of a bloodsucker to fight the demands of the nascent farmworkers' organization, and ultimately calls on the help of the fascists. Salvation appears in the form of the diabolical estate manager and blackshirt leader Attila (Donald Sutherland). His brutal perversity is not just an expression of Bertolucci's desire to present fascism as an embodiment of evil; he also shows these violent outbursts as a psychological consequence of the conflict between the bourgeoisie and the proletariat. The sexual superiority of the working class is

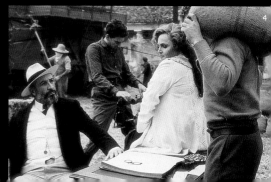

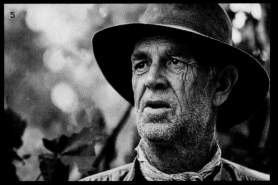

manifested in the figure of Olmo (Gérard Depardieu), an eloquent and impassioned agitator. When the new *padrone* Alfredo Jr. (Robert De Niro) can't find his beautiful wife Ada (Dominique Sanda), he looks for her in Olmo's hovel. Not without reason. Even in their childhood years, Olmo had made him painfully aware of his weaknesses, making fun of his immaturity by challenging him to hair-raising tests of bravery. And now, in adulthood, he continues to laugh in his face. It's hardly possible to say how much irony is intended in this provocative amalgamation of sex and politics. For Bertolucci was himself a middle-class child, and his narrative mannerisms evince a great deal more ambivalence than his depiction of the characters. His mixed feelings are undoubtedly connected to the period in which the film was conceived and created, as is the victorious Olmo's appeal for a "historic

"My son will study Law."
"My son will steal."

Film quotes: Alfredo Berlinghieri Sr. and Leo Dalco

5 Learning by example: Leo Dalco (Sterling Hayden) is the role model for his grandson Olmo.

6 A little R & R: After preaching *revolution* at the workers' school, Anita *romances* Olmo (Gérard Depardieu).

7 Power trip: After a cocaine orgy at Uncle Ottavio's place, Alfredo has a rude awakening. Ada tells him his father is dead and he is the new padrone.

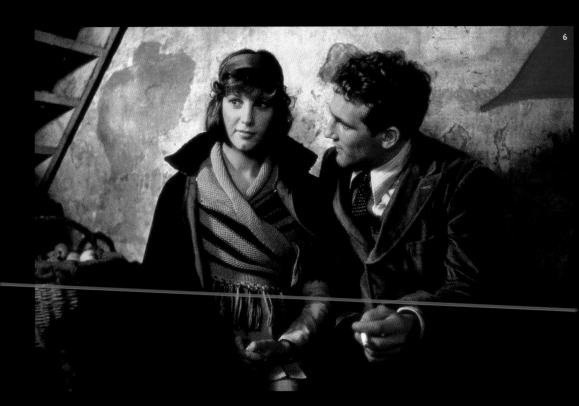

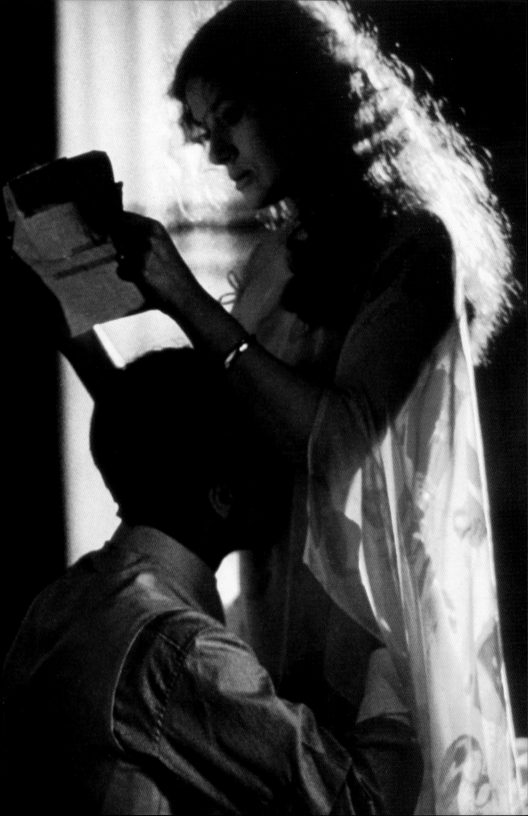

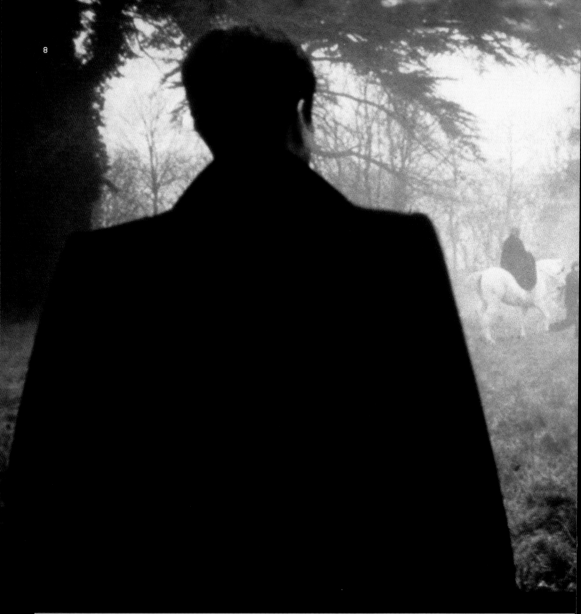

EPIC	The first cinematic epic appeared in the early years of the cinema: D. W. Griffith's *The Birth of a Nation* (1915). Yet the historical epic, a mirror of national destinies, is only one variety among many. There are science fiction epics such as the *Star Wars* films (1977, 1980, 1983, 1999, 2002), and contemporary social epics like *Nashville* (1975). Indeed, the Western, a form that need take no account of historical persons and events, was for a long time the epic form *par excellence*. For the subtext of this super-genre is the mythical, and myths are so infinitely interpretable that a definition of the term "epic" must finally be grounded in subjective perception. Factors such as the length of the film, the number of star actors, or the size of the budget are merely marketing arguments for "big pictures." What count are the high quality of the cinematic realization and the inner logic of the narrative, in which personal, cultural and universally human patterns of behavior are combined in such a way that they mean more than they tell. In this way, the epic acquires a transcendent quality, linking the most important areas of life and history, such as love, family and war.

Epic films depict people forced to contend with difficult, often tragic circumstances. It's interesting to see where the stress lies in different films: thus *Doctor Zhivago* (1965) and *Titanic* (1997) invoke an ideal of romantic love against the backdrop of a significant historical event. The *Godfather* trilogy (1972, 1974, 1990) confronts the American Dream with its relationship to violence and crime, with classical family structures playing an equally important role. Only one other genre can match the popular appeal of the epic, and it stands in almost irreconcilable opposition to this most serious of film forms: comedy.

compromise." In 1975, the failed alliance between the Christian Democrats and the Communists was *the* political topic in crisis-torn Italy.

A betrayal of the class struggle? Or a transparent misuse of history in the interests of agitation, a pompous marriage between Hollywood and Socialist Realism? At the Cannes festival, Bertolucci's idiosyncratic interpretation of history caused an uproar. But Bertolucci had much more pressing problems ahead. Three U.S. production companies – United Artists, Paramount Pictures and 20th Century Fox – had borne equal shares of the production costs, which totaled six million dollars, and they objected to the "unmarketable" five-and-a-half-hour film delivered by Bertolucci. When the case reached the courts, a judge was forced to watch three versions of the film on three successive days. Besides the original version, there was a 4-hour-40-minute *1900* and a

"Long live the revolution! Long live the revolutionaries! Long live the General Strike!"

Film quote: Voices from the crowd

8 The lone white stallion: Ada and Alfredo are soon deeply estranged. Here she rides into the woods, to meet Olmo once again.

9 Brute force: Bailiff Attila builds a concentration camp on the estate. He and his henchmen murder at will. The peasants are powerless to resist.

10 Flags fly for freedom: Spring has come, the war is over, and the revolution is victorious – at least on the Berlinghieri estate. A People's Court puts landlord Alfredo on trial.

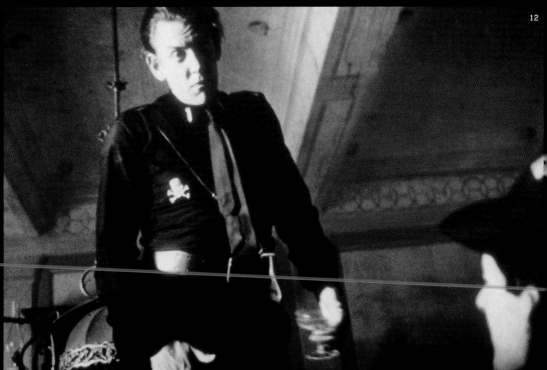

11

3-hour-15-minute version cut and pasted by Paramount themselves. As Bertolucci explained later: "The judge was dazed by an overdose of *Novecento*," but he worked out a "historic" compromise between the filmmaker and the producers. For the American market, Bertolucci assembled a 4-hour version, which was prevented from reaching a large audience by the machinations of the studios. Though the director had remarked that this slimmed-down version was the best, he later retracted this statement. Even in its original length, however, the film took a long time to reach Europe. On Bertolucci's own suggestion, the film was divided into two parts, but only years after it was completed did *1900* achieve recognition as an impressive work of art and gain relative popularity as a cult film. The tattered history of the twentieth century had acquired a cinematic memorial. PB

"The padrone is dead and Alfredo Berlinghieri is living proof of it."

Film quote: Olmo Dalco

11 Of mice and men: Class-conscious Olmo doesn't have much to say to intellectual Ada. But his sheer masculinity makes Alfredo pale in comparison.

12 Throw me a bone: Attila "the watchdog," seems devoted to his master. But soon, Alfredo's power-hungry stomach begins to growl...

13 Splendor in the grass: After the Liberation in 1945, Attila is hunted down. Rough justice for the fascist torturer, whose bloody end was anticipated at the beginning of Part 1.

12

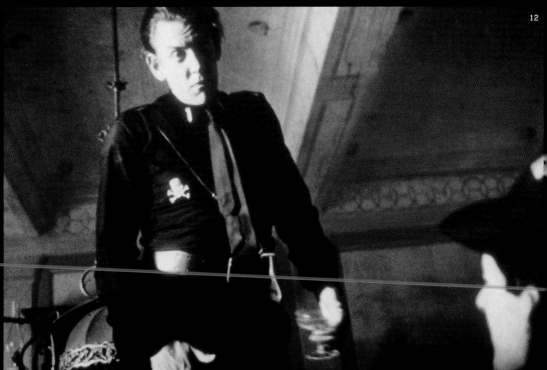

222

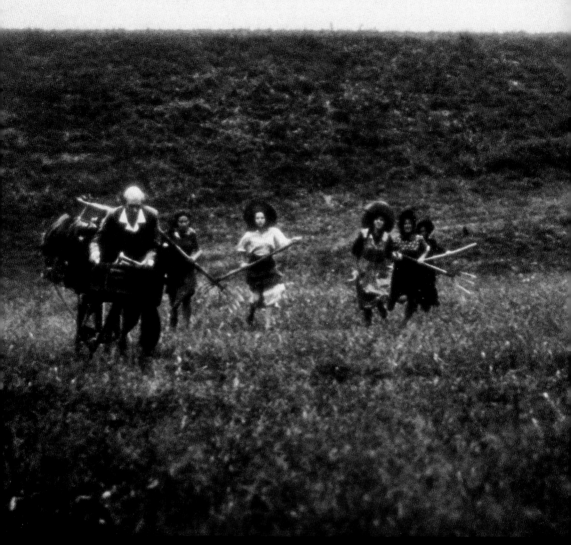

"Bertolucci's film is a bucolic opera in the language of cinema, bursting with vitality, orgiastic fecundity and voluptuous urgency. He shows us an Italy without Riviera kitsch or Santa Lucia schmalz, choosing his images from a latifundium in the vast agrarian land-scape of the Emilia: its endless wheat fields, its open barns with their brick colonnades, its canal-banks and dykes, its cattle stalls, its threshing floors, and its sparse forests of poplar." *Frankfurter Allgemeine Zeitung*

MARATHON MAN

1976 - USA - 125 MIN. - POLITICAL THRILLER

DIRECTOR JOHN SCHLESINGER (*1926)
SCREENPLAY WILLIAM GOLDMAN, based on his novel of the same name DIRECTOR OF PHOTOGRAPHY CONRAD L. HALL EDITING JIM CLARK
MUSIC MICHAEL SMALL PRODUCTION ROBERT EVANS, SIDNEY BECKERMAN for PARAMOUNT PICTURES GELDERSE
MAATSCHAPPIJ N. V.

STARRING DUSTIN HOFFMAN (Babe Levy), LAURENCE OLIVIER (Dr. Szell), ROY SCHEIDER (Doc Levy), MARTHE KELLER
(Elsa Opel), WILLIAM DEVANE (Janeway), FRITZ WEAVER (Professor Biesenthal), RICHARD BRIGHT (Karl), MARC
LAWRENCE (Erhard), TITO GOYA (Melendez), BEN DOVA (Klaus Szell, Dr. Szell's Brother).

"Is it safe?"

It takes more than physical fitness to run a marathon. Equally important is the
will to keep going even when the body is begging to stop. Babe Levy (Dustin
Hoffman) is the Marathon Man, a small man with a big heart, and he'll spend
most of this film running for his life. Out of the blue, Babe is drawn into a
maelstrom of Secret Service machinations, with the elderly German Dr. Szell
(Laurence Olivier) at the center of it all. A former concentration camp physi-
cian, Szell is now living in hiding in South America, from where he supplies
the U.S. with information on the whereabouts of other fugitive top Nazis. In
return, the so-called "Division" – a Secret Service unit somewhere between

the CIA and the FBI – supplies Szell with the money he needs to survive in
Uruguayan exile by paying cash for the diamonds he stole from inmates of
the camp. Babe's brother Doc (Roy Scheider) is a member of this mysterious
Division.

For a piece of Hollywood entertainment, this complex political thriller
touches some pretty sensitive nerves. With its close proximity to real events
of the recent past, coupled with a style that joins elements of French 60s cin-
ema to classic Film Noir conventions, *Marathon Man* is a film with a strong
feeling for history and yet is still firmly rooted in its time. Reference is made

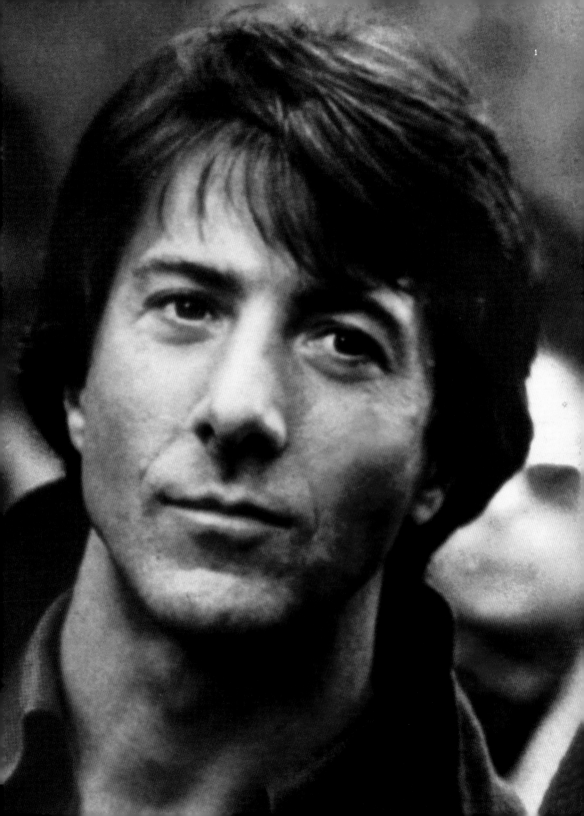

2

to the anti-Communist witch hunts of the McCarthy era, which drove Babe's father to suicide. Demonstrations fill the background of many scenes; and the fictitious figure of Dr. Szell cannot fail to evoke the all-too-real Dr. Jose Mengele, who absconded to Argentina after the war and who was neve found alive. The film is powerfully effective in its combination of nerve wracking tension and elements that so closely mirror reality. The politically motivated Secret Service escapades are hardly less disturbing for being strictly fictional, and the film plays suggestively on our most basic and inad missible fears, intensified by the deadly menace of a hidden and anonymou: force. Carefully timed eruptions of violence raise the tension to almost un bearable levels, most dramatically in the sequences in the dentist's chair. Dr Szell calmly tortures Babe Levy, plucking and poking at nerves laid bare

"In typical Hollywood fashion, Schlesinger shows us the oil truck first to allow us time to consider the implications of what we are seeing. For this, like the opening sequences of many Bergman and Fellini pictures, is the entire film in nucleo." *Literature / Film Quarterly*

1 Run for your life! Dustin Hoffman, one of the biggest names of New Hollywood, stars in the tense thriller *Marathon Man*.

2 An innocent looking face: But Elsa (Marthe Keller) can't be trusted.

3 All in the family: Babe's brother Doc (Roy Scheider) is a man with a dark secret.

4 Running on empty: Babe Levy (Dustin Hoffman), on a lonely, long-distance race to the truth about his brother's death.

3

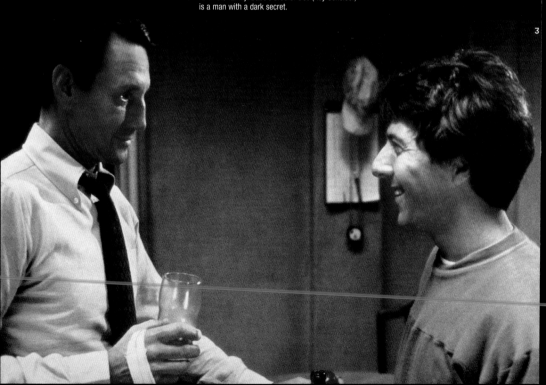

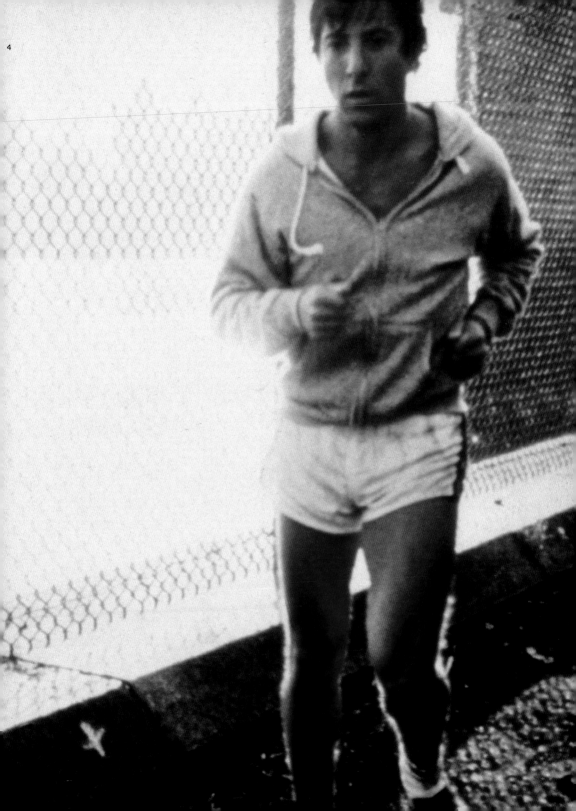

while repeating the sinister and unanswerable question, "Is it safe?" Here and elsewhere, the film makes quite intentional use of shocking violence as an effective narrative device. The audience is never allowed to forget that the white-haired, bespectacled Szell is no harmless old gent but a monster of cynical cruelty. (After test runs of the film, this torture sequence had to be cut substantially.)

The plot is also quite something. For a long time, the audience is left in the dark as to exactly what's going on. Right at the start, we have a mysteri-ous race between two elderly motorists, trading insults until they crash. Ther there's the enigmatic Elsa Opel (Marthe Keller), who steals the heart of Babe Levy. There's Babe's brother Doc, with his puzzling business in Paris; and we have deadly enemies posing as Babe's friends, like the shady Peter Janeway (William Devane). A long time passes before the various pieces of this com plex puzzle can be made to fit together.

The narrative is fragmented, and our feelings are manipulated con stantly by shocks, surprises and ironic twists. The audience is as confused

5 Babe turns the tables with a semi-automatic…

6 … and sadistic Nazi war criminal, Dr. Szell (Laurence Olivier), suddenly can't resist his powers of persuasion.

7 Nice work if you can get it: Doc cashes in on the secrets of Szell's merciless past.

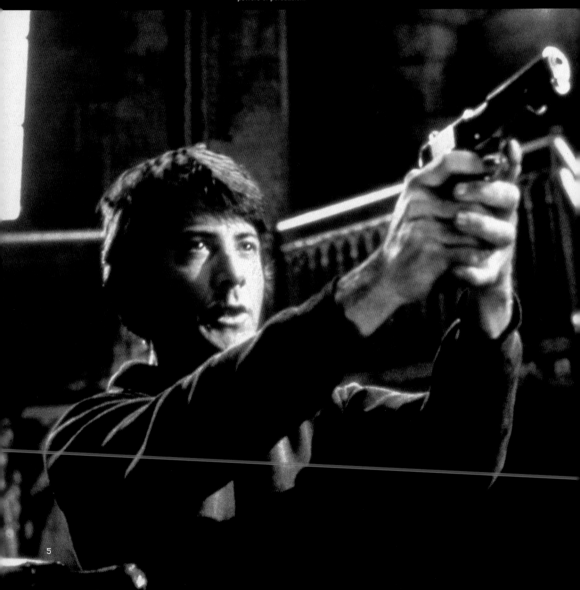

"While the political implications are pushed further than they are able to go, the film runs into even more trouble when it attempts to work the loosely asserted personal elements deeper into the pattern."

Sight and Sound

POLITICAL THRILLERS In general, the word "thriller" denotes a cinema of fear and existential threat. Thrillers are tense tales of criminal misdeeds. As a rule, the viewer identifies with the heroic protagonists, who often don't know why they're being pursued or how they've suddenly landed in a terrible situation with no apparent way out. The thriller has many faces, depending on its thematic orientation and formal structure: there are psychothrillers, horror thrillers, erotic thrillers and political thrillers. As the name suggests, political thrillers derive their potential from fictional stories that are close enough to real political events to appear credible.

The political thriller tells of political corruption and only rarely refrains from commenting on history. One of the most important directors of political thrillers is the pugnacious Constantin Costa-Gavras. In films such as *Z* (1968) and *State of Siege* (*État de siège*, 1972), he did not merely deal with political themes, but also took up a clear political position. The great political scandals of world history are a particularly fruitful field. The murder of John F. Kennedy, for example, has been the subject of several films, most notably Oliver Stone's controversial *JFK* (1991). Oscars were showered on Alan J. Pakula's *All the President's Men* (1976), which dramatized the exposure of the Watergate scandal surrounding President Richard Nixon.

and disoriented as the protagonist. Throughout Babe's long flight, we never know more than he does. Near the end of his ordeal, he traps Szell in a reservoir building, where it becomes clear that the Nazi doctor is only interested in one thing: his "life insurance," in the form of the diamonds he stole from his murdered victims. They have financed his retirement very nicely so far, and he wants them to go on doing so. Once again, we see Szell's murderous cynicism at work: he wants these jewels at all costs, and their inhuman price is irrelevant. As Babe forces Szell to eat the diamonds, the story takes one final, unsettling twist: the torturer's victim tortures the torturer. Thus, even at the end of this disturbing thriller-marathon, it's hard to breathe a simple sigh of relief.

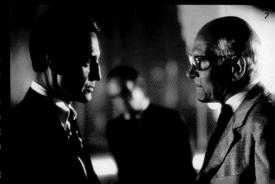

ALL THE PRESIDENT'S MEN

976 - USA - 132 MIN. - POLITICAL DRAMA

DIRECTOR ALAN J. PAKULA (1928–1998)

SCREENPLAY WILLIAM GOLDMAN, based on the factual reports of CARL BERNSTEIN and BOB WOODWARD DIRECTOR OF PHOTOGRAPHY GORDON WILLIS EDITING ROBERT L. WOLFE MUSIC DAVID SHIRE PRODUCTION WALTER COBLENZ for WILDWOOD, WARNER BROS.

STARRING DUSTIN HOFFMAN (Carl Bernstein), ROBERT REDFORD (Bob Woodward), JACK WARDEN (Harry Rosenfeld), MARTIN BALSAM (Howard Simons), HAL HOLBROOK (Deep Throat), JASON ROBARDS (Ben Bradlee), JANE ALEXANDER (Judy Hoback, Bookkeeper), MEREDITH BAXTER (Debbie Sloan), NED BEATTY (Dardis), STEPHEN COLLINS (Hugh W. Sloan Jr.).

ACADEMY AWARDS 1976 OSCARS for BEST SUPPORTING ACTOR (Jason Robards), BEST ADAPTED SCREENPLAY (William Goldman), BEST ART DIRECTION (George Jenkins, George Gaines), and BEST SOUND (Arthur Piantadosi, Les Fresholtz, Dick Alexander, James E. Webb).

"Nothing's riding on this except the, uh, first amendment to the Constitution, freedom of the press, and maybe the future of the country."

Extreme close-up of a typewriter. A single date is hammered out onto the page and each keystroke rings out like a gunshot. The date is "June 17, 1972" and right from the first moment of the film one thing becomes vividly clear – the typewriter can be a lethal weapon.

Bob Woodward (Robert Redford) and Carl Bernstein (Dustin Hoffman) are two "hungry" young reporters working at the *Washington Post*. The two end up unmasking the scandal behind what will be forever known as Watergate. They work methodically, soberly and professionally, driven by a journalist's hunter instincts to trap a good story and their own thirst for success. Their goal is to be better, not to mention quicker, than their counterparts at the *New York Times* and they will let nothing stand in their way.

The picture tells the tale of "Woodstein," as the writing team quickly become dubbed by the rest of the reporting staff. We accompany the two on an expedition that will last approximately six months, starting on that ominous night of June 17, with the break in at Democratic headquarters (where the Republican party apparently paid to have bugging equipment planted)

up until the day when Nixon is sworn into office for a second term in January 1973. As inauguration day is upon them, it appears that the reporters have failed in their attempts to trace the scandal back to the highest White House officials. Nonetheless, the paper's chief editor Ben Bradlee (Jason Robards) offers them his unwavering support. The film's conclusion comes full circle as a television set placed prominently in the *Washington Post* newsroom shows us Nixon taking his presidential oath as well as the surrounding festivities full of pomp, circumstances and ceremonial gunfire while Bernstein and Woodward plug away at their typewriters. The chattering keys quickly drown out the sound of Nixon's fanfare. The film closes with a relentless news ticker that reports the concessions and sentencing of the case's principle suspects, concluding with President Nixon's resignation in August 1974.

Yet despite the subject matter, it's hard to call *All The President's Men* a political drama as the movie provides no forum for researching the cause of the Watergate affair or an analysis of its aftermath. We do, however, see

politicians in actual archived news footage from that year, which is seamlessly integrated into the story's fabric via television sets that appear throughout the film. Because its story unfolds through the eyes of the two investigative journalists, the political scandal seems to read like a detective caper. Although the outcome of the case is far from being a mystery, the path that leads there is what is of real interest. It is a relay race against time that consists of gathering evidence, making phone calls, meeting those involved, making more phone calls and conducting follow-up face to face interviews. We witness as a complex jigsaw puzzle compiled of dozens upon dozens of names, facts, appointments, organizations and secret monetary funds takes shape. This film, whose sights are as ambitious as those of its protagonists, demands our full attention and we gladly acquiesce.

The suspense of *All the President's Men* is born out of the story's authenticity and the impeccable acting. This first aspect is made evident by the film's loyalty to the historical facts and underscored by the Sisyphus-like efforts of the reporters, who screenwriter William Goldman does not ever grant private lives. International mega-stars Redford and Hoffman must be credited for their artistic brilliance, which is absolutely electrifying as they cunningly win over tight-lipped individuals wrapped up in the affair. Silence suddenly speaks volumes. On one occasion, in a theatrical tour de force, the duo force the truth out of a witness by acting as if that which they only suspect is confirmed fact. Our eyes are glued to the screen as the wily Bernstein, much the opposite of the cautious, straight-edged Woodward, finesses his way into the home of an intimidated bookkeeper who worked for the "Com-

> # "By simply sticking to the facts, Pakula and Redford pay tribute to a kind of journalism that has nothing in common with the prevalent clichés, the cheap and deliberate contempt often leveled at this profession."
>
> *Der Spiegel*

ALAN J. PAKULA

Jane Fonda won an Oscar under his direction as call girl Bree Daniels in the detective caper *Klute* (1971), and a decade later he aided Meryl Streep in making a decision that won her the coveted golden statuette for her performance in the Holocaust drama *Sophie's Choice* (1982). Even his screenwriter for *All the President's Men* (1976), William Goldman, was bestowed with the Academy Award. Nonetheless, Alan J. Pakula (1928–1998), director of all these films and a two-time Oscar nominee, always remained the man behind the scenes. This could have to do with the fact that native New Yorker Pakula was never really viewed as a creative force but rather as an actor's director and meticulous craftsman as well as someone who was particularly gifted at helping others achieve their full potential. From 1957 to 1969, at the beginning of his career, he worked as a producer, collaborating on seven films with director Robert Mulligan. In 1969, while he and Liza Minnelli were on the lookout for a "fresh, new director" to take on *The Sterile Cuckoo*, Pakula suggested himself for the project and got his big break at fulfilling his greatest ambition. Much like Mulligan, Pakula had always been interested in political and sociological topics. His thrillers *Klute* (1971), *The Parallax View* (1974) and *All the President's Men*, which have become collectively known as the "paranoia trilogy," are considered exceptionally on-target studies of the political and social tenor of the Nixon era. Pakula further explored the conspiracy theory as a topic in later box-office triumphs like *Presumed Innocent* (1989) and *The Pelican Brief* (1993). In 1998, Pakula lost his life in a freak car accident.

1 Getting to the bottom of things: Reporters Carl Bernstein (Dustin Hoffman) and Bob Woodward (Robert Redford) investigate the Watergate break-in.

2 Out on a limb: Editor Ben Bradlee (Jason Robards Jr.) supports his journalists' detective work.

3 Working 9 to 5: It'll take thousands of phone-calls and hundreds of meetings before Carl Bernstein even has a clue as to what's really going on.

4 Turning cheap theatrics in big pay-offs: The Woodstein team devises a way to get witnesses to spill the beans.

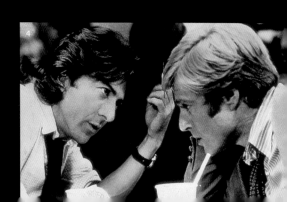

> "I found it brilliant and gripping. Even though the events and characters are familiar, the film has an understated and realistic quality that gives a completely fresh dramatic intensity to the crisis the United States went through so recently. Despite all the glamor of the actors (...) it is the unglamorous nature of newspaper work, even with such an assignment as trying to break open a government conspiracy that strikes home. The film breaks new ground in taking up a middle position between a documentary and a dramatization." *The Times*

mittee to Re-elect the President," the organization whose coffers funded the break-in at Democratic headquarters. Using his savvy and charm, he gradually gains the trust of this "sacrificial lamb" and gets her to reveal everything she knows. The scene is parlor room drama at its finest.

The reporter as hero has a long tradition in the American cinema, often appearing as a clichéd "wise guy." Thankfully, director Alan J. Pakula was careful to avoid this stereotype and even spent several weeks observing the goings-on of the actual *Washington Post* newsroom prior to shooting. While Pakula's film does indeed glorify the prevailing legend of an objective, free press that is capable of bringing superpowers to their knees, one can find but little reason to chide him for it. There are, after all, more problematic myths.

LP

5 The first amendment as lethal weapon: The typewriter that brought down a president.

6 A date with Deep Throat: Bob Woodward has to take greater precautions in obtaining information.

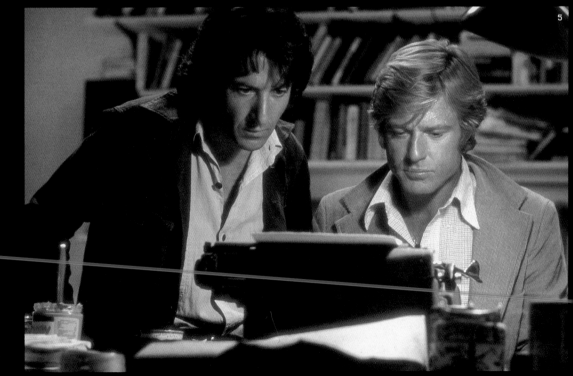

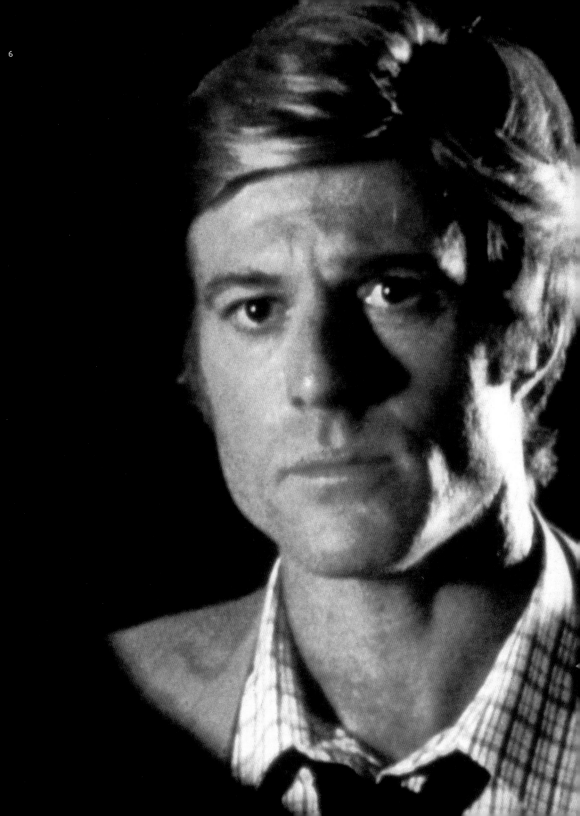

ROCKY

1976 - USA - 119 MIN. - BOXING FILM

DIRECTOR JOHN G. AVILDSEN (*1935)
SCREENPLAY SYLVESTER STALLONE **DIRECTOR OF PHOTOGRAPHY** JAMES CRABE **EDITING** RICHARD HALSEY, SCOTT CONRAD **MUSIC** BILL CONTI **PRODUCTION** IRWIN WINKLER, ROBERT CHARTOFF for CHARTOFF-WINKLER PRODUCTIONS.

STARRING SYLVESTER STALLONE (Rocky Balboa), TALIA SHIRE (Adrian), BURT YOUNG (Paulie), BURGESS MEREDITH (Mickey Goldmill), CARL WEATHERS (Apollo Creed), THAYER DAVID (Miles Jergens), JOE SPINELL (Tom Gazzo), JIMMY GAMBINA (Mike), TONY BURTON (Duke, Apollo's Trainer), JOE FRAZIER (Himself).

ACADEMY AWARDS 1976 OSCARS for Best Film (Irwin Winkler, Robert Chartoff), BEST DIRECTOR (John G. Avildsen), and BEST FILM EDITING (Richard Halsey, Scott Conrad).

"That's your only chance!"

Philadelphia, December 1975, shortly after four in the morning. Continental winter and general depression reign. The city sleeps, illuminated by an electric half-light. There's not even a dog to be seen on the streets. It's bitterly cold. A newspaper deliveryman races through the banking district in his station wagon, distributing papers. Rocky appears behind him. Rocky is a powerfully built man with a broad, somewhat drooping face. He jogs through the city, the white bursts of his breath hanging in the cold air. He wears a baggy jogging suit, a wool cap, and a pair of worn Converse. This is what someone who comes from the bottom looks like. Rocky (Sylvester Stallone) is an unsuccessful boxer from the Italian neighborhood who can't survive on boxing alone and as a result, works as a money collector for a run-of-the-mill Mafioso. His jog leads him to the city art museum, which resembles the Parthenon in Athens, up a wide set of stairs and onto a plateau with a magnificent view over the city. He boxes while he runs, and he runs while he shadowboxes. This is Rocky's first day of training, and it ends with painful cramps. But that doesn't matter — what does matter is taking the first step in conquering one's weaker self. Once that step is taken, one can achieve anything.

Rocky has exactly six weeks to get himself into shape, at which point this third-class "Italian Stallion" is to step into the ring against Apollo Creed (Carl Weathers), a crafty, well-trained heavyweight champion. What Rocky doesn't know is that the bout is a veiled showcase fight for the nation's 200th birthday, an exhibition for the world champion billed as "black boxing champion gives white Italian-American the chance of a lifetime." The message is

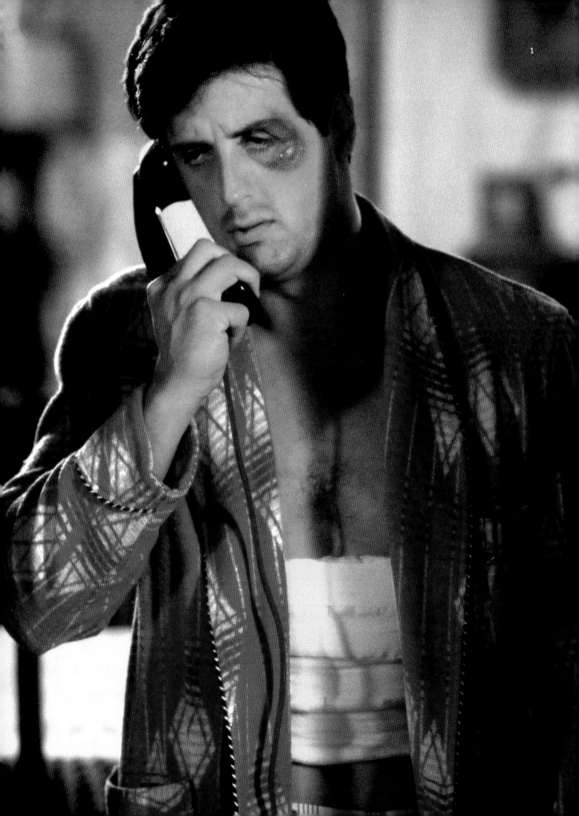

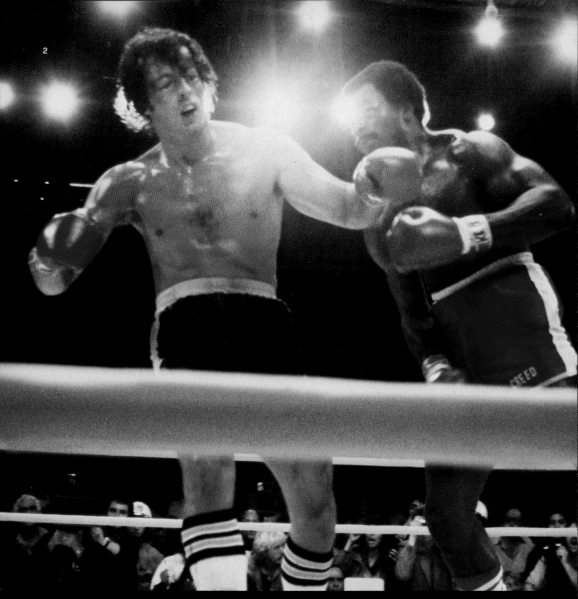

2

1 What doesn't kill you makes you stronger: Rocky, alias Sylvester Stallone, fighting his way to the top of the world.

2 A knock-out sensation: Rocky stands his ground against Apollo (Carl Weathers).

3 "I Want YOU:" Apollo Creed, reigning heavyweight champion, as Uncle Sam.

"Some day, *Rocky* will be seen as a key moment in cinematic history. It's the epitome of the feel-good movie."

Frankfurter Allgemeine Zeitung

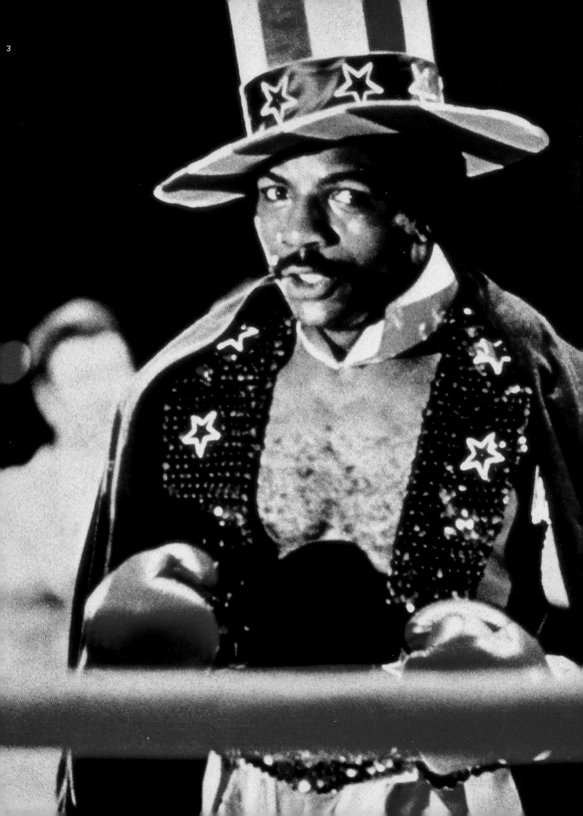

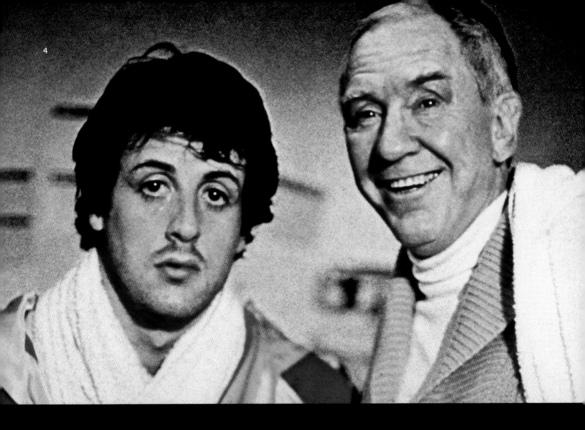

simple: in America, the land of infinite possibilities, anyone can make it. What Apollo doesn't know is that Rocky is taking the fight more seriously than he'd ever imagine. Rocky has brains. The fight will last fifteen grueling rounds. And it will take place in a ring, especially in a cinematic ring where every fist, whether poor or rich, black or white, becomes a pounding sledgehammer. Rocky, the guy from next door, who up until this point has never had an even break, who is too good-natured to break the thumbs of the defaulting debtors, and the only man in the neighborhood interested in the shy, barely discernible Adrian (Talia Shire) – this guy shows everyone that you don't have to be a champion to discover yourself. "No revenge," stammers the exhausted Apollo after the fight. Eyes swollen and bloody, Rocky doesn't

want a rematch either. He just wants to get to his true love. Like a blinded Samson, he screams her name into the crowd: "Adrian!" She pushes her way through the masses. What happens then is a first in screen history: a woman steps into the ring and passionately kisses the sweaty loser.

Hollywood did not expect *Rocky* to be a success. Quite the reverse in fact – the film was deemed an ideal B-movie and given a $1 million production budget. Only the story's author, Sylvester Stallone, believed in the tale of the small man that makes it big. Rocky's story became Stallone's story, and Stallone's determined assertiveness was mirrored in Rocky's stamina. The Rocky character was tailor-made for Stallone and consequently he didn't want the role handed to Paul Newman or Burt Reynolds. He worked

SYLVESTER STALLONE Others would have given up ages earlier. Not him. When Sylvester Gardenzio Stallone (*6.7.1946, New York City) was born everything was already against him. An accident at birth disfigured his face and it was paralyzed on one side, which ironically made Stallone's characteristics in the film quite interesting. He was teased and called "Sylvie" in school because he was as thin and delicate as a girl. For a long time the son of an Italian hairdresser from a Philadelphia ghetto was nothing more than a marginal American afterthought. He was a pizza baker, a cinema attendant, a small-time actor in third-rate films, and even had a role in a porno.
Then the 30-year-old wrote the frustration from his soul with the script to *Rocky* (1976). At that point he already had a fantastic body he had trained hard to get and that he could display with pride. *Rocky* became his film, his career, and his life. And *Rocky* laid the groundwork for *Rambo* (1982, 1984, 1988). But those who have success as physical actors have trouble shedding the muscular role. What good is it that Stallone was proven to have an I.Q. of 141, that he collects modern art, and that he paints? "An image is an image is an image…"
He has attempted to break out of this typecasting several times: in the melodramatic *Over the Top* (1986), the ironic *Tango & Cash* (1989), the comic *Stop! Or My Mom Will Shoot* (1991), or the futuristic *Judge Dredd* (1995). For *Get Carter* (2000), he even grew a meticulous goatee. It didn't matter – Stallone remained and remains forever The Italian Stallion. This is how he wanted it – and the public accepted it. He is someone who doesn't give in, who gets knocked down but stands right back up, a man who struggles on because he doesn't have any other choice. He is a true *Cliffhanger* (1993), a cinematic Sisyphus.

without a salary and negotiated a deal worth 10% of the profits. The film was a box office hit. After four months, it had earned $28 million and in the end it took home over $140 million. It won three Oscars. Stallone and the young director John G. Avildsen suddenly found themselves at the top of the heap.

"Sometimes reality is crazier than all shit," says a Mafioso in Sergio Leone's *Once Upon a Time in America* (1983), the film about the ultimate American Dream. *Rocky* was a smash hit and Sylvester Stallone showed the world that it was time to believe in the dream of the individual's rise once more. Because the winnings were good for the victor in and out of the boxing spectacle, Rocky would step into the film ring four more times. "The Italian Stallion" from the gutters of Philadelphia had become a cult figure. SR

"*Rocky* batters our emotions like almost no other movie before it. Stallone and his brilliant director John Avildsen play to the gallery so effectively that critical objections seem almost irrelevant." *Der Spiegel*

4 One man's future is another man's past: Rocky and his mentor Mickey (Burgess Meredith).

5 Down and out in Philadelphia: Paulie (Burt Young) needs a job – but Rocky, the debt collector, wouldn't recommend his own.

6 In this ring, I thee wed: Rocky and Adrian (Talia Shire) are ready to love each other to the bitter end.

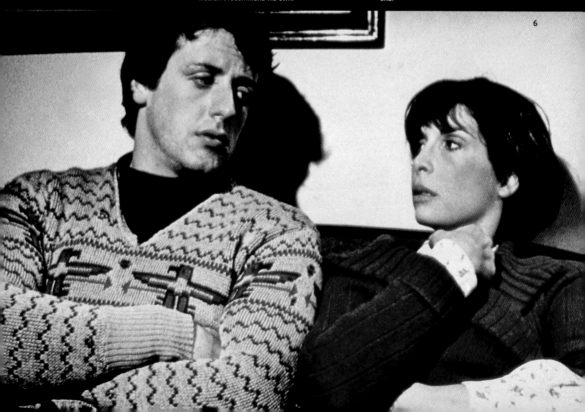

6

L'AILE OU LA CUISSE

aka The Wing or the Leg

976 - FRANCE - 104 MIN. - COMEDY

DIRECTOR CLAUDE ZIDI (*1934)
SCREENPLAY CLAUDE ZIDI, MICHEL FABRE **DIRECTOR OF PHOTOGRAPHY** CLAUDE RENOIR, WLADIMIR IVANOV **EDITING** MONIQUE ISNARDON, ROBERT ISNARDON **MUSIC** VLADIMIR COSMA **PRODUCTION** CHRISTIAN FECHNER for FILMS CHRISTIAN FECHNER.

STARRING LOUIS DE FUNÈS (Charles Duchemin), COLUCHE (= MICHEL COLUCCI) (Gérard Duchemin), JULIEN GUIOMAR Jean Tricatel), ANN ZACHARIAS (Marguerite II.), CLAUDE GENSAC (Marguerite I.), RAYMOND BUSSIÈRES (Chauffeur Henri), DANIEL LANGLET (Lambert), MARCEL DALIO (The Tailor), PHILIPPE BOUVARD (Himself), VITTORIO CAPRIOLI Vittorio).

"A loin of beef – Argentinian, three years old, southern slopes."

The delicate flavor and aroma of fine foods and wines makes life worth living for Duchemin (Louis de Funès), a man whose entire existence revolves around eating. Every day, he visits the best and most expensive restaurants in town with the reverence of a worshipper and the vigilance of a vestal virgin. To him, a prizewinning chef is a high priest of the palate, a privileged guardian of the Grail of good taste. Charles Duchemin is the most respected restaurant critic in France; and today and every day, he expects each cook to do his sacred duty.

He carries out his tests in a series of cunning disguises. One day he's an old lady, the next, he's an American, resplendent in a pink jacket and a Stetson. When he's sure no-one's watching, he checks the temperature of the schnitzel with his trusty thermometer, stores samples of the wine in the tanks in his tailor-made jacket, or tucks anything he can't face eating into a Tupperware box. The laboratory, and his tastebuds, decide how many stars a restaurant will be deemed to deserve. In this way, he and his colleagues banquet and burp their way through the restaurants of the nation, before publishing the verdicts in the *Guide Duchemin*: the gourmets' bible and a

It's an achievement of national significance, and it's only fitting that Charles should be invited to join the hallowed ranks of the Académie française. But he's failed to reckon with his arch-enemy Jean Tricatel (Julien Guiomar), manufacturer of industrial grub and owner of a chain of junkfood restaurants. The scheming Tricatel, who is every bit as slimy as the food he produces, smuggles a spy into Duchemin's house to steal the names of the distinguished restaurants before the book is published. With the help of the list, he plans to buy up some of the best restaurants in the country and force them to accept his own inferior products. And by this somewhat roundabout route, he hopes to see his zero-quality fodder elevated to the rank of *haute cuisine*.

When Charles gets wind of this plot, he is understandably appalled. "I could give a restaurant two stars and this scoundrel would serve the customers dog food with tinned rice. On a saucer." The fanatical epicure resolves to save French cooking by putting Tricatel in his place: he will challenge his rival to a TV talkshow duel and show the world who's boss. But his culinary crusade ends in a trip to Gourmet Hell, for suddenly he's confronted by a

"Louis de Funès doesn't quite explode, but he certainly makes sparks fly, and his sheer comic energy is as powerful as ever." *Le Monde*

LOUIS DE FUNÈS

They called him Rumpelstiltskin, the Poison Dwarf, Mr. Hyperactive and Poltergeist: the small man with the big nose, the World Champ of hysterical rage. A typical de Funès character is the uptight *petit bourgeois* who despises his social inferiors, sucks up to his bosses, schemes to get ahead, and ultimately falls flat on his face.

(Carlos) Louis de Funès (De Galarza) was born in Courbevoie in 1914, the son of a Spanish diamond merchant. His trademark was his rubber face, which he could twist into the most incredible grimaces, combined with some truly wild body language. He was apparently able to increase the length of his nose in order to play it like a violin. While performing such esoteric practices, he occasionally lost the ability to speak his native language, resorting to bizarre onomatopoeic sounds said to be reminiscent of Donald Duck, to whom many of his film characters bore a striking resemblance. He learned a series of trades – furrier, decorator, bar pianist – before making his breakthrough at the advanced age of 50, in *Le Gendarme de Saint Tropez* (1964). After 20 years in supporting roles, he was suddenly a popular favorite, capable of making up to five films in a single year. Many of these were highly successful. Examples include the *Gendarme* series, the *Fantomas* films (1964, 1965, 1966) and *Oscar* (1967). His ascent marked the beginning of the comedy boom in France, and he won countless fans worldwide. They referred to him affectionately as "Fufu." De Funès died in 1983.

1 Frugal gourmet: When Charles Duchemin (Louis De Funès) partakes in France's national pastime, he turns up the heat on farce and tomfoolery.

2 Tour de France: Charles will stop at nothing to get his taste testers into prime physical condition.

3 A wolf in she's clothing: One false move and this black widow will spoil the soup with her poisoned pen. Here, food critic Charles moonlights as the happy homemaker.

4 Catch of the day: Duchemin and his staff close in on an unsavory intruder.

5 A night at Benihana's: This learned Teppan performance artist makes a laughing stock of the Cuisinart.

6 Pigs in a blanket: Keeping in line with his sugary menu, director Claude Zidi's recipe for success also calls for these little weenies to be honey glazed.

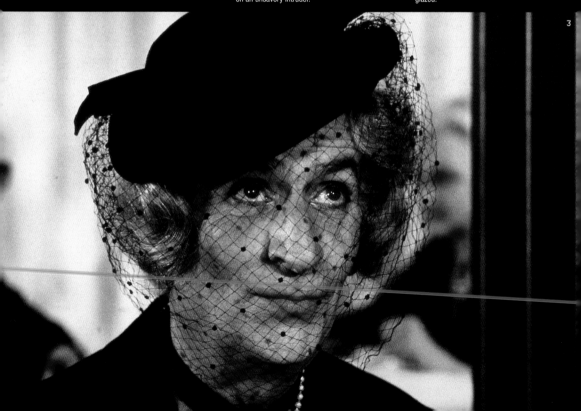

gun at his head, he's forced by his tormentor to eat a Tricatel menu… The expression on Charles' face as he swallows the snails is one of sheer horror, the elderly oysters bring him out in blotches, and the platter of slimy sauerkraut is more than he can bear.

After this culinary inferno, Charles is far from his normal self; more to the point, he's lost his sense of taste. Just 24 hours before his TV showdown with Tricatel, he can't tell the difference between a green bean and a wad of cotton wool. Rescue is at hand, however, in the shape of his son Gérard, played by De Funès' equally famous compatriot, the comedian Coluche; and soon this very odd couple – the father a French Foghorn Leghorn, the son as meek as a mouse – have entered the lion's den: Tricatel's food factory. In the surreal setting of the production halls, father and son only barely escape ending up as canned meat before uncovering the shameless tricks of Tricatel's trade: Among many other sins, he's been using the blessings of modern technology to pass off green bathing caps as lettuces.

L'Aile ou la cuisse is hardly a subtle comedy, but then it never tries to be. Its strength is in its snappy visual gags: a spell in hospital and the resetting of a broken leg are excuses for an orgy of slapstick. But the film also has its quiet moments. Take the scene in which Charles discovers that his son has been leading a double life as a clown: when the outraged father pours a bucket of foam over his son's head, the comedy is so bittersweet that the laughter sticks in our throats. *L'Aile ou la cuisse* is a choice morsel of a movie, and it's often deliciously funny.

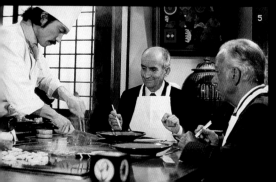

THE AMERICAN FRIEND
Der amerikanische Freund / L'Ami américain

1977 - FRG / FRANCE - 126 MIN. - GANGSTER FILM, LITERARY ADAPTATION, DRAMA

DIRECTOR WIM WENDERS (*1945)
SCREENPLAY WIM WENDERS, based on the novel *RIPLEY'S GAME* by PATRICIA HIGHSMITH **DIRECTOR OF PHOTOGRAPHY** ROBBY MÜLLER
EDITING PETER PRZYGODDA, BARBARA VON WEITERSHAUSEN **MUSIC** JÜRGEN KNIEPER **PRODUCTION** WIM WENDERS for ROAD MOVIES FILMPRODUKTION, FILMVERLAG DER AUTOREN, MOLI FILMS, LES FILMS DU LOSANGE, WESTDEUTSCHER RUNDFUNK.

STARRING DENNIS HOPPER (Tom Ripley), BRUNO GANZ (Jonathan Zimmermann), LISA KREUZER (Marianne Zimmermann), GÉRARD BLAIN (Raoul Minot), NICHOLAS RAY (Derwatt), SAMUEL FULLER (Gangster), PETER LILIENTHAL (Marcangelo), DANIEL SCHMID (Igraham), RUDOLF SCHÜNDLER (Gantner), SANDY WHITELAW (Doctor in Paris).

"I don't know what to do."

In Wim Wenders' melancholy gangster film, based on a novel by Patricia Highsmith, no one really knows what to do any more. The two main characters are wandering in a kind of no-man's-land, bored, existentially desperate and in danger of losing their lives. On the one hand, we have the smart gangster Tom Ripley (Dennis Hopper), who commutes between New York and Hamburg, visiting auctions and buying expensive paintings by the forger Derwatt (Nicholas Ray), while cultivating his links to the underworld. And then we have the meek, unassuming picture-framer Jonathan Zimmermann, played by Bruno Ganz. Deliberately given the false impression that his illness is fatal – Jonathan is a hemophiliac – he is soon a compliant victim of criminal machinations, even becoming a contract killer to ensure the financial survival of his family after his death. Two men, two lives, and the contrasts could hardly be greater: one of them footloose and fancy-free, the other bound to his family and his tiny business – the globetrotting dandy Tom Ripley and the introspective framer in the bleak, depopulated docklands of Hamburg. The political graffiti on the grimly monotonous walls place the film firmly in 1970s Germany.

Ripley encounters Jonathan at an auction and hears about his treacherous illness. Devoid of scruples, Ripley sells the information to the French gangster Raoul Minot, who tempts Jonathan with a suggestion: he will put up the money to treat Jonathan's allegedly fatal hemophilia, if Jonathan carries out a murder for him in return. And – how could it be otherwise? – Jonathan loses his moral integrity. After the first murder, he allows himself to be blackmailed into committing another, this time in a Trans-Europe Express train. Just as things are going badly wrong on this second job, Ripley appears from nowhere and helps Jonathan complete his deadly mission. Having begun by betraying Jonathan, Ripley seems suddenly to have befriended him: he's now Jonathan's dubious "American friend."

And yet they remain strangers. The audience can practically feel their spiritual isolation in the bleak images, half-suppressed movements and distrustful glances, interior monologs and softly-whispered dialogs. A feeling of petrifaction spreads, telling of Jonathan's defenselessness and the ruthlessness of those who exploit him for their own criminal ends. Death for life and life for death: for Jonathan, there seems to be no way out of this vicious circle. Symbolically, he often holds a frame before his face, checking its quality, as if searching for an identity, a suitable frame for his own life.

In *The American Friend*, Wim Wenders created a little gem of a film minutely detailed and without embellishment. Many critics read his work as

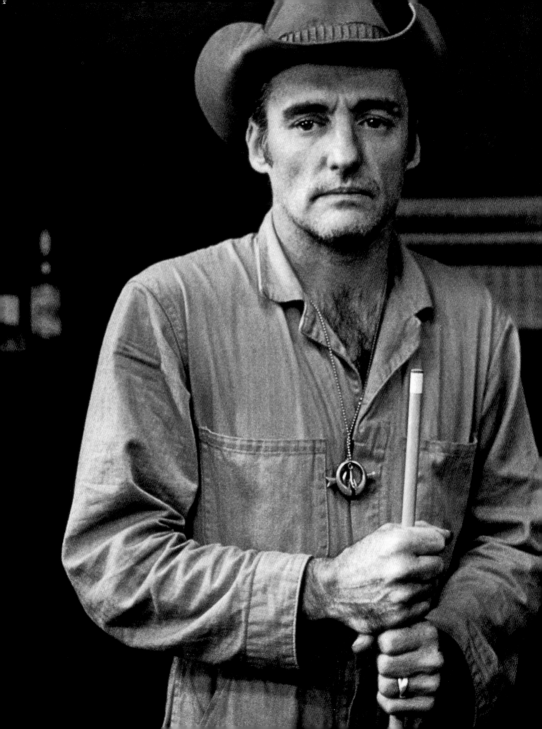

2

parable on the "colonial" relationship between American and German cul-ture, on the triumph of an aggressive, corrupt and bullying attitude that has o time for doubt or self-criticism. At the same time, Wenders delivered a ontemporary reinterpretation of the social realism that has dominated angster films since the earliest days of the genre, with protagonists who truggle to defend themselves even when all the political and economic odds re stacked against them. Wenders is part of this tradition, which he renews nd updates. *The American Friend* is an intelligent thriller that easily com-bines great seriousness with a suspenseful plot. It's a complex film, not easil pigeonholed, in which almost all identities, relationships and motivation remain open. So too the friendship between Jonathan and Ripley. The filr ends with a sequence of images almost surreal in their effect: Jonathan an Ripley, on a beach at the mouth of the river Elbe, set fire to an ambulanc containing the bodies of two gangsters who had been pursuing them. But th final test of their friendship ends in failure: Jonathan flees with his wife, leav ing Ripley behind him – alone. Bl

1 Flying paper dragons: Melancholy gangster Tom Ripley (Dennis Hopper) is holding all the strings.

2 Making quota: Monthly casualties keep business in the black.

3 His hands are tied: There's just no freeing himself of a criminal bind for Jonathan (Bruno Ganz).

4 Down and out in the underworld: Buddy Ripley gives Jonathan's morale a jump start.

3

WIM WENDERS Wim Wenders was born in Düsseldorf in 1945. He took his first steps as a film director when his father gave him a Super-8 camera in 1954. From 1967 to 1970, he studied at the Film and Television Academy in Munich. During this period, he also made short films and wrote critical essays. In 1970, he made his first full-length film, *Summer in the City*. This was followed by a number of successful features, including *Alice in the Cities* (*Alice in den Städten*, 1974), *Kings of the Road* (*Im Lauf der Zeit*, 1975/76), *The American Friend* (*Der amerikanische Freund / L'Ami américain*, 1977), *Paris, Texas* (1984), *Wings of Desire* (*Der Himmel über Berlin / Les Ailes du désir*, 1987), *Faraway, So Close!* (*In weiter Ferne, so nah!*, 1993) and *Buena Vista Social Club* (1998/99).

These films made Wim Wenders one of the most internationally renowned German directors. His style is characterized by long, steady shots and careful cutting. We become aware of the camera as an observer, and we also have time to examine the pictures in detail. Wenders' narratives are correspondingly detailed. They focus on rootless characters and tight-lipped heroes incapable of making contact with their fellow human beings. In many of his films, Wenders uses this constellation to examine the influence of American culture on postwar Germany. At the same time, his poetic-philosophical filmmaking stands in sharp contrast to the fast-moving action-packed cinema of Hollywood, with its one-dimensional characters and transparent motivations. Although Wenders has produced fascinating new interpretations of Hollywood myths – especially in his road movies and gangster films – he advances the tradition in his own, specifically "European" way.

STAR WARS

1977 - USA - 121 MIN. - SCIENCE FICTION

DIRECTOR GEORGE LUCAS (*1944)
SCREENPLAY GEORGE LUCAS **DIRECTOR OF PHOTOGRAPHY** GILBERT TAYLOR **EDITING** PAUL HIRSCH, MARCIA LUCAS, RICHARD CHEW
MUSIC JOHN WILLIAMS **PRODUCTION** GARY KURTZ for LUCASFILM LTD.

STARRING MARK HAMILL (Luke Skywalker), HARRISON FORD (Han Solo), CARRIE FISHER (Princess Leia Organa), ALEC GUINNESS (Ben "Obi-Wan" Kenobi), PETER CUSHING (Tarkin), DAVID PROWSE (Darth Vader), JAMES EARL JONES (Darth Vader's voice), KENNY BAKER (R2-D2), ANTHONY DANIELS (C-3PO), PETER MAYHEW (Chewbacca), PHIL BROWN (Owen Lars), SHELAGH FRASER (Beru Lars).

ACADEMY AWARDS 1977 OSCARS for BEST MUSIC (John Williams), BEST FILM EDITING (Paul Hirsch, Marcia Lucas, Richard Chew), BEST SET DESIGN (John Barry, Norman Reynolds, Leslie Dilley, Roger Christian), BEST COSTUMES (John Mollo), BEST SOUND (Don MacDougall, Ray West, Bob Minkler, Derek Ball), BEST SPECIAL EFFECTS (John Stears, John Dykstra, Richard Edlund, Grant McCune, Robert Blalack), and SPECIAL PRIZE FOR SOUND EFFECTS (voices of the aliens and robots, Ben Burtt).

"May the Force be with you!"

There's something rotten in the state of the galaxy. With the blessings of the Emperor, Grand Moff Tarkin (Peter Cushing) and the sinister Lord Vader (David Prowse/James Earl Jones) have been conquering and subjugating one planet system after the other in the old Republic. Tarkin commands a massive spaceship, whose firepower has the ability to annihilate entire planets. This "Deathstar" is the most dangerous weapon in the universe – perhaps with the exception of "The Force," a mysterious, all-pervading energy. Anyone who learns to master this force through years of ascetic training is possessed with superhuman powers. In the past, the Jedi Knights secured justice and kept the peace with the help of "The Force." But now Darth Vader,

with Tarkin an almost invincible alliance of evil in the once peaceful expanses of the universe.

Only a small group of rebels resist the might of the Empire and fight to restore the old order. To achieve their aspirations, the construction plans of the "Deathstar", which the rebels have acquired, could be of great assistance. But the spaceship of Princess Leia (Carrie Fisher) is captured just as she is returning to her home planet with the plans in hand. At the last moment she is able to save the blueprint of the "Death Star" inside the droid R2-D2 (Kenny Baker). If this tiny robot can get the plans to the old Jedi Knight Obi-Wan Kenobi (Alec Guinness) in time, there could still be a remote hope for the

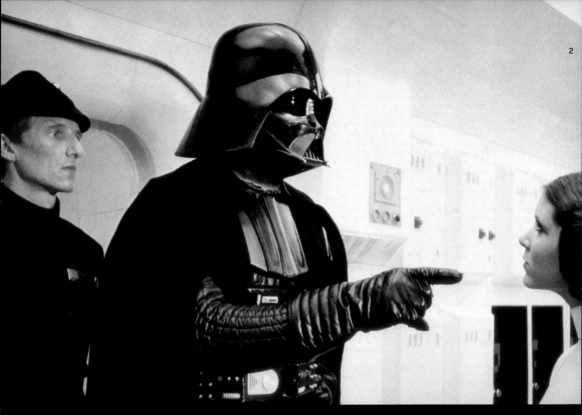

1 May the Force be with you: With a monk's habit and light sabre, Ben "Obi-Wan" Kenobi (Alec Guinness) links medieval mythology to a hi-tech future.

2 Iron lung of evil: Darth Vader (David Prowse) will stop at nothing to conquer the galaxy.

3 Man's best friend according to Lucas: Princess Leia (Carrie Fisher) confides in R2-D2 (Kenny Baker).

The journey of R2-D2 and his companion, the dithering and etiquette-conscious communication robot C-3PO (Anthony Daniels), takes them to the planet Tatooine, where they are purchased by farmer Owen Lars (Phil Brown). His nephew, Luke Skywalker (Mark Hamill) longs for a life more exciting than that of an agricultural worker. He would much rather fight with the rebels against the Empire – just as his father, a legendary Jedi whom he has never met, once did...

Skywalker's dreams of adventure begin to become reality when the two droids meet Obi-Wan. Soon the imperial Storm Troopers are at their heels, and the old Jedi Knight is left with no other alternative but to travel with Luke and the droids to Alderaan, Leia's home planet, bringing the plans of the "Death Star" to help plan a counterattack.

They receive assistance from Han Solo (Harrison Ford), and old pro who, with his ship, the Millennium Falcon, manages to speed away from the fast-approaching imperial cruisers in the nick of time. Even so, they do not reach their destination: Tarkin and Darth Vader have already destroyed the planet Alderaan.

After our heroes free Princess Leia from the "Death Star," nothing stands in the way of the final battle between the Empire and the rebels in the Javin-System. The Achilles heel of the gigantic space station is a small ven-

tilation shaft, and in the end, after several intense battles, it is Luke who is able to hit the weak spot and destroy the "Death Star" in a powerful explosion. Only Darth Vader escapes the blazing inferno. And while one battle may have been won in this war in the stars, it won't be long before the Empire strikes back...

George Lucas began working on his star-saga just as his teenage drama, *American Graffiti*, was poised to become the surprise hit of 1973 – a success from which the director profited much less than the studios that produced the film. For Lucas, this experience was the driving motivation never to give control of one of his projects to anyone else again. *Star Wars* was produced entirely by his own company and the special effects were created by Industrial Light & Magic, also a Lucas company. Rounding out the deal was a clause giving rights to merchandizing (toys, clothing, etc.) and the use of film music to Lucas, initiating a new period in cinema in which the biggest proceeds of a film were no longer made at the box office. The blockbuster movie was born.

Real success always did depend on reaching the largest possible audience. Lucas stressed over and over that he wrote the screenplay with 8 and 9-year-olds in mind. But in the end, the film was able to connect with virtually every age group, primarily because with his "space opera," Lucas

"I wanted to make a film for kids, something that would present them with a kind of elementary morality. Because nowadays nobody bothers to tell those kids, 'Hey, this is right and this is wrong.'"

George Lucas, interview with David Sheff

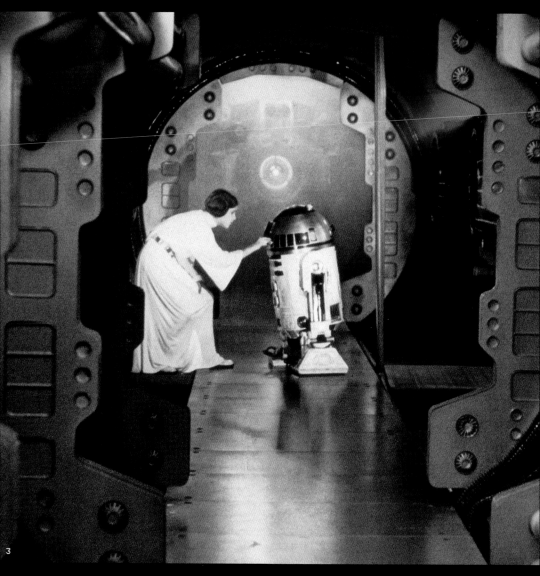

3

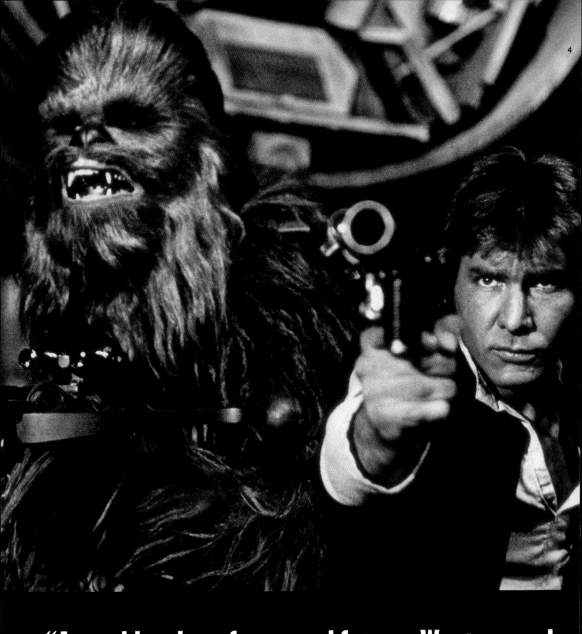

"A combination of past and future, Western and space odyssey, myth and dream world, *Star Wars* may be the most enduring piece of escapism ever put on film." *Sacramento Bee*

as neither attempting to depart from old genres, nor to enthusiastically deconstruct them. In fact, his goal was just the opposite. Like his colleague Steven Spielberg, Lucas pursued a higher path, which led him back to the classical narrative form, meeting the expectations of the public and employing the highest levels of technical mastery.

The subject matter of *Star Wars* is akin to a trip through the annals of cultural and film history. Lucas fused elements from the tales of knights and the myths of heroes with the high-tech world of spaceships, was inspired by German and Soviet military uniforms, based the Jedi religion on the Shaman-cults of Central America, and created the Empire in the image of an Orwellian dictatorship. The android C-3PO is unmistakably based on the machine-woman from Fritz Lang's *Metropolis* (1926), and the concluding hero-honoring ceremony is an obvious reference to Leni Riefenstahl's Nazi party film *The Triumph of the Will* (*Triumph des Willens*, 1935). In short, with *Star Wars* an inter-cultural super-cosmos was created, containing something for every audience member to recognize.

4 Rebels without a shave: Individualists Chewbacca (Peter Mayhew) and Han Solo (Harrison Ford) battle against the evil empire.

5 About face: The imperial storm troopers are trained and ruthless killers.

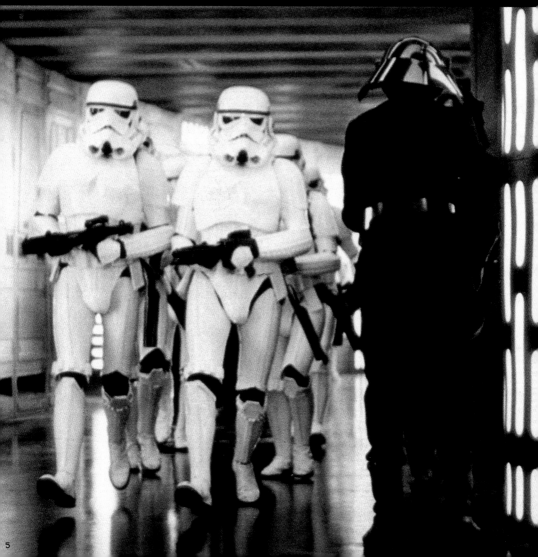

What follows is no singular adventure; it is an entire universe. From the very beginning *Star Wars* was created as a multi-episode project. After the first episode came *Star Wars: Episode V – The Empire Strikes Back* (1980) and then *Star Wars: Episode VI – The Return of the Jedi* (1983). The pre-history of the saga was also conceptualized as a trilogy. Even during the first screenplay drafts, Lucas' Star-world was getting bigger and bigger. This is no exception in the fantasy and science fiction genre. Where new, exotic worlds are created, there will always be questions about how it all began. With the interest in both past and future, the plot possibilities are endless.

Serial science fiction stories were already prevalent and popular in the 1930s. Space heroes like *Flash Gordon* (1936) and *Buck Rogers* (1939) helped their comic forefathers to big screen success. Each 13-part series told of despotic rulers, beautiful women, and heroic men saving the universe; after 20 minutes the plot stopped at the most exciting moment – to be continued next week in this theater!

The *Star-Trek* Universe has been massively popular and has experienced considerable expansion. Since the first episode of the television series about the Starship Enterprise was broadcast in 1966, five spin-off series and ten films have been created, each piece of this long chain of individual stories adding to the colossal inventory of characters, events, time periods, and places that make up this fantastic world.

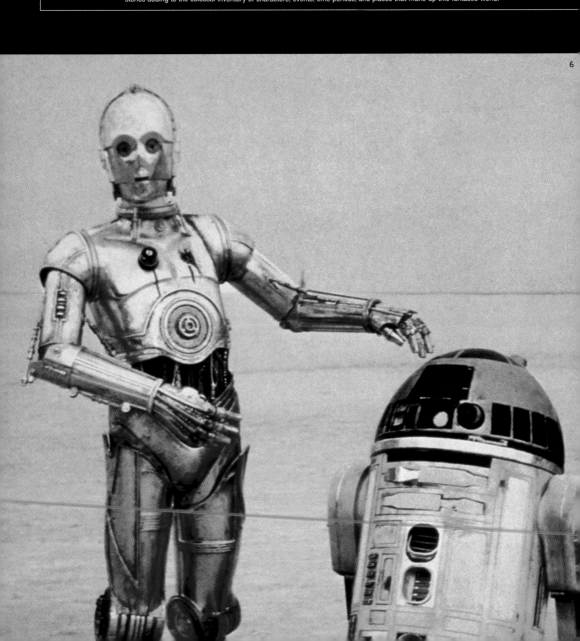

6 Budget getaway: Protocol droid C-3PO (Anthony Daniels) speaks millions of languages; but unlike brave little R2-D2, he's an exasperating penny-pincher.

7 Putting their lives on the line for a pleasant tomorrow: Princess Leia and Luke Skywalker (Mark Hamill).

8 Everyday life in the not-too-distant future: The furniture of the *Star Wars* universe is sometimes credibly and recognizably shabby.

"It's a terrifically entertaining war story, it has memorable characters and it is visually compelling. What more do we want in movies?"
San Francisco Chronicle

The real highlight, however, was that Lucas' film, despite its complex plot, tells a story easily reduced to the battle of good versus evil. *Star Wars* is not a story of broken heroes. Lucas sends clearly defined characters into battle, and the audience are never left in doubt as to who will triumph in the end. The result is that the science fiction opus became an effortlessly digestible mixture of vignettes, whose charm lay not in complicated conceptual worlds, but rather in its fantastic moments and visual spectacles. It was these moments that made the film an ideal springboard for the budding entertainment industry of video and computer games. The space battles were replicated and prolonged on consoles and monitors all over the world, helping to reduce the time between episodes...

8

ERASERHEAD

1974/77 - USA - 90 MIN. - HORROR FILM, PSYCHO DRAMA

DIRECTOR DAVID LYNCH (*1946)
SCREENPLAY DAVID LYNCH DIRECTOR OF PHOTOGRAPHY FREDERICK ELMES, HERBERT CARDWELL EDITING DAVID LYNCH MUSIC DAVID LYNCH, PETER IVERS (Songs), FATS WALLER PRODUCTION DAVID LYNCH for AMERICAN FILM INSTITUTE.

STARRING JACK NANCE (Henry Spencer), CHARLOTTE STEWART (Mary X), ALLEN JOSEPH (Mr. X), JEANNE BATES (Mrs. X), JACK FISK (Man in Planet), JUDITH ANNA ROBERTS (Beautiful Girl Across the Hall), LAUREL NEAR (Lady in the Radiator), JEAN LANGE (Grandmother), THOMAS COULSON (Boy), DARWIN JOSTON (Paul).

"In heaven everything is fine."

The man in space (Jack Fisk) is dreaming. His pockmarked face stares out the window as he works a lever, and a printer named Henry Spencer (Jack Nance) appears against the backdrop of a sad, hermetic, black-and-white world. We see a factory, pipes, courtyards, and one-room apartments – an industrial microcosm in which both the near and distant whine of machines and the buzz of menacing electric lines behind the wallpaper can be heard everywhere.

Henry hasn't heard form his girlfriend Mary (Charlotte Stewart) for ages. Suddenly, her parents invite him to a bizarre dinner. All the women in turn are shaken by nervous fits. Mary's father serves mini chickens whose legs twitch when they are cut, while something that looks like bloody bubbles pours out over the plates. Then his girlfriend's lascivious mother tells Henry that he has become a father.

But it remains questionable whether he is truly the progenitor of the tightly bandaged being that looks more like a sheared sheep than a baby. In any case, Mary moves in with him, only to leave during the first night to go back to her parents, irritated by the constant screaming. Henry remains alone. The monstrous "child" gets sick, an affair with the beautiful girl across

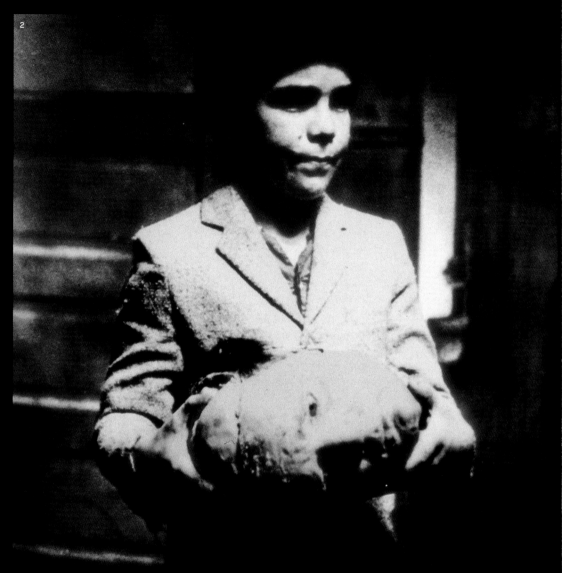

1 Seeing is believing: Jack Nance as Henry Spencer in *Eraserhead*. The film's admirers have included directors as diverse as Stanley Kubrick, John Waters and William Friedkin.

2 Headed for greatness: Henry is the eraser factory's diamond in the rough.

3 All good things to those wait: Three years filming, one year in post-production. To save money, the impoverished director David Lynch actually lived on the set of Henry's apartment for a while.

the hall (Judith Anna Roberts) ends in humiliation, and Henry dreams of an angelic, though horribly disfigured lady in the radiator (Laurel Near) and of a machine that transforms his head into an eraser. He ultimately kills the pitiful, reviled being and when he does so, his world dissolves into nothingness.

Despite the essentially linear plot, the story of *Eraserhead* evades explanation. Just as Henry seems to be merely a vision of the man in space shown at the beginning of the film, who at the end returns to the completely

surreal and unbelievable, the narrated story seems to be permanently put into question by the suggestive quality of the images, the menacing drone of the soundtrack, the surreal events of the subplots, the torturously slow movements, and the characters' strange speech. In the leaden atmosphere of this world, the half-hearted manifestations of life and helpless gestures of the humans have no permanence.

There are plenty of starting points for interpretation. The episode in which Henry's head – whose vertical hair is already highly suggestive – is

The imagery of this eerie film is impossible to pin down, the sound is unnerving, the lighting is dreadful, the settings are execrable, and the characters are horrendous." *Cinema*

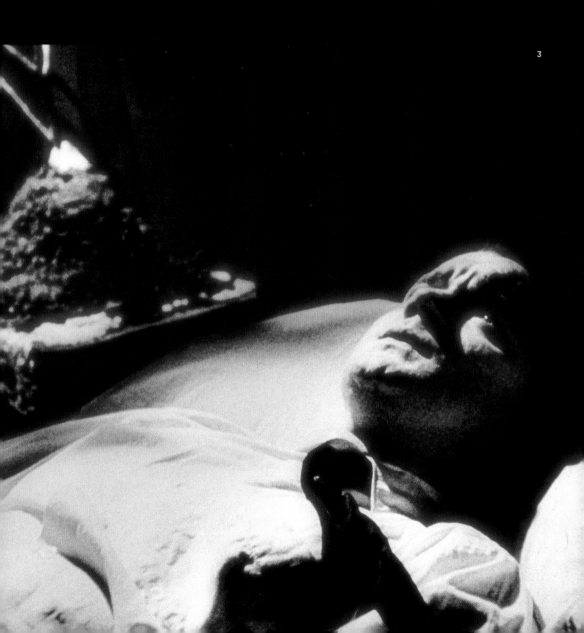

"The only artist I ever felt could be my brother was Kafka."

David Lynch, in: Chris Rodley (Ed.), Lynch on Lynch

used to make erasers for pencils can be read as a metaphor for oblivion and speechlessness. Lynch's daughter Jennifer Chambers Lynch saw herself as an infant in the portrayal of Henry's baby – as an unwanted child that prevented the artist from pursuing his actual vocation.

Confronted with such theses, Lynch routinely responded with such lines as "I don't want to talk about that," or "I can't answer that question." Lynch's anger regarding those who blurt out the technical and artistic secrets of film indicates that he views a glimpse behind the scenes, and one-dimensional interpretations in general, as attempts to demystify the cinematic art form, an intrusion into a fragile, opaque system of meanings, references, and associations that must be protected from outside influences. "No matter how weird

a story is," said Lynch, "as soon as you set foot inside it, you realize that this world has rules you have to follow."

For over four years, the young director worked with a small team on the film that Stanley Kubrick once called his favorite movie. Often on the brink of financial ruin, Lynch meticulously created each and every scene down to the smallest detail and despite warnings from family members and friends he was unable to put the project down – it was almost as if he could only free himself from Henry's claustrophobic artificial world by completing the film.

"I felt *Eraserhead*, I didn't think it up," explained the director. Similarly, the audience is asked to look, instead of trying to understand at all costs.

SH

4 Mary, mother of God!! Is Henry really the father of
 Mary's (Charlotte Stewart) monstrous child?

5 A living hell: In Henry's world, reality and
 nightmare are practically indistinguishable.

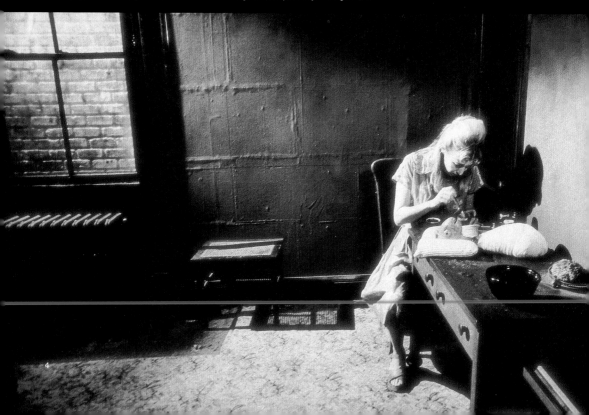

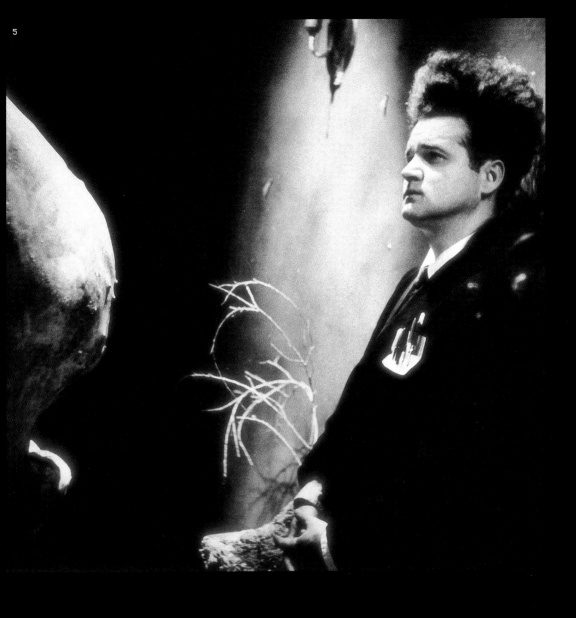

LOW BUDGET PRODUCTIONS

No art is as expensive as filmmaking. While the big Hollywood productions can easily eat up hundreds of millions of dollars, there have always been films that were realized on a financial minimum, so-called low or no budget productions. But necessity can become a virtue. The compulsory renunciation of personal and technical expenditure often contributes to a unique demonstration of a director's personal style. And so it can happen that films made without big studios and without huge budgets can recover their production costs and gross much more than they cost to make.

At the beginning of the 70s, a series of directors who now belong to Hollywood's crème de la crème succeeded in making low budget productions: Dennis Hopper with *Easy Rider* (1969), Sidney Lumet with *Serpico* (1973), or David Lynch with *Eraserhead* (1974/77). If minimal production expenditures are viewed almost as a prerequisite for artistic films – like for example the "Dogma" directors surrounding Lars von Trier (*Breaking the Waves*, 1996) – then the relationship to inexpensively produced B-movies illuminate the difference between art and trash, as with Russ Meyer's orgies of sex and violence (*Supervixens – Eruption, Supervixens*, 1975), the provocative cinema of John Waters (*Pink Flamingos*, 1972) or the in hindsight path-blazing horror masterpieces by George A. Romero (*Night of the Living Dead*, 1968) and Tobe Hooper (*The Texas Chain Saw Massacre*, 1974), whose influence is also evident in artistic productions like *Eraserhead*.

SATURDAY NIGHT FEVER

1977 - USA - 118 MIN. - DANCE FILM, DRAMA

DIRECTOR JOHN BADHAM (*1939)
SCREENPLAY NORMAN WEXLER, based on the magazine article "TRIBAL RITES OF THE NEW SATURDAY NIGHT" by NIK COHN
DIRECTOR OF PHOTOGRAPHY RALF D. BODE EDITING DAVID RAWLINS MUSIC BARRY GIBB, ROBIN GIBB, MAURICE GIBB, DAVID SHIRE
PRODUCTION MILT FELSEN, ROBERT STIGWOOD for ROBERT STIGWOOD ORGANIZATION, PARAMOUNT PICTURES.

STARRING JOHN TRAVOLTA (Tony Manero), KAREN LYNN GORNEY (Stephanie), BARRY MILLER (Bobby C.), JOSEPH CALI (Joey), PAUL PAPE (Double J), DONNA PESCOW (Annette), BRUCE ORNSTEIN (Gus), JULIE BOVASSO (Flo), MARTIN SHAKAR (Frank), SAM COPPOLA (Fusco).

"Nice move. Did you make that up?"

One movie embodies everything that disco stood for in the late 1970s, and all that it has continued to stand for in the years since its disappearance from the public eye. To this day, audiences around the world hear mention of John Travolta and his trademark white leisure suit and are instantly transported to the streets of Brooklyn and the world of *Saturday Night Fever!* The picture itself is not only a golden shrine to the nightlife of the era with the glamorous decadence of its disco dance palaces, but also to its prevailing fashions and zeitgeist. *Saturday Night Fever's* uncanny assessment of these trends is attested to by the waves of disco revivals, each of which has inevitably cited this film's semiotics in its act of tribute.

At the time of its 1977 release, Manhattan dance club Studio 54 was the throbbing hub of disco. The audience for what was known as dance music had by then branched out from non-Caucasians and homosexuals to include the white middle class. *Saturday Night Fever* played a decisive role in contributing to the extreme popularity of the disco movement. Overnight, it launched unknown 22-year-old John Travolta to superstardom. More than his fancy threads or even the beat-pumping Bee-Gees tunes, it was Travolta's sexy gyrations that set a precedent in popular music for all time to come. From that day on, Top 40 hits would be judged on the basis of how danceable they were.

The film itself tells the story of a group of twenty-somethings linked by the socio-economic stratum they have inherited, much like the protagonists of Martin Scorsese's *Mean Streets* (1973). Tony Manero (John Travolta) comes from an Italian-American family and still lives with his parents, who treat him more like a kid than a full grown adult. He works at a mundane job selling paint and finds the recognition denied him at home on the dance floor. Every Saturday night, he and his buddies head over to "2001," a disco with a rainbow colored blinking floor and a fast-talking disk jockey who can always get the crowd moving. The sea of people parts when stallion Tony struts his way over to his table. Women worship him and his amassed following goes wild when he takes the stage with his smooth-as-butter choreography. Tony is a tightly packaged macho stud and takes great care with his appearance. Each night before going out, he partakes in a meticulous ritual surrounded by posters of his idols Al Pacino and Sylvester Stallone as Rocky. Transfixed by his reflection, Tony slicks his hair, pulls on a dress shirt with flared collar and adorns himself with gold chains. He tops it off with a lascivious upward swing that slides the zipper of his hip-hugging slacks into place. Tony is the man with all the right moves and doesn't he know it. "I like the way you walk," remarks Annette (Donna Pescow) with girlish naivety and undying devotion. Tony, however, is shamelessly hurtful toward this ordinary admirer. He clearly

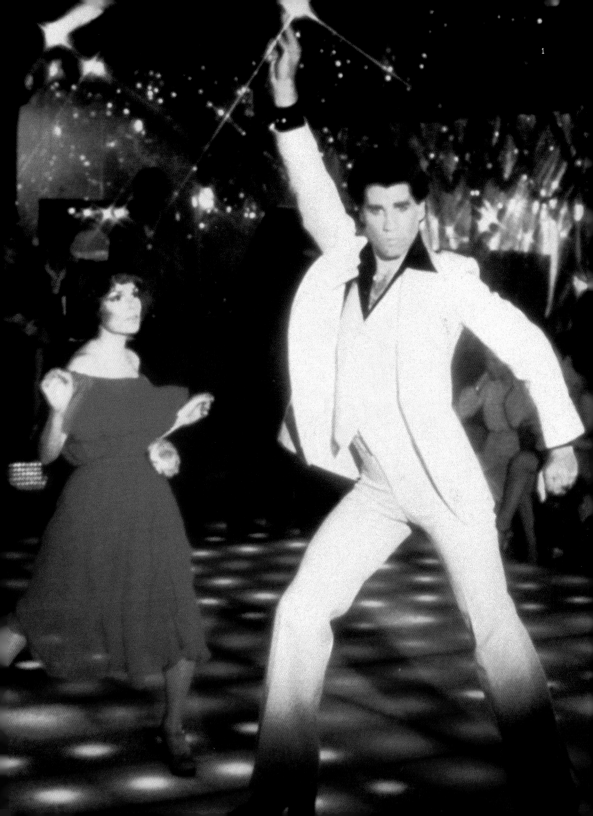

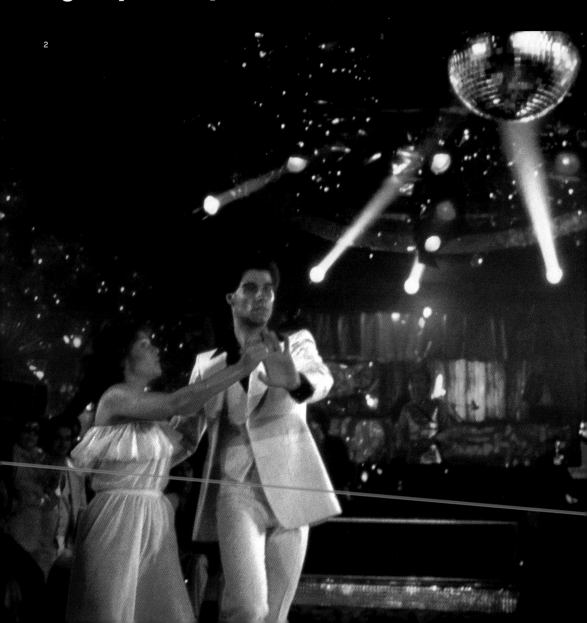

"John Badham's film is a snapshot of a period. Though born of a passing pop-cultural fashion, it has survived in the collective unconscious right up to the present day." *Frankfurter Allgemeine Zeitung*

2

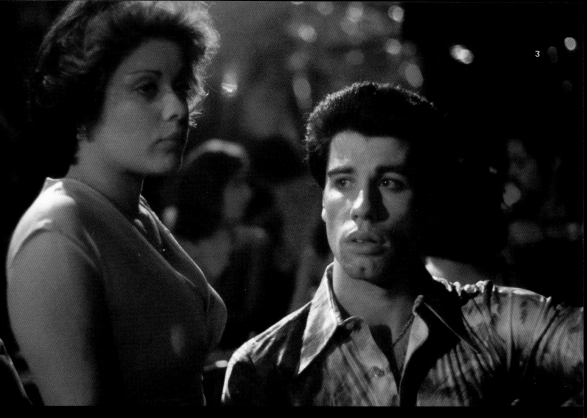

1 Bright lights, big city: Tony Manero (John Travolta) with his goods on display in the legendary white leisure suit.

2 Music as the universal equalizer: But the disco ball's magic won't last forever.

3 "If I Can't Have You:" Annette (Donna Pescow) is in love with Tony, but the feeling isn't mutual.

has problems dealing with the female element and drops crude comments to girls who want to go bed with him, asking Annette whether she's "a nice girl or a slut?" She responds by saying that maybe she's both, throwing the already twisted male logic of Tony and his crew into a loop. These guys think that women who engage in casual sex are filthy whores, while they seek out such specimens night after night. Tony's small world revolves around work, family, dancing and ladies. It is a lifestyle that lacks both goals and direction. Stephanie (Karen Lynn Gorney), the girl of his dreams, lives in another universe altogether, although this wasn't always the case. She has made the quantum leap from Brooklyn to Manhattan, working at a swanky agency that affords her the luxury of looking back on her previous life with a degree of arrogance and disdain. To Tony, she comes across as a sexy, hardened woman of the world, whose glamorous career requires her to consort with the rich and famous on a daily basis.

It's no coincidence that *Saturday Night Fever* opens with the image of a bridge. The device is both a physical link between Brooklyn and Manhattan as well as a metaphoric link between a suffocating life of entrenched tradition and the opportunistic, self-determined escapism of modernity. Tony is an expert on everything there is to know about the Brooklyn Bridge, right down to the exact amount of cement and steel contained in the architectural wonder. The bridge serves as a symbol of ultimate desire, which Tony and his

clique pay homage to in adolescent initiation rituals and daredevil stunts, like scaling the mammoth structure. To the shy Bobby (Barry Miller), this foolhardy activity proves to be as deadly as the call of the ancient Sirens. His fall into the East River abyss is both a departure from a life that has nothing to offer him other than disco, cruising the streets and casual sex, as well as a convenient exit from dealing with the responsibilities brought on by his girlfriend's pregnancy. Although Tony manages to successfully cross the imposing barriers of the bridge, it remains unclear whether he will choose to live out his newfound adulthood in the Manhattan universe that lies beyond.

Making it in the big city has always been a central theme in American film. *Saturday Night Fever* takes an in-depth look at what this entails, subjecting its characters to dire hardships, and its eloquent message resonates to this day. The film triumphs precisely where attempted follow-ups like the sequel *Staying Alive* (1983), fall short. Martin Scorsese's 1968 picture *Who's That Knocking at My Door* told a similar story of an unquenchable thirst for Manhattan life and women trouble among male youth. Yet for all their similarities, *Saturday Night Fever* has the unique distinction of being the disco movie to end all others, forever reminding us that history is made at night!

KK

4 Shaking off the past: In the end, however, only Tony will manage to escape.

5 Prophet of the Disco Cult: As his brother, a priest, puts it, "When Tony hits the dance floor, the crowd parts like the Red Sea before Moses."

"Energetically directed and well acted (...), *Saturday Night Fever* succeeds in capturing the animal drive of disco music and the social rituals of the people who dance to its beat." *Time Magazine*

DANCE MOVIES

Dance is part of a grand Hollywood tradition. One of its earlier highs came in the 1930s and continued well on into the 1940s with great spectacles featuring Fred Astaire and Ginger Rogers such as *Shall We Dance* (1937), as well as with Eleanor Powell in pieces like *Broadway Melody of 1940* (1939–40). These marvels revolutionized the art form and instantly became living legends. Nonetheless, the dance film as we know it today, stems from a later cinematic movement that first became widely popular with the unstoppable disco drama, *Saturday Night Fever* (1977). The film turned dance into a metaphor for self-realization and a passion for life. For these reasons as well as for its intrinsic connection to current pop music, these films have historically spoken to a primarily younger audience and produced a large number of top 40 hit songs.

The 1980s took the genre to new heights with Adrian Lyne's *Flashdance* (1982). Arguably the greatest dance movie of all time, *Flashdance* took the crisp visual aesthetics of the 1980s music video age and magnified them with theatrical, stylized imagery. The film's title song "Flashdance... What A Feeling!" written by Irene Cara, Keith Forsey and Giorgio Moroder took home the Oscar for Best Original Song and the entire soundtrack has since gone triple-platinum. A supplementary instalment of *Saturday Night Fever* hit theaters at the peak of the boom in 1983. That same year, Herbert Ross' enormously successful *Footloose* made its appearance on the film scene. Similar to the 1978 sensation *Grease*, starring John Travolta and Olivia Newton-John, the nostalgic tribute took viewers back to the 1950s when modern pop music and teen culture were still in their infancy. Jennifer Grey and Patrick Swayze took 1987 by storm in *Dirty Dancing* (1987) and captured the hearts of countless young audiences with yet another picture whose story was set in this beloved bygone era. After lying more or less dormant for over an entire decade, Randa Haines' 1998 *Dance with Me*, about the Latin music star Chayanne, was received by an enthused audience and contributed to salsa's popularity at the movies. Two years later, *Cinema* magazine deemed Nicholas Hytner's *Center Stage* (2000) a new teen version of *Flashdance*. Other dance flicks that year included Thomas Carter's hybrid of ballet and hip hop *Save the Last Dance* (2000) and *The Dancer* (2000) about yet another girl who dreams of becoming a dance superstar. The latter movie's soundtrack included a star-studded soundtrack featuring The Prodigy, Fat Boy Slim and Neneh Cherry. The genre has recently expressed renewed interest in tap dancing as evidenced by diverse pieces such as Dein Perry's modern stomp the *Bootmen* (2000), which was also an appeal for social reform. Even more successful was Stephen Daldry's *Billy Elliot* (2000), both a great example of the aesthetic trends in current British cinema as well as a touching dance drama about a little boy whose family tries to pressure him into becoming a boxer, although his dreams are just of ballet.

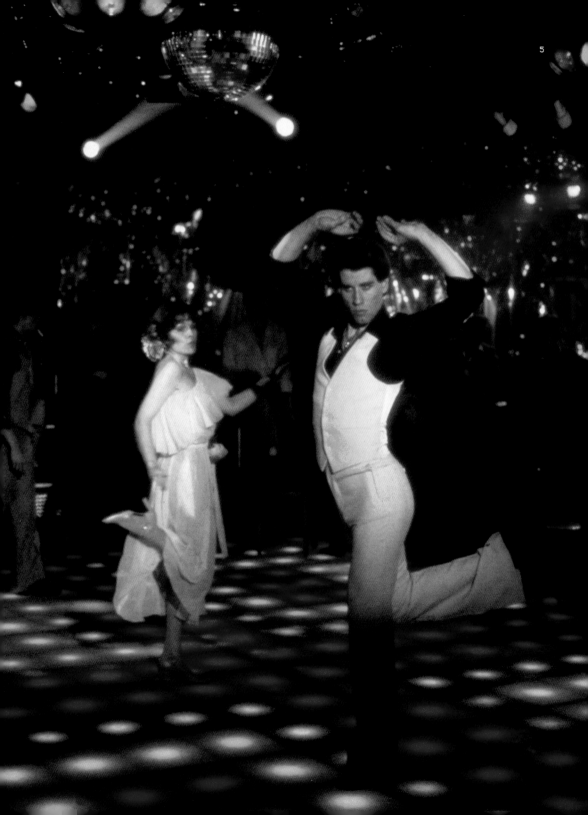

CLOSE ENCOUNTERS
OF THE THIRD KIND

1977 - USA - 135 MIN. - SCIENCE FICTION

DIRECTOR STEVEN SPIELBERG (*1947)
SCREENPLAY STEVEN SPIELBERG DIRECTOR OF PHOTOGRAPHY VILMOS ZSIGMOND EDITING MICHAEL KAHN MUSIC JOHN WILLIAMS
PRODUCTION JULIA PHILLIPS, MICHAEL PHILLIPS for COLUMBIA PICTURES CORPORATION.

STARRING RICHARD DREYFUSS (Roy Neary), FRANÇOIS TRUFFAUT (Claude Lacombe), TERI GARR (Ronnie Neary), MELINDA DILLON (Jillian Guiler), BOB BALABAN (David Laughlin), CARY GUFFEY (Barry Guiler), J. PATRICK MCNAMARA (Project Director), WARREN KEMMERLING (Wild Bill), ROBERTS BLOSSOM (Farmer), LANCE HENRIKSEN (Robert).

ACADEMY AWARDS 1977 OSCAR for BEST CINEMATOGRAPHY (Vilmos Zsigmond) and SPECIAL ACHIEVEMENT AWARD for BEST SOUND EFFECTS EDITING (Frank Warner).

"It's as big as a house!"

Suddenly, a gleaming light fills the sky. Car engines and radios go on the blink and the night is illuminated with brilliant colors. During a night-time procedure, electrical engineer Roy Neary has a strange experience: he sees aliens. But no one believes him. Consequently, he is fired by his company, continually made fun of, and totally misunderstood by his family. What Roy doesn't know is that his encounter is part of a string of strange phenomena that have been occurring around the world. Fighter bombers reported missing since 1945 suddenly appear in the desert of New Mexico, and the people of North India hear a melody coming from the sky.

Since his experience, Roy has been tortured by visions of an oddly formed mountain. He later sees the mountain again in a television program – apparently it's the "Devil's Tower" in Wyoming. The report tells of an accident during which poisonous gas was released near the mountain. The entire area is being immediately evacuated. It becomes clear to Roy that he must travel to Wyoming. He begins his journey to the mountain with Jillian (Melinda Dillon), a single mother who also had an encounter with aliens in the same night. Five years later in E. T. – The Extra-Terrestrial (1982), director Steven Spielberg again portrayed a visit from outer space. But the earlier narration is more

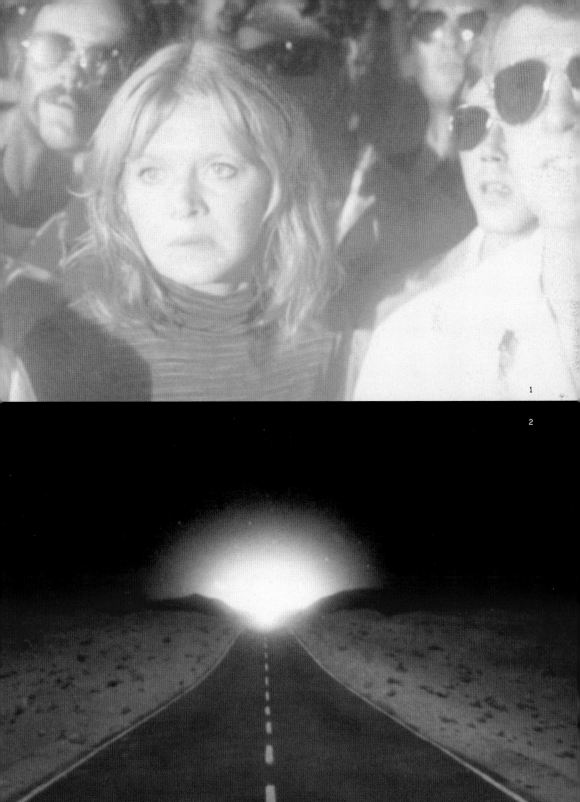

1

2

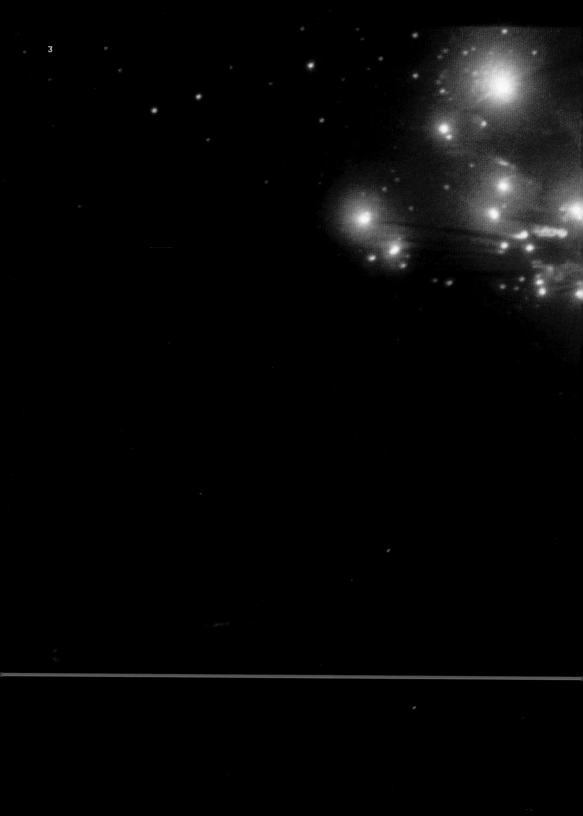

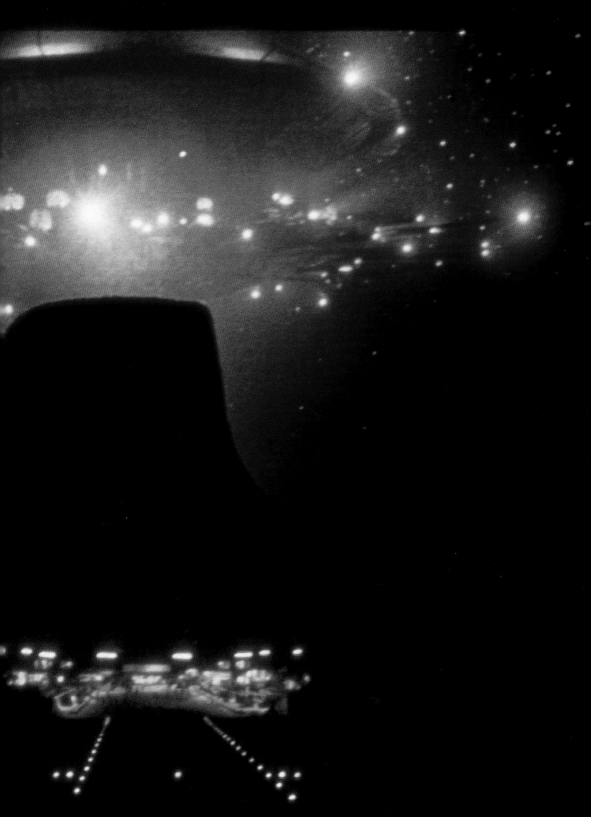

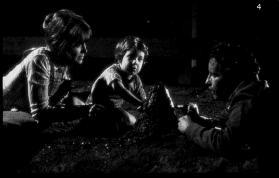

serious, more complex, and above all, more mature. Parallel to Roy's experiences, Spielberg depicts a worldwide UFO research team, led by Lacombe, a scientist from France (played by French director François Truffaut). The main plot of the film – an alien landing on the Earth – is accompanied by two subplots. One shows how Roy (excellently portrayed by Richard Dreyfuss) believes he is going mad and begins to doubt his own reason, ultimately causing his family to break apart. The other plot is a criticism of the media, which is still pertinent a quarter of a century later. The government, military, and media collaborate to spread lies about a poisonous gas disaster that never occurred. Their aim is to evacuate people from the area where they are expecting the alien landing to take place. In so doing, they even anesthetize animals to make their fairy-tale appear more believable.

> ## "I had such a yearning for the stars, such a longing for space travel. I wanted to take off and fly away from our planet. My childhood wasn't particularly happy, which is why I was always looking for ways to escape." *Steven Spielberg, in: Tony Crawley, The Steven Spielberg Story*

1 Mine eyes have seen the glory: Jillian Guiler (Melinda Dillon) has been touched by an angel, if that's what you want to call it.

2 An alien landing looks like that pot of gold at the end of the rainbow.

3 Star light, star bright: "Of all the UFO films ever made this is the most edifying – a wonder of superb special effects." (*Motion Picture Guide*)

6

4 Group therapy: Roy (Richard Dreyfuss) had
 begun to question his own sanity until Jill
 shared her own out-of-this-world experience
 with him.

5 Spirits in the sky: Master technician Douglas
 Trumbull composed a forty-minute special
 effects extravaganza for the film's conclusion
 that left audiences in awe.

6 Keeping the faith: Electrical engineer Roy Neary
 is publicly ridiculed for his convictions and aban-
 doned by his family.

The "main story" tells of the alien landing. As in *E. T.*, these aliens come to the Earth with peaceful intentions. The aliens, who appear only at the end of the film, are fragile, child-like figures who spread harmony, and with whom communication is only possible via music. They come to Earth as a kind of savior and their arrival is accompanied by unmistakably religious symbols, including celestial light and the mountain itself, which recalls Mount Sinai, where God gave the Ten Commandments to Moses. The almost forty-minute climax is an overwhelming orgy of special effects, with glowing spaceships of every size and shape, and a brilliant choreography of light in the sky. The effects were the work of Douglas Trumbull.

However, *Close Encounters* did not win the Oscar for special effects – the Oscar went to George Lucas' *Star Wars*, also released in 1977. Nonetheless, the film was a huge success at the box office. Both the production company and fans demanded a sequel. But Spielberg produced only a "Special Edition," which was eventually released in 1980. This version is three minutes shorter than the original – Spielberg cut 16 minutes and added 13 new minutes, including newly shot scenes (including a "stranded" ship in the Gobi desert) and initially unused material.

HJK

DOUGLAS TRUMBULL Special effects wizard Douglas Trumbull (*1942) began his career as a background illustrator for NASA promotional films. Stanley Kubrick saw one of these films and hired Trumbull as "special photographic effects supervisor" for his film, *2001: A Space Odyssey* (1968). Kubrick's masterpiece founded Trumbull's reputation as special effects magician and cleared the way for his directorial debut, the apocalyptic drama, *Silent Running* (1971). When afterwards, he was unable to realize further projects as a director, he started working as a trick specialist once again. He received Oscar nominations for his effects from *Close Encounters of the Third Kind* (1977), *Star Trek – The Motion Picture* (1979), and *Blade Runner* (1982).

For many of his films, Trumbull, son of an engineer, invented several technical devices, like the so-called Slit-Scan, a machine with which he captured the psychedelic color haze in the final sequence of *2001* (the flight through the star gate), or a zoom-microscope for *The Andromeda Strain* (1971). For his second film as director, *Brainstorm* (1983), he experimented with various film formats. He later developed the "Show-Scan" procedure. The film is projected at 60 frames per second instead of the normal 24, which results in a sharper image. But the format never caught on and was seldom used in the production of feature-length films.

ANNIE HALL

1977 - USA - 93 MIN. - COMEDY

DIRECTOR WOODY ALLEN (*1935)
SCREENPLAY WOODY ALLEN, MARSHALL BRICKMAN DIRECTOR OF PHOTOGRAPHY GORDON WILLIS EDITING RALPH ROSENBLUM,
WENDY GREENE BRICMONT MUSIC CARMEN LOMBARDO, ISHAM JONES PRODUCTION CHARLES H. JOFFE, JACK ROLLINS
for UNITED ARTISTS.

STARRING WOODY ALLEN (Alvy Singer), DIANE KEATON (Annie Hall), TONY ROBERTS (Rob), CAROL KANE (Allison),
PAUL SIMON (Tony Lacey), COLLEEN DEWHURST (Mother Hall), JANET MARGOLIN (Robin), SHELLEY DUVALL (Pam),
CHRISTOPHER WALKEN (Duane Hall), SIGOURNEY WEAVER (Alvy's Date), BEVERLY D'ANGELO (TV Actress).

ACADEMY AWARDS 1977 OSCARS for BEST PICTURE (Charles H. Joffe), BEST DIRECTOR (Woody Allen), BEST ACTRESS (Diane
Keaton), and BEST ORIGINAL SCREENPLAY (Woody Allen, Marshall Brickman).

"You know, it's one thing about intellectuals, they prove that you can be absolutely brilliant and have no idea what's going on."

"There's an old joke. Two elderly women are at a Catskills mountain resort, and one of them says: 'Boy, the food at this place is really terrible.' The other one says, 'Yeah, I know, and such… small portions.' Well, that's essentially how I feel about life," says *Annie Hall's* actual protagonist, Alvy Singer (Woody Allen) at the top of the film. "(It's) full of loneliness and misery and suffering and unhappiness, and it's all over much too quickly."

Singer is a stand-up comedian, professional cynic and full-time misanthrope. When a big tall blond crew-cutted guy in a record store tells him that Wagner is on sale this week, Jewish Alvy knows exactly how to take it. He also despises Los Angeles for being a city whose only cultural advantage is that you can make a right turn on a red light. What ties this seemingly unrelated hodge-podge of scenes and sketches pieced together by editor Ralph Rosenblum from a heap of over 50,000 feet of film is Alvy's relationship to the movie's title character, Annie Hall.

We meet the couple after the two of them have called it quits for the very last time, and then take an endearing yet heart-breaking trip with them down memory lane to discover what led to the demise of their year-long romance. Annie (Diane Keaton) is the quintessential pseudo-intellectual, a caricature of the urban woman. Alvy brands her as eternally flawed for being born with original sin – she grew up in rural America. On the other hand Alvy's condemning remarks about everyone and everything (including himself) are just his way of concealing his own unique, neurotic blend of self-loathing, self-pity and self-worship, which not even 15 years of therapy could cure him of. As he explains in a TV interview he was deemed "four-P" by a personality assessment test: a hostage in the event of war.

Allen biographer Marion Meade rightly stated that *Annie Hall* could have just as easily been entitled *Alvy Singer* or even better, *Allan Konigsberg*, Woody Allen's given name. The Alvy character is an unmistakable self-portrait of the director, who himself started out as a gag writer for stand-up comics. Up until three weeks before the premiere, Allen insisted that the film be called *Anhedonia* (the debilitating absence of pleasure or the ability to experience it). Arthur Krim, head of United Artists and Allen's paternal role model, allegedly threatened to throw himself out the window if he went through with it.

The almost non-existent cinematic structure of the piece allowed Allen to pack the movie full of amusing quips and snide remarks, more concisely,

it supplied him with a vehicle for unabated hilarity. Nonetheless, *Annie Hall* remains a particularly significant work for two main reasons. The first being that the director makes a point of tweaking classic modes of cinematic depictions of reality and storytelling. Whereas he filmed his 1969 piece *Take the Money and Run* (1969) in the style of a news exposé, *Annie Hall* is a veritable cornucopia of narrative conventions and even manages to weave in an animated sequence. Time and again, Alvy directly addresses his audience sitting in the theater. Such is the case in a movie ticket line, when he wishes to one-up and embarrass the wannabe film buff who loudly pontificates claims to teach a course on TV, Media and Culture at Columbia University and quotes extensively from influential Canadian media theorist Marshall McLuhan. Alvy quickly wins their debate by surreally calling upon McLuhan

> "Personal as the story he is telling may be, what separates this film from Allen's own past work and most other recent comedy is its general believability. His central figures and all who cross their paths are recognizable contemporary types. Most of us have even shared a lot of their fantasies." *Time Magazine*

1 He'd never join a club that would have him as a member: Alvy Singer is Woody Allen's filmic alter ego.

2 A walk on the mild side: Neurotic New Yorkers Annie (Diane Keaton), Alvy and Dick (Dick Cavett) analyze life, art, and above all themselves.

3 New York is full of interesting, undiscovered places to hang out…

4 Uppers and downers: Alvy reveres European
cinema – and especially Ingmar Bergman.

to personally step in and set matters straight. In another memorable se-
quence, Allen uses a split-screen to illustrate two incompatible worlds, as
Alvy's New York Jewish family is compared in similar, juxtaposed dinner
scenes to Annie's family. On the left third of the screen is the brightly lit, af-
fluent, politely gracious, aloof and sober Hall family discussing subjects such
as the Christmas play and the 4-H Club. On the right two-thirds of the screen
is a darkly lit, sloppy and informal, noisily argumentative, competitively bab-
bling Singer family talking about illness (diabetes, heart disease) and unem-
ployment (illustrating that Alvy's argumentative nature and fear of marriage
were inherited from his family). The genius of the episode is born out of the
actual conversation of the two families that takes place *across* this divided
split-screen. This brand of narrative anarchy was both a liberating artistic
breakthrough and a triumph for Allen.

The second significant achievement for Allen that came out of *Annie
Hall* was the creation of his alter ego, which finally succeeded in distancing
him from his purely comic self. Since this picture, Allen's cosmopolitan neu-
rotic has been a free-floating entity who can be readily integrated into the
context of more serious pieces like *Hannah and Her Sisters* (1985) and *Hus-
bands and Wives* (1992), or just observe the action from the sidelines as in
his 1978 drama, *Interiors* (1978). SH

DIANE KEATON In a quirkily perfect performance that won her the Best Actress Oscar, Woody Allen's then flame Diane Keaton reveals Annie Hall's and her own zany
yet huggable nature through the character's stumbling, flailing gestures. These are reinforced by self-conscious, shyly banal statements, particularly
her self-effacing "La-dee-dah." The similarities between these two women include their over the top and "not quite with it" manner as well as their
taste in clothing, which according to Allen, includes an affinity for football jerseys matched to skirts, combat boots and mittens. Given all this, it
should come as no surprise that Keaton's original last name supplied the character with hers.
The actress born on January 5, 1946 in Los Angeles, met Allen in 1969 while acting with him in his Broadway play "Play it Again, Sam." A few years
later, she appeared for the first time in an often-overlooked performance at the side of Al Pacino in the role of Michael Corleone's wife in Francis
Ford Coppola's *Godfather* trilogy (1972, 1974, 1990).
She worked on numerous Woody Allen films, both before and after their relationship came to an end. In 1981, she collaborated with Warren Beatty,
with whom she was also romantically involved for some time, on the film *Reds*. Before long, Keaton proved she had what it took to join the male-
dominated world of directing and has been making pictures and TV shows, including an episode of the legendary TV show *Twin Peaks*, since the
1980s. Her 1995 work *Unstrung Heroes* is a little-known masterpiece in filmmaking. Her 1996 acting and comedic bravado in *The First Wives Club*
(1996) and dramatic eloquence in *Marvin's Room* (1996) reconfirmed her star appeal. Today, it is hard to imagine that this star in her own right was
once inextricably tied up with Allen.

THE DEER HUNTER

1978 - USA - 183 MIN. - VIETNAM FILM

DIRECTOR MICHAEL CIMINO (*1943)
SCREENPLAY DERIC WASHBURN, MICHAEL CIMINO, LOUIS GARFINKLE, QUINN K. REDEKER **DIRECTOR OF PHOTOGRAPHY** VILMOS ZSIGMOND
EDITING PETER ZINNER **MUSIC** STANLEY MYERS **PRODUCTION** BARRY SPIKINGS, MICHAEL DEELEY, MICHAEL CIMINO, JOHN PEVERALL for EMI FILMS LTD., UNIVERSAL PICTURES.

STARRING ROBERT DE NIRO (Michael), JOHN CAZALE (Stan), JOHN SAVAGE (Steven), CHRISTOPHER WALKEN (Nick), MERYL STREEP (Linda), GEORGE DZUNDZA (John), CHUCK ASPEGREN (Axel), SHIRLEY STOLER (Steven's Mother), RUTANYA ALDA (Angela), PIERRE SEGUI (Julien).

ACADEMY AWARDS 1978 OSCARS for BEST FILM (Barry Spikings, Michael Deeley, Michael Cimino, John Peverall), BEST DIRECTOR (Michael Cimino), BEST SUPPORTING ACTOR (Christopher Walken), BEST FILM EDITING (Peter Zinner), and BEST SOUND (C. Darin Knight, Richard Portman, Aaron Rochin, William L. McCaughey).

"One shot is what it's all about. A deer has to be taken with one shot."

There are films that lose all their magic as soon as you know how they end; and there are others that keep their thrill even after several viewings. One of the cinema's undying magic moments is the scene at the end of *The Deer Hunter,* in which Nick (Christopher Walken) walks out of the back room of a Saigon gambling den with a red scarf round his head. His old friend Michael (Robert De Niro) steps towards him – he wants him to come home. But Nick can no longer recognize him; he's spent too long with his temple pressed to the barrel of a revolver with just one bullet in the chamber. He's gambled with his life so often, he can't believe it's still his. He moves towards the crowded gaming table with a bunch of banknotes in his hand. Michael tries in vain to persuade him to leave. And suddenly there's a flicker of recognition in Nick's eyes. He laughs, takes the gun, holds it to his head and pulls the trigger.

It's the end of the 60s. Michael, Nick and Steven (John Savage), three friends from a steel town in Pennsylvania, are sent to Vietnam. By coincidence, they meet again in the midst of war. And by misfortune, they end up in the hands of the Vietcong. The prisoners are forced to play Russian Roulette

while their captors lay bets on the outcome. Finally, only Michael and Nick are left, face-to-face across the table. Michael demands three bullets instead of one, in order to raise the stakes. His ruse is successful: the two friends overcome the Vietcong guerillas, free Steven from the "tiger cage" (a half-submerged bamboo basket) and flee for their lives. But Michael is the only one who makes it home intact. Steven loses his legs, and Nick gets stuck in Saigon, making money with the game of death.

Only around one-third of this great epic takes place in Vietnam – the middle part. These are among the most impressive images of war ever filmed. The contempt for human life so typical of any war, the hatred, the powerlessness, the fear, and the pride: Michael Cimino brings all these together in a single symbolic action – Russian Roulette. Yet Cimino shows the Americans purely as victims of the Vietnam War, and this provoked a lot of protest, especially in Europe. The Americans, it was claimed, were much more guilty than their opponents of torturing POWs. The film was accused of being racist, and the controversy came to a head at the Berlin Film Festival in

1 War on the home front: Linda (Meryl Streep) and Michael (Robert DeNiro) tackle daily life and its many ghosts.

2 Birds of prey: Michael and Nick (Christopher Walken) on a hunting trip in the mountains.

3 Fun and games in Clairton, Pennsylvania. Cimino shot the Clairton scenes in eight separate locations to breathe life into the fictitious town.

4 Camerawork that is right on target. Cinematographer Vilmos Zsigmond went on to film *Heaven's Gate* (1980) for Cimino.

"There can be no quarrel about the acting. De Niro, Walken, John Savage, as another Clairton pal who goes to war, and Meryl Streep, as a woman left behind, are all top actors in extraordinary form."

Time Magazine

1979, as the Soviet Union, followed by the rest of the Eastern Bloc, withdrew all its films in protest.

But Cimino is not even attempting to provide a political commentary to the Vietnam War. Instead, his film tells the story of people uprooted from everything they used to call home, and it shows the destruction of everything that once made friendship possible. The first hour of the film is devoted to the rituals of the two friends, Michael and Nick. We see their last day in the steelmill; we see them drinking with their buddies from the little community of White Russian immigrants; we see their wild celebrations at Steven's wedding reception, after the Russian Orthodox ceremony. One last time before Vietnam, the friends go hunting in the mountains of Pennsylvania, a pristine contrast to the dirty steel town. Michael's hunting ambition, to kill a deer with

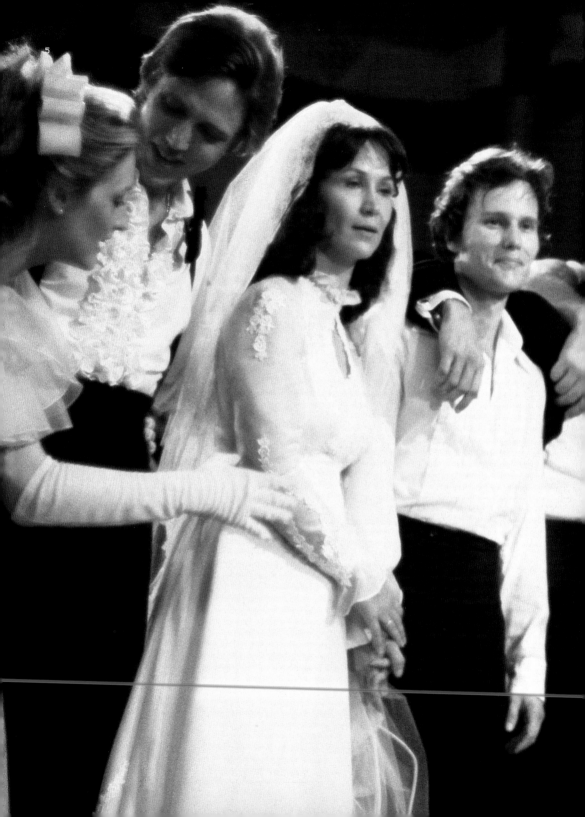

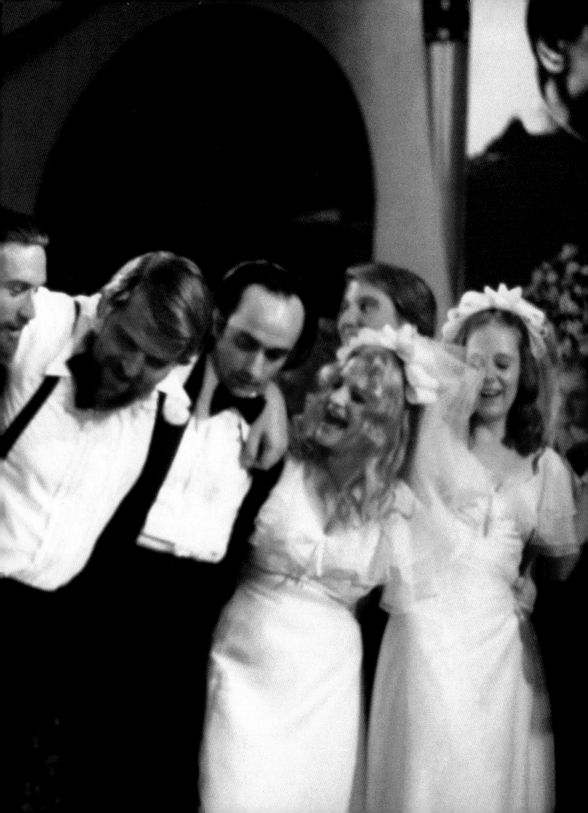

5 Celebrate good times: Steven's (John Savage, fourth from left) wedding marks the last joyous occasion of the boys' lives. Soon they'll be drafted to Vietnam.

6 Caught in the crossfire: Robert de Niro called this role "his toughest yet" after shooting was completed.

7 "One of the most frightening, unbearably tense sequences ever filmed – and the most violent excoriation of violence in screen history," wrote *Newsweek*.

8 Secret admirer: Back from the war, decorated soldier Michael visits the true love of his life – Nick's girl, Linda (Meryl Streep).

a single shot, will not survive his experiences in Vietnam. Indeed, when he returns in the third part of the film, he'll have difficulties even finding his home – because someone's missing, and he's made a promise. That's why he leaves once more, to search for Nick in Saigon.

At the end, the little group of mourners in the bar will strike up "God Bless America," but their rendition of the hymn is anything but triumphant. These people are the walking wounded, and each of them has lost something: a friend, physical wholeness, trust in life, or hope for the future. The fault lies with America; and yet America is their home, a part of their very selves. In *The Deer Hunter*, Cimino shows us this painful contradiction, and gives us a subtle, exact and outstandingly photographed portrait of American society after Vietnam.

NM

'Equally at ease in the lyrical and the realistic modes, a virtuoso of the shocking image who never loses sight of the whole, a consummate master of his technique, Michael Cimino is a supremely accomplished filmmaker.' *Le Monde*

MICHAEL CIMINO

His films are always controversial: *The Deer Hunter* (1978) was showered with Oscars in Hollywood and condemned as a falsification of the Vietnam War in Europe. The epic Late Western *Heaven's Gate* (1980) was hailed as a masterpiece in Europe, and decried as a "catastrophe" in the USA. *Year of the Dragon* (1985), in which a sole cop takes on the Chinese mafia in New York, brought accusations of racism. *The Sicilian* (1987), an opulent biography of the Sicilian popular hero Salvatore Giuliano, was dismissed as historical kitsch.

Michael Cimino (*16.11.1943) came to filmmaking after studying architecture and painting. By the end of the 60s, he was making commercials. In 1973, he joined with John Milius to write the screenplay to *Magnum Force*, starring Clint Eastwood. Cimino's first feature film was *Thunderbolt and Lightfoot* (1974), a tragicomic thriller about a gangster in search of his money, with Eastwood and Jeff Bridges in the leading roles. The debut signaled some of the motifs that would be found throughout Cimino's work: male friendship, detailed milieu studies, and gorgeous landscape panoramas. His expensive obsession with authenticity drove United Artists to bankruptcy, and to this day, *Heaven's Gate* is a synonym for megaflops. Although his last film *The Sunchaser* (1996) was a fairly conventional effort, Michael Cimino is still regarded as one of the most visually brilliant directors in America.

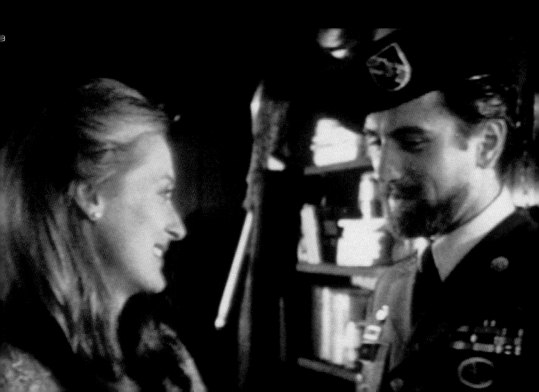

SUPERMAN: THE MOVIE

1978 - GREAT BRITAIN - 143 MIN. - COMIC BOOK ADAPTATION, SCIENCE FICTION

DIRECTOR RICHARD DONNER (*1930)
SCREENPLAY MARIO PUZO, DAVID NEWMAN, LESLIE NEWMAN, ROBERT BENTON, TOM MANKIEWICZ, NORMAN ENFIELD,
from the comics by JERRY SIEGEL and JOE SHUSTER DIRECTOR OF PHOTOGRAPHY GEOFFREY UNSWORTH EDITING STUART BAIRD,
MICHAEL ELLIS MUSIC JOHN WILLIAMS PRODUCTION ALEXANDER SALKIND, PIERRE SPENGLER for DOVEMEAD FILMS,
ALEXANDER SALKIND, FILM EXPORT A. G., INTERNATIONAL FILM PRODUCTION.

STARRING CHRISTOPHER REEVE (Superman / Clark Kent), GENE HACKMAN (Lex Luthor), MARLON BRANDO (Jor-El),
MARGOT KIDDER (Lois Lane), NED BEATTY (Otis), JACKIE COOPER (Perry White), GLENN FORD (Pa Kent), TREVOR
HOWARD (Senator), MARIA SCHELL (Vond-Ah), TERENCE STAMP (General Zod), VALERIE PERRINE (Eve Teschmacher).

ACADEMY AWARDS 1978 SPECIAL AWARD for SPECIAL EFFECTS (Les Bowie, Colin Chilvers, Denys N. Coop, Roy Field, Derek
Meddings, Zoran Perisic).

"Look Ma – No Wires!"

The opening credits, an operatic overture of Wagnerian magnitude, indicate the dimensions of the tale that is to follow. A curtain slowly opens, the clattering of a projector is heard, and a date appears on the screen: "June, 1938." Aficionados understand – this was the month in which Superman made his debut in an issue of the comic series "Action Comics." And there on the screen is the comic book in question; a child's hand gently opens it and leafs through its pages.

The camera dives directly into the comic strip, showing the globe-crowned editorial building of the "Daily Planet." By means of a special effects blend-in, the comic image slowly transforms into a real life representation and the camera steadily wanders higher, focusing on the moon and then speeding past it. From the depths of outer space the first line of the opening credits zooms to the fore, jumping directly into the audience's face. The three words, "Alexander Salkind presents," grow bigger, bursting the borders

of the still visible theater stage and are ultimately emblazoned in the full width of the scope format on the screen. And on we go, hurtling through the cosmos.

An opulent comic book opera like *Superman* must naturally begin deep in the realms of the heavens, and the authors take their time, opening with the pre-story, which takes place on the crystal planet Krypton. Councilor Jor-El (Marlon Brando) warns his people of a threatening catastrophe, but the remaining members of the planet's government sense defeatism in his warning and force him to swear that he will never leave Krypton. Jor-El remains true to his word, as does his wife, but they send their small son, Kal-El towards the Earth in an escape pod. The boy is to be the last of his people, for Krypton falls victim to destruction, just as Jor-El had prophesized. In the meantime Kal-El is taken in by adoptive parents on Earth and grows into Clark Kent, alias Superman (Christopher Reeve).

1 Clothes make the man: With the help of a suit, hat and pair of glasses, the Man of Steel assumes the identity of mild-mannered reporter, Clark Kent.

2 Leaping to new heights in a single bound: With a giant "S" across his chest, Superman (Christopher Reeve) fights for truth, justice and the American way.

3 X-ray vision: Somewhere under all that muscle and bravado lies the Daily Planet's most endearing dolt.

"... to commit the Crime of the Century, a man would just naturally have to face – the Challenge of the Century."

Film quote: Lex Luthor

Director Richard Donner regarded the Superman figure as an age-old American myth and dramatized it accordingly – in epic breadth, with numerous vignettes that highlight the irreproachable character of the boy wonder who falls from the sky. Contrary to Richard Lester, who in the two subsequent *Superman* films employed much more irony, Donner allowed his hero to be a child – a child who must take painful abuse from his peers, voluntarily doing without his superpowers because his mother and father forbade him to use them.

Retribution is granted to the Man of Steel in the last portion of the film when he gains the respect and gratitude of the earth's citizens after preventing a deadly inferno. And of course he wins the love of Lois Lane (Margot Kidder), a reward that surely made saving the world worthwhile.

"Richard Donner's direction is appropriately broad but not unnuanced; each segment of the film has its own mythic unity, related to various genres and movie types; and each has Superman developing not so much as a character but as the focus for different kinds of entertainment." *Monthly Film Bulletin*

4 The perfect illusion: neither a bird nor a plane, but Christopher Reeve as Superman.

5 Swept off her feet: Superman shows Lois Lane (Margot Kidder) the greatest sites Metropolis has to offer.

6 No way out: Armageddon is upon the crystal planet of Krypton.

7 Desperate times call for desperate measures: Jor-El (Marlon Brando) anticipates Krypton's catastrophic end and saves the life of his newborn son.

CHRISTOPHER REEVE During the prolonged preparation phase for *Superman: The Movie* (1978), the search was on for the perfect leading actor. Several male stars of the time were considered, including Burt Reynolds, Sylvester Stallone, Clint Eastwood, and Charles Bronson. But the producers eventually decided upon Christopher Reeve (*1952), who had only appeared as an actor on Broadway. The decision was to prove correct, because as an unknown, Reeve was able to play Superman without eclipsing the new character by previous film roles.

He donned the Superman costume four times for the big screen, but rejected further action films like *The Running Man* (1987). He acted for the theater and appeared in television movies and in one-off screen roles, such as *The Remains of the Day* (1993). In May 1995 he had a severe riding accident and was paralyzed from the neck down. Nonetheless, Reeve remained active, writing his autobiography, *Still Me*, and several screenplays. He also produced and took on suitable roles, like that of the handicapped Jason Kemp in the Hitchcock remake, *Rear Window* (1998). Reeve devotes the majority of his time speaking on behalf of paraplegics; he collects donations and on May 3, 2002, together with his wife, he launched "The Christopher Reeve and Dana Reeve Paralysis Resource Center," which is dedicated to research and information.

Donner's dramatization isn't limited to a mere projection of the familiar themes of the *Superman* saga onto the big screen. He naturally knows where cinematography can surpass the static comic drawings, whose creators were limited to depicting movement with graphic tricks and onomatopoeia. Even well-versed fans of the Superman comics will enjoy watching Superman romping through the heavens like a dancer with Lois Lane in his arms, slinging missiles into outer space, or twisting himself into the Earth's core to prevent the separation of the coast of California.

Donner lays his trumps on the table right at the beginning of the film, focusing on an individual drawing and transcending its borders by making the camera zoom deeper and deeper into the flat surface of the illustration in dimensions that impressively burst the spatial relationships of the comic's story-telling formula, which must adhere to finite viewpoints. Here the film teaches yet another lesson, demonstratively switching from normal to scope format and flexing its technical muscles. The medium not only shows its capacity for monumental imagery but in the way in which the seemingly unbridled camera hurtles at light speed through space, announces its intention to take the audience along on a journey that can be offered nowhere else but in the cinema. For it is only here that Supermen can truly fly.

HK

LA CAGE AUX FOLLES
aka Birds of a Feather

1978 - FRANCE / ITALY - 91 MIN. - COMEDY

DIRECTOR ÉDOUARD MOLINARO (*1928)
SCREENPLAY MARCELLO DANON, ÉDOUARD MOLINARO, JEAN POIRET, FRANCIS VEBER, based on the play of the same name by JEAN POIRET DIRECTOR OF PHOTOGRAPHY ARMANDO NANNUZZI EDITING MONIQUE ISNARDON, ROBERT ISNARDON MUSIC ENNIO MORRICONE PRODUCTION MARCELLO DANON for DA MA PRODUZIONE, LES PRODUCTIONS ARTISTES ASSOCIÉS.

STARRING UGO TOGNAZZI (Renato Baldi), MICHEL SERRAULT (Albin Mougeotte / Zaza Napoli), CLAIRE MAURIER (Simone), RÉMI LAURENT (Laurent Baldi), CARMEN SCARPITTA (Louise Charrier), BENNY LUKE (Jacob), LUISA MANERI (Andrea Charrier), MICHEL GALABRU (Simon Charrier), VENANTINO VENANTINI (Chauffeur).

"What I am supposed to do? He's flying the coop."

What happens when an off-the-wall transvestite walks into a bar like a John Wayne impersonator, rolling her shoulders and standing tall? You guessed it, she is immediately ridiculed as a "faggot," forcing her other half to bravely confront the louse who made the remark and defend her honor. Even when the rogue suddenly reveals himself to be two heads taller than the gallant knight, and possibly a close relative of James Bond's nemesis, Jaws (*The Spy Who Loved Me*, 1977; *Moonraker*, 1979), that's no deterrent – honor is honor. Loved ones are not to be profaned with derogatory terms like that, especially when the person is question is not just an artiste but a star!

The drag-queen who has a whirl at playing cowboy is nightclub diva "Zaza Napoli," in a divine performance by Michel Serrault, who is both a "he" on stage and in life, even when his inner "she" bursts out on occasion with glistening mile-long lashes. Her significant other, the mature and dashing Renato Baldi (Ugo Tognazzi), who is forever sporting a white suit and trimmed moustache, is the owner of the "La Cage aux Folles," a club where night

after night, Zaza leads a high-pitched, high-heeled chorus line of silk-stockings and feather boas to victory. Renato and Zaza have been happily "wed" for the last 20 years. Yet married life can have its ups and downs, like the pair of pumps that are hurled at Renato's head when he bursts into Zaza's flat without first proving his affection. Luckily he's used to such displays of affection and knows exactly when to duck. Just one day in the life of Baldi and Zaza, who goes by the name of Albin Mougeotte during the daylight hours.

This world of fun and games comes to a shuddering halt when Renato's 20-year-old son Laurent (Rémi Laurent) announces his intention to marry Andrea (Luisa Maneri), the young daughter of Simon Charrier (Michel Galabru), deputy general of the Tradition, Family and Morality Party. Unfortunately, Andrea has told her bumptious dad that her father-in-law to be is the Italian consul in Nice. To make matters worse, the putative consul's apartment is full of paraphernalia bound to create an uproar: vases shaped like comely rear

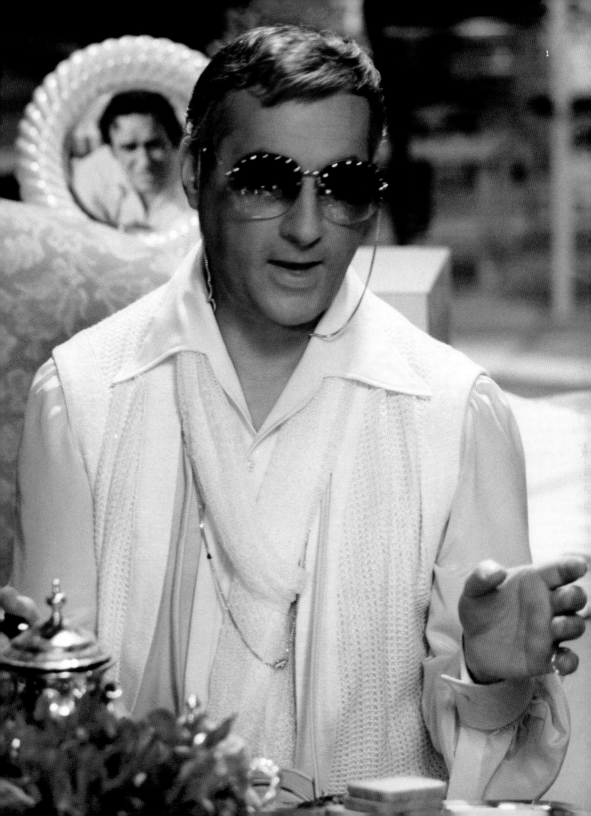

ends, pink frou-frou pillows, a plaster statue of the Greek Adonis and china with lewd kouros motifs. Not forgetting Jacob (Benny Luke), a black manservant who wiggles his way across their deep-pile rugs in a French maid's costume waving a feather duster. None of that would matter, were it not for the fact that the deputy general and his wife announce their imminent visit. The colorful members of this happy family had better put their heads together fast, or they might have one giant catastrophe on their hands…

In *La Cage aux Folles,* virtually every aspect of life is turned on its head. Each paradigm of social normality suddenly indicates its opposite. All that is off-kilter is transformed into the given norm, whereas norms are taboo and leave both the characters and spectators aghast. The film valiantly takes on a barrage of homosexual and effeminate stereotypes, and puts them through

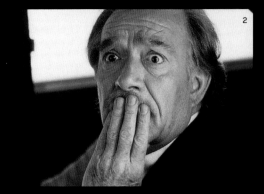

"Édouard Molinaro's light touch ensures that *La Cage aux Folles* is never embarrassing, and he avoids any *faux pas* in dealing with the topic of love between men. This is a bubbly and highly enjoyable film with an unobtrusive moral." *Karlsruher Filmschau*

1 A little dab will do ya: Michel Serrault is a man – he's just a touch more charming, ostentatious and supple than average.

2 A father's worst nightmare: Not only must Renato (Ugo Tognazzi) embrace his son's heterosexuality; he also has to come to terms with his future daughter-in-law – who happens to be the off-spring of Simon Charrier, deputy general of the "tradition, family and morality" party…

3 Charmed, I'm sure: The good-mannered Charrier (Michel Galabru) pays his respects to the alleged woman of the house (Michel Serrault).

4 Birds of a feather: Renato and Albin are storybook soulmates.

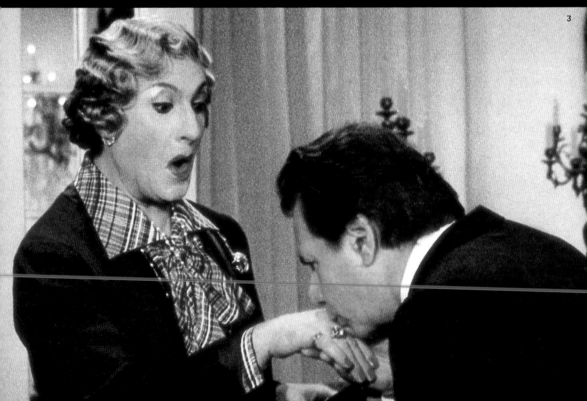

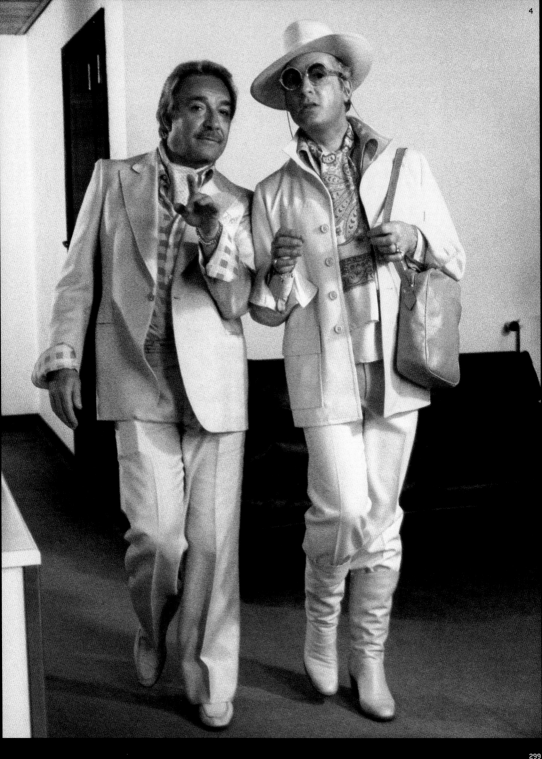

4

"Ugo Tognazzi's nonchalant virility constantly threatens to collapse into girlish affectation, and it harmonizes deliciously with the shamelessly exaggerated effeminacy of Michel Serrault."

Neue Zürcher Zeitung

5

MICHEL SERRAULT

Aged 50, and after countless supporting roles, Michel Serrault (born 1928) was finally offered a part that launched him to new heights. With the greatest of ease, the thespian slipped into the skin of *La Cage aux Folles'* Albin, a sensitive, highly-strung transvestite. In addition to his film portrayal, Serrault gave over 2000 stage performances as Albin in the play of the same name.

It was on the Paris stage that this gifted artist first flew his comedic colors. At the age of sixteen he received acting instruction from Bernard Blier. His film debut followed in 1954. Serrault was successful in moving on to other projects after the enormous public response to *La Cage aux Folles* and its two sequels (1980, 1985). He received the César for "Albin" and then abruptly switched gears from comedy to character acting. No-one could have played the double role of Biedermann and the arsonist better than Serrault. In both Chabrol's *Les Fantômes du chapelier* (*The Hatter's Ghost*, 1982), and Christian de Chalonge's *Dr. Petiot* (1990), he played perfidious, pathological serial killers masked by a façade of decorum and propriety. Simply clothed as an old man in a black hat with a well-trimmed moustache, he'd just tilt up his head, arch his eyebrows and purse his lips and it was instantly clear what sort of sinister intentions were actually harbored in the soul of this upstanding citizen. He played a downtrodden, fatherly private investigator, who combs Europe looking for young murderess Isabelle Adjani in Claude Miller's *Mortelle randonnée* (*Deadly Run*, 1982). He becomes more fixated by her with each passing mile, and is gradually convinced that the modern day Circe is the embodiment of innocence. "Don't laugh too quickly, and take your time before resorting to tears. The trick is to be sober and then wait." These were the words Serrault used on his 70th birthday to characterize what he considered to be the fundamentals of perfect acting.

5 They'll never notice: The grand inquisitor of propriety and morality, M Charrier, makes a graceful exit from the "Cage aux Folles" nightclub in three-inch pumps to dodge the paparazzi waiting at the door.

6 Basking in the limelight: Temperamental diva, Zaza (Michel Serrault), is less than delighted by her new supporting cast.

the wringer. The depiction of Charrier, the defender of propriety, is also hyperbolized. He and his wife sit twelve feet apart from one another at their grand banquet table, and the interior design of their not-so-humble abode is reminiscent of a medieval torture chamber.

Beyond the over-the-top antics and the hare-brained slapstick lies some genuine depth. This is evidenced in the moments of Albin's fragility, such as when he is to driven out of the house because he finds it impossible to act like anyone other than himself. He even makes a concerted effort to play along with the set of the set of the set of the set of the set.

decorated in "good taste," in a black suit and tie. Without his makeup and cramped by a heavily starched dress shirt, he attempts to seat himself as masculinely as possible. His posture while lowering himself, not to mention the way in which he places his hand on the arm rest, immediately give him away. Yet it is precisely when Serrault succeeds in showing how Albin fails at getting outside his own skin that *La Cage aux Folles* is at its most brilliant. In the 1980s, two further installments of the saga rode on the coat-tails of the enormous success of this picture. But like the American remake *The Birdcage* (1996), they couldn't hold a candle to the original.

THE MARRIAGE OF MARIA BRAUN

Die Ehe der Maria Braun

1978 - FRG - 120 MIN. - DRAMA

DIRECTOR RAINER WERNER FASSBINDER (1945–1982)
SCREENPLAY PETER MÄRTHESHEIMER, PEA FRÖHLICH DIRECTOR OF PHOTOGRAPHY MICHAEL BALLHAUS EDITING JULIANE LORENZ
MUSIC PEER RABEN PRODUCTION MICHAEL FENGLER for ALBATROS PRODUKTION, TRIO FILM, FILMVERLAG DER AUTOREN,
TANGO FILM, FENGLER FILMS, WESTDEUTSCHER RUNDFUNK.

STARRING HANNA SCHYGULLA (Maria Braun), KLAUS LÖWITSCH (Hermann Braun), IVAN DESNY (Karl Oswald), GOTTFRIED
JOHN (Willi Klenze), GISELA UHLEN (Maria's Mother), HARK BOHM (Senkenberg), ELISABETH TRISSENAAR (Betti Klenze),
GEORGE BYRD (Bill), CLAUS HOLM (Physician), GÜNTER LAMPRECHT (Hans Wetzel).

IFF BERLIN 1978 SILVER BEAR for BEST ACTRESS (Hanna Schygulla), and BEST TECHNICAL CREW.

"I'd rather perform my own miracles than wait for them to happen."

It's 1943. Maria (Hanna Schygulla) and Hermann (Klaus Löwitsch) have been married for half a day and a single night when the war pulls them apart. Hermann is sent to fight on the Eastern Front, while Maria struggles to make a living on the black market. When the war ends, she's informed that her husband is dead. In the postwar period, everything's in short supply; so Maria ensures her material survival by doing something that can get a girl a bad name: she goes to work in a bar for American soldiers. But she soon makes the rules clear to her clientele: "I sell beer, not me." Maria is no man's property, and she takes what she needs: nylons, cigarettes, and above all warmth, which she finds in the arms of Bill (George Byrd), a black G.I. When the husband she had given up for dead appears in the door one day, there's one man too many in her bedroom. In the heat of the moment, Maria kills her naked lover with a blow from a bottle. Cameraman Michael Ballhaus films this scene in such a distanced fashion that Maria's act of murder seems both unspectacular and wholly absurd. In court, Maria insists that while Bill only liked her, her husband loves her. The judge is uncomprehending, but Hermann understands: he takes the rap for Maria and goes to jail. Maria, meanwhile, goes to work for the textiles manufacturer Karl Oswald (Ivan Desny). In the years that follow, the young woman pursues a brilliant career as a businesswoman and as Oswald's mistress. As she makes clear to the businessman, however, it's not he who's having an affair with her, but she with him. Maria may be calculating, but she's also emotionally honest. She really does like Oswald, but all the time she's saving her money for the house she plans to build for herself and Hermann. By now, Germany is looking tidier: the rubble of wartime has been swept away, and Maria is a wealthy woman, the first member of her family who can afford a house of her own. Suddenly Oswald dies of a heart attack,

"With this cool melodrama full of strong emotions, Rainer Werner Fassbinder has created something exceptional: a densely concentrated film, lively, precise and witty. The dramaturgy is coherent, the dialogue tight, and the actors give highly discerning interpretations of their roles – especially Hanna Schygulla, who was crowned Best Actress at the Berlinale." *Kölner Stadt-Anzeiger*

1 The dragon lady of new Germany: Hanna Schygulla as radiant opportunist Maria Braun.

2 The price of capitalism: In the ruins of post-war Germany, Maria's man takes the fall for her dirty deeds and her career starts to soar.

and shortly thereafter Hermann is released from prison. While the radio transmits the legendary World Cup Final of 1954, the married couple in the big house try to get to know each other all over again. By the time the German soccer team have become World Champions, Maria and Hermann have inherited Oswald's considerable fortune – and they're dead. A gas explosion has destroyed the house and buried the two of them in its ruins.

The Marriage of Maria Braun was Fassbinder's first major international success. Like *The Merchant of Four Seasons* (*Händler der vier Jahreszeiten*, 1972), it paints a depressing and unprettified picture of the German "eco-

nomic miracle." Maria's story reflects the rise of West Germany from the ruins of the lost war to a society in which money, possessions, and social standing count for more than human relationships. Maria Braun is a woman who takes charge of her own life, single-minded in her determination to build a career and accumulate wealth in order to achieve her dreams of happiness. Only when it's too late does she realize that she's lost the very thing she's been working for, that a shared life with Hermann is no longer possible. The film never makes it entirely clear whether the gas explosion was a tragic accident or an act of suicide.

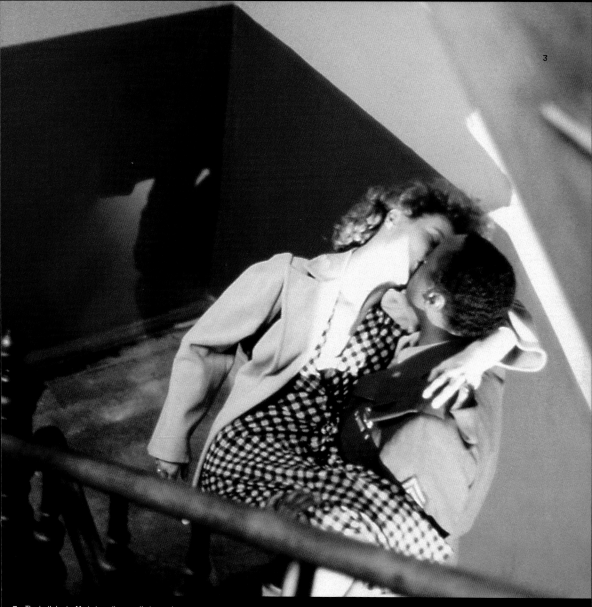

3 The truth hurts: Maria is well aware that sexual relationships have both emotional and financial implications.

Maria begins as an embodiment of the strong women of postwar Germany, who shouldered the reconstruction of the country in the absence of their menfolk. Very soon, however, she's become a typical protagonist of the economic miracle. Hanna Schygulla, one of Fassbinder's favorite actresses, gives a performance of astonishing versatility: the young girl in the American bar is every bit as convincing as the cold and frustrated business-woman. Yet *The Marriage of Maria Braun* offers no kitchen-sink realism. The narrative is concentrated, attenuated, and the characters are highly stylized.

Fassbinder creates a bizarre chronicle of the Adenauer era, in which fragments of superpower politics are strewn casually across the lives of the protagonists. The radio in the living room functions as a link between the private and the public spheres. We hear Adenauer making a speech on the rearmament of the Federal Republic; and a soccer commentary forms a counterpoint to the tragic deaths of Maria and Hermann, as it proclaims the rebirth of the nation in the field of sport. "Germany are World Champions!" indeed; but two of the country's minor players will never share in the celebrations. **KK**

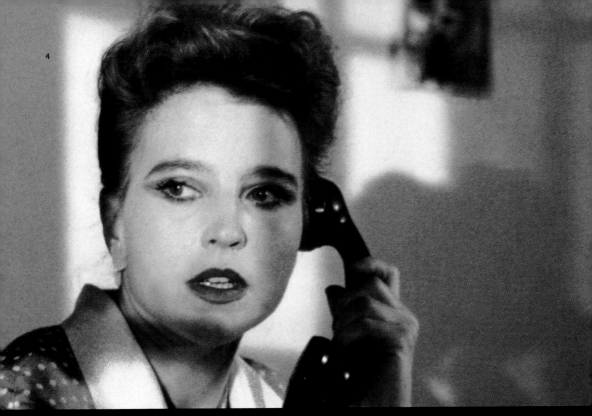

4

4 They left her hanging: Hanna Schygulla was one of the great Fassbinder actresses. But in later years, her inflexible acting style made her little more than a monument to herself.

5 "Who knows Hermann Braun?" Their marriage was only a day and a night old when Hermann departed for the Russian front. When he returns, he'll find life with Maria is not what he bargained for.

"An ambiguous and solidly directed melodrama, *The Marriage of Maria Braun* is undoubtedly the director's best film to date" *Le Monde*

HANNA SCHYGULLA Known as the *femme fatale* of the subculture, Hanna Schygulla was one of the great female icons of the German cinema in the 60s and 70s. It was above all her work with Rainer Werner Fassbinder that made her so instantly recognizable. In no less than 20 productions, she developed a consciously cool, understated style, and an image that made her a kind of anti-star. Born in Kattowitz (now Katowice in Poland) in 1943, she was a young drama student in Munich when she met Fassbinder, who introduced her to his experimental "action-theater" in 1967.

After roles in Danièle Huillet's and Jean-Marie Straub's short film *The Bridegroom, the Comedienne and the Pimp* (*Der Bräutigam, die Komödiantin und der Zuhälter*, 1968) and Peter Fleischmann's *Hunting Scenes from Bavaria* (*Jagdszenen aus Niederbayern*, 1969) she appeared in Fassbinder's *Love is Colder Than Death* (*Liebe ist kälter als der Tod*, 1969). Until 1974, she had roles in all of his subsequent films, including *Katzelmacher* (1969), *The Bitter Tears of Petra von Kant* (*Die bitteren Tränen der Petra von Kant*, 1972) and *The Merchant of Four Seasons* (*Händler der vier Jahreszeiten*, 1972). After *Effi Briest* (1974), there followed a temporary break with the *enfant terrible* of German filmmaking: as Hanna Schygulla explained to the *Berliner Zeitung* in 1994, "There came a time when I no longer wanted to see myself on screen. I felt like a doll, a puppet…" After a four-year pause, the two resumed their collaboration, on a film that achieved international success: *The Marriage of Maria Braun* (*Die Ehe der Maria Braun*, 1978). In the intervening period, she had worked with other directors, on films including Wim Wenders' *The Wrong Move* aka *The Wrong Movement* or *False Move* (*Falsche Bewegung*, 1974) and Vojtech Jasny's adaptation of a Heinrich Böll story, *The Clown* (*Ansichten eines Clowns*, 1975). Hanna Schygulla cultivated an understated acting style, to such an extent that some of her later films made her look like a caricature of herself; examples include Fassbinder's *Lili Marleen* (1980) and Margarethe von Trotta's *Sheer Madness* (*Heller Wahn* / *L'Amie*, 1982). The latter film is regarded as a key work of the feminist movement. In *Passion* (1982), Jean-Luc Godard made subtly ironical use of her image: the character she plays is called Hanna, and her performance has a certain self-reflecting quality.

During the 80s and early 90s, Hanna Schygulla turned up more frequently in foreign films than in German productions. She appeared in Ettore Scola's *La Nuit de Varennes* / *Il mondo nuovo* (1982 – aka *That Night in Varennes*), in Andrej Wajda's *A Love in Germany* (*Un amour en Allemagne*, 1983), and in Kenneth Branagh's *Dead Again* (1991). In the years since then, she has concentrated on theater and concert appearances, often singing songs by the French film and theater composer Jean-Marie Sénia. Her relationship to Fassbinder is a subject she's struggled to come to terms with, and it continues to find expression in her art.

Wer kennt

HERMANN
BRAUN?

Letzte Nachricht aus
dem Raum Smolensk
Fp.Nr. 16310-342

NOSFERATU

Nosferatu – Phantom der Nacht / Nosferatu – Fantôme de la nuit

1978 - FRG / FRANCE - 107 MIN. - HORROR FILM, REMAKE

DIRECTOR WERNER HERZOG (*1942)

SCREENPLAY WERNER HERZOG, based on the novel *DRACULA* by BRAM STOKER, and on motifs from the film *NOSFERATU – EINE SYMPHONIE DES GRAUENS* (1922) by FRIEDRICH WILHELM MURNAU **DIRECTOR OF PHOTOGRAPHY** JÖRG SCHMIDT-REITWEIN **EDITING** BEATE MAINKA-JELLINGHAUS **MUSIC** POPOL VUH, FLORIAN FRICKE **PRODUCTION** WERNER HERZOG, MICHAEL GRUSKOFF for WERNER HERZOG FILMPRODUKTION, GAUMONT.

STARRING KLAUS KINSKI (Count Dracula), ISABELLE ADJANI (Lucy Harker), BRUNO GANZ (Jonathan Harker), JACQUES DUFILHO (Captain), ROLAND TOPOR (Renfield), WALTER LADENGAST (Doctor Van Helsing), JAN GROTH (Harbormaster), CARSTEN BODINUS (Schrader), MARTJE GROHMANN (Mina), RIJK DE GOOYER (Official).

IFF BERLIN 1979 SILVER BEAR for BEST ART DIRECTION (Henning von Gierke).

"Your wife has a beautiful neck."

The camera crawls past a row of mummified corpses: to judge by their grimacing faces, most of these people died in terror. They look as if they had seen Death itself. Our flesh creeps to the funereal sounds of the German band Popol Vuh. Next image: a bat in slow-motion flight. Cut. A waxen-faced woman awakens with a start and releases a bloodcurdling scream.

Only dreaming…

Thus begins one of the most idiosyncratic vampire films of modern times. *Nosferatu* inhabits a world of dim, constricted spaces; extreme contrasts of light and dark give way to nearly monochrome images; long, static shots contrast with an almost hysterically unbridled handheld camera. The film is a cinematic homage to Murnau's dark and magical *Nosferatu – a Sym-* phony of Terror (*Nosferatu – Eine Symphonie des Grauens*, 1922), one of the earliest adaptations of Bram Stoker's *Dracula*.

In a dilapidated castle in the Carpathian Mountains, the sinister Count Dracula (Klaus Kinski) exists, or rather vegetates. Only Lucy (Isabelle Adjani), the beautiful wife of Jonathan Harker (Bruno Ganz) can free him from his terrible lethargy. The film begins with Lucy's nightmare, in which Dracula appears as a bat. She has a terrible foreboding that something dreadful is about to take its course, and that there's nothing she can do stop it. Dracula has written to Renfield, a property agent, expressing his interest in an empty house in Wisborg, Lucy's hometown. It's the beginning of an inexorable courtship dance, which will end in the Count's demise.

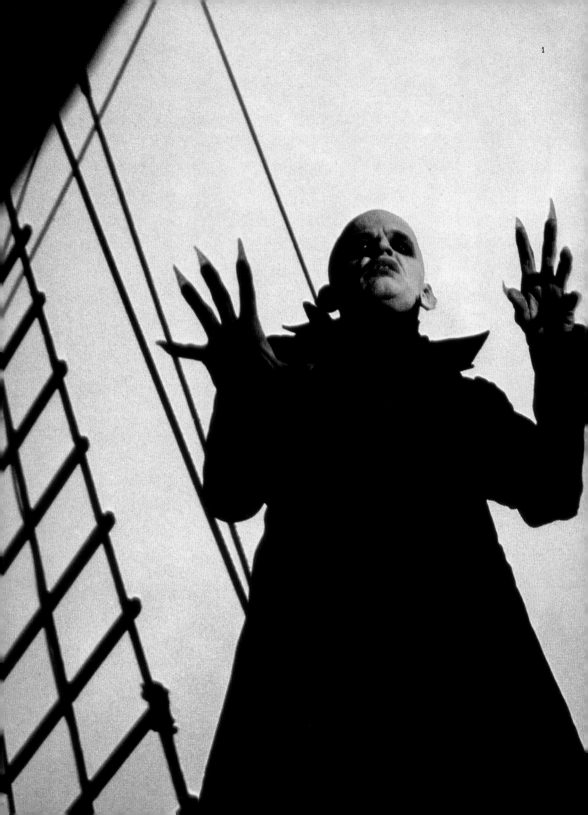

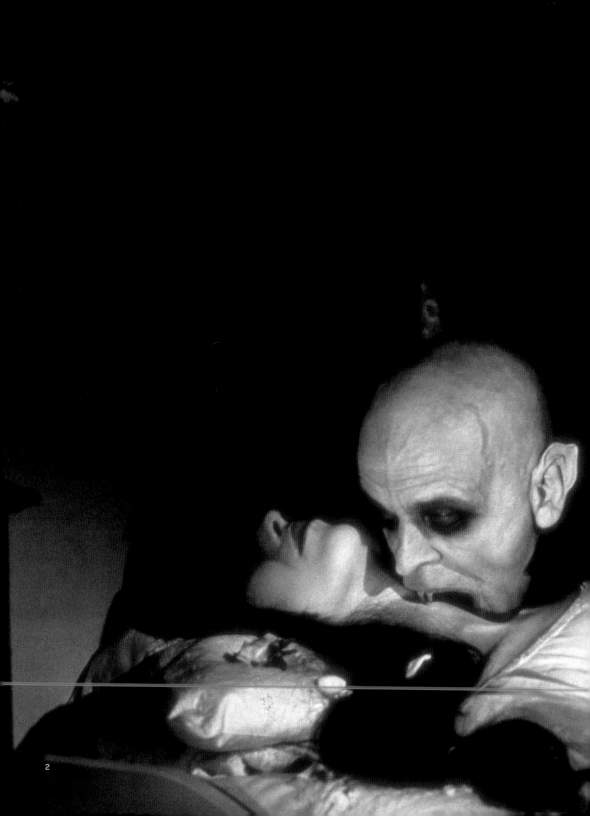

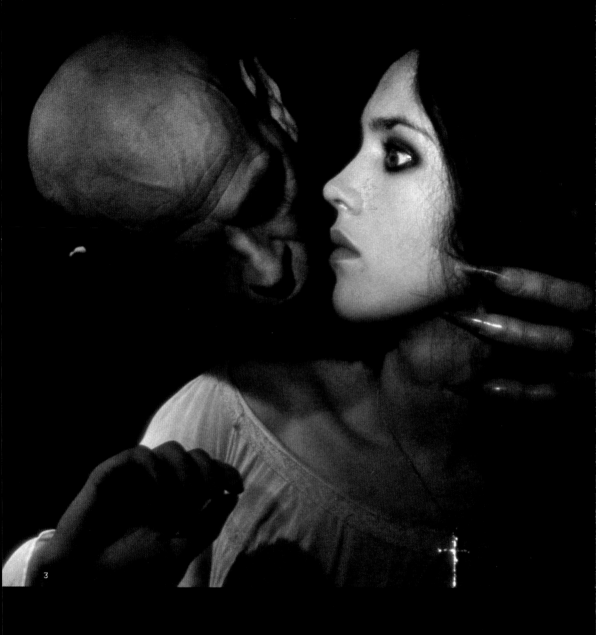

3

KLAUS KINSKI Nikolaus Günther Nakszynski was born in 1926 in Zoppot near Danzig/Gdansk, in the region of Silesia: German territory at the time, but now part of Poland. Kinski's theater career began after the Second World War, and he soon made a name for himself as a brilliant but "difficult" actor. After his cinema debut in *Morituri* (1948), he appeared in numerous films, in which he usually embodied eccentric villains. These included a large number of Edgar Wallace adaptations. His collaboration with Werner Herzog marked Kinski's breakthrough into "serious" cinema and established his reputation as the *enfant terrible* of European film. Both manically extroverted and a tortured perfectionist, Kinski thrillingly depicted a series of malignant, obsessive and untamable characters, in films such as *Aguirre, Wrath of God* (*Aguirre, der Zorn Gottes*, 1972), *Fitzcarraldo* (1978–81) and *Cobra Verde* (1987). In 1987, Kinski directed for the first and only time: the bizarre film biography *Kinski Paganini*, which he also wrote, and in which he played the main character, the Italian violin virtuoso who was said to be possessed by the devil. Again and again, Kinski produced masterly and shocking performances, combining iron professionalism with the ability to "lose control" unforgettably on screen. Werner Herzog produced a fine memorial to the joys and trials of his working relationship with Kinski, in a documentary whose title speaks volumes: *My Beloved Enemy* (*Mein liebster Feind*, 1999). Klaus Kinski died near San Francisco on November 23, 1991.

"My head is one big garbage can where everything is jumbled around."

Klaus Kinski

Nosferatu is more than a skillful reworking of Murnau's film classic and Stoker's novel. Probably only Werner Herzog and his magnificent protagonist Klaus Kinski could have transformed this material into an apocalyptic vision of such unparalleled romantic intensity. Kinski's stylized interpretation of the vampire figure is an unforgettably powerful piece of acting. Take the scene when Dracula receives Jonathan Harker, who has been sent to the castle by Renfield to negotiate the sale of the house in Wisborg. Kinski is the first actor to show the terrifying melancholy at the heart of the Count's murderous obsession. Though the room is gloomy, lit only by candles, Dracula averts his deathly face as if in shame; yet his skinny fingers, with their claw-like nails, seem to reach out for Harker with a terrible life of their own. Jonathan soon falls victim to the undead Count, who can survive only by feeding on the blood of others.

Having placed Harker temporarily out of action, Dracula departs immediately for Wisborg – a pilgrimage to Lucy, from whom he hopes to acquire a new lease of life. He will arrive with an entourage of rats, bringing a plague epidemic to the solid and prosperous German town. In the delirium that follows, we are witness to an apocalyptic drama, a succession of grotesque and

1 The horrors of a bad manicure: Nosferatu (Klaus Kinski) is ready to scratch the eyes out of anyone who dare compare him to his predecessor, Max Schreck.

2 Bloodlust: Lucy (Isabelle Adjani) is precisely Nosferatu's taste.

3 Your kiss is on my list: Does Lucy have the courage to resist the touch of evil?

4 Struck down by the light of day: The Count cannot survive the sun's caress.

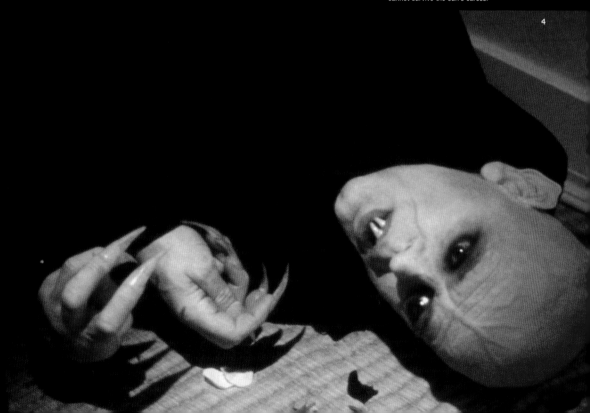

4

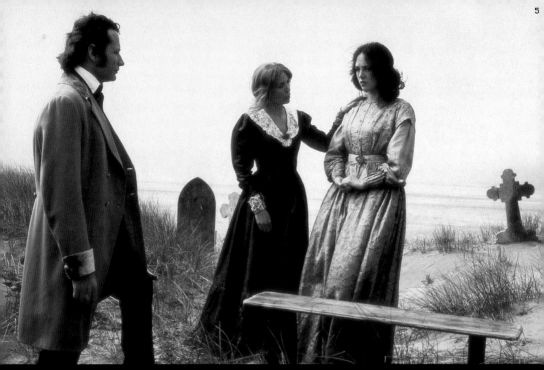

5 Lucy's premonition: Death is written in the wind.

6 The poetry of death: Nosferatu scuttles through the streets of a plagued city.

7 A man on a mission: Jonathan (Bruno Ganz) rides on to Wisborg.

"With this work, Herzog intended 'to forge a link to one of the great films of the German Expressionist era:' Fritz Murnau's 'symphony of horror,' made in 1921. Indeed, Herzog has laced his film with citations from this classic movie."

Frankfurter Allgemeine Zeitung

chilling scenes: an endless procession of coffins, choreographed like a dance of death; a table set for a feast among the rats, with the human guests vanishing in an instant by means of a simple cut. The horror that engulfs Wisborg could hardly be conveyed more poetically, or with a greater feeling for the sheer sadness of death. In the midst of this calamitous confusion, Lucy is the only person who knows what lies at the root of it all, and her nightmares are the source of her knowledge. But no-one will listen to her, not even Van Helsing, the local doctor, whose medical skills are no match for the mysterious powers he finds himself up against.

The film does a great deal more than simply quoting or imitating its predecessors. Herzog's *Nosferatu* casts an entirely new light on the old story. Aesthetically, the film is groundbreaking: the sparing use of dialog, the ethe-

real music, the strange images of the natural world and the claustrophobic treatment of space combine to create an eerie audio-visual *Gesamtkunstwerk* – a total work of art. In content, too, the film opens up new perspectives: unlike Murnau, Herzog depicts Lucy as an autonomous woman, sacrificing herself willingly to free Wisborg from Death's embrace. By pretending to find him attractive, she lures the Count to her bedroom, where she holds him at bay until dawn. The first rays of sunlight are enough to extinguish his life. In the end, however, Lucy's heroism is in vain; for Jonathan Harker, too, has struggled back to Wisborg – and he has become the new Dracula. In a symphony of hypnotic images and sounds, the film shows how the powers of darkness survive, as Jonathan rides towards the darkening horizon with his cloak billowing in the wind ... in search of new blood.

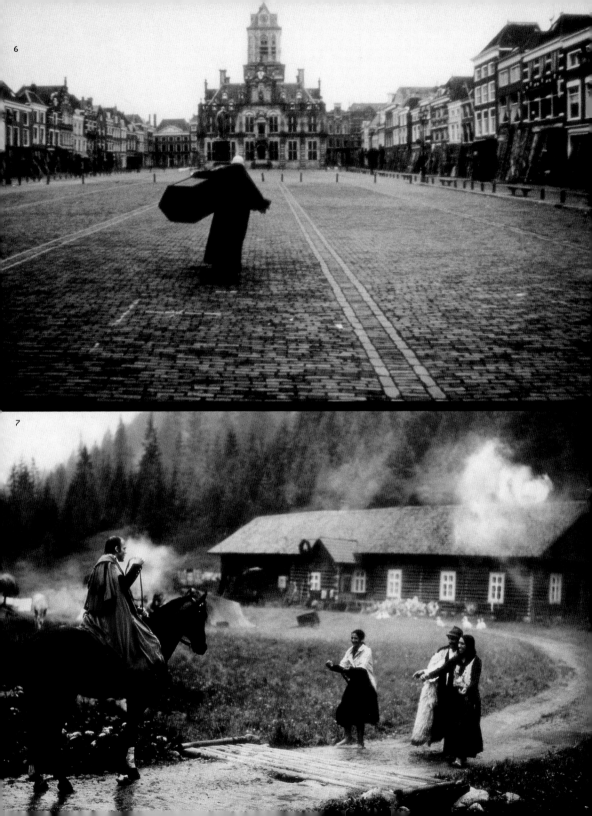

DIRECTOR WOODY ALLEN (*1935)
SCREENPLAY WOODY ALLEN, MARSHALL BRICKMAN **DIRECTOR OF PHOTOGRAPHY** GORDON WILLIS **EDITING** SUSAN E. MORSE **MUSIC** GEORGE GERSHWIN **PRODUCTION** CHARLES H. JOFFE for JACK ROLLINS & CHARLES H. JOFFE PRODUCTIONS.

STARRING WOODY ALLEN (Isaac Davis), DIANE KEATON (Mary Wilkie), MICHAEL MURPHY (Yale), MARIEL HEMINGWAY (Tracy), MERYL STREEP (Jill), ANNE BYRNE (Emily), KAREN LUDWIG (Connie), MICHAEL O'DONOGHUE (Dennis), WALLACE SHAWN (Jeremiah), KENNY VANCE (TV Producer).

"I think people should mate for life, like pigeons or Catholics."

Isaac (Woody Allen) and Tracy (Mariel Hemingway) are a couple. However, since she's only 17 and he's pushing 43, Isaac sees no future prospects for the two of them. "I want you to enjoy me, my wry sense of humor, and astonishing sexual technique, but don't forget you have your whole life in front of you." He dare not term what they have between them as love, instead insisting that it would be better if Tracy regarded him as more of a detour on the highway of her life.

At the end of the day, Isaac has enough problems of his own as it is. His second ex-wife, who left him for another woman, is in the process of writing a book about their failed marriage. Even his job as a comedy writer is any- thing but pleasurable as his true aspiration is to write a novel and establish himself as a serious artist. Acting on a rash impulse, Isaac resigns from his lucrative job in television, which in turn forces him to give up his apartment

and reduce the monthly income he allocates his parents. "This is going to kill my father. He's not going to have as good a seat at the synagogue. He'll have to sit at the back, away from God."

One of the few guiding lights that remain in the midst of Isaac's midlife crisis is his friend Yale (Michael Murphy), who surprisingly confides in the writer about his own infidelity. Isaac just can't come to terms with it, and es- pecially not after he happens to run into Yale's mistress, Mary (Diane Keaton), at the Museum of Modern Art. The woman proceeds to praise a cluster of steel cubes to the skies, quite possibly the most revolting exhibition piece Isaac has ever laid eyes on. "To me it was really textural, it was perfectly integrated, and it had a marvelous sort of negative capability. The rest of the stuff downstairs was bullshit." This type of pseudo-intellectual mumbo jumbo is just the kind of crap Isaac can't stand – at least initially.

Anyone who thinks that first impressions are invariably correct clearly never met these two, for little by little romance blossoms between Mary and Isaac. The affair itself is afforded some of the film's most beautiful imagery, including the oft-cited sunrise scene, in which the two Manhattanites are taken aback by the majesty of the 58th St. Bridge and discuss their deep mutual affection for New York on the riverbank. The scene turns cosmic soon thereafter, when Isaac and Mary seek sanctuary from an incoming storm at the Hayden Planetarium; backlighting accompanied by black and white photography transform them to flirting silhouettes and floating celestial shadows, lifting these two loving souls to new levels of sublimity.

After Yale breaks off his affair with Mary, she turns to Isaac for comfort and succumbs to his charms. Before long, he calls it quits with

"Why is life worth living? It's a very good question. Um... Well, There are certain things I guess that make it worthwhile. Uh... like what... okay... um... For me, uh... ooh... I would say... what, Groucho Marx, to name one thing... uh... um... and Willie Mays... and um... the second movement of the Jupiter Symphony... and um... Louis Armstrong, recording of Potato Head Blues... um... Swedish movies, naturally... *A Sentimental Education* by Flaubert... uh... Marlon Brando, Frank Sinatra... um... those incredible apples and pears by Cezanne... uh... the crabs at Sam Wo's... uh... Tracy's face..." *Film quote: Isaac*

1 The May December romance: Sweet young Tracy (Mariel Hemingway) meets old curmudgeon Isaac (Woody Allen).

2 Mixed-up mother goose: Ex-wife Jill (Meryl Streep) is just about ready to break Isaac's crown.

3 Shadow selves: The characters' gestures and attitudes seem out of sync with the small talk.

4 Mary, Mary, quite contrary: Isaac is subject to extreme mood swings. In the midst of all the emotional turbulence, he can't be sure whether he loves or hates Mary (Diane Keaton).

NEW YORK AS A HOLLYWOOD BACKDROP

Be it *Ghostbusters* (1984), *Three Days of the Condor* (1975), *Sleepless in Seattle* (1993), John Carpenter's *Escape from New York* (1981) or Hitchcock's *Rear Window* (1954), the Big Apple plays an integral role in countless Hollywood films but has itself never been awarded the Oscar. The great U.S. metropolis served as the birthplace of the American cinema in 1896 when Thomas Edison unveiled his moving picture producing "vitascope" on the corner of 34th St. and 6th Avenue in front of Macy's department store. This new marvel of technology quickly attracted enthusiasts like Edwin S. Porter, who is deemed today to be the inventor of film editing and who shot such film hits as *The Great Train Robbery* (1903) with Edison's equipment. There is, however, no denying the film industry's 1914 mass exodus to California, where more space, better weather as well as the peace and quiet essential for the talkies that would come were in abundance. Nonetheless, a great deal of the production companies' administrative and executive offices could still be found in New York for years to come.

Ironically, its climb to fame in front of the camera accompanied the filmmakers' departure from the city. Many screenwriters of the day had resided in the East Coast magnet of urban life and began to produce scripts about the place they knew best. The 1930s saw Hollywood set designers recreating New York City streets, subway stations, bars and even the megalithic skyline whenever called for. The result gave rise to a larger than life image of the town perfumed by the futuristic allure of concepts like "Gotham" and "Metropolis." New York gradually gained mythical character. By many, it was regarded as a modern day Sodom and Gomorrah that would just as soon crush a man as crown him.

Following the end of the World War II, the camera began to return to its actual streets in search of an authenticity inspired by the documentary footage of wartime newsreels and European neorealism. Such was the case when Billy Wilder had Ray Milland walk down the real 3rd Avenue in his *Lost Weekend* (1945) instead of on an artificial Hollywood set. This "return to reality" reclaimed a stronghold on the Hudson River and allowed new film studios that lacked true movie lots of their own to appear on the scene. In particular, the New York based United Artists started to reap some of the sweetest harvests in its company's history. Yet somehow the negative stigma associated with the city lived on at the movies, even in comedies. In the large number of *Superman* and *King Kong* flicks, it continued to represent the bastion of human civilization; in Billy Wilder's classic, *The Apartment* (1960), it embodied isolation and anonymity, whereas *Serpico* (1973) and *Taxi Driver* (1975) branded it the hub of vice and corruption. When one stops to consider the directors who have shown the town's direct impact on their lives through film, the names Sidney Lumet, Martin Scorsese, Spike Lee and Woody Allen immediately come to mind. Of these, Allen stands alone in consistently painting an overwhelmingly positive portrait of the city that has never let go of his heart.

oung Tracy and for the blink of an eye appears to have arrived victoriously in the winner's circle. His dreams are crushed before he even he has ime to take it all in, as Mary brushes him off to try her luck once more with Yale.

The endearingly neurotic characters, led by Isaac, are like atomic particles buzzing about with their constant quips and puns, randomly encountering one another in restaurants or museums, only to lose each other again or no good reason. Adding some zing to the tune of these often off-beat paramours, director Allen zaps the television and film industry with a few volts of Jewish kvetching and deadpan. "Years ago I wrote a short story about my mother. It was called 'The Castrating Zionist'." Allen once stated in an nterview that *Manhattan* was an attempt to blend the comedy of *Annie Hall*

"A masterpiece that has become a film of the ages by not seeking to become a film of the moment. The only true great film of the 1970s."

Andrew Sarris

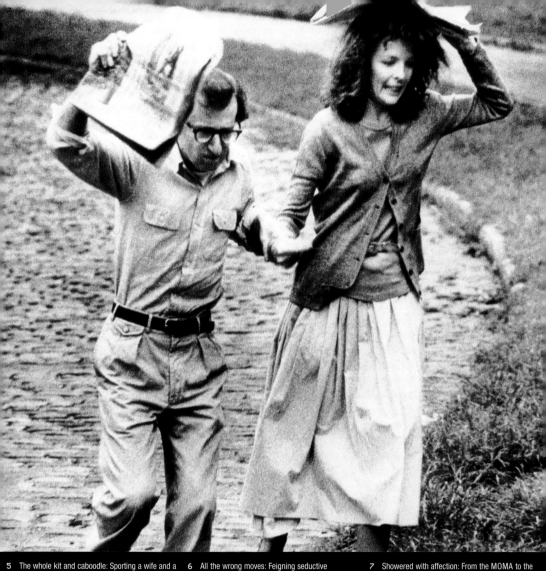

5 The whole kit and caboodle: Sporting a wife and a perfect life, Yale (Michael Murphy) seems to be everything Isaac isn't.

6 All the wrong moves: Feigning seductive nonchalance on a romantic boat trip with Mary, Isaac lets his hand drift casually through the water – and it's soon dripping with something brown and slimy…

7 Showered with affection: From the MOMA to the Planetarium, every inch of Manhattan holds some sentimental value for Woody Allen.

1977) with the seriousness of *Interiors* (1978), his thoroughly unsuccessful tribute to Ingmar Bergman. By abstaining from the forked-tongue satire and horn-honking yuck-yuck jokes that stole scenes in previous works like *Bananas* (1971) and *Everything You Always Wanted to Know About Sex – But Were Afraid to Ask* (1972), the eternal neurotic and one-time stand-up comic created a subdued yet amusing drama that contemplates the romantic

As their appointed knight, Isaac battles the dragons of 60s free love and the ensuing sexual indifference from behind a shield of self-pity and cynicism on his infernally frustrating quest for true love. Yet when the over-the-hill nebbish stands before Tracy like a schoolboy with a crush at the film's conclusion, we are struck by both the vulnerability and the heroic tragedy of his character. It is this heartfelt truthfulness that continues to fill the spectator

ALIEN

1979 - GREAT BRITAIN / USA - 117 MIN. - HORROR FILM, SCIENCE FICTION

DIRECTOR RIDLEY SCOTT (*1937)
SCREENPLAY DAN O'BANNON, RONALD SHUSETT DIRECTOR OF PHOTOGRAPHY DEREK VANLINT EDITING TERRY RAWLINGS, PETER WEATHERLEY MUSIC JERRY GOLDSMITH PRODUCTION GORDON CARROLL, DAVID GILER, WALTER HILL for 20TH CENTURY FOX, BRANDYWINE PRODUCTIONS LTD.

STARRING TOM SKERRITT (Dallas), SIGOURNEY WEAVER (Ripley), VERONICA CARTWRIGHT (Lambert), HARRY DEAN STANTON (Brett), JOHN HURT (Kane), IAN HOLM (Ash), YAPHET KOTTO (Parker), BOLAJI BEDEJO (Alien).

ACADEMY AWARDS 1979 OSCAR for BEST SPECIAL EFFECTS (H. R. Giger, Carlo Rambaldi, Brian Johnson, Nick Allder, Denys Ayling).

"In space no one can hear you scream."

The late 70s were overrun by the science fiction film, a trend that had begun with George Lucas' *Star Wars* (1977). Consequently, when Ridley Scott's *Alien* was released in theaters in 1979, the producers confidently expected the film to attract attention. But audiences were somewhat surprised: the film did not contain impressive space battles, but centered on the almost futile struggle of average, fallible humans against an eerie being, the like of which had never been seen before. *Alien* was pure horror set in outer space – the logical combination of two film genres.

The story takes place somewhere in the near future on the commercial trade space ship "Nostromo," which is on its way back to Earth filled with cargo. The seven-member crew, among them Captain Dallas (Tom Skerritt), his deputy, Ripley (Sigourney Weaver), and helmswoman Lambert (Veronica Cartwright), routinely go about their daily business. No one wastes a minute thinking about the dangers that might be hidden in outer space. But their routine is interrupted by an emergency signal from a planet previously thought to be uninhabited. There, Dallas, Kane (John Hurt) and Lambert find an empty space ship with a hold full of strange eggs. A ghastly

being jumps from one of the eggs and attaches itself to Kane's face, where it remains stuck, as though almost welded to his skin. Back on their ship, the crew determine that the strange being can't be removed from the victim's face. But just a short time later it falls off by itself. The danger seems to have been averted. A deadly meal then ensues. As the crew sit down to eat, we initially believe that Kane's hunger is a sign of his recovery, until a disgusting beast pierces its way through his chest and disappears like lightning into the ventilation shafts of the Nostromo. Clearly the "Alien" transforms its outer appearance during its development and the crew realize that they are going to have to kill the monster before it gets them. One crew member after the other falls victim to this mysterious being. When Captain Dallas is also killed, Ripley takes command of the ship. She learns the true reason for their mission from the ship's computer, "Mother." Their corporation on Earth knowingly misled the crew in order to get their hands on one of the aliens.

Sigourney Weaver, who also played the main role in the three sequels (1986, 1992, 1997) is initially an unsympathetic figure in *Alien*. Consequently

1 All systems operational: Second officer Ripley performing a routine maintenance check.

2 Space bait: A member of the Nostromo investigates the alien distress signal and comes down with a case of indigestion.

3 Shoot the moon: Screenwriter Dan O'Bannon is the veritable bard of futuristic space voyages. In addition to working on *Alien 3 & 4*, he chartered the waters for *Screamers* (Canada/USA, 1995) and John Carpenter's cult classic *Dark Star* (USA, 1974).

4 Regaining consciousness: An alien distress signal leads Mother to wake up her Nostromo crew. Only when it is too late does Ripley realize that the "cry for help" is actually an ominous warning...

"When, as a director, you are offered a project like *Alien* – or any science-fiction-film, really – it is an offer to start with and becomes a confrontation afterwards."
Ridley Scott, in: American Cinematographer

the camera depicts her from a slightly low angle during the first half of the film. She acts in a "manly" fashion and refuses to allow herself to be governed by her emotions. She has no sense of humor and follows the rules by the book, while the other crew members behave helpfully and interact harmoniously. When she is left as the lone survivor, she attributes it to her judgment. In what is literally the last minute she finally manages to blow up the "Nostromo" and thereby destroy the alien.

Alien was Ridley Scott's second feature film after *The Duellists* (1977), and its success instantly catapulted him into the first rank of Hollywood filmmakers. Today his film is regarded as a milestone in the history of horror, applauded with numerous imitations and frequent emulation over the following decades. Scott's recipe for success is based on his preference for

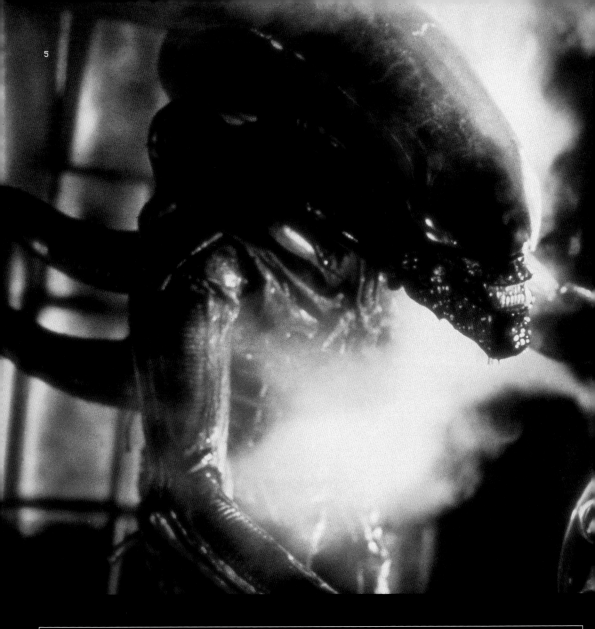

5

H. R. GIGER

The Swiss artist Hans Ruedi Giger was born on 5 February 1940 in Chur. Initially he worked for several years as a construction artist and began studying industrial design at the Zurich School of Arts and Crafts in 1962. After graduating in 1966, Geiger worked as a freelance artist, sculptor, and furniture designer for the renowned production company Knoll. In 1967 he met the actress Li Tober, with whom he lived until her suicide in 1975. In 1969 he designed his first "biomechanical" monsters for Fredi M. Murer's thirty-minute film *Swissmade – 2069.* Erotically sinister machine fantasies would soon become his trademark. At the end of 1977 Giger met his future wife, Mia, whom he divorced in 1982. After contacts with director Alejandro Jodorowsky, for whom he later created the world of the Harkonnen in David Lynch's *Dune* (1984), he was brought aboard the *Alien,* which won an Oscar for Best Special Effects in 1980.

In addition to his work on other films, including David Fincher's *Alien 3* (1992), Roger Donaldson's *Species* (1995), Jean-Pierre Jeunet's *Alien: Resurrection* (1997), and Peter Medak's *Species II* (1998), Giger designed album covers for bands like Blondie, Emerson, Lake & Palmer, and Danzig. He has run the Giger-Bar in Zurich since 1992 for which he even designed the furniture himself. Giger has been together with Carmen Maria Scheifele y de Vega since 1996, and lives and works in Zurich.

subtle horror as opposed to roaring action scenes. In *Alien*, one can detect intimations of the dark, cyber-punk vision the director would demonstrate three years later with *Blade Runner* (1982). From the beginning of the film, Jerry Goldsmith's soundtrack, as rousing as it is oppressive, and Derek Vanlint's slow-motion-like camera movements through the spaceship create a sinister and torturous atmosphere, gradually compressing into pure claustrophobic terror in the last third of the film. The monstrous "Alien," created by H. R. Giger, combines the characteristics of a living organism and a machine – the organic and the inorganic. Blood does not flow through its veins, but corrosive acid. It is surely one of the most terrifying monsters in film history.

APO

"It's an old-fashioned scare movie about something that is not only implacably evil but prone to jumping at you when (the movie hopes) you least expect it." *The New York Times*

5 The A-Team's newest warrior: "Its structural perfection is matched only by its hostility."

6 Raising Cain: The baby alien hatches out of Kane's belly. Unfortunately, the proud mother dies during childbirth.

7 Lip locked: Defying Ripley's orders, Kane is brought back on board the Nostromo along with the alien object hugging his face. Interestingly, Walter Hill was originally signed to direct Alien, but soon passed the baton on to Ridley Scott.

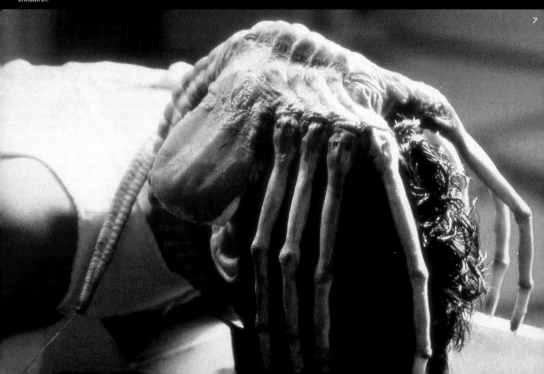

THE TIN DRUM
Die Blechtrommel / Le Tambour

1979 - FRG / FRANCE / POLAND / YUGOSLAVIA - 145 MIN. - LITERARY ADAPTATION, DRAMA

DIRECTOR VOLKER SCHLÖNDORFF (*1939)
SCREENPLAY JEAN-CLAUDE CARRIÈRE, VOLKER SCHLÖNDORFF, FRANZ SEITZ, based on the novel of the same name by GÜNTER GRASS DIRECTOR OF PHOTOGRAPHY IGOR LUTHER EDITING SUZANNE BARON MUSIC MAURICE JARRE, FRIEDRICH MEYER PRODUCTION FRANZ SEITZ, ANATOLE DAUMAN for BIOSKOP FILM, ARTÉMIS PRODUCTIONS, ARGOS FILMS, HALLELUJAH FILMS.

STARRING DAVID BENNENT (Oskar Matzerath), ANGELA WINKLER (Agnes Matzerath), MARIO ADORF (Alfred Matzerath), DANIEL OLBRYCHSKI (Jan Bronski), KATHARINA THALBACH (Maria), HEINZ BENNENT (Greff), ANDRÉA FERRÉOL (Lina Greff), CHARLES AZNAVOUR (Sigismund Markus), MARIELLA OLIVERI (Roswitha), ILSE PAGÉ (Gretchen Scheffler), OTTO SANDER (The Musician Meyn).

ACADEMY AWARDS 1979 OSCAR for BEST FOREIGN FILM.
FF CANNES 1979 GOLDEN PALM (Volker Schlöndorff).

"I first saw the light of the world in the form of a 60-watt bulb."

The film starts and ends in a field of potatoes. "I begin long before me," says the narrator, and describes the events that led to the conception of his mother. We see policemen pursuing a man, before a country girl grants him refuge under her voluminous skirts, where matters take their course. The begetting of Oskar, our narrator, is no less strange: his kindly mother Agnes (Angela Winkler) is married to the loudmouthed grocer Alfred Matzerath (Mario Adorf) and in love with the sensitive Pole, Jan Bronski (Daniel Olbrychski). Oskar is conceived "within this trinity." When he's born, his mother promises him a tin drum; on his third birthday he gets it. And on the same day, already disgusted by the drunken, gluttonous, cacophonous world of the adults around him, he makes an important decision: he's going to stay small. He throws himself down the cellar stairs and immediately stops growing. For the next 18 years, he'll go through life in the body of a three-year-old with a tin drum hanging round his neck. And anyone who tries to take th

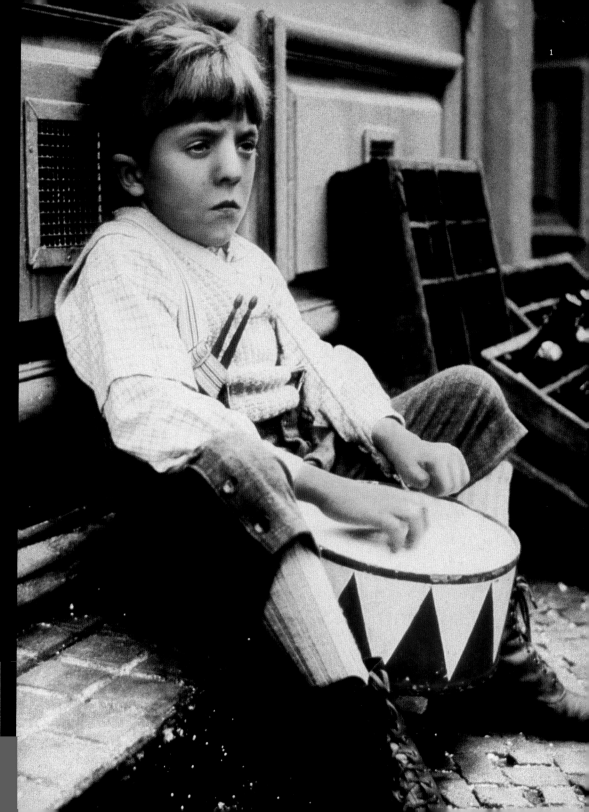

"Schlöndorff deliberately looked for a simpler narrative style. Whole fragments of the book were simply left out. Yet I still feel that he's succeeded in casting a new light on the whole story." *Günter Grass, in: Sequenz*

1 Toy soldier: On his third birthday, Oskar Matzerath (David Bennent) is given a tin drum...

2 ... and, disgusted at the adult world, he resolves to stop growing immediately.

3 Sins of the fatherland: Oscar's father, grocer Matzerath (Mario Adorf), is a fervent fan of Adolf Hitler.

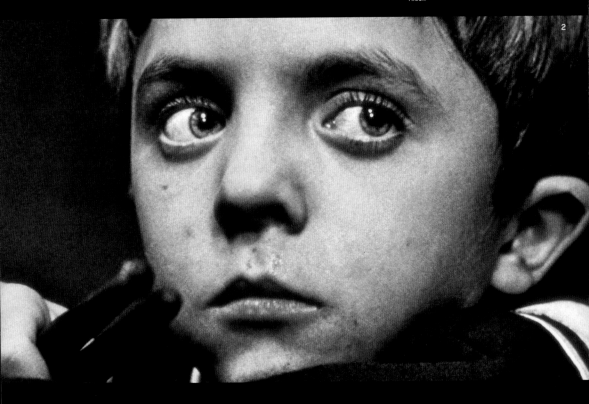

drum away from him will be subjected to little Oskar's unearthly, glass-shattering scream.

Oskar is no normal child. From the day he's born, he can think and make decisions for himself; and his strangeness sets him apart. *The Tin Drum* is an opulent panorama of German-Polish history, seen through the eyes of an outsider. We are witness to the years between 1899 and 1945, from the peaceful co-existence of Germans and Poles in Danzig, to the German attack on the city, to Oskar's flight westwards as the war draws to a close. In the film's final image, the camera watches from the potato field as he fades into the distance. Tectonic shifts in politics are made visible in tiny details, as when Beethoven's portrait makes way for Hitler's. Oskar takes

no sides in all this; he remains an outsider. Once, however, his drumming causes chaos at a Nazi meeting. Oskar carries on drumming till everyone present is swaying happily to the strains of "The Blue Danube." It's reminiscent of the scene in *Casablanca* (1942), where the "Marseillaise" does battle with "Die Wacht am Rhein." On another occasion, Oskar lets the Nazis draw him in: he meets some kindred spirits at a circus, dwarves employed as clowns and later as "a tonic for the troops." Oskar joins them, and soon he too is wearing a Nazi uniform.

If the story is episodic and discontinuous, the cinematic style is a riot. Adapted from the novel by Nobel Prizewinner Günter Grass, the film is a kind of comical yarn, a burlesque bubbling over with ideas, by turns naturalistic

VOLKER SCHLÖNDORFF The German weekly *Die Zeit* once had the following to say about Völker Schlöndorff: "Together with Fassbinder, he's undoubtedly the most skilled craftsman in German cinema; but he's not a director whose films can be said to add up to an inimitable style." Yet most of his films can be brought under a single heading: literary adaptations. So Volker Schlöndorff was perhaps an ideal director for *The Tin Drum* (*Die Blechtrommel* / *Le Tambour*, 1979).

He learned his trade in the Paris of the Existentialists and the *Nouvelle Vague*. He assisted Jean-Pierre Melville and Louis Malle before making *Young Toerless* (*Der junge Törless* / *Les Désarrois de l'élève Törless*) in 1966 – based on a story by Robert Musil. The works of other great writers would follow: Heinrich von Kleist (*Michael Kohlhaas – der Rebell*, 1969), Marcel Proust (*Swann in Love* / *Eine Liebe von Swann* / *Un amour de Swann,* 1983), and Arthur Miller (*Death of a Salesman,* 1985). In the 70s, he turned his attention to the contemporary political scene. Together with his then-wife Margarethe von Trotta, he made *The Lost Honor of Katharina Blum* (*Die verlorene Ehre der Katharina Blum,* 1975), based on a short novel by Heinrich Böll. He then took part in a collective project involving directors such as Alexander Kluge, Rainer Werner Fassbinder and others: *Germany in Autumn* (*Deutschland im Herbst,* 1977/78) described the atmosphere in the country after the abduction of Hanns Martin Schleyer by the Red Army Faction, otherwise known as the Baader-Meinhof Group. In 1999, Schlöndorff returned to this theme, in the drama *Legends of Rita* (*Die Stille nach dem Schuss*), which tells the story of former terrorists gone to ground in East Germany.

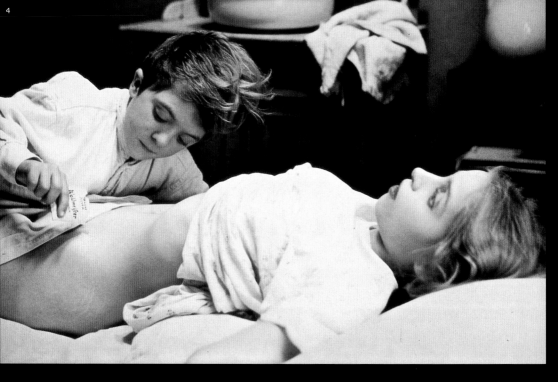

"A very German fresco: world history seen and experienced from below. Huge, spectacular images, held together by tiny Oskar."
Volker Schlöndorff

4 Maid to order: A bellybutton full of sherbet marks Oskar's first sexual experience with servant Maria (Katharina Thalbach).

5 Marching band: Oskar's musical interludes disrupt his mother's regular Thursday rendezvous with Jan.

6 An officer and a gentleman: Oskar falls in love with the midget Roswitha (Mariella Oliveri).

7 The joker's wild: Gambler and ladies' man, Jan Bronski (Daniel Olbrychski), is also an anti-fascist.

MONTY PYTHON'S LIFE OF BRIAN

1979 - GREAT BRITAIN - 94 MIN. - COMEDY, SPOOF

DIRECTOR TERRY JONES (*1942)
SCREENPLAY GRAHAM CHAPMAN, JOHN CLEESE, TERRY GILLIAM, ERIC IDLE, TERRY JONES, MICHAEL PALIN **DIRECTOR OF PHOTOGRAPHY** PETER BIZIOU **EDITING** JULIÁN DOYLE **MUSIC** GEOFFREY BURGON, MICHAEL PALIN ("Brian's Song"), ERIC IDLE ("Always Look on the Bright Side of Life") **PRODUCTION** JOHN GOLDSTONE for HANDMADE FILMS LTD., PYTHON (Monty) PICTURES LIMITED.

STARRING GRAHAM CHAPMAN (Brian and two other roles), JOHN CLEESE (Reg, Centurion and four other roles), TERRY GILLIAM (Jailor and three other roles), ERIC IDLE (Stan, Loretta and eight other roles), TERRY JONES (Brian's Mother, St. Simon and three other roles), MICHAEL PALIN (Francis, Prophet and six other roles), TERENCE BAYLER (Gregory), CAROL CLEVELAND (Mrs. Gregory), KENNETH COLLEY (Jesus), Sue Jones-Davies (Judith).

"Blessed are the cheese makers?"

The zeal of the righteous knew no limits: this film was banned even in isolated Scottish communities that didn't have a cinema. Yet offense should have been taken only where it was intended: by religious fanatics, who can tolerate opposition as little as they can take a joke. The humor of Monty Python is simply beyond these latter-day scribes and Pharisees. In fact, few of the film's opponents had actually seen the film; and even now, John Cleese and Terry Gilliam insist that their monumental epic has nothing whatsoever to do with the life of Jesus. It can't be denied, though, that the film raises doubts about his uniqueness as a religious founder, telling the tale of a parallel Passion endured by a simple man: Brian of Nazareth, a reluctant Messiah, born on the same day as Jesus and crucified under Pontius Pilate. We should probably count our blessings, for the revolutionary British comedy team had originally planned an alternative biography of the Man from Galilee. The title, proposed by Eric Idle: "Jesus Christ: Lust for Glory"... The real Jesus makes a brief and dignified appearance, but his Sermon on the Mount can barely be heard by most of the people in the massive crowd. ("Blessed are the Greek?")

Brian too, played by Graham Chapman, is sadly misunderstood; indeed, in his clumsiness, he achieves almost tragic stature. His central message,

"You're all individuals," (The crowd: "We're all individuals!") brings him into fatal conflict with the merciless yearning for salvation so prevalent at the time. Though he asks his disciples to leave him in peace ("Piss off!"), they refuse to take the hint. A large part of the film's comic effect consists in its impressive attempt to sum up 2,000 years of world history in a very small number of characters; and what's more, they're all played by Pythons. Brian's selfless dedication to the cause of the People's Front of Judea reflects the eternal struggle against imperialism and the tortured history of the Holy Land. The movement of resistance against Roman occupation is crippled by internal divisions, and restricted almost entirely to the kind of revolutionary rhetoric to be heard at British universities in the 60s and 70s. Again and again, the film thwarts the audience's expectations of a historical epic, and the results are sometimes astonishing. When Brian scrawls graffiti on the palace walls, he's caught by a Roman centurion (John Cleese); but instead of arresting the culprit, he subjects him to a painful Latin lesson, in which the phrase "Romans go home" is reduced to a grammatical conundrum. This dialectic of form and content is at the root of several successful jokes, involving ex-lepers, proconsuls with speech defects, and women who disguise themselves with false beards in order to take part in a public stoning. The

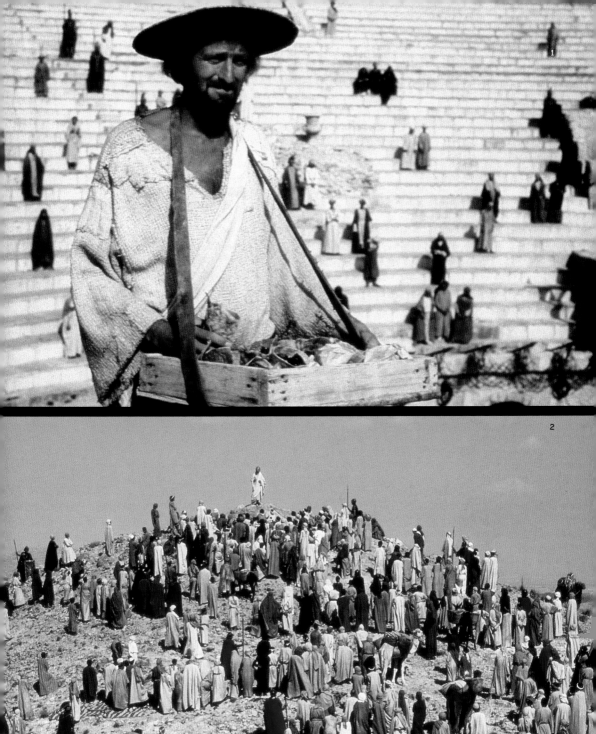

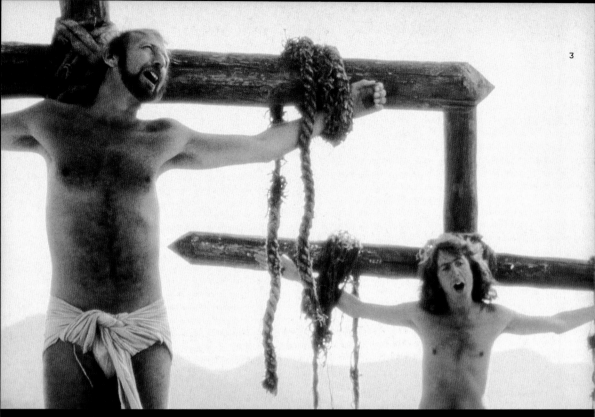

1 "Larks' tongues! Otters' noses! Ocelot milk!" Brian (Graham Chapman) scrapes a living selling Roman delicacies in the Colosseum. But not for much longer…

2 If only they'd had Dolby Surround: In the Pythons' movie, as in several serious takes on the New Testament, Jesus is relegated to a marginal role.

3 That's all folks! "Always Look on the Bright Side of Life" was the ultimate hymn to optimism.

absurdity – the madness – only fully dawns on Brian as he's hanging on the cross, serenaded by Eric Idle and a host of crucified miscreants. Their advice? "Always look on the bright side of life."

Breaking with their usual practice, the sketch specialists worked long and hard on the internal unity of this fulminating late work. The short inter-mezzo with an alien spacecraft was an affectionate nod to Terry Gilliam's animated fillers, and as such, indispensable. The film owes its visual brilliance to the recycled sets of Franco Zeffirelli's TV mini-series *Jesus of Nazareth / Gesù di Nazareth* (1977) – an elegant solution to the Pythons' permanent problems with money. The Tunisian locations lent further splendor to this parody of bombastic Biblical blockbusters, and additional help was provided by the former Beatle George Harrison, who rescued the project at the last minute by forming Handmade Films. He simply wanted to see one more Python movie. Later, he enabled them to realize projects like *Time Bandits* (1981) and *Monty Python Live at the Hollywood Bowl* (1982). In *The Life of Brian*, he makes a cameo appearance as Mr. Papadopolous, a man trying to sell his olive grove.

PB

CHRIST AT THE MOVIES OR THE NEW TESTAMENT IN FILM

Years before *Monty Python's Life of Brian* (1979) and Martin Scorsese's scandalous *The Last Temptation of Christ* (1988), an American-Israeli co-production delivered the most daring cinematic interpretation of the New Testament. *The Passover Plot* (1976) depicted Jesus as an opportunist who fakes his own resurrection as a clever propaganda trick in the struggle against Roman occupation. The churches' official image of Jesus was more closely approximated in Hollywood's Biblical epics. Cecil B. DeMille's silent classic *The King of Kings* (1927), the 1961 remake by Nicholas Ray (*King of Kings*), and George Stevens' *The Greatest Story Ever Told* (1964) all drew strongly on the visual tradition of Renaissance painting. Such films made no attempt to examine Jesus' personality, presenting him instead as a pious and passive victim of unavoidable events. In movies like *Barabbas* (1962), Biblical sidekicks acquired unexpected promotion, in an effort to accommodate armies of Hollywood stars. In the Stevens blockbuster, John Wayne made a cameo appearance as a Roman centurion at the foot of the Cross. His delivery of the line "Truly this man was the son of God" was indeed unforgettable.

The dilemma was: how could the epic structure of the material be reconciled with a humanized depiction of the central figure? Italian productions indicated a possible answer. Directors such as Franco Zeffirelli and Roberto Rossellini brought a realistic treatment of the historical context to the Bible's message of redemption. It was a self-confessed atheist, however, who came up with the most convincing cinematic solution: austere and evocative in its visual imagery, Pier Paolo Pasolini's *The Gospel According to St. Matthew* (*Il vangelo secondo Matteo*, 1964) places its trust in the poetic power of the Biblical texts. May we be pardoned for remarking that this film had a script made in Heaven.

"Just when you thought that the uproarious English comedy troupe had taken bad taste as far as it could go in *Monty Python and the Holy Grail*, along comes *Monty Python's Life of Brian* to demonstrate that it's possible to go even farther in delirious offensiveness. Bad taste of this order is rare but not yet dead." *The New York Times*

4 Hair-brained schemes: In first-century Judea, there's a booming market in loopy ideas. Michael Palin played a particularly furry prophet.

5 *Au naturel:* The Pythons have never been afraid to look ugly…

6 Cutting room execution: King Otto's suicide squad was axed from the picture before it had a fighting chance.

APOCALYPSE NOW

⚊⚊

1979 - USA - 153 MIN. - WAR FILM

DIRECTOR FRANCIS FORD COPPOLA (*1939)
SCREENPLAY JOHN MILIUS, FRANCIS FORD COPPOLA, MICHAEL HERR (off-screen commentary), based on motifs from the novella *HEART OF DARKNESS* by JOSEPH CONRAD **DIRECTOR OF PHOTOGRAPHY** VITTORIO STORARO **EDITING** LISA FRUCHTMAN, GERALD B. GREENBERG, RICHARD MARKS, WALTER MURCH **MUSIC** CARMINE COPPOLA, FRANCIS FORD COPPOLA, THE DOORS (Song: "The End") **PRODUCTION** FRANCIS FORD COPPOLA for ZOETROPE CORPORATION, OMNI ZOETROPE.

STARRING MARLON BRANDO (Colonel Walter E. Kurtz), ROBERT DUVALL (Lieutenant Colonel William Kilgore), MARTIN SHEEN (Captain Benjamin L. Willard), FREDERIC FORREST ("Chef" Jay Hicks), ALBERT HALL (Chief Quartermaster Phillips), SAM BOTTOMS (Lance B. Johnson), LAURENCE FISHBURNE (Tyrone "Clean" Miller), DENNIS HOPPER (Photo-journalist), G. D. SPRADLIN (General R. Corman), HARRISON FORD (Colonel G. Lucas).

ACADEMY AWARDS 1979 OSCARS for BEST CINEMATOGRAPHY (Vittorio Storaro), and BEST SOUND (Walter Murch, Mark Berger, Richard Beggs, Nathan Boxer).

IFF CANNES 1979 GOLDEN PALM (Francis Ford Coppola).

"I love the smell of napalm in the morning."

Vietnam, 1969. Captain Willard (Martin Sheen) is on a top-secret mission to find Colonel Kurtz (Marlon Brando), a highly decorated U.S. Army officer. And when he's located the man, his next task will be to kill him; for Kurtz has clearly gone mad, is defying the control of his superior officers, and now commands a private army in the jungle beyond the Cambodian border. His soldiers are a mixed bag of indigenous people, South Vietnamese, and rogue G.Is, who he uses to his own unauthorized and murderous ends. Willard boards a patrol boat and heads upriver through the rainforest in search of Kurtz; and the further he penetrates into the jungle, the more intensely he and his four comrades experience the horror of war.

No other movie of the 70s received so much attention before it was even released. Francis Ford Coppola was the first director to risk making a big-budget film about the Vietnam War, and he did so with almost demonstrative independence. As his own production company American Zoetrope financed the film, *Apocalypse Now* could be made without the usual assistance – and interference – from the Pentagon. (Even today, such help is practically obligatory when a war film is made in the United States.) Coppola said later that he had originally aimed to make a lucrative action movie. Instead,

the film became an unparalleled nightmare for the celebrated director of *The Godfather* (1972) – and not just in financial terms.

Coppola was looking for a country with a climate similar to Vietnam's, so he chose to film in the Philippines. As the necessary infrastructure was lacking, conditions were quite hair-raising from the word go. The military equipment, for instance, was the result of a deal with the dictatorial President Marcos, who was fighting a civil war against communist rebels while the film was being made. As a consequence, helicopters were sometimes requisitioned from the set at short notice and sent off by the military to take part in real battles. Conditions as tough as these made it hard to find stars willing to take part. Initially, the role of Willard was taken by Harvey Keitel, but he was replaced by the little-known Martin Sheen after only three weeks' filming, as his expressive acting was not to Coppola's taste, and he wanted a more passive protagonist. This was an expensive mistake, but harmless in comparison to the problems the director would later face. There was the deadly typhoon that destroyed the expensive sets; the almost fatal heart attack suffered by Martin Sheen; the difficulty of working with the grossly overweight Brando; and above all, the trouble caused by the director's own constant departures

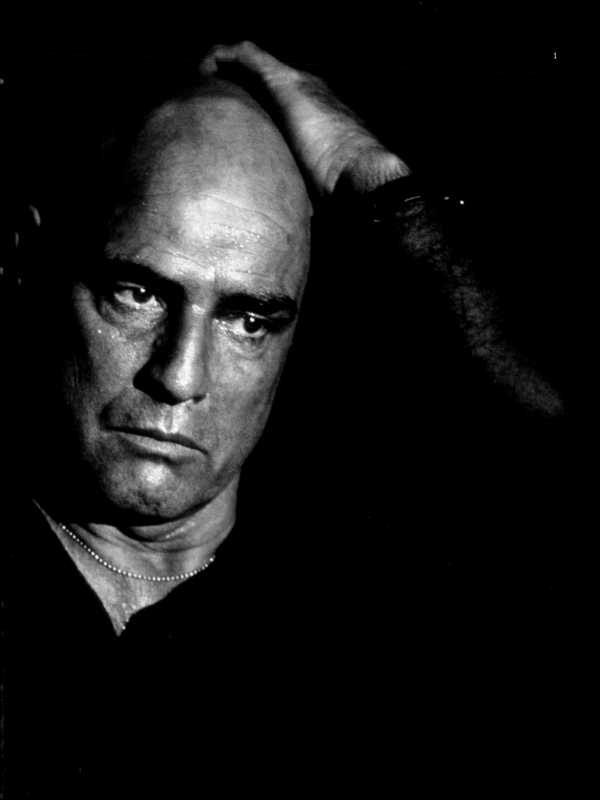

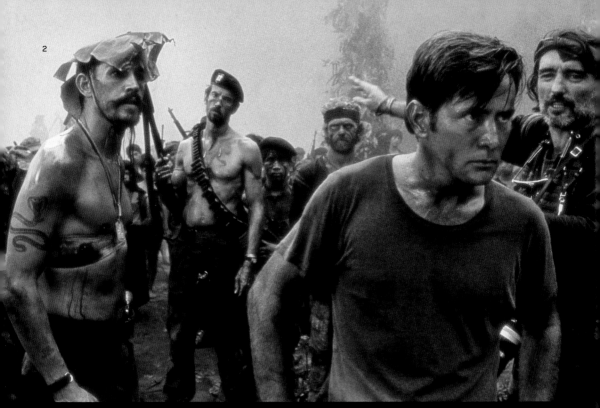

1 Tribal titan: Marlon Brando rocked the screen in his role as Colonel Kurtz although he only appeared at the end of the movie.

2 Battle of the Bulge: Captain Willard (Martin Sheen) and the photographer (Dennis Hopper) flesh out the fate of Colonel Kurtz.

3 Duty calls: Filmed on location in the Philippines, *Apocalypse Now's* helicopter was taken off the set and flown into the front lines of battle.

"My film is not a movie. My film is not about Vietnam. It is Vietnam. That's what it was really like. It was crazy."

Francis Ford Coppola, IFF Cannes

from the script. As a result, work had to stop on several occasions, and the filming period expanded from four to 15 months. Soon, the 16 million dollar budget was exhausted, and Coppola – close to physical and mental collapse – was forced to mortgage his own property in order to raise the same sum all over again. The press could smell a disaster of previously unheard of proportions. But though two more years were taken up by post-production, the film ultimately became a box-office hit – despite mixed reviews, and the fact that other "Vietnam movies" had by then already reached the screen.

The legendary status of *Apocalypse Now* is inseparable from the spectacular circumstances of its making. Many people, including Coppola himself, have drawn an analogy between the Vietnam conflict itself and the agonized struggle to complete the film. It's all the more remarkable, then

that Coppola succeeded in freeing himself, gradually but radically, from the superficial realism that tends to typify the war-film genre. The Vietnam War has often been described as a psychedelic experience, but Coppola and his cameraman Vittorio Storaro created images that actually do justice to the description. Willard's trip upriver, inspired by Joseph Conrad's novella *Heart of Darkness*, is a journey into the darkness of his own heart, and so the various stages on his journey acquire an increasingly fantastic, dreamlike quality. At the beginning of his odyssey, Willard encounters the surfing fanatic Lieutenant Colonel Kilgore (Robert Duvall), who sends his squad of choppers in to obliterate a peasant village so that he can enjoy the perfect waves on the neighboring beach. Kilgore's insane euphoria is heightened by the musical accompaniment: Wagner's "Ride of the Valkyrie." At this point, Willard is

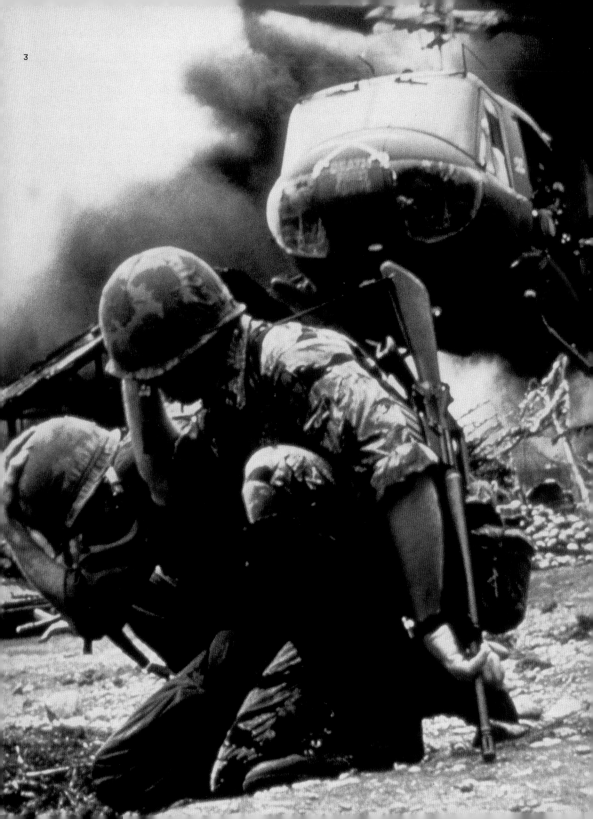

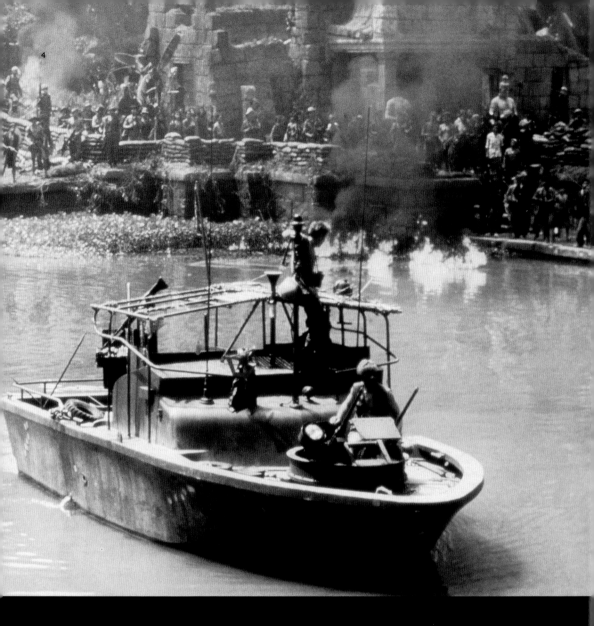

4

no more than a passive observer of a monstrous spectacle, which is ironic-
ally depicted by Coppola as a kind of hi-tech U.S. Cavalry. It's a grimly satir-
ical scene, in which the director makes masterly use of aesthetic conventions
for his own purposes.

Willard's journey terminates in a realm of the dead: Kurtz's bizarre and
bloody jungle kingdom, a garishly exotic and obscenely theatrical hell-on-
earth. As embodied by Marlon Brando, Kurtz has the quality of a perverted
Buddha. When he first receives Willard in his murky temple residence, both
men are sunk in the surrounding shadows. At the end of the line, in the heart
of darkness, good and evil have grown indistinguishable, and Willard has lost
what distance he ever had: Kurtz has become part of his very self. When

Willard finally kills him, the act – like an archaic ritual – is at once an exor-
cism and a manifestation of the darkness at the heart of mankind, a black
stain no civilization will ever erase. Ultimately, it's the cause and the irre-
ducible essence of war – whatever the epoch, and whatever the weapons
deployed.

In 2001, Coppola brought out *Apocalypse Now Redux*, a director's cut
that was 49 minutes longer. It contains some sequences that had fallen
victim to the cutter's shears, and the director says it's the closest possible
approximation to his original intentions. Yet although the *Redux* version is
undoubtedly somewhat more complex than the original, it constitutes neither
a radical alteration to, nor a significant improvement on the original. JH

4 The river wild: Civilization on a voyage downstream.

5 The buck stops here: Having made it to the end of his journey, Willard is prepared to kill Colonel Kurtz.

"It is not so much an epic account of a grueling war as an incongruous, extravagant monument to artistic self-defeat."

Time Magazine

FRANCIS FORD COPPOLA Francis Ford Coppola (*7.4.1939 in Detroit) enjoyed a sheltered middle-class childhood in a suburb of New York. His father Carmine was a composer and musician who would later write the music to some of his son's films. Coppola at first studied theatre at the Hofstra University, then film at UCLA. While still a student, he worked as an assistant director to Roger Corman, who also produced his first feature film, *Dementia 13* (1963). Coppola made his breakthrough at the early age of 31, when his screenplay to *Patton* (1969) was awarded the Oscar.

A short time later, he was also world-famous as a director – and as the Boy Wonder of the New Hollywood: the Mafia saga *The Godfather* (1972) became one of the biggest hits in movie history and won three Oscars, including Best Film. Two years later, he topped even this: *The Godfather – Part II* (1974) scooped six Academy Awards – including Best Director. In the meantime, Coppola had also made an outstanding movie about an alienated surveillance expert: *The Conversation* (1974), which carried off the Golden Palm at the Cannes Festival.

In 1976, Coppola began work on the Vietnam film *Apocalypse Now* (1979), which he produced himself, and which came very close to ruining him. But after four years in production, that film also won the Golden Palm and two Oscars, and even recouped the huge sum that had been spent making it. Only two years later, however, the failure of the love story *One from the Heart* (1981) drove him into such horrendous debt that he was forced to sell his production company, American Zoetrope. Though he has since directed other films, such as *The Cotton Club* (1984) and *The Godfather – Part III* (1990), none have been as successful as his huge hits of the 70s.

Top-left: 5

INDEX OF FILMS

GENERAL INDEX

Production companies are listed in italics; film categories are preceded
by a dash; numbers in bold refer to a glossary text.

GENERAL INDEX

GENERAL INDEX

ABOUT THE AUTHORS

Philipp Bühler (PB), *1971, studied political science, history and British studies. Film journalist, writing for various regional German publications. Lives in Berlin.

David Gaertner (DG), *1978, studied film and art history. Freelances for the German film archives division of the Berlin Film Museum. Lives in Berlin.

Malte Hagener (MH), *1971, degree in Literature and Media Studies. Editor and author of numerous academic articles. Lecturer in Film History at Amsterdam University. Lives in Amsterdam and Berlin.

Steffen Haubner (SH), *1965, studied Art History and Sociology. Has written many academic and press articles. Collaborator on the science and research section of the *Hamburger Abendblatt*. Lives in Hamburg.

Jörn Hetebrügge (JH), *1971, studied German Literature. Author of many academic and press articles. Academic assistant at the Dresden Technical University Art and Music Institute since 2003. Lives in Berlin.

Harald Keller (HK), *1958, media journalist, works for national newspapers, essays and book publications on the history of film and television. Lives in Osnabrück.

Katja Kirste (KK), *1969, media journalist and academic. Author of numerous publications on film and related subjects. Lives in Munich.

Heinz-Jürgen Köhler (HJK), *1963, chief copy editor for *TV Today*. Author of many academic and press articles. Lives in Hamburg.

Oliver Küch (OK), *1972, studied English language and British history. Media and computer journalist; author of articles on film and television. Lives in Hamburg.

Nils Meyer (NM), *1971, studied German Literature and Politics. Has written many articles in various papers and magazines. Academic assistant at the Dresden Technical University Art and Music Institute since 2003. Lives in Dresden.

Eckhard Pabst (EP), *1965, film theorist, numerous publications as editor and author. Lives in Rendsburg near Kiel.

Lars Penning (LP), *1962, film journalist, works for numerous national newspapers, various articles and books on the history of film. Lives in Berlin.

Anne Pohl (APO), *1961, active as a journalist since 1987. Author of numerous academic articles. Lives in Berlin.

Stephan Reisner (SR), *1969, studied literature and philosophy in Hanover. Freelance journalist in Berlin, writing for *Edit, BELLAtriste, Glasklar* and the *Tagesspiegel*. 1st prize, Kritischer Salon-Preis 2001, Hanover; 2nd prize at the 2002 Vienna Studio Awards.

Burkhard Röwekamp (BR), *1965, researcher at the Institute for Contemporary German Literature and Media at the Philipps University in Marburg. Has taught numerous courses and published many articles on the aesthetics and theory of contemporary film. Lives in Marburg.

CREDITS

The publishers would like to thank the distributors, without whom many of these films would never have reached the big screen.

AFM, APOLLO, ARSENAL, ATLAS, BASIS, CINEMA INTERNATIONAL, COLUMBIA TRI STAR, CONCORDE, CONSTANTIN, FANTASIA, FIFIGE, FILMVERLAG DER AUTOREN UND FUTURA FILM, JUGENDFILM, DIE LUPE, MFA, MGM, NEF, NEUE VISIONEN, P.H.-KNIPP-FILM, PROGRESS, PROKINO, SCOTIA, SILVER CINE, TOBIS STUDIOCANAL, TWENTIETH CENTURY FOX, UIP – UNITED INTERNATIONAL PICTURES, UNITED ARTISTS, WARNER BROS., ZEPHIR, ZORRO, ZUKUNFT.

Academy Award® and Oscar® are the registered trademark and service mark of the Academy of Motion Picture Arts and Sciences.

If, despite our concerted efforts, a distributor has been unintentionally omitted, we apologise and will amend any such errors brought to the attention of the publishers in the next edition.

ACKNOWLEDGEMENTS

As the editor of this volume, I would like to thank all those who invested so much of their time, knowledge and energy into the making of this book. My special thanks to Thierry Nebois of TASCHEN for his coordination work and truly amazing ability to keep track of everything. Thanks also Birgit Reber and Andy Disl for their ingenious design concept that gives pride of place to the pictures, the true capital of any film book. My thanks to Philipp Berens and Thomas Dupont from defd and *Cinema*, and Hilary Tanner from the British Film Institute for their help in accessing the original stills. Then, of course, I am hugely indebted to the authors, whose keen analyses form the backbone of this volume. I would also like to thank David Gaertner for his meticulous technical editing, and Petra Lamers-Schütze, whose commitment and initiative got the project going. And last but not least, Benedikt Taschen, who has included the book in his programme and enthusiastically followed the publication's progress from start to finish. My personal thanks to him and everyone else mentioned here.

ABOUT THIS BOOK

The 55 films selected for this book represent a decade of cinema. It goes without saying this involved making a number of difficult choices, some of which may be contested. A note also on the stills from some of the earlier films: it is a regrettable but inevitable fact that the older the film, the more difficult it is to obtain images of the required technical quality.

Each film is presented by an essay, and accompanied by a glossary text devoted to one person or a cinematographic term. An index of films and a general index are provided at the back of the book to ensure optimal access.

As in the preceding volumes, the films are dated according to the year of production, not the year of release.

IMPRINT

PAGES 1–19	A CLOCKWORK ORANGE / Stanley Kubrick / WARNER BROS.
PAGE 20	EDWARD SCISSORHANDS / Tim Burton / 20TH CENTURY FOX

© 2006 TASCHEN GmbH
Hohenzollernring 53, D–50672 Köln
WWW.TASCHEN.COM

	Original edition: © 2003 TASCHEN GmbH
PHOTOGRAPHS	defd and CINEMA, Hamburg
	BRITISH FILM INSTITUTE, London
PROJECT MANAGEMENT	PETRA LAMERS-SCHÜTZE, Cologne
EDITORIAL COORDINATION	STILISTICO and THIERRY NEBOIS, Cologne
DESIGN	SENSE/NET, ANDY DISL and BIRGIT REBER, Cologne
TEXTS	PHILIPP BÜHLER (PB), DAVID GAERTNER (DG), MALTE HAGENER (MH), STEFFEN HAUBNER (SH), JÖRN HETEBRÜGGE (JH), HARALD KELLER (HK), KATJA KIRSTE (KK), HEINZ-JÜRGEN KÖHLER (HJK), OLIVER KÜCH (OK), NILS MEYER (NM), ECKHARD PABST (EP), LARS PENNING (LP), ANNE POHL (APO), STEPHAN REISNER (SR), BURKHARD RÖWEKAMP (BR)
TECHNICAL EDITING	DAVID GAERTNER, Berlin
ENGLISH TRANSLATION	DANIEL A. HUYSSEN (texts), PATRICK LANAGAN (introduction and texts), SHAUN SAMSON (texts and captions) for ENGLISH EXPRESS, Berlin
EDITING	DANIELA KLEIN for ENGLISH EXPRESS, BERLIN and JONATHAN MURPHY, Brussels
PRODUCTION	UTE WACHENDORF, Cologne

TO STAY INFORMED ABOUT UPCOMING TASCHEN TITLES, PLEASE REQUEST OUR MAGAZINE AT WWW.TASCHEN.COM/MAGAZINE OR WRITE TO TASCHEN AMERICA, 6671 SUNSET BOULEVARD, SUITE 1508, USA-LOS ANGELES, CA 90028, CONTACT-US@TASCHEN.COM, FAX: +1-323-463.4442. WE WILL BE HAPPY TO SEND YOU A FREE COPY OF OUR MAGAZINE WHICH IS FILLED WITH INFORMATION ABOUT ALL OF OUR BOOKS.

PRINTED IN CHINA
ISBN 3–8228–5092–6